P9-CJN-334

2002 BIENNIAL EXHIBITION

WHITNEY bie

nnial 2002

2002 Biennial Exhibition

Introduction by Lawrence R. Rinder

Lawrence R. Rinder
Chrissie Iles
Christiane Paul
Debra Singer

Whitney Museum of American Art, New York
Distributed by Harry N. Abrams, Inc., New York

This book was published on the occasion of the *2002 Biennial Exhibition* at the Whitney Museum of American Art, New York, March 7–May 26, 2002.

The *2002 Biennial Exhibition* is sponsored by Philip Morris Companies Inc.

Additional support is provided by The Brown Foundation, Inc., Houston; The Greenwall Foundation; and the New York City Department of Cultural Affairs.

Net-based art is sponsored by France Telecom North America.

Research for Museum publications is supported by an endowment established by The Andrew W. Mellon Foundation and other generous donors.

A portion of the proceeds from the sale of this book benefits the Whitney Museum of American Art and its programs.

Cover: Meredith Monk, Score of *Eclipse Variations*, 2000. Colored ink on paper, 7 x 8 1/2 in. (17.8 x 21.6 cm). Drawn by Allison Sniffin. © 2001 Meredith Monk (ASCAP)

Library of Congress Cataloging-in-Publication Data
2002 biennial exhibition / introduction by Lawrence R. Rinder ; Lawrence R. Rinder ... [et al.].
 p. cm.
Includes bibliographical references.
 ISBN 0-8109-6832-0
 1. Art, American—20th century—Exhibitions. I. Rinder, Lawrence. II. Whitney Museum of American Art.
 N6512 .A17 2002
 709'.73'0747471—dc21

 2001008048

© 2002 Whitney Museum of American Art
945 Madison Avenue at 75th Street
New York, NY 10021
www.whitney.org

All rights reserved. No part of this publication may be reproduced or transmitted in any form or by any means, electronic or mechanical, including photocopy, recording or any other information storage and retrieval system, or otherwise without written permission from the Whitney Museum of American Art.

Distributed in 2002 by

Harry N. Abrams, Inc.
100 Fifth Avenue
New York, N.Y. 10011
www.abramsbooks.com

Abrams is a subsidiary of

LA MARTINIÈRE
G R O U P E

This publication is made possible by a generous gift from Emily Fisher Landau.

In the year of the seventy-first Whitney Biennial, America has suffered a tragic loss at the hands of those whose creed is violently antagonistic to our ideal of free expression. These embattled times make the Whitney's importance as an arbiter and advocate of contemporary art clearer than ever. The global village Marshall McLuhan predicted has not been realized; instead, warring factions and sharpened divisions among nations threaten democratic ideals around the world. A museum devoted to understanding the achievements of artists who work in the United States offers a welcome forum, freed from the superficialities of ostensibly global surveys that provide highlights, rather than a substantial review of any country's contributions.

The Whitney's Anne and Joel Ehrenkranz Curator of Contemporary Art, Lawrence R. Rinder, provides in this catalogue an eloquent introduction affirming the power of art in this age of uncertainty. His leadership of the 2002 Biennial has been exemplary throughout. With a dogged determination to give every corner of the United States its due, he has logged tens of thousands of miles of travel in search of an illuminating picture of American art today. We all owe him our thanks for this earnest and thoughtful odyssey.

Larry Rinder assembled a stellar team from the Whitney including Chrissie Iles, curator of film and video; Christiane Paul, adjunct curator of new media arts; Debra Singer, associate curator of contemporary art; Kirstin Bach, Biennial coordinator; Elizabeth Fleming, Biennial assistant; Evelyn Hankins, curatorial assistant; Henriette Huldisch, curatorial coordinator, film and video; Tanya Leighton, curatorial assistant; Chris Perez, curatorial assistant; Ilaria Bonacossa, Kirstin Butler, Elizabeth Fisher, and Frank Motz, Biennial researchers; and Silvia Carmen Cubiña, Biennial consultant. Essential assistance was also provided by Lisa Berthoud, Tracey Fugami, Liz Glynn, Marit Knollmueller, Laura Mott, Glenn Phillips, Jose Roca, and Naseem Wahlah.

The Whitney's chairman, Leonard A. Lauder, and president, Joel S. Ehrenkranz, continue to provide leadership for a dedicated Board. The museum's entire staff is involved with each Biennial, and it is only possible to single out those with primary responsibilities: Barbara Bantivoglio, associate director for external affairs; Keith Crippen, exhibition designer; Mary Haus, director of communications; Raina Lampkins-Fielder, acting Helena Rubinstein Chair of Education; Christy Putnam, associate director for exhibitions and collections

management; Suzanne Quigley, head registrar, collections and exhibitions; Debbie Rowe, manager of information technology; and the Publications and New Media Department, led by its director, Garrett White.

In planning the exhibition, the curators convened an extraordinary group of advisors: Bonnie Clearwater, director and chief curator, Museum of Contemporary Art, North Miami; Steve Dietz, curator of new media, Walker Art Center, Minneapolis; James Elaine, curator, Hammer Projects, UCLA Hammer Museum, Los Angeles; Peter Taub, director of performance, Museum of Contemporary Art, Chicago; and Hamza Walker, education director, The Renaissance Society at The University of Chicago. In addition, Mark McElhatten, an independent curator in New York City, gave us invaluable advice throughout the research process.

The catalogue was a collaborative effort of designers J. Abbott Miller and Roy Brooks, Pentagram; Kate Norment, project manager; and David E. Brown, editor. In addition to the curators' texts, catalogue contributions were made by curatorial assistants Evelyn Hankins, Tanya Leighton, and Chris Perez, and grantswriter Alexander Villari.

The Public Art Fund, under the guidance of Susan K. Freedman, president, and Tom Eccles, director, collaborated with the Whitney on a first-ever presentation of Biennial works in Central Park, which is sponsored by Bloomberg. We are very grateful to Richard Griggs and Anne Wehr, project director and communications manager of the Public Art Fund, respectively. We would also like to thank Creative Time and its executive director, Anne Pasternak, for their cooperation in the presentation of Biennial work.

The exhibition is sponsored by Philip Morris Companies Inc. Significant support for this exhibition has been provided through an endowment established by Emily Fisher Landau and Leonard A. Lauder. Additional support is provided by The Brown Foundation, Inc., Houston; The Greenwall Foundation; and the New York City Department of Cultural Affairs. Net-based art is sponsored by France Telecom North America.

The artists in the Biennial are due our special thanks. This exhibition is theirs.

Maxwell L. Anderson, *Alice Pratt Brown Director*

I'd been on the road for three months, visiting with artists from one end of America to the other, stopping in forty-three cities and towns in twenty-seven states and the Commonwealth of Puerto Rico. Late on the night of September 10, I made the last leg of my trip, flying from Chicago back to New York City. I can't recall ever having seen Manhattan look more serene and resplendent and, as a transplanted West Coaster who was having a rough time adjusting to life in Gotham, I felt for the first time genuinely glad to be home. I was awakened the next morning by voices on the roof of the building next door, but didn't realize what was the matter until I was outside and on my way to work. Looking south from Houston Street, I saw bright flames and a sickly gray cloud enveloping the towers of the World Trade Center.

As I write this, in the aftermath of the attack, the questions of what is American art, what is an American artist, and what is a museum of American art have taken on a keen and tragic importance. Our uniqueness as a nation has suddenly been thrown into high relief, even as we experience an unprecedented sense of solidarity and common humanity with people of almost every nation on the globe. There is a profound sense of being at the most portentous crossroad in history. The wisdom of our response will depend on how well we know ourselves. It is imperative that we have the courage to look deeply, and critically, into our own national character. Already there is a stirring sense of a need to change, once the immediate threat to our security has been allayed. Will these changes be material, such as a lessening of our reliance on nonrenewable energy sources? Will they be political, a renewing of the spirit of global partnership and brotherhood? Will they be spiritual, a transformation of our priorities and daily interactions? The events of September 11, 2001, have accelerated a process of self-reflection and debate that has been integral to this country since its founding. Americans have been blessed with a remarkable capacity to imagine the unimaginable and, more than that, a determination to achieve it. We desperately need to call on that imagination and determination now.

As dwellers in the realm of the imagination, artists are a profound resource for a society that has both been robbed of a potent symbol and is casting about for new images and

metaphors to express the character of life in this shaken world. Instead of limiting our self-representations, sacrificing the genuine diversity that makes us strong in order to achieve a loud but hollow unity, we can find strength in the fluidity of symbols and even in the ambiguity of our desires. Faced with a fundamentalist foe, the choice between artistic freedom and repressive doctrine has never been more starkly drawn. Even President Bush, a self-avowed conservative born-again Christian, acknowledged in the aftermath of the attack the importance of creativity in American society and denounced the restrictive social agendas of America's own fundamentalist factions.

At the beginning of the Biennial research process, I gave myself and the other curators—Chrissie Iles, Christiane Paul, and Debra Singer—a single directive: Whenever you find a work that intrigues you, but which seems to lie beyond the pale of the contemporary art world as it is normally defined, stop to ask why. What are the assumptions that underlie the divisions and boundaries that we have come to take for granted and which stipulate that this, but not that, is suitable for museum display? What qualities are implicit in terms like "craft," "outsider art," or "popular culture"? How hard do we have to look to find vestiges of sexism, classism, and racism in the ways that the creativity of Americans is categorized, marketed, and shown? What is to be lost and what gained by loosening these definitions and embracing a broader spectrum of practices? The 2002 Biennial does not provide answers to these questions, and it opens the door only hesitantly to the possible richness of a truly expanded view of artistic practice. But it is a step in that direction.

A number of exhibitions laid a foundation for such an exploration of artistic boundaries. Jean-Hubert Martin's seminal 1989 exhibition "Magicians of the Earth" and, more recently, his Bienalle d'art contemporain de Lyon in 2000 combined works by Western and non-Western, schooled and unschooled creative practitioners, united under the notion of the common spiritual foundations of the aesthetic enterprise. Still, these exhibitions have been roundly, and rightly, criticized for placing artists on an unequal footing by, for example, leaving some of the non-Western works unattributed and undated in the Lyon exhibition. Another important precedent was "Manifesta 3," the European Biennial

of Contemporary Art, which took place in Ljubljana, Slovenia, in 2000 and which took for its theme "the border syndrome." The curators structured the exhibition around a parallel between the phenomenon of national borders and the psychoanalytic notion of a border syndrome, a mental state akin to manic depression. By linking art, politics, and psychology, they arrived at a rich territory in which the images, symbols, and metaphors of the exhibited works gained a feeling of timeliness and urgency.

Even before the events of September 11, I was convinced that there was little need for works of art that lack a powerful sense of conviction. It has not been fashionable to speak of sincerity as an important attribute in works of art, yet today nothing seems more urgent than to know one's own heart and to speak one's own mind as directly and honestly as possible. Perhaps beauty and irony are luxuries of peacetime, something to cherish as much as unrestricted travel and life without gas masks. Yet for many artists I encountered over this past summer, there seems to have already been an awareness of the need for art to perform some greater role than mere decoration or ironic critique. Time after time, I was told by the artists I met that, finally, they aimed for one thing alone, to represent "truth" as they knew it. Now, truth can be as dangerous a word as doctrine and is just a step or two away from the logic of fundamentalism. But, if there can be different kinds of truth, then I believe what these artists are getting at is not at all related to the restrictive "truth" of a Jerry Falwell or an Osama bin Laden. Rather it is a personal, conditional, and generous truth that seeks nothing more than to reclaim the individual's expressive capacity from the corporate monolith of mass-media entertainment, from the market-dominated trends of the mainstream art world, from academic notions of the "simulacrum" and the "spectacle," and from the inertia-bound trajectories of many art periodicals and institutions.

It is astonishing how many Americans are making art. Despite the general lack of interest in the visual arts shown by our educational system and government, Americans of all classes and ethnicities turn to art for everything from political expression to self-reflection. We have very recently gone to war with those for whom many forms of artistic representations are anathema.

It is useful to remind ourselves at this moment just how important and ubiquitous art-making has become in our own society.

My travels around the country led me to artists whose work I had known but whom I had never met as well as to wholly new and surprising contacts. I depended to a large degree on the generous advice of colleagues along the way as well as on recommendations from artists themselves. I had to plan ahead, of course, but also tried to keep time free for whatever might turn up after I'd spent time in a given locale. Some places, especially certain American cities, reveal themselves slowly. Seeing so much art in a relatively brief period of time helped me to sense patterns and tendencies, as well as to heighten my awareness of exceptional situations.

While I visited artists of all ages, I was especially curious to see how the younger generation was going about the difficult task of creating and exhibiting art. I found many young people throughout the country looking for ways to sustain creative practices without concern for the art market or art world accolades. Their most important concerns seemed to be cheap rent, communities of like-minded individuals, and opportunities to show in their own localities. In some cities I saw how a handful of people—or sometimes just one passionate individual—could galvanize a "scene" and create a feeling of buzz and vitality. Providence, Detroit, Minneapolis, Philadelphia, San Francisco, Chicago, Houston, San Antonio, San Juan, and Miami were all places outside the New York–L.A. axis where I found tremendous energy and self-sufficiency. I didn't notice much in the way of regional differences, perhaps because people move around so much these days. There were some exceptions, though. In the so-called Rust Belt of the Northeast and Upper Midwest, there seemed to be a renewed feeling of local pride and an enthusiasm for the conditions peculiar to the region. Many young artists I met—those in Providence, Albany, Buffalo, and Detroit especially—were delighted to be working amid the blight and decay of American industry. There they found not only absurdly low rents, at least by New York standards, but also a cornucopia of material riches in the form of scavenged supplies from abandoned factories. Another tendency among the younger artists I met was to be simultaneously engaged in multiple art forms:

it was altogether common to encounter an accomplished artist who was also a musician, dancer, puppeteer, or other kind of performer. The propensity of performing artists to tour has led to the beginnings of visual art networks among far-flung cities. Still, despite the healthy trend toward greater artistic strength and autonomy in cities and towns across the country, New York remains the economic center of the art world and, for better or worse, the place where countless ambitious artists come to make their mark. So, despite my extensive travels and my honest desire to open up the research process to a much wider pool of artists, the usual predominance of New Yorkers on the Biennial roster is unshaken.

Stylistically, the American art world is as eclectic, or pluralistic, as it has ever been. There is really no prevailing orthodoxy, except in pockets around certain high-profile art schools. Nevertheless, I noticed a number of intriguing tendencies. Especially among the younger artists, the recent fascination with super-high-end production values has been supplanted by a more spontaneous, do-it-yourself aesthetic. In addition to the ongoing influence—both in content and form—of the Hollywood film industry, comics have become a major inspiration to artists of every generation. Much as many young artists play in bands as well as making visual art, many also self-publish their own comics, zines, or graphic novels. The distribution of these publications may contribute as much as touring performers to the exchange of ideas and aesthetic strategies around the country.

Contemporary American culture continues to be invigorated by the arrival of artists from around the world. Bringing techniques, styles, and subject matter from their home countries, these artists are increasingly finding a place in the fabric of the American art world. For the Biennial, our criteria for inclusion require that the artist either be an American citizen, no matter where he or she lives and works, or be a citizen of any country and be making art in America. This definition is broad enough to be true to the real flux of the American experience. The unique cultural diversity that makes this country what it is also remains a special focus of many artists. During my travels, I was particularly impressed by the range and depth of artistic investigations into the condition of contemporary race relations. There is no question

that the black-white divide remains an open wound in our national psyche.

While it is impossible to characterize the state of contemporary art in strict terms, as the research period for the Biennial drew to a close I began to see a number of key themes emerge. Once I had a list of artists, I made an initial sketch of how the works I was most interested in might be arranged among the museum's three primary floors. I was surprised to find that they divided quite neatly into three related themes, which I identified as Beings, Spaces, and Tribes. Discussions with my co-curators confirmed that in the areas of film, video, sound, performance, and Internet art, these three terms could be used to characterize related artistic tendencies.

A concern for fundamental states of existence—often represented by imaginary or, sometimes, mythological "beings"— seems to have replaced the focus on identity and the body of the recent past. It is at once a more philosophical and spiritual concern as well as being, at times, more playful and even ludicrous. And it enables artists to treat questions of identity and individual agency at arm's length, to project qualities of humanity onto surrogates that stand in for our passions and fears. This has been the role of mythology from the dawn of art and literature. In some cases today's artists are returning to ancient narratives and characters, while in others they are developing highly personal, complex narratives and mythologies.

The spaces that seem to interest artists today are ones of habitation. How, they ask, does space fit around us and conform to our bodies, actions, and wills? As with the contemporary interest in notions of being, the representations of space included here are frequently abstracted: subtle qualities of color and form are used to elicit visceral sensations of occupiable space. Other artists treat space symbolically or metaphorically, often using distinctly common materials such as foamcore and lace to allude to even the most complex and technological conditions of a globalized and often virtual reality. The already permeable boundary between art and architecture has been further eroded by this broad interest in the physical, social, and cultural conditions of space. The road between these fields of practice is increasingly well traveled both by artists who create what

15

amount to architectural models, and by architects who create drawings and watercolors of abstract light and form.

The word "tribe" may call to mind primitive social groups and tendencies toward xenophobia, isolation, and hostility. Yet the events of September 11 remind us that for all of our world's civilized advances, we remain a hair's breadth from the fanatic, murderous tribalism known to us from Herodotus and other ancient authors. We remain divided, by everything from our beliefs to our lifestyles to our insignia. What future is there for humanity when patterns of division and distrust persist? The artists here examine a variety of social groups and find reason for hope. They find similarities where only differences are assumed, ambiguity where certainty prevailed, and gentleness where violence seems the order of the day. Collective artistic projects, too, appear to be increasingly common, sometimes even involving communal living arrangements or, more often, artists who borrow the structure of the rock band as a model for ongoing collaboration and group identity.

At the outset of our work together I informed my co-curators that they would have autonomy in their own areas of focus but that we would carry on a dialogue that would inform each of our decisions and, hopefully, lead to a coherent exhibition of independent, but interrelated parts. Although they were charged with exploring a range of different media, the reality of contemporary art is that today's artists are increasingly unconcerned with categories and definitions. This led to quite a few artists finding themselves being pursued simultaneously by multiple Whitney curators. Much as architecture has become one of many formal languages used by artists, so have film, video, the Internet, sound, and performance simply become new elements in the increasingly varied artistic toolkit.

Still, in each of these areas, the Biennial curators found medium-specific tendencies worth noting. As Chrissie Iles describes, "I was struck by the amount of current film work that is handmade, or engaged in visceral, material processes. In some works, the surface of the film is altered by physical and organic decay. In others, light, color, focus, objects, and the body become means and materials by which film is redefined as a performative experience. The cinematic apparatus itself is often intrinsic to

the work's meaning. Narratives constructed using early-nineteenth-century, precinematic devices, and the mechanics of film projection, reassert the viscerality of film and the materiality of the cinematic experience." Debra Singer's investigation into recent sound art led to the observation that an increasing number of artists are exploiting the capabilities of surround sound technology to create immersive, multichannel aural environments. The types of sonic experiences of interest to contemporary artists include works based on site or field recordings, pieces based on thresholds of perception, and works that use sound in a sculptural way. In the field of performance, Singer decided to focus on pieces that occur either in the galleries themselves or in the public arena, and her selections are characterized by a direct and often remarkably informal mode of presentation. "The emerging generation of performers," comments Singer, "is strongly influenced by the Fluxus movement of the 1960s, engaging political issues through acts of endurance and vulnerability, as well as exhibiting, on the other hand, a certain kind of pranksterish impulse." Christiane Paul's selection of Internet-based art was intended to give an impression of the variety of forms that Net art can take and the multiple themes that have emerged over the years. Among these themes are data visualization and mapping, database aesthetics, gaming paradigms, agent technology, and nomadic devices.

Virtually all of the works in the 2002 Biennial were identified before the events of September 11. The timing of the catalogue did not allow us the opportunity to include many of the vast number of works made in response to the World Trade Center and Pentagon attacks, nor to document the subsequent transformations in contemporary American art. Nevertheless, I hope that the exhibition captures the sentiment and direction of artistic practice as it was headed even before the tragic attack. Perhaps it will even come to be seen as anticipating the direction of things to come.

Lawrence R. Rinder
Anne and Joel Ehrenkranz Curator of Contemporary Art

From one of Lara's fans on-line :
"I think Lara should have a silenced
pistol. Also she should have all her
weapons at her house to kill the butler
in style. Desert Eagle silencer equipped
.22 pistol, Magnum revolver, Uzis, long-
barrel MAC 10 (more to spray fire than
as a precise shot weapon), Shotgun
twin-barrel (for single fire double-shot-
gun impact) MP5, M-16 or G-11 or AK-47
(these weapons should vary depending
on where on the globe she's adventur-
ing. AK-47 in Africa, Eastern Europe,
Middle East countries and
terrorist/smugglers/drug contrabandist
operations; G-11 for Western European
places and M-16 for USA, South
America, Far East countries and mili-
taries.) Grenade launcher, sniper rifle,
climbing hook thrower, flamethrower,
bazooka, M-60 or MiniGun (those
should be real devastating)."

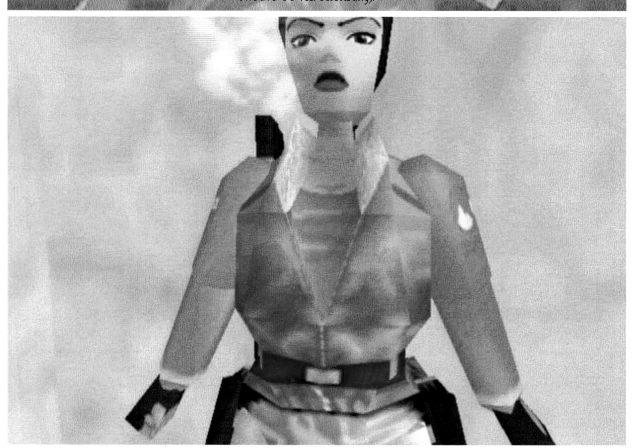

Stills from *She Puppet*, 2001. Video, color, sound; 15 minutes

Throughout Peggy Ahwesh's distinguished career as an experimental film- and videomaker, her work has explored the ways in which social constructions of female sexuality and power are played out through cultural expressions of fantasy and desire. Ahwesh's films address the politics of cinematic representation, exploring American popular culture as a site for potential transformation and empowerment. For her, the most potent contemporary female model of empowerment is Lara Croft, the busty female star of the popular video game *Tomb Raider* and the subject of Ahwesh's new video, *She Puppet*.

Lara Croft is the quintessential fantasy woman: sexually alluring, impossibly voluptuous, physically powerful, well-bred (the orphaned daughter of a British aristocrat), courageous, thrill-seeking, and smart—a cross between Emma Peel and Arnold Schwarzenegger. Editing video footage of Croft recorded directly from the screen as she repeatedly played the video game, Ahwesh was struck by the surreality of Croft's composite 3-D animation. "Like earlier magical entertainments that operated with technological metaphors for the body, such as late-nineteenth-century trick film...Lara Croft is the girl-doll of the late twentieth century gaming world," she explains. "What we like most about her is that she is a collection of cones and cylinders—not human at all— most worthy as a repository for our post-feminist fantasies of adventure, sex and a violence without consequence."

Ahwesh reworks sections of the original video game to create a portrait of a fantasy constructed from a triadic persona: alien, orphan, and clone. Female power is articulated through action and risk: in the video game Lara visits the South Seas, the rooftops of London, the glaciers of Antarctica, and the canyons of the desert. As Ahwesh observes, Croft's "artificiality offers a curious sense of liberation from the conventional constraints of womanhood. We gaze admiringly at her special attributes of unconstrained gender as she guides us through our adventures into dangerous and unknown territory...." Yet, "for all the personality and backstory with which the franchise has endowed her, she remains a forever- accommodating and private fantasy ideal, facilitated by clever computer programmers."

BOSMAT ALON
AND TIRTZA EVEN

In 1998 Tirtza Even began a collaborative project with Bosmat Alon, a friend, editor, and translator from Jerusalem. *Kayam Al Hurbano (Existing on Its Ruins)* stemmed from conversations between the two directors and was initially inspired by short anecdotal dream texts written by Alon.

Their digital video, shot in Deheishe, a Palestinian refugee camp near Bethlehem, and in the surroundings of Hebron (Halil), addresses the highly charged subject of the Palestinian-Israeli conflict. The directors interviewed dwellers in the camp and people from Hebron whose homes had been demolished by the Israeli government. Fragments of the interviews are interwoven with languorous images of daily life, which create an unsettling disjunction with the hard reality they depict. Exploiting formal digital devices such as opening cracks in the picture and planes of light slowly sliding off the edge of the frame, Even and Alon create a visual syntax that expresses the fractured and transient life of the Palestinian refugees. Images are held for long moments, hovering between stillness and movement. In "the charged silence of a continuous pause, an extended margin of inaction," listless men sit, endlessly waiting, in a limbo of displacement and uncertainty.

The complex relationship of the Israeli directors to their subject, and of the viewer's role as witness to the scene, is epitomized in a story by Alon, told in silent words scrolling vertically down the screen at the beginning of the film. The narrator encounters an educated man on a beach in Beirut and makes a strong emotional connection with him. Gradually, it is revealed that he kills routinely for political reasons. As the recognition of each other's identities dawns, the warmth between them is replaced by suspicion and their roles as enemies in an ongoing conflict. Alon's text, which operates somewhere between fact and fiction, articulates the contested terrain not only of the Israelis and Palestinians, but of reality itself.

Stills from *Kayam Al Hurbano (Existing on Its Ruins)*, 1999. Digital video, color, sound; 35 minutes

Knowledge Session, *number IV,*
(Tonal), 2001. Performance still

For nearly a decade, José Alvarez has been developing a complex
body of work involving performances before mass audiences,
appearances on global network television, and private interventions
at sites throughout the world, as well as related photographs,
sculptures, prints, drawings, paintings, and videos. The central
theme of Alvarez's art is belief. His work explores the ways
that four key types of belief—artistic, religious, political, and
scientific—intersect, specifically in relation to such phenomena
as charisma, aesthetics, and power. In order to delve into the
social construction of belief, one aspect of Alvarez's work has
involved "channelings" of an ancient spirit he identifies as Carlos,
which are performed at large public theaters and auditoriums.
Media coverage of the Carlos events too has become an integral
aspect of Alvarez's overall artistic work. "The ideas of truth/
illusion, reality/falsehood, power/marginalization, the nature
of charisma, are all elements of my work," comments Alvarez.
"The media phase of the project is an investigation of the
agencies of power—the media in general—and how consensus
is created through repetition, emphasis, editing, etc. It is a study
of the anatomy of the inner workings of image production and
its consequences to the public."

Alvarez's Biennial installation consists of a row of monitors
showing continuous looped video collages of media coverage
of the Carlos events. Discreetly embedded in one wall is a mirror-
lined diorama showing Alvarez crouching behind a bed of
hallucinogenic mushrooms. On an adjacent wall he has placed
a silk-screened quotation from Carlos Castaneda's popular book
The Teachings of Don Juan: A Yaqui Way of Knowledge. With the
inclusion of these elements, Alvarez places his public channelings
in the broader context of contemporary mystical thought
as well as hinting at drug-induced delusion and the practice
of "smoke and mirrors" magical fakery.

MARYANNE AMACHER

Composer and sound artist Maryanne Amacher is best known for her exhilarating sound environments and performances set in expansive and unusual architectural spaces. For more than twenty-five years, she has created compositions that use digital technologies in conjunction with the unique acoustic properties of particular structures to transform studio recordings into three-dimensional sound installations of epic proportions.

Since the 1970s, when she studied with Karlheinz Stockhausen and composed works with John Cage and Merce Cunningham, Amacher has focused her efforts on developing a form of encompassing aural architecture that gives the effect of a virtual immersion in sound. Filled with explosive bursts, thundering roars, and piercing pitches, Amacher's dynamic works explore the modes and mechanisms of hearing, specifically how we locate, sense, and feel sonic events. Many of her pieces called "ear dances" experiment with her idea of "third ear music," wherein certain frequencies and pitches cause a listener's inner ear to act like an instrument and generate its own new sounds. These tones, referred to as "otoacoustic emissions," appear to emanate solely from inside the head and exist only in the ears, yet add to the sonic complexity of the music. Other compositions are made up of almost imperceptible, low droning tones that gradually fade out and are intended to create aural "afterimages," noises that seem to linger in one's head long after the actual sound has ceased.

In her multichannel sound installation in the 2002 Biennial, Amacher circulates the sound throughout the room, allowing listeners to perceive the spatial dimensions and sensory presence of acoustic experience. She likens her extreme, animated sound-scapes to "sonic theater" that is "felt throughout the body as well as heard."

Maryanne Amacher performing *The Wire* at the Kunstmuseum Bern, 1998

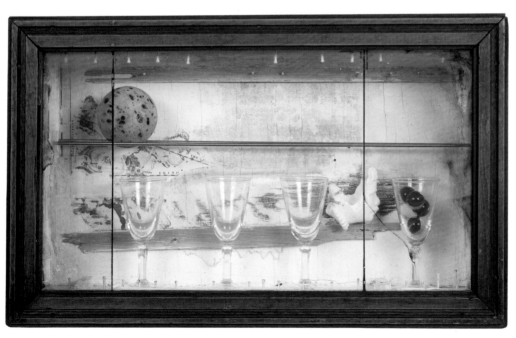

ARCHIVE
(CHRIS KUBICK AND ANNE WALSH)

Archive (Chris Kubick and Anne Walsh) after a séance with dance movement therapist/trance medium Valerie A. Winborne, December 2001. Works in background: Joseph Cornell's *Rose Castle*, 1945; *Custodian—M.M.*, 1962; and *Untitled (Celestial Navigation)*, n.d., all from the Whitney Museum of American Art, New York

Joseph Cornell, *Untitled (Celestial Navigation)*, n.d. Box construction with wood, glasses, marbles, plaster head, painted cork ball, metal rods, nails, paper collage, tempera, and painted glass, 9 5/8 x 16 1/4 x 4 in. (24.4 x 41.3 x 10.2 cm) sight. Whitney Museum of American Art, New York; 60th Anniversary Gift of Estée Lauder Inc. 92.24. © The Joseph and Robert Cornell Memorial Foundation/Licensed by VAGA, New York, NY

What would a dead artist say if given the chance to respond to posthumous critical analysis? Intrigued by the way art historians "speak" for artists who are no longer alive, Archive, a Los Angeles–based collaboration between Chris Kubick and Anne Walsh, decided to give deceased artists a "voice" by interviewing them through séances conducted by professional spirit mediums and psychics. In Archive's *Art After Death* project, the complex possibilities and pitfalls of the interpretative act are explored in a series of audio CDs featuring excerpts from these sessions. For the 2002 Biennial, Archive has created an audio work of interviews with Joseph Cornell, conducted via private séances in the Museum.

Archive is drawn to artists whose work engages issues of identity, spirituality, self-portraiture, or masquerade as well as those who during their lifetime had an interest in the afterlife, the occult, or contact with the dead. Past subjects include Yves Klein and the Countess of Castiglione, a late-nineteenth-century Italian noblewoman who obsessively reinvented her image in a series of photographic self-portraits.

Walsh and Kubick exhaustively research the chosen artist's life and work as well as meditate on and create shrines for the artist. For every subject up to four séances are held with different psychics each time. Archive provides only the full name, birth and death dates, and a photograph of their subject. In some cases the séance is conducted in the presence of the artist's work, in a museum or private collection.

When listening to a series of accounts about a single artist, perhaps the most unsettling aspect is the uncanny conformity of different mediums' detailed descriptions of an artist's traits, habits, and idiosyncrasies. Whether the listener believes these reports is, in the end, beside the point. The project is not about belief or disbelief, right or wrong, true or false. Rather, *Art After Death* is an endeavor in alternative modes of storytelling, interpretation, and communication as well as a wry reminder that history itself is not an irrefutable construct of fact, but a creative act of narration.

GREGOR ASCH
(DJ OLIVE THE AUDIO JANITOR)

Gregor Asch (DJ Olive the Audio Janitor) mixes recordings of common urban noises with samples of assorted styles of existing music into highly distinctive audio collages that cross musical genres. Known for using multiple turntables as both musical instruments and compositional tools, Asch ingeniously manipulates and fuses everyday street sounds with musical clips from wildly eclectic sources, ranging from works by John Cage and 1950s *musique concrète* to electronica, dance hall, drum 'n' bass, and house music. The resulting sonic works are often described as "illbient," a style of experimental club music that, while complex and beat-driven, is not dance-based. A term of his own invention and widely used in the last five years, illbient denotes rugged, atmospheric works made by interweaving extremely disparate musical elements. Like the music it describes, the term comes from pairing two unlikely words together— "ambient," a typically relaxed-sounding genre of atmospheric electronic music, and hip-hop culture's "ill," a complimentary term used to describe the successful combination of two seemingly incompatible components, like unusual juxtapositions of colors or clothing.

In his new surround sound installation, *Roof Music: Sunrise on a Rooftop in Brooklyn*, Asch introduces another potential new subgenre of music. As Asch explains, "We've had garage music, house music, dance hall...this is Roof Music, where all music— all sound—all cultures are relevant and float in the same soup without hierarchy." Alluding metaphorically to the heightened sensorial effects and alternative perspectives—whether visual, aural, or physical—experienced when observing the world from the encompassing vantage of a rooftop, "roof music" is as much a philosophical attitude as a musical style. Its basic concept is an unconditional inclusion of diverse and incongruous sounds into integrated listening experiences. In *Roof Music*, Asch creates a densely constructed, erupting soundscape of raw percussive effects, throbbing beats, and subtly modulated rumbles that aim to reflect the chaotic and contradictory realities of our technology-obsessed and consumer-driven culture.

Gregor Asch (DJ Olive the Audio Janitor) performing at The Cooler, New York, October 3–4, 1998

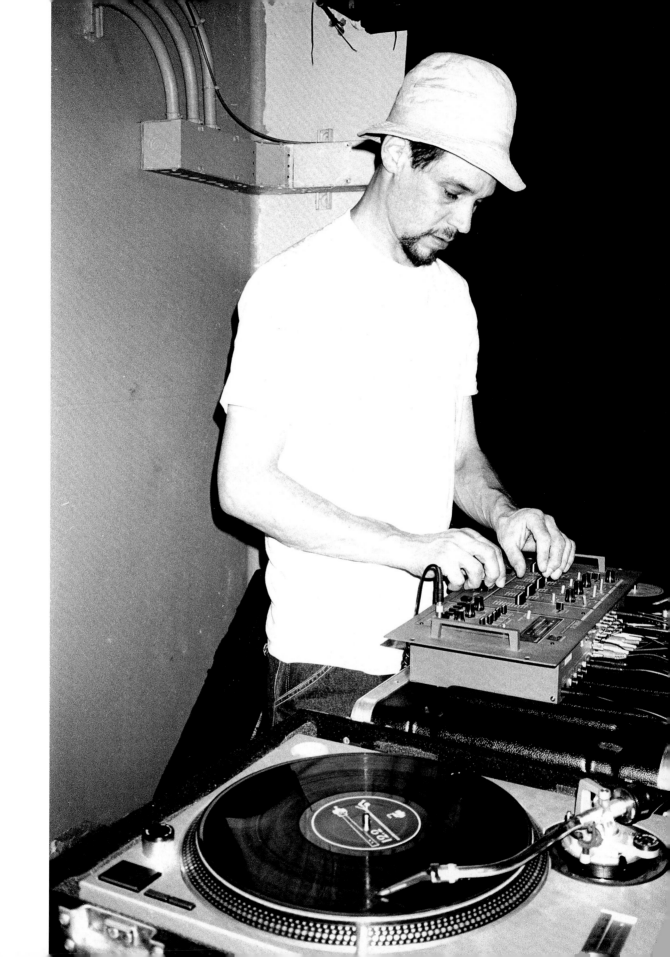

Still from *These Are Not My Images (Neither There Nor Here)*, 2000. Video, color, sound; 80 minutes

These Are Not My Images (Neither There Nor Here) is video and installation artist Irit Batsry's first feature film; it belongs to an ongoing thematic project, *Neither There Nor Here*, begun in 1994. The title of both the film and the ongoing project articulates a deep sense of displacement, dispossession, and ambivalence. Rhetorically refusing both the content of her film and any stable definition of her own location, Batsry creates a dislocation of place, medium, genre, and meaning, interweaving different layers of each. The film is shot on video and digitally edited; the place, Southern India, is both a physical location and a metaphor for remoteness; and the genre shifts between documentary, experimental narrative, and personal essay. In the film, a Western filmmaker journeys through Southern India, accompanied by a half-blind guide, and encounters a local filmmaker. All three characters narrate their different views on the meaning of place. Each is removed in some way: the guide by his near-blindness, the Western filmmaker by her remoteness to the country she is recording, and the local filmmaker by the recontextualizing of his own perspective through the experiences of the other two.

Throughout the film, Batsry denies the viewer a clear visual sense of the place through which all three are traveling. Richly colored footage of the journey gives us elusive glimpses, quickly blurred through soft focus; images shot from moving trains sweep the landscape into streaks of color. Sounds—in a soundtrack by Stuart Jones—linger after their accompanying images have disappeared, breaking the conventional linearity of sound and image. Batsry's intense questioning of what constitutes truth, fiction, reality, and memory is reflected in her fusion of film and video techniques. This hybrid approach to image-making creates a liminal, in-between space similar to Jean-Luc Godard's "border-crossing" of cinema with electronic imagery in the 1970s. This space serves as a distancing device by which truth becomes stranger than fiction.

ROBERT BEAVERS

Robert Beavers has been making films since the late 1960s, yet screenings of his work are rare, and are always stringently supervised by the artist. Beavers's meticulously composed films are influenced by the structural tradition of the Greek-American avant-garde filmmaker Gregory Markopoulos, his teacher and long-term partner. However, they stem from a more visceral, lyrical source. Each of his films is conceptually complex, carefully crafted, and concise. Several of them explore what Beavers calls "the question of how to show the 'reverse' side of an object in film. How to give the full sense of this as it is related to other facets of prismatic space in film."

In *The Ground*, the three-dimensionality of Beavers's "prismatic space" is articulated through a dialogue between the actions of a bare-chested stonecutter and the curved, sun-baked surface of a ruined tower. Filmed on the Greek island of Hydra, *The Ground* captures the sensual, precise details of a stonemason's body as he cups his hand to his chest, echoing the curve of a ruined tower nearby and implying a connection between the concave spaces of the large and small forms. Beavers also draws a parallel between the actions of the stonemason's chisel on stone and his own editorial cuts. His deep understanding of the material, volumetric possibilities of cinema is revealed in his statement for *The Ground*: "What lives in the space between the stones, in the space cupped between my hand and my chest?...With each swing of the hammer I cut into the image, and the sound rises from the chisel. A rhythm, marked by repetition and animated by variation; strokes, of hammer and of fist, resounding in dialogue."

Beavers's sensibility evokes Rainer Maria Rilke's transmutation of everyday objects into images that are invested with the power to become autonomous vessels of thought. In *The Ground*, one of three recent films by Beavers presented at the 2002 Biennial, this thought, as P. Adams Sitney has observed, is "the coming into being and testing of perceptions, associations and ideas, [which invest] his work with a lucid serenity."

Still from *The Ground*, 2001. 35mm film, color, sound; 20 minutes

Still from *Shadow Land or Light from the Other Side*, 2000. 16mm stereoscopic film, black-and-white, sound; 32 minutes

Zoe Beloff's work embraces both nineteenth-century proto-cinematic forms and the digital environment of new media. Her films, stereoscopic projections, performances, and interactive CD-ROMs explore the nineteenth-century belief in technology as a conduit for parapsychological phenomena, and cinema as a medium capable of resurrecting the spirits of the dead.

Beloff's works articulate the repressed desire and fantasy triggered by technology's potential to unlock the unconscious. This potential was manifested in the Victorian age through quasiscientific practices such as parapsychology, psychoanalysis, and Charcot's studies of hysteria. Her *Shadow Land or Light from the Other Side*, a stereoscopic film based on the medium Elizabeth D'Esperance's 1897 autobiography, explores the nexus of these three practices. In Beloff's film, the stereoscopic layering of the images and the unusual, vertical aspect ratio of the film compress the viewer's reading of the narrative into a narrow, three-dimensional, prismatic space, in which objects appear to float in front of our eyes and people move backwards and forwards, as though in separate visual planes.

The materialization of ghostly forms through the female medium is understood to be a manifestation of a repressed Victorian feminine unconscious. In Beloff's hands, the cinematic image becomes, itself, a kind of phantasm, whose illusory presence could melt away at any moment into the darkness.

In *A Mechanical Medium*, Beloff, in collaboration with sound artist Gen Ken Montgomery, creates a live "stereoscopic séance," in which stereoscopic 16mm home movies from the 1930s are projected over vintage 3-D color slides of Asbury Park, New Jersey. The work was inspired by Thomas Edison's search for a machine that could communicate with the spirit world. Montgomery's soundtrack, of 78 rpm records and recordings of cinematic machines, mixed live, evokes Edison's phonograph, whose recordings of disembodied voices suggested the presence of the departed. The live participation of both artists in the presentation of *A Mechanical Medium* recalls nineteenth-century magic lantern shows, in which the projectionist "performed" each screening.

SANFORD BIGGERS
AND JENNIFER ZACKIN

Sanford Biggers and Jennifer Zackin's video work *a small world…* consists of silent clips from their childhood Super-8 home movies running side-by-side. Although cultural differences are immediately evident in their middle-class upbringings—African American and Jewish, respectively—the piece draws attention to the remarkable similarities in the activities and rituals of their daily lives. Much of the six-and-a-half-minute loop displays uncannily similar shots of festive family occasions: birthday parties, Hanukkah and Christmas gatherings, barbecues, and vacations to Disneyland. Other shots show Biggers and Zackin simply being kids, riding tricycles, practicing the piano, and playing games with their relatives. This often humorous collage of images illustrates the underlying social cohesion in America, but the shared identity produces an inherent conundrum. As Biggers explains, "The middle-class Jewish and African American families act as metaphors for the ongoing emergence of the next America, a society delineated more on the likes of economics than ethnicity. This vision of an American culture of class makes us all more interchangeable than we are willing to admit, leaving our individual cultural heritage the only truly distinctive aspect of our identities."

The artists' installation includes a 1970s-style sofa and a shag rug set up in front of the projection. "The intent," says Biggers, "is to create a space where random viewers sit next to one another on the sofa as if in the comfort of a family room. The viewers' respective worlds combine into a shared, albeit temporary, family experience."

Stills from *a small world…*, 1999. Video installation, dimensions variable; 6 1/2 minutes. Collection of the artists

Stills from *Heaven on Earth*, 2001.
Video, color, sound; 3 minutes

Susan Black's video works are landscapes of American suburbia whose physical reality is subjected to a surreal visual reinterpretation. In *Heaven on Earth*, a single, long tracking shot of bungalows and neatly tended gardens in Palm Springs, California, is inverted. This simple device, analogous to Andy Warhol's slowing of his films from 24 to 16 frames per second, renders the image newly concrete. The ordinariness of a row of suburban houses is replaced by a dramatic abstraction of form, in which the shape, volume, and weight of each house, fence, and tree now hanging from the ceiling is given a new density and three-dimensionality.

Black renders the video's metaphorical title in literal visual terms, placing the sky where the earth should be, with the horizon dividing the screen evenly across the center. The inversion suggests a surreal reading of the popular American belief in suburbia as an oasis, or "heaven on earth." The flipping of earth heavenward creates a feeling of estrangement, heightened by the absence of people and the lack of any movement on the sidewalks. The endless tracking shot is accompanied by a homemade soundtrack, which includes sampled songs by Oz Mutantes, a 1960s Brazilian psychedelic band. The mesmeric music echoes the hypnotic flow of the endless panorama, while Black's nauseating merry-go-round of sameness and repetition renders a figurative space an abstract study of suburban ennui. *Heaven on Earth* depicts the hyper-reality of American suburbia, recalling Jean Baudrillard's comment on Disneyland, which he states is "presented as imaginary in order to make us believe that the rest is real."

JEREMY BLAKE

Jeremy Blake's video projection *Winchester* combines film, digital video, and computer-generated effects to represent the San Jose, California, home of Sarah Winchester, widow of the founder of the Winchester rifle company. After her husband's death in 1881, Sarah Winchester believed that she was being pursued and punished by the phantoms of those who had been killed by Winchester guns. In order to accommodate friendly spirits by providing them with their own quarters, and to ward off evil ones with the noisy activity of construction work, Winchester continually added new rooms, stairs, and chimneys to her home over a thirty-eight-year period, resulting in a sprawling architectural oddity.

Winchester's convoluted expressions of guilt and her hope for solace in endless productivity are transformed in this piece into a powerful allegory of American history. Blake extends into virtual space Winchester's mania for building, using the computer to "rebuild the space, exaggerating its peculiarities and indicating the activities of its spectral occupants." His piece explores Winchester's habit of constructing stairs to nowhere and her obsession with the number thirteen. Good and evil spirits are represented with painterly abstract imagery that draws on late-nineteenth- and early-twentieth-century experiments with "color organs" and "color harmonies." Blake's sources include works by Bainbridge Bishop, Alexander Scriabin, and others who, by linking projected light and organ music, sought to evoke the spiritual sublime. "My intention in pursuing this work," comments the artist, "is to gently confront by example the way in which American culture grieves and mythologizes violence."

Storyboard from *Winchester*, 2001–02. 16mm film, drawings, and digital artwork transferred to DVD, sound, dimensions variable. Collection of the artist; courtesy Feigen Contemporary, New York

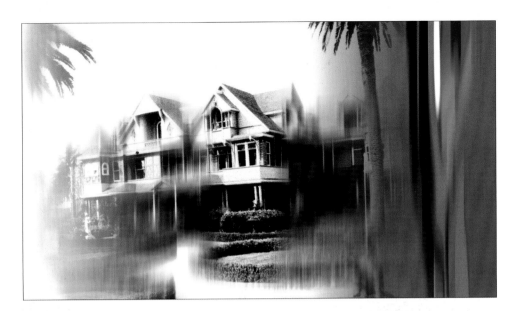

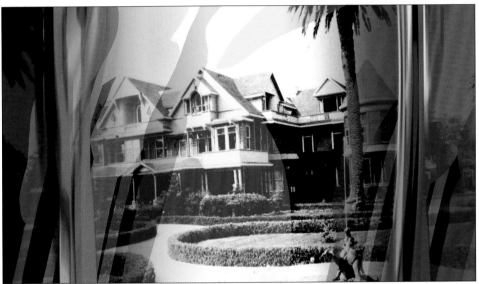

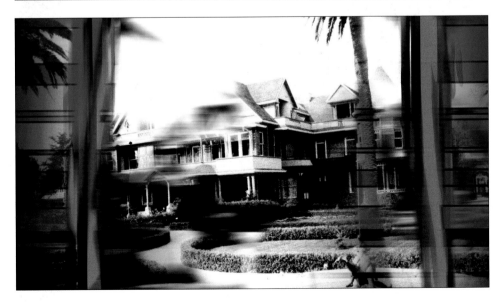

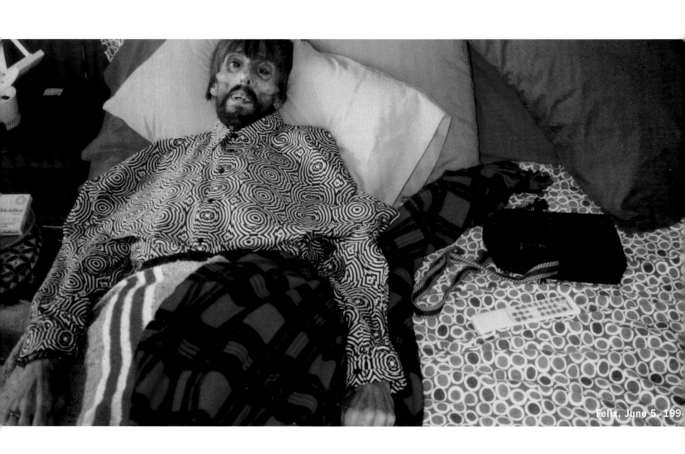

Felix, June 5, 199

Felix Partz, June 5, 1994, 1994 and 1999. Lacquer on vinyl, 84 x 168 in. (213.4 x 426.7 cm). Collection of the artist

AA Bronson was one of the three members of the influential Canadian art group General Idea, which for more than two decades created a wide-ranging body of work that challenged conventional standards of art and politics. Imbued with wit and irony, General Idea's works broke many taboos, often by transforming the meaning of images borrowed from fine art and popular culture. In one typically controversial work, the group appropriated Robert Indiana's famous painting, *Love*, rendering the word "AIDS" in the same distinctive graphic arrangement. One critic, impressed by their high-profile antics, commented, "imagine them as pop stars, who play the media instead of guitars." Two of the group's members, Jorge Zontal and Felix Partz, succumbed to AIDS-related causes in 1994. AA Bronson, the surviving member, decided to retire General Idea, move to New York City, and continue making art under his own name.

Felix Partz, June 5, 1994 is a photographic portrait of Partz made hours after his death. The artist is surrounded by a cheerfully bright array of garments, pillows, and sheets. His lifeless eyes stare straight ahead, meeting our own in a harrowing grip of absence. The surprisingly large scale of the image recalls nothing so much as a commercial billboard, ironically undermining our society's taboo on images of death. "We need to remember," says Bronson, "that the diseased, the disabled, and, yes, even the dead walk among us. They are part of our community, our history, our continuity. They are our co-inhabitants in this dream city."

JAMES BUCKHOUSE
IN COLLABORATION WITH HOLLY BRUBACH

Tap is a virtual dance school for animated characters that exist on the Internet and can be downloaded to individual users' PDAs (personal digital assistants) and desktops. Users can choose animated dancers at the *Tap* website. The dancer takes on a life of its own, practicing, taking lessons, learning from other dancers, and giving recitals. New characters start to learn to dance by following the routines of teachers. They do not immediately know how to follow the steps, but must build up skills through practice. Users do not have to be present during the lessons—the animated characters can be "dropped off" and left to practice for an unlimited time. Dancers can practice at home, as a screen saver on the user's desktop. Their learned routines can also be performed for other users.

These performances take place on the individual users' PDAs. Dances are downloaded from their desktops or from "beaming" stations to their PDAs, where they can be performed as well as beamed to other PDA users. The shared dance contains a link to the *Tap* website, as well as a record of what it took to learn a particular routine. Individual steps from a dance can be incorporated into new dances, and users can encourage their characters to continue working with certain moves. Also, two users can let their characters teach each other to dance.

Tap treats digital data not as perfectly reproducible packets of information, but as seeds for new ideas that spread and evolve. As an artwork that relies on exchange, learning processes, and community, *Tap* becomes a metaphor of networked communication itself. As digital data, tap dance is modular and remixable. The similarities between data and the dance routines point to the question of how we think about art through the cultural filter of technology.

Tap, 2002. Sketch of a dancer from *Tap* performing on a PDA (personal digital assistant)

Commisioned by Dia Center for the Arts, New York. Presented in cooperation with Creative Time, with support from Palm, Inc. and hi beam

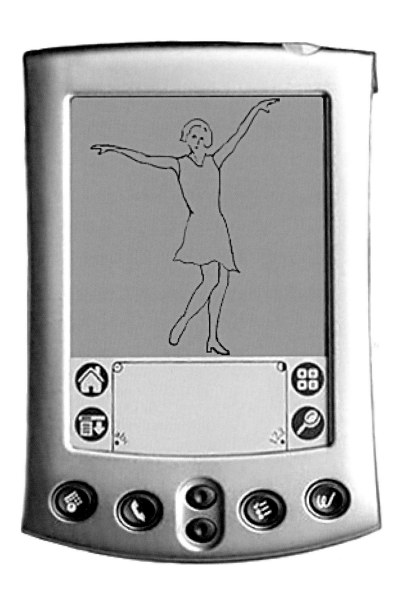

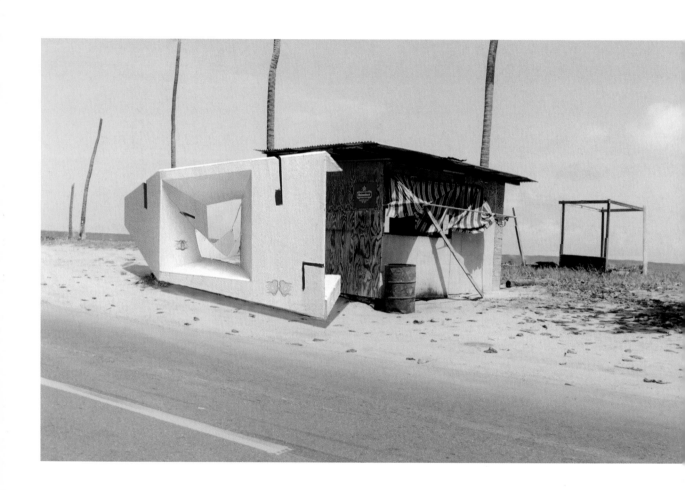

Preparatory Photoshop image for *Habitat en Tránsito: Piñones (In Situ)*, 2001. Wood, paint, graphite wall drawings, hammock, and wood shack, dimensions variable. Collection of the artist

A native of San Juan, Puerto Rico, Javier Cambre studied architecture in Medellín, Colombia, and fine art at The Art Institute of Chicago. His new installation, *Habitat en Tránsito: Piñones*, brings together these various influences as well as the experiences of his own peripatetic life into a work that explores the persistence of memory in dislocated space.

Piñones is named for a beachfront area just outside San Juan where for decades vendors have sold seafood and refreshments at small roadside kiosks. Familiar to Cambre from his youth, these structures—and the working-class recreation area they support—are threatened by the development of luxury resorts. For this installation, Cambre has simultaneously accelerated and memorialized the disintegration of Piñones by dissecting one of the kiosks and moving half of it to New York City. The half of the kiosk remaining on the beach in Puerto Rico and the half transported to New York have been made whole again by the artist; however, in place of the traditional, informal design and construction, Cambre has substituted sleek Modernist forms to create peculiar hybrid buildings.

The juxtaposition of these two elements is not a simple matter of new versus old, modernity versus tradition, global versus local, or rich versus poor. Cambre's angular white addition is as eccentric in shape as the fragmented kiosk, if not more so. Intersected by shafts of open space and adorned with a hammock, the constructed section calls to mind a more sensual, even erotic sensibility than is usually associated with High Modern design. The layout of the windows and walls is based specifically on the orientation of these elements in the artist's childhood bedroom. "My artwork," says Cambre, "intends to establish a dialogue between the poetics of space and the social and economic implications of architectural frames as the blueprint for our behavioral activities."

JIM CAMPBELL

For Jim Campbell, one of the most compelling questions of our digital age is, "What is the relationship of information to meaning?" Specifically, Campbell's work explores the points at which pure, abstract information (for example, a pattern of 0s and 1s) is transformed into a recognizable text or image. His work also begs a number of other questions: As information becomes more and more compressed and increasingly ubiquitous, are we becoming conditioned to read ever more subtle messages? Or are we becoming increasingly desensitized to the subtle meanings of the information that bombards us daily? Campbell's art explores the ambiguous terrain that lies between information and meaning, capturing the sensation of perception, literally and figuratively, coming into focus.

The three panels of Campbell's *5th Avenue* series are each composed of 768 red LED lights that have been programmed to display slow-motion images, derived from video, of figures walking along Fifth Avenue in midtown Manhattan. Campbell has created a variety of effects by placing screens of treated Plexiglas in front of two of the panels. In one case, the Plexiglas is placed at an angle to the LEDs. Because the diffusing characteristics of the material change markedly according to its distance from the LEDs, this work has little visible pixel structure on the right side of the image and extremely visible pixels on the left. Thus, as figures slowly move from left to right, they gradually pass from the digital world to the analog world. In another panel, the screen is placed parallel to the LEDs and far enough away that the image is readable only as an abstract pattern of light and shadow. A third panel has no screen at all, yet is still readable as figures in motion, albeit in a highly reduced, digitized state.

In these works, made shortly after the attack on the World Trade Center, Campbell creates haunting and meditative images of endlessly flowing humanity, transforming over time from corporeal to abstract beings.

Stills from *5th Avenue cutaway #1*, 2001. LEDs, custom electronics, and treated Plexiglas, 22 x 30 x 12 in. (55.9 x 76.2 x 30.5 cm). Collection of the artist; courtesy Hosfelt Gallery, San Francisco

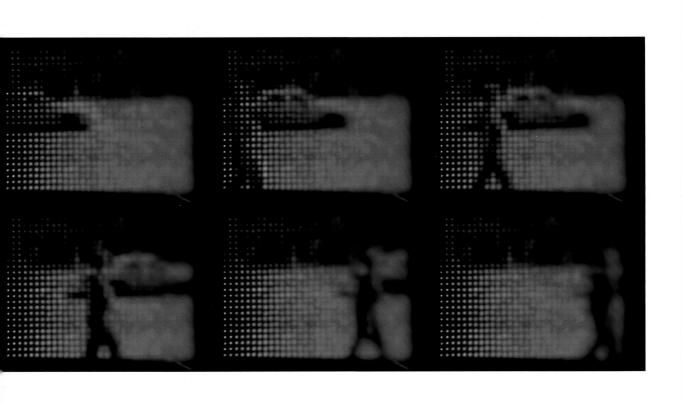

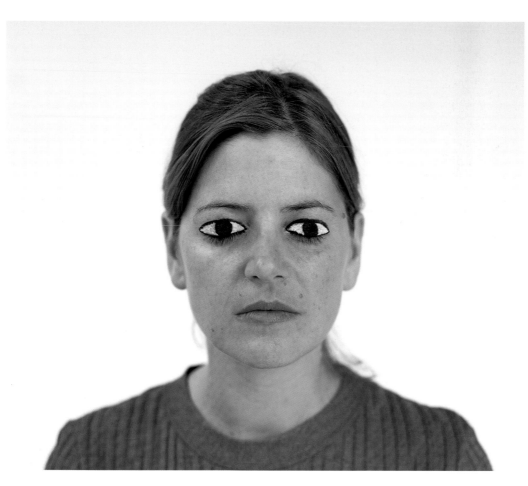

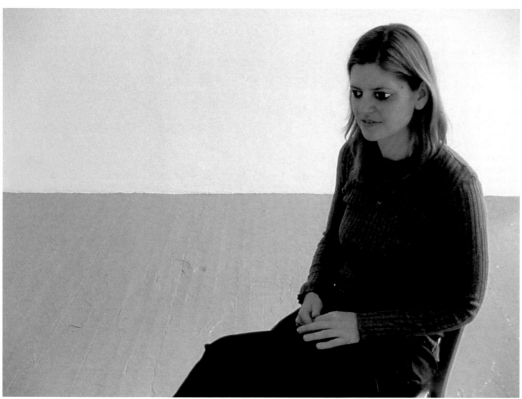

When I Close My Eyes, 2001.
Performance still from P.S.1
Contemporary Art Center/
The Museum of Modern Art,
Long Island City, New York

Karin Campbell's performances explore the dynamics of social interactions through succinct gestures that experiment with notions of presence and absence while also upending conventional roles of performer and audience. In *When I Close My Eyes*, Campbell sits in a chair in the middle of a gallery with her eyes closed; boldly painted on her eyelids are cartoonlike depictions of her blue eyes. Placing herself in a public viewing context with eyes shut, Campbell makes herself vulnerable to the unseen people and events around her. Although ostensibly presenting herself to the public in a forthright way, Campbell is also hiding from them behind her mask of fake eyes. Arguably, this lets her assume a place of empowerment as she withholds a degree of intimacy expected in person-to-person interactions. As she sits still for hours at a time, Campbell coyly lures gallery visitors into participating in her performance by passively inviting them to talk with her. It is these exchanges between the artist and an unknown public that complete the work.

With these tactics reminiscent of childhood games and juvenile pranks, Campbell's transgressions of prescribed modes of social behavior focus our attention on the complex and fluctuating relationships of power and control that unfold as people attempt to communicate. At the same time, she investigates how internal states of being can shape external realities by playing with boundaries between private and public space, vulnerability and security, generosity and restraint.

PETER CAMPUS

Peter Campus has been a major figure in the field of video and digital media since the early 1970s, creating installations, videos, and digital photographic works. In his most recent group of videos, *Receiving Radiation*, *Disappearance*, and *Death Threat*, Campus turns his existential enquiry toward the subject of his own mortality. Triggered by a recent bout of cancer from which he has fully recovered, each video addresses the emotional and psychological anxieties around the disappearance of the physical self. In *Receiving Radiation*, the superimposition of one layer of imagery over another becomes symbolic of the diffusion of radiation through the body. Campus appears at a distance, a shadowy figure wearing a hat, standing motionless by trees, and near a barn. The images become saturated in red light, then in green, then blue—the three primary colors of video— and reversed in negative. Against a green background, red numbers count down from eight to zero.

The dread of death is visualized in *Disappearance*, as Campus gradually fades his own image out of a series of countryside places near his home—a landscape, a lake—as his dog and partner look toward, and away from, him. The video becomes a poignant self-portrait, in which the fragility of existence is expressed through the fading of one image into another. This trilogy echoes his work *Three Transitions* (1973), in which Campus uses superimposition to dislocate, and gradually eradicate, images of himself. Where in *Three Transitions* eradication suggests an existential quest for psychological transformation, in these recent works it implies the potential for greater spiritual awareness. In *Death Threat*, shots of Campus getting into a car, through reflections of barren trees in the windshield, evoke his enclosure by the radiation machine and the lifelessness resulting from the procedure. A large red tomato is cleaved in half and chopped by a large knife; a spinning ceiling fan, seen from below, evokes the monotony of waiting; and the warmth of a log fire suggests both irradiation and comfort. In all three videos, Campus confronts the fear of death, seen through the lens of survival.

Still from *Death Threat: Receiving Radiation, Disappearance, Death Threat*, 2000.
Video, color, sound; 11 minutes.
Courtesy Electronic Arts Intermix, New York

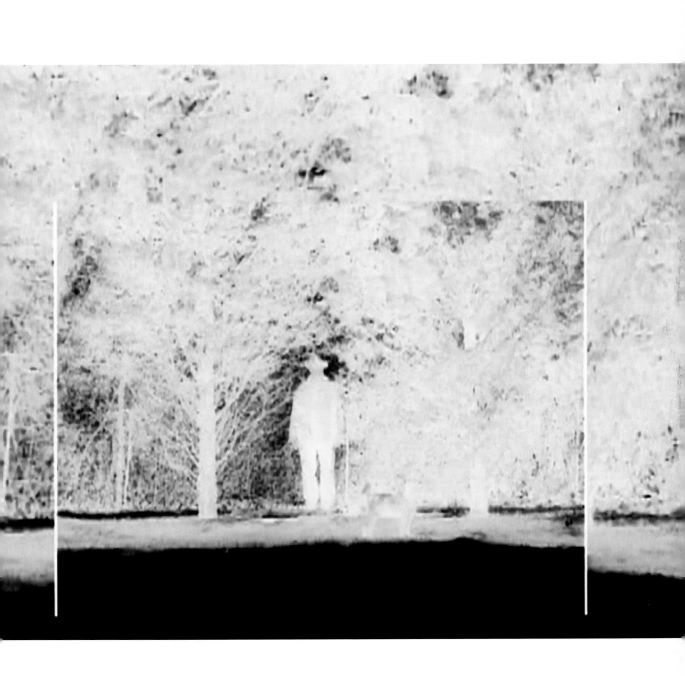

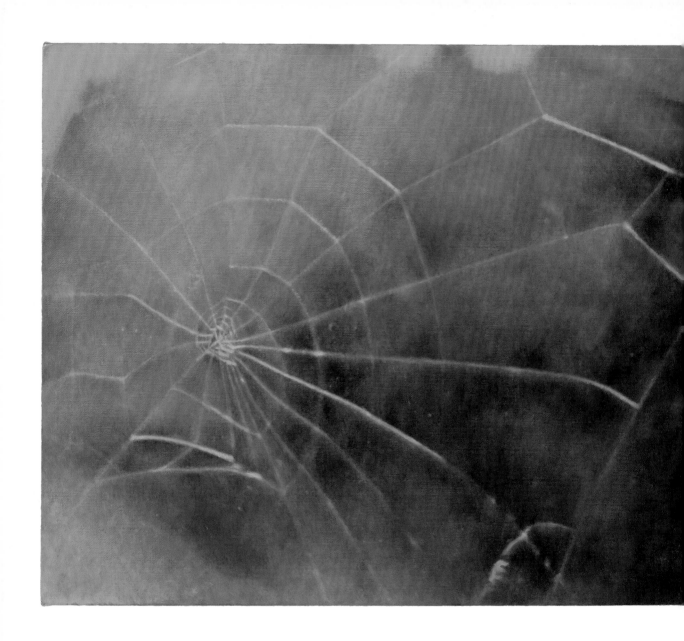

Untitled (Web), 2000. Oil on canvas,
15 1/4 x 18 in. (38.7 x 45.7 cm).
Collection of Lyn and Gerald Grinstein

Over the past thirty years, Vija Celmins's art has been concerned with a narrow range of subjects: darkly radiant night skies, mesmerizing ocean surfaces, and finely detailed desert landscapes. Based on photographs, her paintings, drawings, and prints present a vision of the natural world distinctly devoid of human presence. Although her subject matter inspires a sense of wonder, Celmins's artworks do not exploit the landscape's easy sentimentality or romanticism. Rather, in their quietude and restraint, her painstakingly crafted works magnetically compel the viewer to move closer to investigate the artist's remarkable technique and artistry.

Celmins's latest fascination is spiderwebs. What this new subject lacks in cosmic grandeur, it makes up for in sheer perfection and intricate beauty. Ironically, the labor that the artist invests in the representational process exponentially exceeds that of the spiders' original creative act. Over the past ten years, Celmins has created only two web paintings, each of which took many months to complete. The art critic Peter Schjeldahl has written of these paintings, "Celmins's web pictures do for time what her starscapes do for space: they make its unknowable extent *felt*. A spider's—or a painter's—fleeting stab at perfection is a negligible stitch in an unbounded fabric. Its only significance lies in our own momentary, mortal gaze as we reckon with eternity."

CHAN CHAO

The photographs that make up Chan Chao's *Something Went Wrong* series were shot during several trips that the artist made to see his native country, Burma (now officially Myanmar). Chao's initial visit was meant to be an opportunity to meet old friends and family members. When he found it impossible to enter the country legally, however, Chao made his way to the refugee camps scattered across the Indian and Thai frontiers. Here, he found the subjects of his photos, Burmese refugees and prodemocracy insurgents who have been displaced, sometimes for many years, by the brutally repressive regime known as SLORC (State Law and Order Restoration Council), which has ruled Burma since seizing power in 1988.

"I wondered," says Chao, "if I had stayed in Burma, would I have had the courage to do what these people have done? These visits to the border camps were very much a kind of self-reckoning." Indeed, there is something almost mirrorlike in the direct and placid way his subjects reflect the camera's gaze. The people themselves are clearly the focus of his attention as the jungle bush and squatter dwellings recede into an indistinct blur. Besides the stoic dignity of his subjects, the most remarkable aspect of Chao's series is the way he captures the diversity of these communities that exist nearly forgotten at the margin of the world. Almost like a cross-section of humanity one might encounter at a mall anywhere in America, Chao's portraits include men in business suits, a youth with his guitar, soldiers in camouflage fatigues, and men wounded in the war. In brief annotations to the photographs, Chao gives scattered clues to his subjects' lives, as in the laconic note—"former member of ABSDF, an armed student group"—appended to his riveting portrait of a saffron-robed Buddhist monk.

Young Buddhist Monk, June 1997, 2001. Chromogenic color print, 36 x 26 in. (91.4 x 66 cm). Collection of the artist; courtesy Numark Gallery, Washington, D.C.

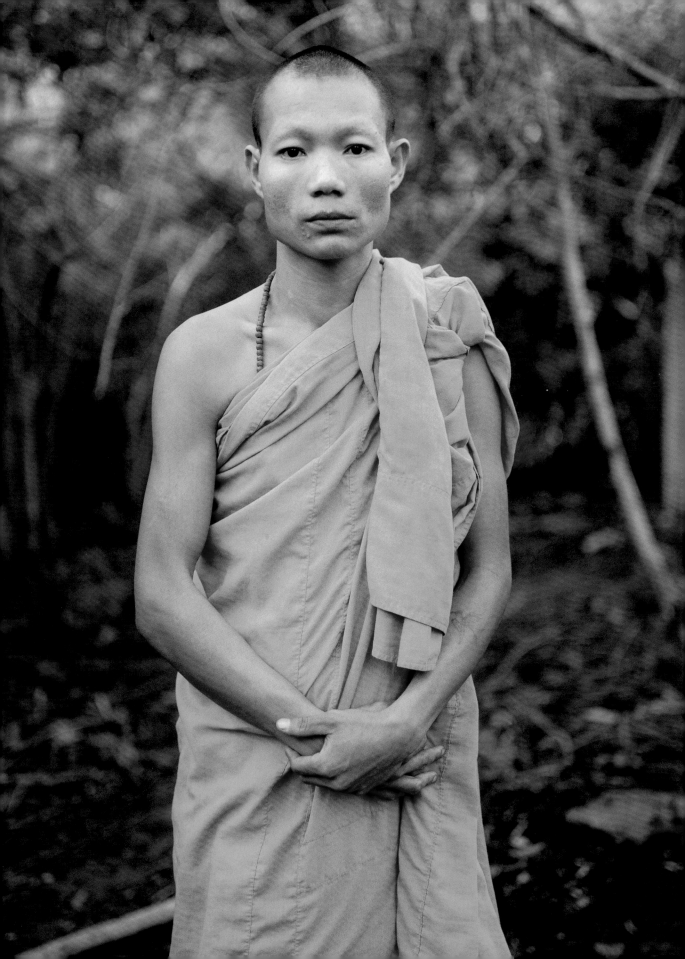

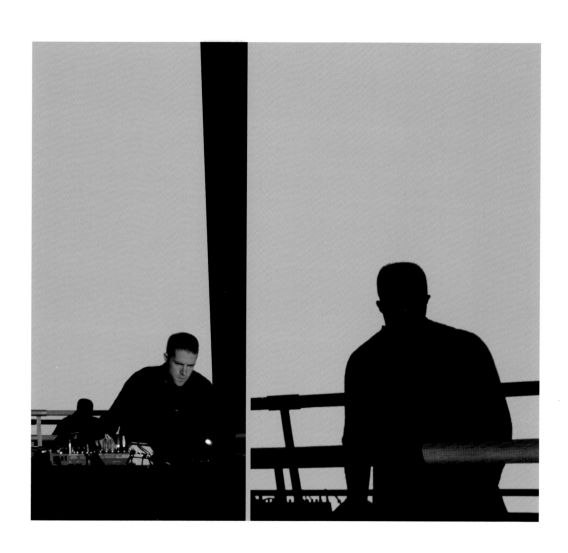

RICHARD CHARTIER

Richard Chartier performing
at Micro Mutek 2, Montreal,
April 6, 2001

Richard Chartier creates extremely spare and subtle compositions that explore the unexpectedly rich threshold between sound and silence. Chartier, a sound artist based in Virginia, uses digital tools to craft his own unique, extremely small sounds. These faint microsounds are reminiscent of the inner mechanized workings of common electronic devices or appliances; however, Chartier considers his work to be more akin to abstract audio sculptures that map the physicality of sound, rather than referencing existing noises. His sound works are meant to be played at extremely low volumes, either on headphones or in site-specific installations, in order to create tactile environments that let the listener become totally absorbed in the act of perception.

In this untitled track from Chartier's CD *series*, quickly passing, pulsing waves of hushed whirs, gentle hisses, delicate clicks, and staticky pops are separated by measured intervals of silence or low rumbling drones that resonate back and forth across the perceptual limits of human hearing. With concentrated listening, these discrete elements gradually yield a discernible flow of sonic patterns and cycles that nonetheless resist coalescing into a regular rhythm. Chartier's subtle arrangements, at once structured and intuitive, reveal the complex quality and texture of each individual sound fragment. They also extend into the digital realm of experimental sound some of the ideas of minimalist composers such as Morton Feldman. By taking us to the brink of the inaudible, Chartier invites us to focus our attention on the process of listening and to reconsider our preconceptions about the nature of sound and silence.

TONY COKES

In the video and multimedia installation works Tony Cokes has produced since the mid-1980s, he uses the accessibility of video to critique received assumptions of race, class, gender, and popular culture. Analyzing what he calls the "representational regimes of image and sound," he dismantles the structures by which stereotypes are perpetuated in popular culture.

2@ is the fourth in a series of five videos made with the band SWIPE, of which Cokes is a member. SWIPE's manifesto suggests something of the critical approach that 2@ embodies: "Pop music is associative and contextual. It doesn't mean anything in isolation. It does not have a pure form....It is always, already corrupt. It is never free, pure, personal, or abstract." 2@ investigates this corrupt form of popular culture and the ideological discourse surrounding the music industry. Its formal and theoretical inspiration stems from two seminal works of video art: Dan Graham's *Rock My Religion* (1982–84), a quasi-documentary video with a provocative thesis on the relation between religion and rock music in contemporary culture, and Richard Serra's *Television Delivers People* (1973), in which text scrolls vertically down the screen to deliver a searing volley of facts regarding the strategies the television and advertising industries use to manipulate the viewing audience.

Original music by SWIPE mimicking the major shifts in pop music from the 1960s to the present accompanies a series of sentences in black letters, excerpted from song and album titles that spring one after the other from a white background. Lyrics, texts from runout grooves, headlines, slogans, blunt words, and barbed phrases are all washed over in turn, as black rolls in from the top and bottom of the screen, rhythmically veiling one word or phrase as it gives way to the next: "Clash or Jam? Punk Turns Pop. Pleasure Without Emotion." As the capitalizing of words shifts each phrase into an ambivalent status somewhere between statement and logo, 2@ becomes a taxonomic cultural critique that epitomizes the very form it seeks to deconstruct.

Still from *2@*, 2000. Video, color, sound; 6 minutes. Courtesy Electronic Arts Intermix, New York

Blitzkrieg Pop.

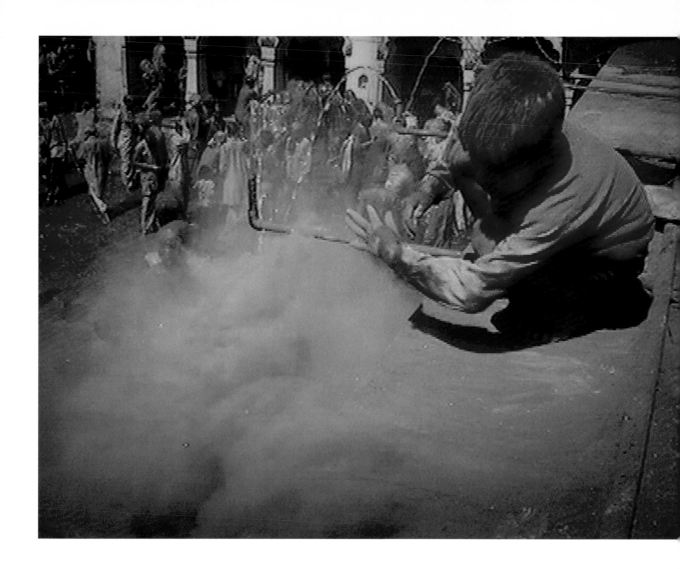

Still from *Pulse*, 2001. DVD projection, sound, dimensions variable; 7 1/2 minutes. Collection of the artist; courtesy Henry Urbach Architecture, New York

Color, exploding into a physical, spatial dimension, is the subject of Stephen Dean's video installation *Pulse*. Shot at the annual festival of Holi in Uttar Pradesh, India, Dean's video captures the giddy, ecstatic sensation of a crowd becoming one with color as they toss handfuls of pigment into the air and onto each other's bodies. Holi marks the return of spring and, like Carnival and Mardi Gras, involves a temporary suspension of caste (or class) and gender hierarchies. But *Pulse* makes no pretense toward documentary objectivity. The camera itself becomes engulfed in mica glitter and swirling clouds of magenta, blue, and green. Through deft editing, subtle manipulations of the speed of the image, and alternating passages of sound and silence, Dean heightens the viewer's awareness of the remarkable sensuousness of this extraordinary moment of radical disequilibrium.

So abstract at times as to become almost painterly, *Pulse* seeks to propel the viewer into a profound, even metaphysical experience of color and space. Rather than building his colors up layer by physical layer, however, Dean captures them all at once by directing his camera's gaze at an existing color phenomenon. The installation mimics the typically large scale of many Color Field paintings, and to this Dean adds temporality and sound to create an encompassing experience of sheer chromatic bliss.

DESTROY ALL MONSTERS COLLECTIVE

Mike Kelley, Cary Loren, and Jim Shaw, who comprise the Destroy All Monsters Collective, were among the original members of the noise band Destroy All Monsters, which originated in Detroit in the early 1970s. The Collective's installation, *Strange Früt: Rock Apocrypha*, includes four mural-size paintings and a video.

The paintings, which were created by Kelley and Shaw, are, in Kelley's words, "historical in nature and focus on entertainment and subculture personalities associated with the Detroit area in the late 1960s and early 1970s. This was the time period in which Detroit was renowned for its alternative hard rock scene and also the era in which local television fare was eclipsed by syndicated programs." The two smaller works represent Destroy All Monsters' four original band members and the legendary music producer John Sinclair, who helped integrate free jazz and blues into the pop and rock scene. The larger paintings use Detroit as a backdrop for an array of cameo portraits of the city's musical legends, local children's TV-show hosts, and other performers. Among those thus enshrined are The Stooges, MC5, Sun Ra, George Clinton, Pat Oleszko, Soupy Sales, Captain Jolly, George "The Animal" Steele, and Milky the Clown.

The video component was directed by Cary Loren and documents the dynamic Detroit music scene with archival television footage, interviews, and, as he explains, "reenactments of period rock-oriented urban myths performed by denizens of a contemporary Detroit-area goth nightclub."

"This once marginalized and very eccentric local culture has become widely respected, even mainstream," observes Kelley. "It's a phenomenon of the mass media which, on the one hand, can obliterate a local scene, for example by the replacement of the local TV shows that once thrived in Detroit with syndicated ones, and, on the other hand, can make a local Detroit band like The Stooges a mass culture phenomenon as far away as Australia. So we decided to make grand history paintings of a small local history."

The Heart of Detroit by Moonlight, 2000, from the installation *Strange Früt: Rock Apocrypha*, 2000–01. Acrylic on canvas, 120 x 204 in. (304.8 x 518.2 cm). Collection of the artists; courtesy Patrick Painter Inc., Santa Monica, California

JOHN LEE HOOKER

THE VERNOR'S GNOME

JAMES BROWN

JOHNNY GINGER

ALICE COOPER

LESTER BANGS

MORGUS THE MAGNIFICENT

SOUPY SALES

CAPTAIN JOLLY

GEORGE "THE ANIMAL" STEELE

EMIL
DOBBELSTEIN

ILLINOIS
PFC
AIR CORPS
WORLD WAR II

MARCH 21 1916
DEC 1 1944

HENRY J
DROPE

ILLINOIS
TEC 4
ORD DEPT
WORLD WAR II

MAY 6 1916
SEP 2 1995

KEITH EDMIER

Emil Dobbelstein and Henry Drope, 1944, 2002 (work-in-progress). Bronze and granite, 96 1/2 x 34 x 34 in. (245.1 x 86.4 x 86.4 cm). Collection of the artist; a project of the Public Art Fund program *In the Public Realm.* Whitney Biennial in Central Park, Organized by the Public Art Fund; sponsored by Bloomberg

Keith Edmier's work exists on the cusp of the personal and the public. In a variety of projects, he has mined his own life experiences to extract forms and imagery that resonate on an almost archetypal level with American society at large. His most recent work is a monument to the World War II service of his two grandfathers. Edmier has made three-quarter-life-size bronze casts of the two men, complete with the appropriate uniforms and military regalia. They stand on granite plinths that note their regiments and dates served. The men, who never met each other, were both twenty-seven in 1944, the date marked by the monuments. Emil Dobbelstein, Edmier's father's father, committed suicide shortly after the war. Henry J. Drope, his mother's father, lived to the age of seventy-nine.

Edmier has placed these sculptures in Central Park's Doris C. Freedman Plaza, a siting that connects the work directly to the history of pre-Modern public monuments. Such civic sculpture strove to foster a social consensus around the establishment of heroes. The figures represented were usually "great men"— such as General William Tecumseh Sherman, memorialized in Augustus Saint-Gaudens's golden equestrian statue in the plaza across the street from Edmier's work—or leaders or symbolic amalgams that could stand in for a mass of individuals, such as the "doughboy" memorials dedicated after World War I. We are certainly not used to seeing war memorials with as personal a meaning as Edmier's. In this tender, moving work, the artist places himself in the flow of history by acknowledging his grandfathers' unique, if modest, role.

OMER FAST

Omer Fast's *Glendive Foley* is a synchronized two-channel video installation in which two monitors face each other across a small room. One monitor shows frontal views of homes in Glendive, Montana. Fast selected this out-of-the-way community because it is the nation's smallest self-contained television market, representing a microcosm of America itself. The opposite monitor displays a grid of images of Fast producing a vocally complete soundtrack of "Foley effects" to accompany the placid images of this Montana town. Foley effects, as they are known in the radio and television industries, are ambient sounds usually recorded in a studio and later added to the main soundtrack. With humorous intensity and concentration, Fast uncannily mimics the banal sounds of chirping birds, barking dogs, humming lawnmowers, and whistling prairie winds. As a car drives past one of the homes, for example, Fast is seen on the other monitor zipping past the microphone to emulate the distinctive sounds of engine and wind.

For Fast, who emigrated to America as a teenager, these exercises in simulation echo his own efforts to fit in and become an "ordinary" American. Through his remarkable whistling, buzzing, blowing, and hissing, he insinuates himself into this stereotypically American scene. "*Glendive Foley* is about the exchange that occurs between an individual and an environment," explains Fast. "The work attempts to create a space that literalizes this exchange, through a complete displacement of aural phenomena from one end of the exchange to the other."

Stills from *Glendive Foley*, 2000. Two-channel video installation, surround sound, dimensions variable. Collection of the artist

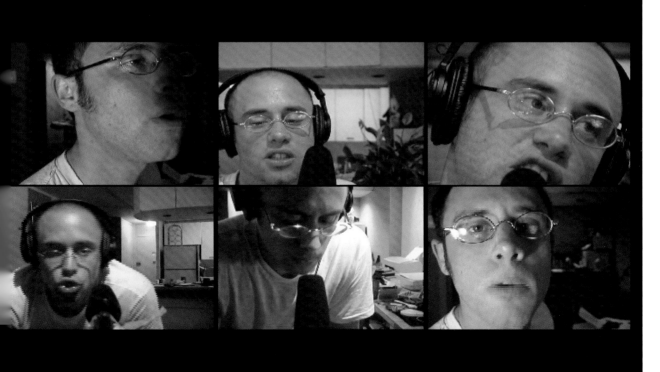

Two views of *Untitled*, 1999.
Foamcore, collage, and plastic,
4 x 17 x 15 in. (10.2 x 43.2 x 38.1 cm).
Collection of Marc Foxx

Vincent Fecteau's small-scale sculptures are deceptively simple investigations into the perceptual resonances of form, shape, color, and material. Although they are made from everyday materials, including foamcore, cardboard, and plastic, Fecteau's works are painstakingly thought out and meticulously crafted, revealing an extraordinary attention to the nuances of seemingly offhand details. His otherwise minimal designs are occasionally interrupted by an incongruous rubber band, magazine clipping, length of yarn, or even a toilet paper roll, endowing the works with a disarming quirkiness. Producing barely a handful of these sculptures each year, Fecteau works and reworks their compositions until they appear to him to strike just the right balance between idiosyncrasy and familiarity.

Using a formal vocabulary that is more typical of large-scale Modernist abstraction, Fecteau creates tabletop-scale objects that confound our expectations of utility or purpose. In some cases they appear to be models for larger works or even, on occasion, for architectural forms. Several works, for example, suggest experimental theatrical stage designs. Other pieces appear to be self-sufficient, autonomous constructions that represent nothing but themselves. Fecteau consciously operates in this gap between the represented and the real. By embracing ambiguity, he creates works that playfully undermine our expectation of the seriousness and certainty of abstract sculpture. In their diminutive scale and whimsical use of materials, his sculptures possess an almost cartoonlike sense of play and humor.

KEN FEINGOLD

Ken Feingold has spent much of the last decade making interactive artworks as a means to investigate perception, thought, language, emotion, and memory. His growing universe of artificially intelligent life forms includes a range of puppets, robots, and talking heads, as well as a variety of virtual organisms that have appeared in projected artworks. Sometimes looking suspiciously like the artist himself, these virtual beings combine toylike accessibility with often disturbing reflections on the nature of reality and of life in our increasingly mechanized and digitized world.

Loaded with custom software that Feingold calls "artificial pseudo intelligence," the two bald silicone heads that comprise *If/Then* engage in a seemingly sensible back-and-forth conversation. With the ability to understand English and access to more than 50,000 individual "thought units," the heads carry on a nuanced, free-form, open-ended discussion about their own existence and identity. The gender of the two heads, hairless and virtually identical, is unclear. Feingold explains, "I wanted them to look like replacement parts being shipped from the factory which had suddenly gotten up and begun a kind of existential dialogue right there on the assembly line."

If/Then, 2001. Silicone, pigment, fiberglass, steel, and electronics, 24 x 28 x 24 in. (61 x 71.1 x 61 cm). Collection of the artist; courtesy Postmasters Gallery, New York

ROBERT FENZ

Stills from *Soledad: Meditations on Revolution III*, 2001. 16mm film, black-and-white, silent; 15 minutes

Robert Fenz studied filmmaking at Bard College, as well as trumpet, improvisation, and jazz theory. *Soledad: Meditations on Revolution III* is the third in a series of short black-and-white films, begun in 1997, exploring the meaning of revolution and modernity in different Latin American countries. The previous two films addressed the streets of Havana, Cuba, and the Rio shantytown of Rocinha; *Soledad* takes as its subject three cities: Mexico City, San Cristóbal de las Casas, in the Mexican state of Chiapas, and New York. The improvisational structure of *Soledad* evokes Fenz's musical training in jazz. Random glimpses of daily life from different eras in the three cities appear and disappear, in shifting relationships to each other.

The juxtaposition of historical film footage with contemporary scenes shot by Fenz expresses an innate tension between mechanization and manual labor, tradition and modernity. Mexico City is portrayed as a city held back from the present by the past. Four lanes of old, smog-producing cars, a leitmotif of the metropolis, stream along the highway, framed by the cupolas of ancient churches, under whose spires gather priests wearing tunics and large crosses in the style of the age of conquistadors. A Coca-Cola truck drives along a dusty road. A visual correlation is drawn between the diamond shapes of the chains on an old tortilla machine and a bird's-eye shot of cars on the street with similar diamonds painted on the sidewalk. Fragments of Mexican tradition are intertwined with images of revolution: Day of the Dead skull masks; an old Mexican woman talking with a mural of an Aztec village in the background; historical footage of people walking in a park; newspaper references to Trotsky, who was assassinated in Mexico; a man in a Soviet military cap looking continually upwards toward its hammer and sickle badge; TV footage of masked guerrilla fighters. Fenz's silent, black-and-white images weave these paradoxical social, cultural, and political references together, underlining the role played by the oppositional forces of tradition and revolution in defining, and resisting, modernity.

MARY FLANAGAN

[collection] is a networked computer application that creates a
visible, virtual collective unconscious. Bits and pieces of data—
sentences from email or letters, graphics, images cached by
a Web browser, sound files, etc.—are harvested from the hard
drives of users who have downloaded the *[collection]* software.
A dynamic three-dimensional collage of images is created from
this information, an ever-changing vision of users' data. In
combining and re-presenting information (both personal and
computer-specific) from myriad users, *[collection]* uses the Internet
as a collective memory space and in the process raises questions
about the nature of memory as a network.

[collection] is an extension of Mary Flanagan's previous project,
[phage], which created the same kind of moving 3-D maps based
on data culled from a single user's computer. The title *[phage]*
refers to bacteriophage—from the Greek *phagein*, "to eat"—a virus
that consumes harmful bacteria. Instead of being destructive, this
virtual life-form treats data as raw material and brings up items
from the depths of a computer's memory. While *[phage]* allows a
user to experience his or her own computer's memory, *[collection]*
extends this notion into the network, where the combined data
becomes a multilayered rendering of users' life experiences. By
allowing Flanagan's software to visualize and recontextualize their
personal data, users give up creative control over their machines
and let their information be reshaped in a kind of nonhierarchical
organization.

The new data relationships Flanagan's software explores
connect to the promise of hypermedia. Electronic writing and
imaging systems are intended to mimic the brain's ability to
make associative references and its complex electrodynamics
of consciousness. By exploring the parallels and borders between
human and computer memory, *[collection]* reflects the profound
impact of new media technology on our culture.

Screenshot from *[collection]*, 2001

www.maryflanagan.com/collection.htm

1119.50
000000

rights

the
relations
hip

satisfies
at
Custome
rBret
Baird
Bobbie
Harderr
aye

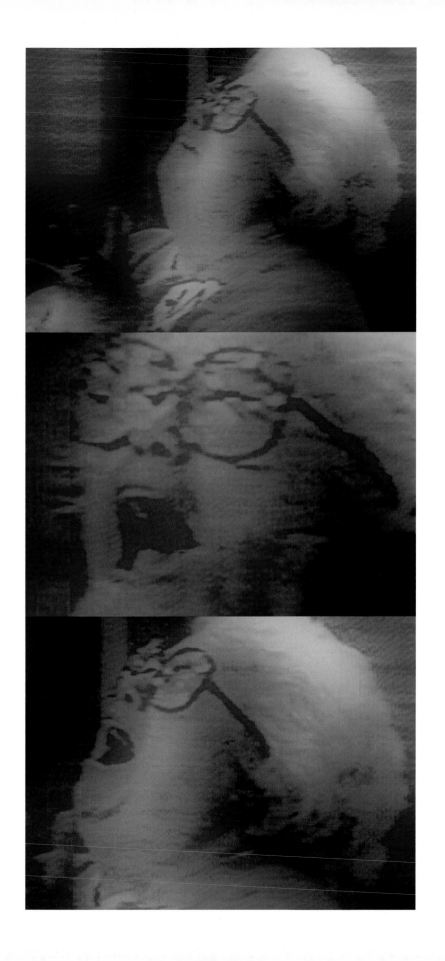

Stills from *Ascension*, 2001.
Video transferred to 16mm film,
superimposed film and gelled light
projection, color, sound; 6 minutes

The films of Glen Fogel are intensely personal, constructing an intimate, immersive space, removed from reality and infused with emotion. Shot in Super-8, 16mm, and video, each film explores a series of junctures: between pleasure and pain, freedom and entrapment, and what is hidden and what is revealed. The intimacy of Fogel's images is reinforced by an enclosing, almost physically palpable sound, which surrounds the viewer in a resonating, all-enveloping embrace. In *Reflex*, close-up images of a face fill the screen through filtered colored light, accompanied by a soundtrack of a pulsing heart and a slow breathing in and out, creating an erotic, claustrophobic space. The face splits in two in hand-processed close-up, in a veiled Narcissus motif. As Hannes Schupbach has observed, "the chromatic range deepens to red-orange, while a soft lip movement alludes to sensual experience. Undefined folds of flesh fly past, fingers flash in the dark…the piercing sound…[echoes] a sense of nervousness in the filmed body…in this…intimate stratum of images…the effect is one of paradox…a thick cover, and a fragile veil." At the film's climax, the hand-processed surface explodes into a riot of dramatic color.

In *Ascension*, Fogel explores the intense emotional transformation of contestants on a TV game show, at the moment where they discover they have won the prize. Manipulating a brief moment from the TV game show *The Price is Right*, Fogel combines 16mm film and digital editing, manipulating footage of women's faces as they throw back their heads in expressions of pure joy and excitement. Fogel slows down the image and sound, causing their faces to contort into ambiguous expressions that meld smiles, ecstasy, horror, and pain. The sound of the women's screams of pleasure is transformed into a carnal moan, simultaneously unsettling and melodic. Fogel's film freezes the moment in which the everyday is catapulted into the unimagined dream.

FORCEFIELD

Since its founding in 1997, Forcefield, a Providence, Rhode Island–based artist collective, has developed a unique combination of media and modes, including printmaking, costume design, installation, video, film, and live musical performance. Collective activity is essential to the group's work, and it is often impossible to distinguish one member's contribution from another's. Until recently, much of their work centered around Providence's legendary Fort Thunder, an art commune that served as the nexus for a remarkable explosion of creative activity from 1995 until it was shut down in 2001.

Frequently humorous and occasionally disturbing, Forcefield's work takes great advantage of the material and imaginative possibilities that lie dormant within the refuse of late-industrial society. With a do-it-yourself ethos, the members of the group fashion much of their work out of found materials, transforming abandoned or useless things into remarkably expressive forms. These works have included knit costumes, zines, animations, and architectural installations. A touch of the surreal as well as a strange sense of ritual and ecstasy pervade Forcefield's work. Their imagery is simultaneously monstrous and naive, childlike and psychedelic, encouraging a sensation of infinite possibility. Going by their adopted names—Patootie Lobe, Meerk Puffy, Le Geef, and Gorgon Radeo—the members of Forcefield appear to take great pleasure in opening the door to our collective Pop unconscious.

Still from *Welcome, Major Gnome*, 2000. Video, color, sound; 3 minutes. Collection of the artists

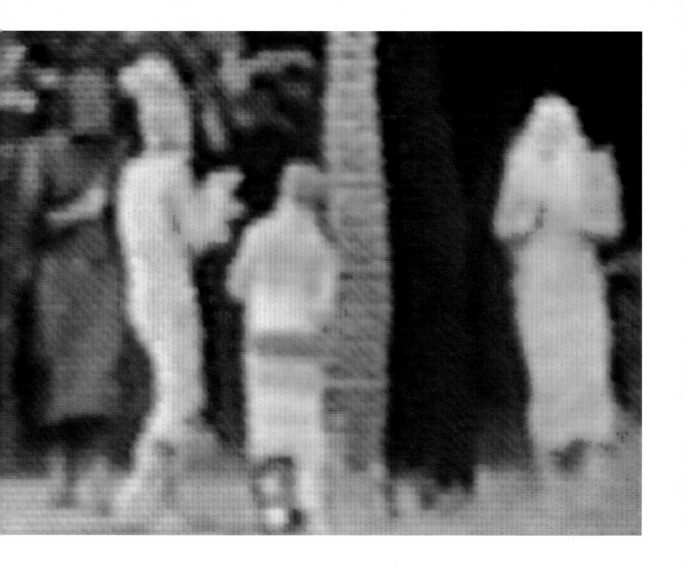

Screenshot from *Valence*, 1999. Using
Valence to read the 200,000-word text
of Mark Twain's *The Innocents Abroad*.
Courtesy MIT Media Laboratory,
Aesthetics + Computation Group
© 1999–2002

acg.media.mit.edu/people/fry/valence/

Benjamin Fry's data visualization software *Valence* creates visual constructions of large bodies of information that are both interesting and help us understand them in new ways. Static methods for representing data—charting, graphing, sorting, etc.—have been established over centuries. Since the advent of digital technologies, the dynamic representation of large data sets has become a field of scientific and aesthetic research. In *Valence*, individual pieces of information are represented visually according to their interactions with each other.

Valence can be used for visualizing almost anything, from the contents of a book to website traffic, or for comparing different texts or data sources. The program can read a text, for example, and add each word into a three-dimensional data space; frequently used words appear at the outside of the space, and less common ones at the center. When two words are found adjacent to each other, they experience what Fry calls "a force of attraction that moves them closer together in the visual model." The resulting visualization changes over time as it responds to new data. Instead of providing statistical information (i.e., how many times a particular word appears in a text), *Valence* furnishes a qualitative feel for the perturbations in the data and builds a self-evolving map driven by patterns.

Fry's project is based on the premise that the best way to understand a large body of information—whether it is a 200,000-word book, usage data from a website, or financial transactions—is to provide a feel for general trends and anomalies in the data by presenting a qualitative slice of the information's structure. *Valence* functions as an aesthetic "context provider," setting up relationships between data elements that might not be immediately obvious, and that exist beneath the surface of what we usually perceive.

BRIAN FRYE

Brian Frye is a filmmaker, curator, and founder of the Robert Beck Memorial Cinema, an alternative screening space in New York City's Lower East Side. Many of the works shown at Robert Beck are small-gauge, home-processed, edited in camera, and handmade. Frye himself most often uses 16mm film and manually edits his final print. In *Oona's Veil*, Frye submits Charlie Chaplin's screen test of his eighteen-year-old soon-to-be spouse, Oona O'Neill, to a complex series of manual reworkings, weaving a "veil" of surfaces and time lapses over the original film. The veil Frye draws over O'Neill's image evokes the young woman's fragility, and her dashed hopes for a future movie career.

Oona, a beautiful, depressive New York socialite and daughter of the playwright Eugene O'Neill, is seen self-consciously moving her head, smiling to the camera, and singing a song. Frye rephotographed a print of the original screen test and dissolved one frame into the next at twenty-frame intervals. This slowing down of the film heightens the young O'Neill's awkwardness before the gaze of her powerful, older almost-husband. Frye exposed the film negative to various chemicals, then buried it in dirt and left it on his fire escape for several months. Untangling the decayed film some time later, he spliced together the remaining pieces into a continuous strip, adding a soundtrack of a 78 rpm recording of "Whispering Hope," a well-known American sentimental song, played at 33 rpm.

In the winter of 2000, the Brooklyn screening venue Ocularis organized a party celebrating Andy Warhol's 1963 film *Kiss*, in which a sequence of couples are filmed in close-up, kissing each other for long periods of time. During the party, several filmmakers, including Frye, restaged versions of the film. In between directing his own remake of *Kiss*, Frye filmed other filmmakers and participants making theirs. In the resulting film, titled *Wormwood's Dog and Monkey Show* after a turn-of-the-century nickelodeon variety show, Frye observes the scene with a Warholesque detachment similar to the original film.

Still from *Oona's Veil*, 2000. 16mm film, black-and-white, sound; 8 minutes

Still from *Wormwood's Dog and Monkey Show*, 2001. 16mm film, black-and-white, sound; 11 minutes

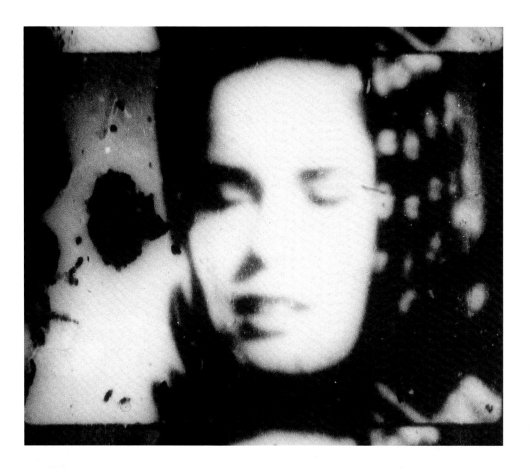

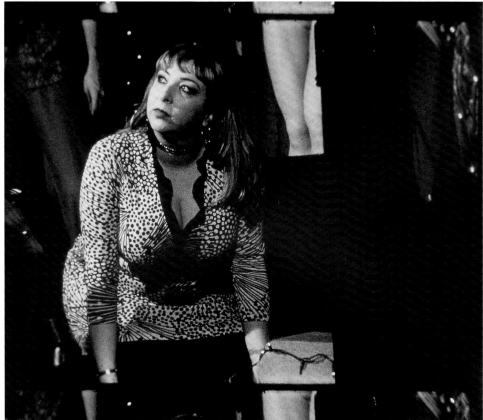

A typical press room. The puller and beater are shown in two stages of the operations. On the left, a sheet of paper is placed on the tympan by the puller, and the type is inked by the beater. On the right, the puller is printing an impression on the paper, and the beater is distributing ink on his stocks while he inspects the previous pull. DIDEROT.

DAVID GATTEN

Stills from *Moxon's Mechanick Exercises, or, The Doctrine of Handy-Works Applied to the Art of Printing*, 1999. 16mm film at 18 fps, black-and-white, silent; 26 minutes

David Gatten's work explores the materiality of language and the relationship between printed text and the moving image. His handmade films are often created by a cameraless process in which conventional photographic techniques are replaced by a physical interaction with the celluloid. For one film, Gatten soaked unexposed film in a crab trap submerged in seawater for a week; in another, he etched words directly onto the film's emulsion.

Moxon's Mechanick Exercises, or, The Doctrine of Handy-Works Applied to the Art of Printing renders Gatten's engagement with the relationship between language and image concrete. The film, he has said, is "a meditation on the development of the printing press, and its role in the spread of Christianity throughout Europe.... [It] continues and expands my previous investigations into the relationship between the text and image, legibility and illegibility, translation and adaptation." *Moxon's Mechanick Exercises* was made by transferring words lifted from historical texts onto the clear surface of the film using cellophane tape and an ink-transfer process. Twenty-four thousand individual frames of text were contact-printed onto 16mm filmstock.

The invention of the printing press, Gatten believes, marked the beginning of the philosophical split between mind (text, logic) and body (image, irrationality, subjectivity). His words articulate the ambivalence within this split, oscillating between comprehension and illegibility, textual linearity and concrete image. Legible text is lifted away from the "page," or surface, of the film and, Gatten suggests, melts into an abstract "flow of material, which constitutes a passage through time and space."

JOE GIBBONS

For twenty-five years, Joe Gibbons has documented his life in an ongoing series of sardonic, autobiographical Super-8 films and video diaries. His most recent work, *Confessions of a Sociopath*, is a feature-length, existential digest of his neuroses. Combining family home movies of himself as a child with factual and fictitious tableaux in which he plays his own alter ego, Gibbons enacts various dramatic episodes in his life, from childhood to troubled young adult and, finally, to his present self. Transgressive acts and traumatic events—becoming addicted to heroin, shoplifting, drinking, court appearances, and evading his parole officers, all experienced alongside his success as an avant-garde filmmaker—are laid before the viewer with disarming honesty.

Gibbons's searing self-exploration intertwines the confessional aspects of both psychoanalysis and criminal investigation. His exhumation of his past refers directly to Samuel Beckett's seminal play *Krapp's Last Tape*, in which Krapp reflects on his wasted life, arriving at a tragic epiphany as he listens to the musings of his younger selves. Gibbons similarly confronts the passage of his own life from the perspective of a world-weary man as he sits at a table staring into a half-empty wine glass. The self, that elusive and unknowable stranger, presents itself as an "other" that Gibbons obsessively revisits, yet can never finally face. In this existential dance with his own shadow, the psyche takes on the form of a catastrophic, yet comical labyrinth, within whose corridors Gibbons is condemned to perpetually roam.

Still from *Confessions of a Sociopath*, 2001. Video and Super-8 film transferred to video, color and black-and-white, sound; 60 minutes

LUIS GISPERT

Untitled (Single Floating Cheerleader),
2001. Fujiflex print mounted on
aluminum, 72 x 40 in. (182.9 x
101.6 cm). Collection of the artist;
courtesy Massimo Audiello,
New York

Luis Gispert's recent photographs are wry celebrations of cultural heterogeneity. In compositions borrowed from throughout art and pop culture history, Gispert substitutes for the original figures young women of various ethnicities, dressed in generic cheerleader uniforms and liberally adorned with gold jewelry. Combining the flashy style of hip-hop culture with the mystical themes of Renaissance religious art and modern science fiction, Gispert's composite images capture the perplexing but rich cultural stew of our present time.

"Hip-hop is the contemporary Baroque," says Gispert, explaining that the sources for his imagery include works by the great Italian Baroque sculptor Bernini as well as contemporary subjects such as Buffy the Vampire Slayer. Gispert infuses these sources with the insignia and gestures of contemporary youth culture. In one photograph, for example, a young woman seems to float in midair, as if in a state of spiritual apotheosis, while her hands make gestures that seem a combination of Hindu mudras and the gang signs of Miami, where Gispert lived for many years before moving to New York.

In addition to making photographs, Gispert fabricates objects that are similarly complex cultural amalgams. Resembling a cross between low-rider sound systems and luxury furniture, these improbable forms are made from materials as disparate as walnut, mahogany, babinga, and cherry wood along with rhinestones, fake fur, stereo speakers, and chrome. He displays these hybrid sculptures on a slick green floor surface, identical in color to the backgrounds of his photographs. Set off from the surrounding world, they look like spectacular swap-meet or car-show fetish objects. "They're a unique mix of ghetto style and Danish Modern design," observes Gispert.

GOGOL BORDELLO

Combining eclectic sounds and reckless fervor with outlandish lyrics, circus antics, and ritualistic acts, the performance group Gogol Bordello stages theatrical music events in a genre their lead singer, Eugene Hütz, describes as "Ukrainian Gypsy punk cabaret." The band's aggressive, flamboyant style draws on Gypsy (or Roma), Slavic, and punk-rock music traditions, as well as cabaret and street culture. Formed in 1998, Gogol Bordello features an unpredictable mix of wailing vocals, lilting rhythms, and thrashing movements that may be brought together with contortionists, animals, pyrotechnics, Mongolian throat singers, dancing maidens, and/or a full brass section. The band's lyrics spin darkly humorous, macabre tales about immigrant experiences, Ukrainian folklore, and bizarre erotic dreamscapes. These stories can be as absurd as anecdotes about a gang of supernatural immigrant vampires or a backyard barbecue with Joseph Stalin. For the 2002 Biennial Gogol Bordello performs at the Museum and at a site of their choice.

Although the size of the group often expands with frequently invited guest participants, Gogol Bordello is made up of nine key members who come from Eastern Europe, Israel, and the United States: singer and songwriter Eugene Hütz, fiddler Sergei Ryabtsev, guitarist Oren Kaplan, drummer Eliot Ferguson, accordion player Yuri Lemeshev, saxophonist Ori Kaplan, *bayan* player Sasha Kazatchkoff, dancer and vocalist Piroshka Racz, and costume and set designer Rachel Comey. According to Hütz, the group's name refers to Ukrainian author Nikolai Gogol—known for his trickster tendencies and cunningly phrased writings that made both radicals and the Russian czar believe that his texts supported each of their sides—and the institution of the bordello, with its connotations of erotic pleasure and street vulgarity. As the group combines its sincere embrace of traditional Gypsy music and the contemporary underground music scene with storytelling, elaborate props, and complex stage sets, Gogol Bordello relays aspects of many recent diasporic realities and redefines outdated notions of authenticity through their uniquely infectious spectacles that offer up nothing short of a new, free-for-all theater of anarchy.

Gogol Bordello in performance, September 2001

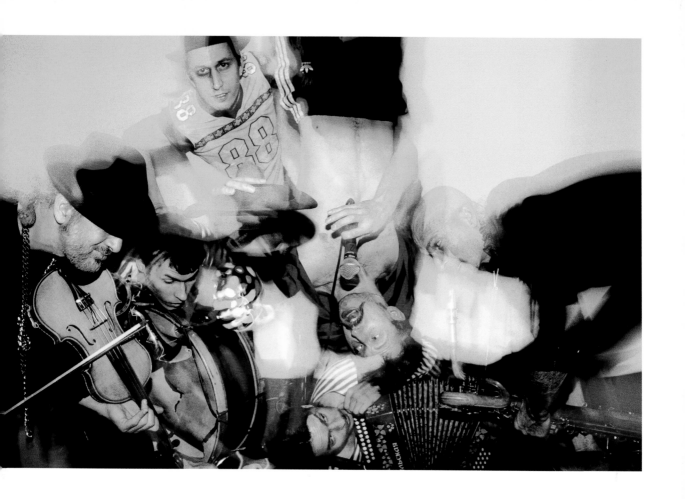

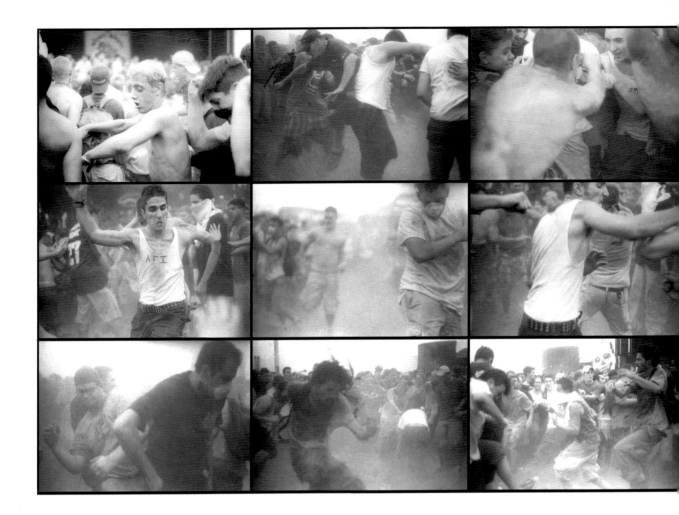

JANINE GORDON

I'm a human bomb, 2001. Nine gelatin silver prints, 72 x 108 in. (182.9 x 274.3 cm) overall. Collection of the artist; courtesy Refusalon, San Francisco

For nearly a decade, Janine Gordon has been almost exclusively photographing communities of young men: body builders, punk rockers, samba dancers, gang members, strippers, wrestlers, and boxers. Shot in grainy black and white, Gordon's photographs explore both the bonds among the men and her own personal interactions with these groups. Rather than document her subjects from the position of a dispassionate observer, Gordon enters fully into their lives, becoming a participant in their social rituals. Her photographs are not so much documentary as they are expressive and personal encounters with male subcultures that Gordon wholeheartedly, and sometimes daringly, embraces.

In her *Mosh Pit* series, Gordon captures the unique combination of thrashing violence and graceful motion that occurs in a punk-rock concert's mosh pit. Mosh pits form spontaneously when audience members begin to dance by throwing themselves against each other with Dionysian abandon. In Gordon's images the frenzied mosh pit action is frozen and the young men's bodily gestures suspended at moments of powerful, self-expressive beauty. Her own participation in the dance is essential to photographing the movements around her. "I become part of the pit and ad-lib when I shoot it," explains Gordon. "I'm still moshing—I have to or I'll get hurt. I do find the pits frightfully sexual, but it's the thrill of the moment that leads me there in the first place."

ALFRED GUZZETTI

Since Alfred Guzzetti began his filmmaking career in the mid-1960s, he has made short films, feature-length autobiographies, conventional and experimental documentaries, and, in the last few years, digital video works. His collaborative work on documentaries engaging controversial political topics such as the Nicaraguan revolution influenced his more recent video works, including *The Tower of Industrial Life*. This experimental, critical portrait of the late capitalist landscape depicts a series of urban and natural scenes—a traffic jam, a lake, etc.—into which texts communicating disturbing information on political events is inserted. As Guzzetti observes, "The world before us in our daily experience—city streets, landscapes, interiors, television images—is laced with reports of distant, unimaginable violence, and with the turmoil of our unconscious."

The Tower of Industrial Life reveals our false sense of protection as Guzzetti addresses the alienating experience of television and its illusory shelter from a doomed "elsewhere." The exquisitely constructed work draws the viewer into a gentle flow of lazy sensual images, then abruptly disrupts it. Our suspicions, our recollections, and our strange, refracted day-to-day understanding of the world are signaled to our conscious and unconscious stream of thoughts and desires. The words and sentences that periodically scroll across the screen remind us of what we know, or think we know, and that which we have repeatedly heard, yet have consistently forgotten, "news of distant places and of distant and scarcely imaginable violence." Guzzetti ultimately describes the particular punctuation of his moving images as "a lesson on thinking of something and being far away from it, and seeing other things entirely."

Stills from *The Tower of Industrial Life*, 2000. Digital video, color, sound; 15 minutes

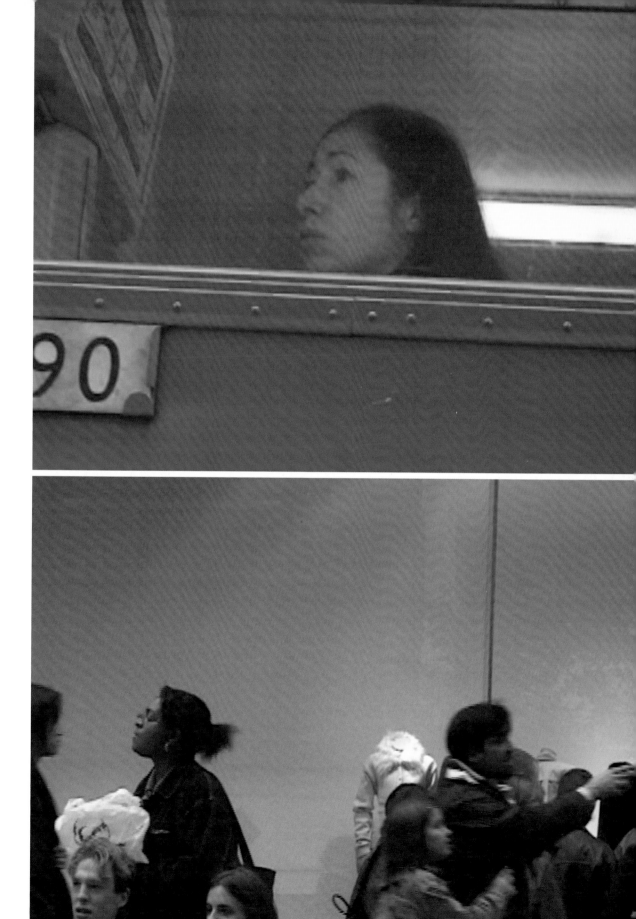

TRENTON DOYLE HANCOCK

Rememor with Membry, 2001.
Collage, pieced acrylic on canvas,
60 1/8 x 72 1/2 in. (152.7 x 184.2 cm).
Whitney Museum of American Art,
New York; purchase, with funds
from the Contemporary Committee
2001.229

Trenton Doyle Hancock's art revolves around a personal mythology of epic dimensions. The key characters in this mythology are "strange furry, smelly heaps," half-animal, half-plant beings that Hancock calls "mounds." He has identified fourteen of these forest-dwelling organisms, the original, longest-lived, and most important of them being Mound #1, also known as The Legend. According to Hancock, the genesis of The Legend occurred about 50,000 years ago, when an ape masturbated in a field of flowers. In his most recent works, Hancock describes the anguished death of The Legend. "I had been able to see death nudging towards The Legend for almost a year," says Hancock, "but I was powerless to stop it. Ultimately, The Legend succumbed to injuries sustained during an attack by a band of vicious vegan rebels." For Hancock, veganism has come to symbolize the sin of self-righteousness. In various drawings, he describes with cynical wrath bands of emaciated vegans cringing in horror as hunks of meat hang dripping in front of them.

Rememor with Membry depicts the forest from the dying mound's perspective. Looking up into the trees, Mound #1 sees the branches, sky, and forest floor interlaced with the words "rememor with membry." This neologistic phrase appears to mix together the words "remember" and "memory" and serves as a eulogy for The Legend, voiced perhaps by Loid, another character in Hancock's strange universe. Loid, whose name is derived from "lichen amyloidosis" (a discoloring skin disease), plays the role of a stern, omniscient father figure who is typically incarnated in the form of mysterious epigrams.

Hancock's richly inventive narrative unfolds in a visual form that is as uniquely expressive as the story itself. A single work may combine painting, drawing, photography, and pieces of fur. Stylistically, Hancock's work is highly idiosyncratic, yet it also calls to mind a wide range of existing works, from Edward Gorey's faux-Victorian comics to the intricate Pre-Raphaelite imagery of Dante Gabriel Rossetti and Holman Hunt to the cartoonlike, yet incisively political late paintings of Philip Guston.

RACHEL HARRISON

Rachel Harrison imbues seemingly abstract forms with open-ended narratives by attaching framed photographs to her sculptural constructions. The collision of these two disparate artistic modes creates situations rife with ambiguity and accidental meanings. Many of the sculptures have an intentionally ad hoc, cobbled-together appearance and are typically made from found materials such as cheap home paneling or bits and pieces of discarded wood. The photographs, which may be found as well, often contain an image of a person or persons. This figurative aspect is sometimes echoed in the scale of the sculptural forms, which often possess the general proportions of a standing human figure.

The presence of the photographs inspires questions about the relationship between these two-dimensional images and the three-dimensional forms on which they rest. Do the objects represent the settings in which the photographs were shot? Do they connect in some narrative fashion to the people who are shown? In some cases, as in *Bustle in Your Hedgerow*, Harrison suggests a direct link between the photograph and the supporting object. Though the piece may at first appear to be a geometric, Minimalist form, our impression shifts radically when we notice the two small photographs mounted on either side of the wall-like structure. These two paparazzi-style color photographs, apparently appropriated from a tabloid magazine, show the film star Elizabeth Taylor, walking in her garden. Suddenly Harrison's dark green abstract sculpture is transformed into a well-clipped hedge.

In another work, *Unplugged*, a tower pieced together from wood fragments supports a framed photograph of the pop star Michael Jackson greeting a rabbi. On another side of the sculpture, Harrison has placed a row of electrical outlets, suggesting a punning relation to the title of the work. The meaning of this piece, though, remains cunningly unclear. In the photograph, shot by Harrison from a video still, the glare of the camera's flash obliterates Jackson's face, endowing him with a kind of unearthly, perhaps divine aura. The crate, though, hollow and partially transparent, suggests a false facade that reveals an inner emptiness.

Unplugged, 2000. Wood, electrical outlet, and chromogenic color print of Michael Jackson touching a rabbi's head, 68 x 40 x 24 in. (172.7 x 101.6 x 61 cm). Collection of Diane and David Waldman

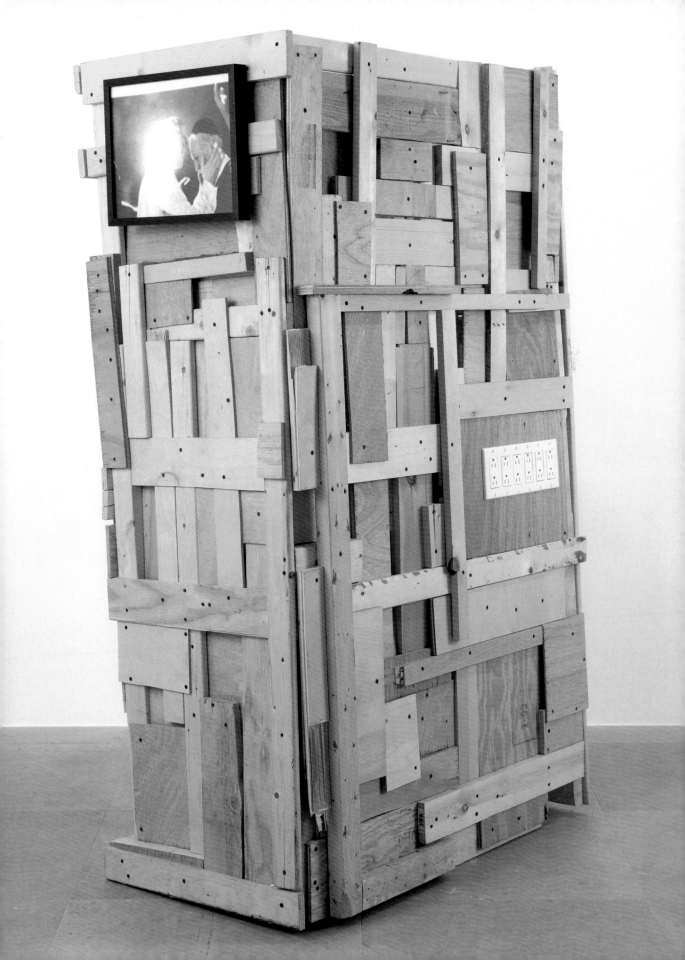

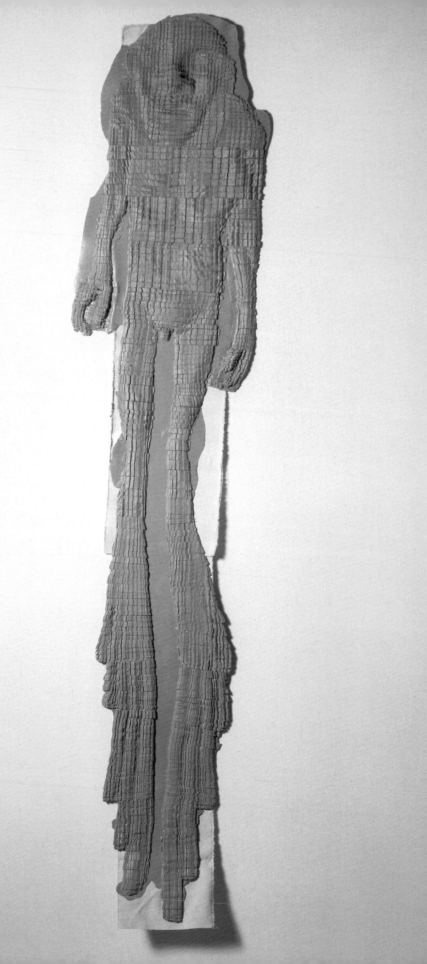

Mirror, 1999. Polyurethane on canvas, 76 x 16 1/2 x 2 in. (193 x 41.9 x 5.1 cm). Collection of Akira Ikeda

Tim Hawkinson's art combines an almost childlike naïveté with a very accomplished sense of craft and technical prowess. Each of his works springs from a comparatively simple concept that is played out to its most fantastical conclusion. The end results are propelled by the artist's fascination with gadgets and gizmos; he often creates new tools to produce his images and forms, and many of his works are themselves rudimentary, albeit extraordinary, machines. Hawkinson's intense, unrelenting focus on mundane subjects pushes his works to the point of strangeness, much like the children's game of repeating a familiar word over and over again until it starts to seem incomprehensible and weird.

 Mirror is a self-portrait in which Hawkinson represented not how he imagined he looked, but exactly how his image appeared in a mirror. "I produced my reflection in three dimensions by sculpting my self-image onto the surface of a mirror exactly as I saw it reflected," writes Hawkinson. "The result was a three-foot-tall 'gnome,' seemingly grotesque and distorted but, from my original perspective, quite accurate. I made four of the figures, cut them into small cubes, and spliced the cubes together to 'grow' the figure to life size. This accounts for its somewhat digitized appearance." While *Mirror* is a kind of practical experiment in spatial perception, it is simultaneously a glimpse into the distorting powers of an obsessive psyche. Alternately humorous and disturbing, Hawkinson's work demonstrates the remarkable images and forms that may arise when the material world is infused with an unbridled human imagination.

ARTURO HERRERA

Arturo Herrera's paintings, sculptures, collages, and installations feature a distinctive blend of abstract and figurative imagery inspired by cartoons, fairy tales, and twentieth-century abstract art. These works evoke both reassuring and unsettling associations as he combines the culture of childhood with the workings of the adult unconscious. Herrera uses ordinary materials and playfully organic shapes to create works that at first glance seem innocent and alluring. Yet the artist often leaves us with feelings of slight unease and an uncomfortable sense that disturbing fantasies may lie beneath the fanciful surface of his work.

Herrera's large-scale wall hanging *At Your Side* is a dense pattern of lines, shapes, and gaps cut from a single piece of black felt. The network of languid lines and forms mimics the spontaneous gestural marks of Abstract Expressionist paintings, though Herrera's excisions are neither quickly executed nor completely abstract. *At Your Side*'s contrasting vertical shapes amid the horizontal mass of black felt and exposed white wall evoke an abstracted wooded landscape at the edge of a pond. This illusion is reinforced by the symmetry of forms in the upper and lower registers, which evokes trees being reflected on the water's surface.

The forest is a meaningful and recurring reference point for Herrera because of the contradictory emotions we often associate with it: it is a place of relaxation and comfort, but also a dark place where unknown dangers lurk. In the world of fairy tales the forest is always the latter—a site of fear and threat, often interpreted by psychoanalysts as signifying the taboo nature of unconscious desire. The suggestions of a forest and pond in this work, however, congeal only momentarily and then melt away as new, unidentifiable shapes emerge from the outlines of the excised areas. Like a tactile Rorschach inkblot mutating before our eyes as soon as recognition seems to crystallize, Herrera's work resists our attempts to find definitive meaning, but instead triggers an open-ended interpretive process based on personal memories and unconscious associations.

At Your Side, 2000. Wool felt, 65 x 240 in. (165.1 x 609.6 cm). Marieluise Hessel Collection on permanent loan to the Center for Curatorial Studies, Bard College, Annandale-on-Hudson, New York

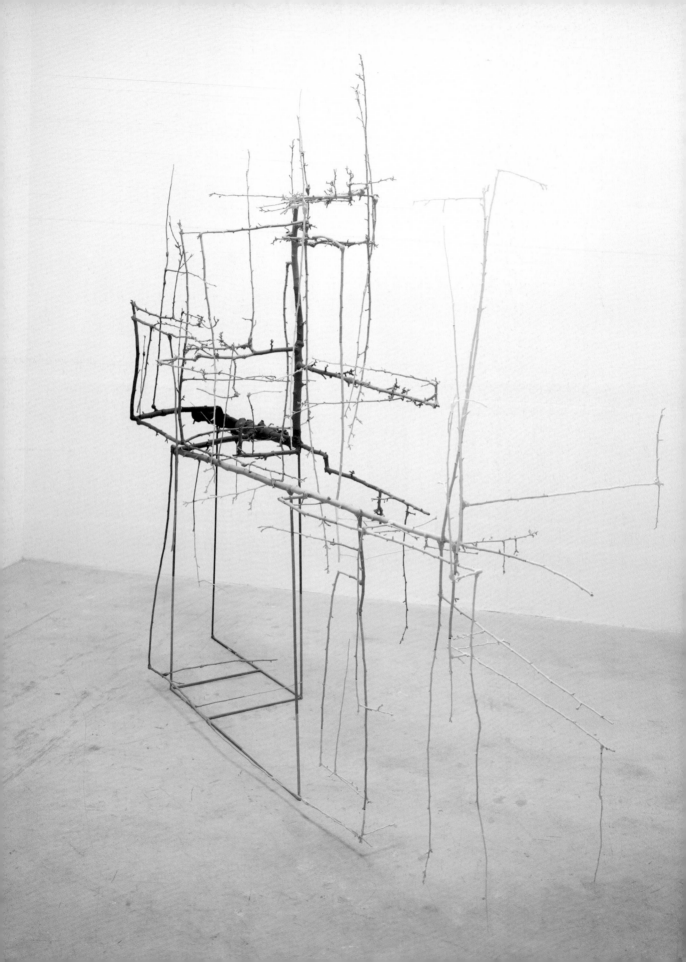

Gray Scale, 2000. Tree branches, paint, and metal, 78 x 30 x 100 in. (198.1 x 76.2 x 254 cm). Collection of Kenneth L. Freed

Evan Holloway's work exemplifies a strong tendency in contemporary Los Angeles art-making. Inspired in part by influential local figures such as Liz Larner and Charles Ray, a new generation of young artists is creating sculptural works that combine formal rigor with an irreverent, playful use of materials. Holloway's highly idiosyncratic works have several key features in common: formal succinctness, the acceptance of chance, and the overlaying of diverse systems and media.

Gray Scale alludes to the gray scale of colorless tones that photographers are often at pains to accommodate in their black-and-white prints. In this piece, Holloway applies a rudimentary version of the gray scale, which runs from white to black with various shades in between, onto a structure made from a single tree branch. Following a self-imposed system, Holloway reconstructed the limb, breaking off each branch exactly halfway before the next branch began and then reattaching it at a right angle. In another work, *Wildly Painted Warped Lumber #2*, the artist adapts a length of found wood to artistic purposes through the addition of a psychedelically painted pattern on the board's underside. The board is attached to a simple metal stanchion that keeps it at a level that requires an average-height adult to stoop to view its painted belly.

DENNIS HOPPER

Dennis Hopper is widely known as an actor and director in Hollywood cinema. Since the early 1960s, his work has also included photography, painting, assemblage, and, more recently, film and video. In *Homeless*, his most recent digital video, a homeless woman is portrayed sleeping on the boardwalk of a beach in Southern California. The film follows her as she wakes, dresses in full view of surprised passersby, brushes her teeth at the public water fountain, uses the public toilet, and walks around town, pushing a shopping cart filled with her possessions and watching the world go by. The tedium and depression of life on the street are palpably felt as the camera tracks her listless movements, starkly contrasting with the purposeful strides of people passing her left and right.

At certain moments, the narrative is interrupted by flashbacks of the woman dancing in a topless bar, as though she were recalling moments in her past. Her remembered erotic poses are intercut with similar movements, executed in real time. But where she hoists herself lasciviously up from the floor in the flashback, in reality she lifts herself up on the side of a Dumpster, looking for food or items to scavenge. The underlying humiliation of the woman's topless bar work is paralleled by the humiliation of homelessness; both are created by economic deprivation, and both consume pride and self-esteem.

Hopper's portrayal of a life falling apart demonstrates his long-term interest in the abjection and nihilism of the American social environment. From his raw early 1960s photographs of street scenes to *Easy Rider* and his 1980 film *Out of the Blue*, in which he plays the criminal, alcoholic father of a punk teenage girl, he has engaged in what he quotes Shakespeare having described as a "dumb show," which "will hold up [a] mirror to nature."

Still from *Homeless*, 2000. Digital video, color, sound; 9 minutes

Still from *Time and Tide*, 2001. 16mm
film, color and black-and-white,
silent; 35 minutes

Peter Hutton has been an important influence on experimental
film since the early 1970s. Since he began teaching film at
Bard College in 1985, he has made numerous films that take as
their subject the Hudson River. Hutton's silent, slow films operate
somewhere between the still and moving image, evoking
Louis Lumière's declaration that "cinema is simply a branch
of photography" or Hollis Frampton's argument that "a still
photograph is simply an isolated frame taken out of the infinite
cinema." In Hutton's films, a single shot is often sustained over
a period of time, within which minimal movement occurs. This
fixed-frame approach, echoing the language of early cinema,
invites a contemplative reading of the image, in which the simple
act of looking replaces the consumption of an ongoing dramatic
narrative. Hutton's use of black and white further distances the
subject from real time, and suggests a formal reading.

 Time and Tide begins with a short reel of the Hudson River shot
by Billy Blitzer in 1903 for Biograph, titled "Down the Hudson."
In a sequence of slow, formally composed images, Hutton
continues Blitzer's study of the river, exploring both its beauty
and the way industrial development has altered its shores. In one
sequence, the screen becomes splattered with raindrops, diffusing
the river into a soft, watery haze, as though seen through the
porthole of a boat. Hutton's use of light evokes the river landscapes
of the Hudson River school painters. His training in sculpture
is also evident in the high contrasts between depth and surface,
and the three-dimensionality of each image. This impression,
combined with a slowness of movement, draws the viewer into
a journey, so that, as Hutton explains, each shot becomes a film
in itself. His interest in contemplative observation developed
out of long periods of time spent at sea as a merchant seaman.
The timelessness of his films evokes the removal from daily
experience felt on the ocean; subtle changes of light and
movement, experienced as though in slow motion, suggest
small epiphanies of nature.

KEN JACOBS

Since the late 1950s, Ken Jacobs has occupied a central position in the history of experimental cinema, creating a substantial body of films as well as a series of *Nervous System* film performances. For Jacobs, film is a form of thinking. In his *Nervous System* works, he dissects small lengths of film, analyzing and reworking them in order to open pockets of activity that are undetectable in a conventional cinematic context. Using two adapted 35mm stop-motion projectors and an exterior shutter system, he alters the films' focus, speed, image size, and aspect ratio, creating a single composite, three-dimensional screen image.

Flo Rounds a Corner, a digital video, and *Crystal Palace (Chandeliers For The People)*, a recent performance work, shift Jacobs's *Nervous System* concerns into new territory. *Flo Rounds a Corner* demonstrates a patented optical technique in which his cinematic manipulations are transferred to digital form. Successive frames showing Jacobs's wife, Florence, walking around a street corner in Italy are computer-manipulated, creating a disorienting optical reading of arrested movement and hovering steps. The figure of Flo appears to occupy a plane nearer to the eye than its background, agitated and staccato as she strides purposefully toward the corner of a hillside street, only to be pulled back into the space she just left behind. As curator Mark McElhatten observes of Flo's strobed movements, "Figure and ground do a slow motion see-saw on shifting tectonic plates. Fold into Cézanne-like origami."

In *Crystal Palace (Chandeliers For The People)*, Jacobs dispenses with film: employing a single-slide projector and an exterior shutter (a spinning propeller), he hand-manipulates objects in the path of the light, "generating visions of a vast crystalline dynamo, a color-spectrum 'metropolis' in deep space." *Crystal Palace* was inspired by the interior of the Moscow subway; Jacobs says of its passengers: "They spread without hurry to radiating tracks, passing under enormous chandeliers liberated from the palace ballrooms of the once-ruling class. They were now The People's Chandeliers, their crystals vibrating in sympathy with local and express trains."

Still from *Flo Rounds a Corner*, 1999.
Digital video, color, silent; 6 minutes

Peter Spencer
Pastor - Harvest Fellowship Church

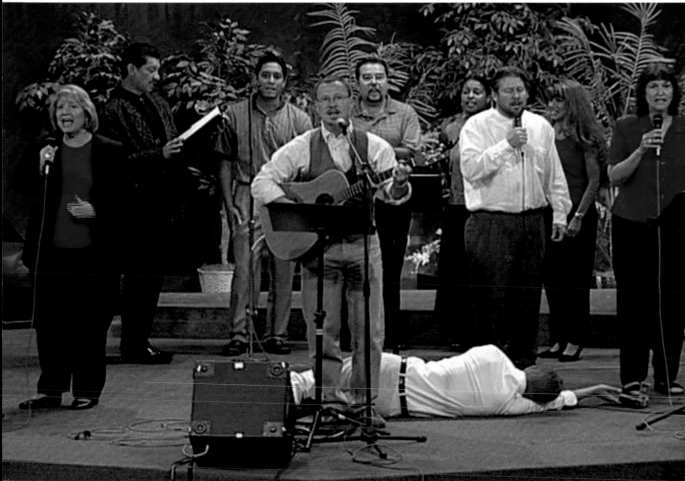

Stills from *The Holy Artwork*, 2001, featuring Pastor Peter Spencer, Harvest Fellowship Church, San Antonio, Texas. DVD projection, sound, dimensions variable; 16 1/2 minutes. Collection of the artist; courtesy Maccarone Inc., New York, and Klosterfelde, Berlin; originally commissioned by ArtPace, A Foundation for Contemporary Art, San Antonio, Texas

Christian Jankowski's video and photography projects blur distinctions between the staged and the real. In *The Holy Artwork*, Jankowski worked with a Baptist televangelist, Pastor Peter Spencer, to create a video that is simultaneously a work of art and an authentic broadcast sermon. Made during Jankowski's residency at ArtPace, a San Antonio arts organization, *The Holy Artwork* was initially inspired by a Baroque painting Jankowski saw in Spain, *Saint Dominic in Soriano ri*, by Juan Bautista Maino (1578–1649). In Maino's work, an angel takes up the brush of a painter who appears to have suddenly died. Near the start of Jankowski's piece, the artist approaches the stage with a handheld video camera, taping the preacher as he introduces Jankowski to the audience. When Jankowski suddenly collapses on the stage at Spencer's feet, the preacher, like the angel in Maino's painting, completes the artwork as he proceeds to deliver a spontaneous sermon on the meaning of contemporary "holy art."

At once dramatic and comical, Jankowski's collapse sets the stage for Spencer's own discourse, providing the material both for the preacher's televised sermon and for the artwork that the two would ultimately edit together. Spencer's improvised sermon is briefly interrupted by a performance of hymns by the Harvest Fellowship Praise Team, the members of which appear remarkably undisturbed by the presence of the fallen artist. Shot and edited with the full cooperation of the Harvest Fellowship Church, the video was televised on a San Antonio cable access station, just like all the church's services. In Jankowski's piece the worlds of art and religion come together to stimulate a larger dialogue on the nature of art and the role of the artist.

LISA JEVBRATT / C5

1:1 is a portrait of the World Wide Web that focuses on database aesthetics and the formal qualities of the network. The project consists of five different visualizations of the Web as a "numerical" space. Every website has a numerical Internet Protocol, or IP, address—a string of numbers such as 12.126.155.22—that usually remains hidden behind a .com, .org, or .net address. *1:1* is a visualization of a database of IP addresses, compiled by C5— a research group, of which Lisa Jevbratt is a member, that devises theoretical models and tactical implementations of theory as product. The database is the result of an ongoing search that begins with a sample of possible IP addresses, iterates all the potential variations, tests them for inclusion, and then starts a new search with other samples. C5's database currently encompasses about two percent of the Web and includes hosts that have limited or restricted access or not even a Web page as a front end. Visitors to *1:1* can navigate the Web—i.e., access an IP address—by clicking on any pixel in the different visualizations of the database. This is a very different experience of the Web than the usual route through search engines or other portals. The visualizations present the Web as the territory it is, an environment that consists not only of websites and homepages, but also of undeveloped sites and missing pages and warnings about restricted access. The database and its visualizations can be used to compare the development of the Internet over several years, juxtaposing portraits of the Web for any given time period.

1:1 collapses the distinction between map and interface. Its interface suggests that it *is* the environment it refers to, on a 1:1 scale, the realization of a metaphor previously explored by Lewis Carroll and other writers. At any given point, Jevbratt's interfaces give us a portrait of the Web that continuously increases in precision, zeroing in on a territory that we usually do not see.

Screenshot of the "Every" interface of *1:1*, 1999. New Museum of Contemporary Art, New York

www.c5corp.com/1to1

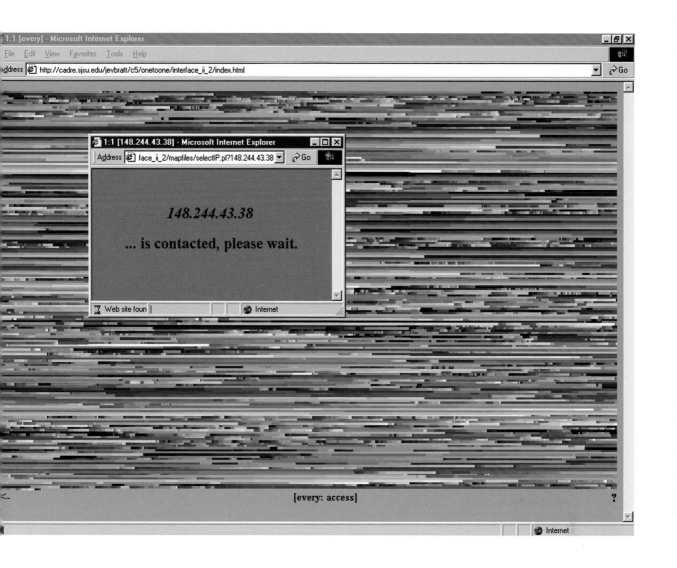

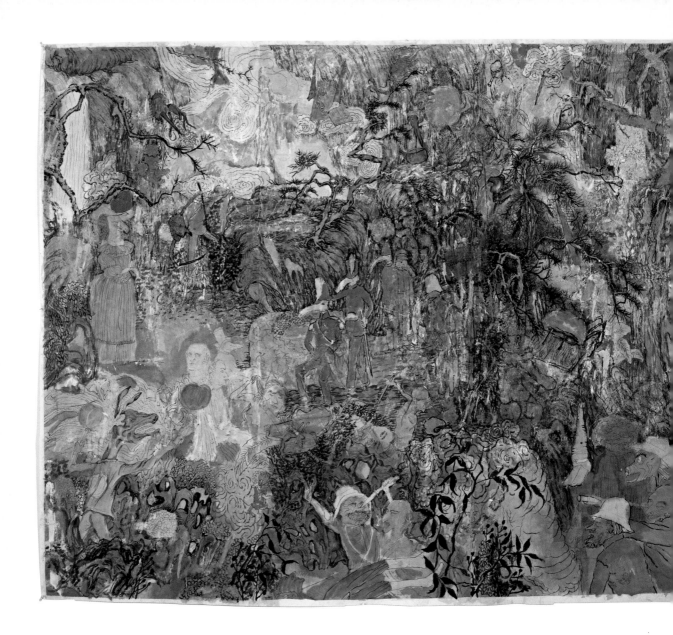

Dinner at the Forbidden City, 2001.
Mineral pigment on rice paper.
54 x 67 in. (137.2 x 170.2 cm).
Collection of the artist; courtesy
Pierogi, Brooklyn, New York

Yun-Fei Ji grew up in Hangzhou in southern China, an area renowned for its centuries-old tradition of *literati* ink brush painting. Under Communist rule, however, such time-honored methods were considered "reactionary" and were discouraged. Ji's first art teachers, during the repressive Cultural Revolution, were Social Realists. It wasn't until he left China in 1986 that Ji became seriously interested in the traditional ink brush techniques and began to see them as a means of expressing contemporary concerns. "Much of the work focuses on natural, industrial, and social disasters as a personal way of coping with the looming danger that challenges us all globally," comments Ji. "By combining the lyrical quality of classical ink painting with playful satire, the work suggests a multilayered reading. The continual shift in scale, from panoramic to miniature, intensifies our understanding of the human condition."

Ji's large-scale painting *Dinner at the Forbidden City* exemplifies this approach. The subject is the British army's occupation of Beijing's Forbidden City at the conclusion of the Opium Wars (1839–1860), fought over Britain's demand for open markets for its Indian-grown opium, which was illegal in China. At the center of the painting is a bevy of British officers in bright red uniforms, standing with a distinctive combination of diffidence and unease. Their heads possess odd beaklike protuberances reminiscent of the grotesque physiognomies of Hieronymous Bosch's monsters. Surrounding these haughty characters is a scene of natural and social chaos: hidden amid ragged pine trees and craggy mountain ledges, ghostly figures perpetrate murderous assaults. The surface of the painting itself seems to have been beaten and torn until it is literally raw. More than a visualization of a long-forgotten historical event, Ji's painting is a powerful allegory of the destructive legacy of imperialism.

CHRIS JOHANSON

Chris Johanson's art expresses the conflicting energies of life in contemporary American society. Like fellow San Francisco artist Margaret Kilgallen, Johanson's work includes paintings, drawings, and sculptural installations and draws broadly upon graffiti, underground comics, and surfing and skateboard culture. Johanson constructs three-dimensional vignettes using painted wooden cutouts of figures, cars, buildings, bridges, mountains, and other forms. Responding to the character of a given exhibition space, he arranges these elements into scenes that echo the chaos of a modern city, complete with traffic jams, crowds, and abandoned buildings.

Johanson is prolific and his work often feels both urgent and cathartic, as if he was barely able to contain a flood of possible representations. His recent installations are explorations of a prevailing social and cultural malaise that he sums up with a single word: brown. To Johanson, the color brown symbolizes a world in which all diversity and uniqueness is transformed by capitalism and globalism into an undifferentiated sameness. In this dystopic vision, free will and the experience of community are replaced by robotic solitude. Despite this dire view, Johanson injects his scenes with hints of humor and glimpses of a better life. Indeed, in all of his work, the artist seeks to convey a positive, hopeful message. Thus, his installations are often given a particular direction or narrative flow that invariably leads from a zone of despondency toward one of enlightenment and joy.

Installation detail of *Untitled* at the Institute of Contemporary Art, University of Pennsylvania, Philadelphia, 2001. Mixed-media installation, dimensions variable. Collection of the artist; courtesy Jack Hanley Gallery, San Francisco

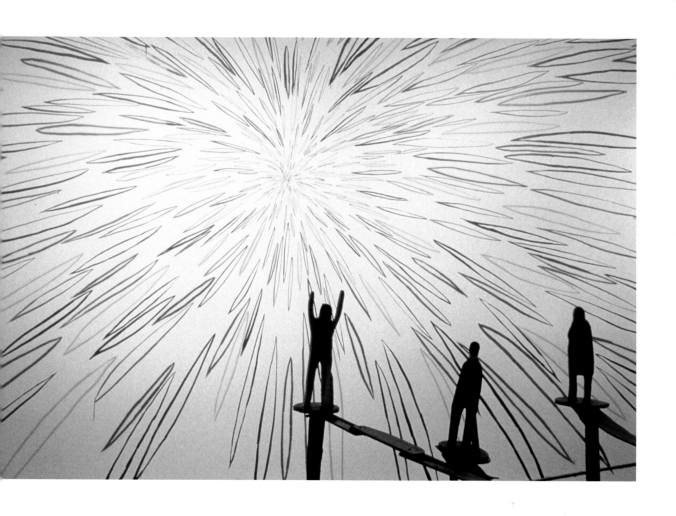

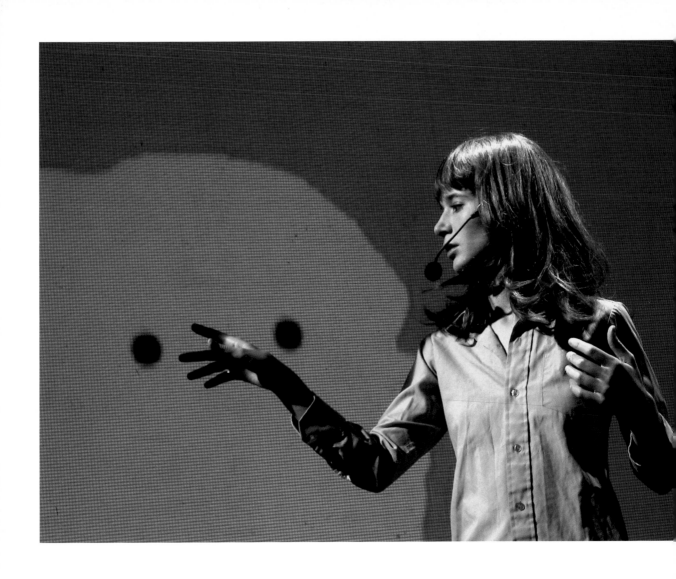

Miranda July performing in
The Swan Tool, Evergreen State
College, Olympia, Washington,
October 27, 2001

Miranda July's films, videos, and multimedia solo performances explore both the shocking and the subtle disconnects that lie beneath the mundane surface of daily life. Her acute observation of social behavior forms the basis for her disconcerting yet engaging narratives and her dysfunctional but irresistible characters that struggle to cope with everyday existence. July is represented in the 2002 Biennial by a video, *Nest of Tens*, and a sound installation, *The Drifters*.

Nest of Tens interweaves four seemingly unrelated plots: an adolescent boy undertaking odd experiments with a baby girl; a developmentally disabled man giving a lecture about fear; a woman recounting an absurd story to her sleazy boyfriend and precocious daughter or niece; and a young girl making advances toward a businesswoman in an airport. July's cryptic scenarios are filled with dark humor and psychosexual overtones as they mix fantastical situations and ordinary circumstances. At once banal and unsettling, the stories elicit both unclassifiable anxiety and empathetic concern as her characters betray with their body language, offhand gestures, and verbal slipups the vulnerability hiding beneath their social veneer.

July's sound installation, *The Drifters*, sited in the Museum's main elevator, translates the distilled offhand gestures evident in *Nest of Tens* into fragments of dialogue that convey various cinematic associations with an economy of means. July reveals her transfixing storytelling skills as she enacts all of the roles herself through obvious vocal shifts. Bringing together music samples, sound effects, and conversational snippets into a series of extremely short vignettes, *The Drifters* offers disjointed glimpses of unidentified conversations and experiences, both dramatic and casual, real and imagined, that add up to an eclectic assortment of powerful moments.

YAEL KANAREK

The core of the *World of Awe* website is a journal, an original narrative that uses the ancient genre of the traveler's tale to explore the virtual world. As the website's introduction explains, the (fictional) journal was found on a laptop—evidently built by a traveler in Silicon Canyon, a graveyard for old computer components. The journal utilizes a standard-looking Graphical User Interface (GUI), though many aspects of this interface are skewed. Included in the journal are twenty-one love letters, three travel logs, and three unique navigation tools. *World of Awe* contains multiple and continuously evolving manifestations; in addition to the journal, the website also features a "Love Letters Delivery System" (which emails the journal's letters to the system's 2,000 subscribers) and "Nowheres," a series of renderings of the territory being explored.

The traveler's tale focuses on the search for a lost treasure in a desert terrain called the Sunset/Sunrise. There, the narrator's determination to find the treasure meets his or her nostalgia for imagined technology and a longing for a loved one left behind. *World of Awe* explores the virtual world in terms of the relationship between storytelling and travel, as well as technological and "lived" memory. As Michel de Certeau has pointed out, it is impossible to distinguish between a travel metaphor and metaphor as travel, since "every story is a travel story—a spatial practice." Texts and stories select and organize places, they link them together and transform them into sentences and itineraries. The *World of Awe* narrative uses a personal journey as an exploration of the deserted places of memory and the imagination, drawing parallels between our mind and technology. Language, the building block of narrative, informs our worldview, which in turn is rendered by our own built-in virtual reality machine, imagination. In *World of Awe*, a personal worldview becomes a customized, shared narrative pointing to the way we construct our reality through the filter of technologies.

Digital landscape in the Sunset/Sunrise desert terrain of *World of Awe*, 2000

www.worldofawe.net

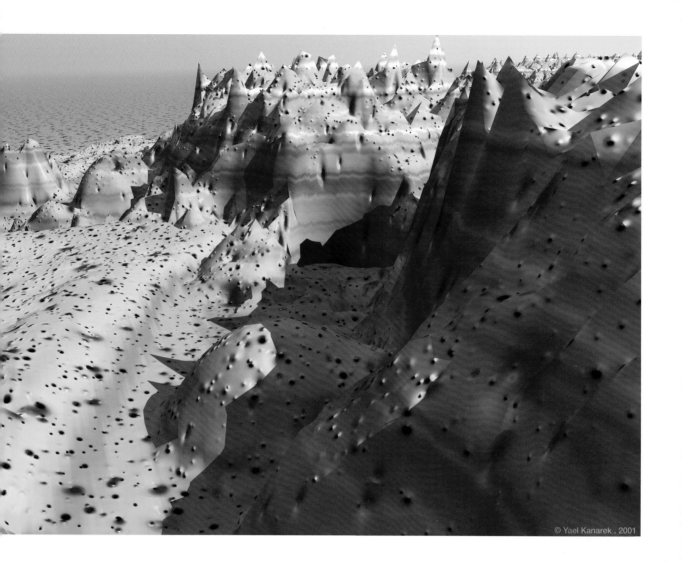

© Yael Kanarek . 2001

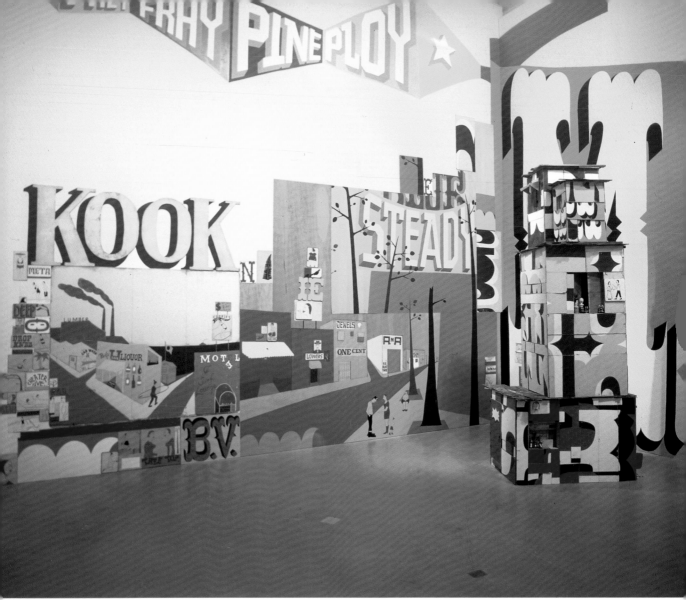

Installation view of *Main Drag* at the Institute of Contemporary Art, University of Pennsylvania, Philadelphia, 2001. Mixed-media installation, dimensions variable. Courtesy the artist's estate and Deitch Projects, New York

When Margaret Kilgallen passed away from cancer in the summer of 2001, she left behind a large body of work that embodies her fascination with American vernacular culture. Part of a close circle of San Francisco artists including Chris Johanson and Kilgallen's husband, Barry McGee, she created work that is rooted in mural painting, graffiti and tramp art, and underground comics. The world she evokes is rife with desolate streets lined with broken-down liquor stores, bars, and cheap motels. Her women smoke cigars and her men, one imagines, are not strangers to the bottle. The comiclike appearance of her art and its autumnal color palette of burnt siennas, dark olive greens, and muted oranges imbue the sad-sack atmosphere with a nostalgic charm.

Main Drag, an installation she first exhibited at Philadelphia's Institute of Contemporary Art, has been adapted for the Biennial. The installation displays a semideserted street scene with leafless trees, a bar, a jewelry shop, and a factory with two smokestacks set in the distance. Between the two long, painted walls stands a peculiar tower, composed of fragments of abandoned shacks. *Main Drag* reveals Kilgallen's fascination with vernacular lettering; the work is replete with dilapidated store signs and streetscapes marked with ambiguous words like "Steady" and "Kook." Kilgallen worked as a book conservator at the San Francisco Public Library for eight years, a job that enabled her to immerse herself in the history of typography.

Despite its rather morose tone, Kilgallen's installation reflects a resourceful spirit. Much of her work was made with discarded materials, including scraps of wood and house paint retrieved from local recycling centers. Using no preparatory sketches or guidelines, Kilgallen typically created her installations on the spur of the moment, instilling the final artwork with an improvised, do-it-yourself feel.

KIM SOOJA

Kim Sooja's installations, videos, and performances link art with everyday life by transforming common materials and concise gestures into poetic commentaries on the human condition. One key body of work involves the use of traditional Korean bedcoverings as sculptural elements. These textiles, traditionally given to newly married couples, are typically embroidered with symbolic patterns and made of contrasting colors, such as red and blue, which together signify the unification of yin and yang. In Kim's works, the bedcovers are laid flat on the ground, hung in rows like laundry on a line, or filled with old clothing and knotted in clusters of *bottari*, flexible bundles traditionally used to transport household goods. The bedcoverings are always used, artifacts of anonymous lives.

Kim's bedcover pieces are deceptively simple in form, yet resonate with multiple layers of experience and meaning. On one level, they are strikingly sensuous compositions, spreading out before the viewer in an array of color, pattern, and texture. These fabrics are also immediately accessible: we all use bedcoverings virtually every night, from birth to death. They are fraught with feelings and emotions from comfort and desire to solitude and exhaustion. Bedcovers, in Kim's words, "are frames of our bodies and lives." When bundled as *bottari*, the bedcovers become a kind of universal symbol of human movement, hinting at migration, nomadism, and the experience of refugees. *Bottari* are also metaphors for the human form. "I find the body to be the most complicated bundle," explains Kim. On their most abstract level, which is the level most important for Kim herself, the bedcovers are veils that divide one state of being from another, inside from outside, the hidden from the seen. "Through the quite present and simultaneously distanced engagement of cloth," comments curator Harald Szeeman, "she challenges us to reflection on our most basic conduct: consciousness of the ephemera of our existence, of enjoying the moment, of change, migration, resettlement, adventure, suffering, of having to leave behind the familiar. She masterfully sets her fabrics, rich in memory and narrative, into the situation of the moment, as zones of beauty and affecting associations. With a grace that knows ever so much."

Encounter—Sewing into Looking, 1998. Used bedcovers on body, dimensions variable. Collection of the artist; courtesy The Project, New York and Los Angeles

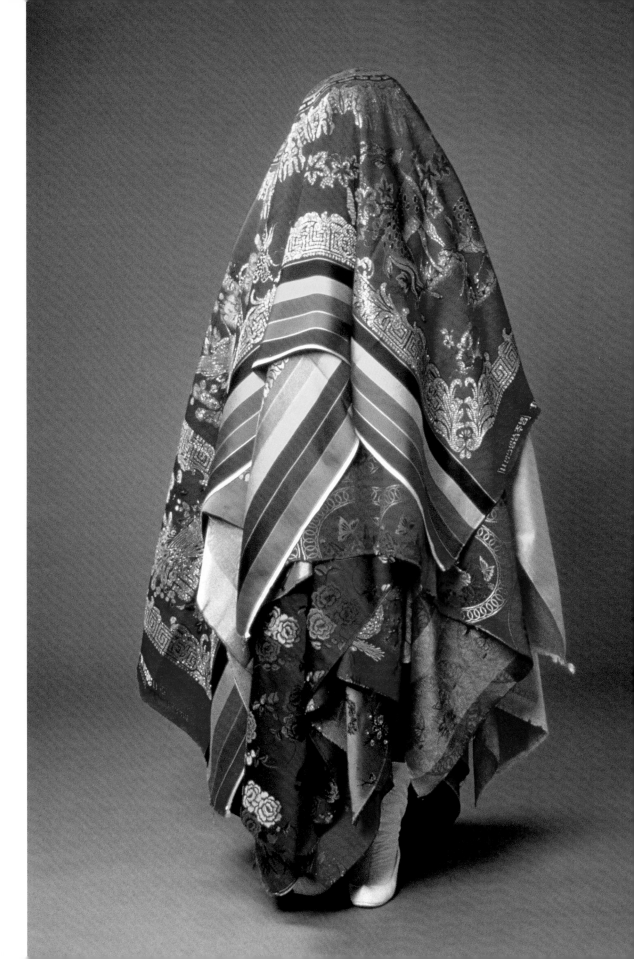

Stills from *Wot the Ancient Sod*, 2001.
16mm film, color, silent; 17 minutes

Diane Kitchen's film practice embraces two genres: ethnographic documentary, exploring indigenous life in the Amazon basin, and a more personal cinema, in which her lens focuses on the magnificent details of nature—autumn leaves, the pelt of a deer, or the glistening surface of snow. In *Wot the Ancient Sod*, autumn leaves appear in close-up, nodding gently on their stems, then blur into diffused halos of colored light. Through focal adjustments of the camera lens, Kitchen transforms the veined surfaces of leaves and twigs into abstract forms, whose diffused light fills the entire screen for several moments before the camera shifts once more to bring another form into focus.

Kitchen uses light to both underline and redefine the properties of natural forms, evoking the films of Marie Menken and that filmmaker's use of light to articulate the rain-pocked surface of water, candlelight, leaves, and flowers. The shifting images also recall Oliver Wendell Holmes's 1859 observation on the new medium of photography: "Matter as a visible object is of no great use any longer, except as the mould on which form is shaped." The sod of the title, Kitchen explains, "refers to the earth and the build-up of organic material that becomes soil or humus." Coincidentally, she continues, sod "also refers to 'drunken' or 'fermented'—which comes to mind as I watch my compost pile at home work from a tall pile of leaves, orange peels, coffee grounds, etc., down to a beautiful clean humus that I use to prime the vegetable garden….And 'wot' appears from another old word, a derivation of 'to wit' which is 'to know, to have knowledge of.'"

JOHN KLIMA

EARTH, a unique geo-spatial visualization system, represents a broad range of information about our planet in multiple data layers. The software accurately positions real-time data culled from the Internet on a three-dimensional model of the earth. Viewers are able to travel from layer to layer, retrieving imagery and data for specific regions. The outer layer consists of a detailed three-dimensional outline of the earth's coasts, based on United States Geological Survey data. This information is projected on a spherical mapping of GOES-10 weather satellite imagery. From this layer, users can zoom in on LANDSAT-7 satellite imagery of the earth's surface. In *EARTH*'s final layer, the viewpoint switches to a local one. Here, viewers can "fly" through a five-degree-by-five-degree patch of the earth's terrain and observe the current local weather conditions. The terrain's geometry and textures are generated dynamically from raw data files available from a U.S. military website.

EARTH is the living room globe of the digital age, giving users access to multiple data sources within one self-contained environment. However, it is less a tool than a reflection on the aesthetics of visualization models. Klima's work points to the relativity of our "worldview" and perception as it manifests itself in processed and mediated live representations: the combination of 2-D and 3-D views of the planet—all of which depict facts and "reality"—invites an examination of the validity of real-time data sources and highlights their respective aesthetics.

Screenshot from *EARTH*, LANDSAT-7 layer, 2001. Courtesy Postmasters Gallery, New York

www.cityarts.com/earth

1.60989
atitude

49.3661
longitude

Still from *The Glass System*,
2000. 16mm film, color, sound;
20 minutes

Mark LaPore's filmmaking is both antidocumentary and nonfictional. Filming in rural Sudan, Sri Lanka, India, Eastern and Western Europe, and the United States, he creates a sense of perpetual recording, evoking the devotion and intimacy of a diary keeper. *The Glass System*, a double portrait of the streets of Calcutta and New York, is a meditation on how ideas about culture are learned through language. LaPore captures a series of tableaux from the streets of Calcutta: a knife-sharpener honing blades on a stone rotated by the pedaling of a bicycle; a tiny child performing a tightrope walk high above a small crowd, on a rope strung between two trees; mannequins with dark eyes, staring impassively out of a dusty store window. As each image sequence appears, a child and an adult read phrases from a Bengali-English primer, the text underlining LaPore's and the viewer's presence as outsiders, attempting to enter another culture through its most basic tool of communication: language. The tension between our distance as mute observers and our desire to connect with the people and their world is contained by the sensuality of LaPore's images, each of which unfolds with a delicate precision. Within their ordinariness, each one reveals an unspoken fragility and transience. Two young Indian girls on their way home from school are filmed standing self-consciously against a wall, dressed in school uniforms. In their steady stares, they resolve to maintain eye contact with the camera, vulnerable yet trusting subjects.

LaPore intersperses his diaristic tableaux of Calcutta with scenes from New York, such as a man selling watches in front of a store on Fifth Avenue, and the skyline reflected in a Chinese movie poster. In the fleeting street life of both cities the filmmaker recognizes a slower, more humanistic existence, whose infinitesimal aspects he meticulously records as the boundaries of the two worlds become increasingly permeable.

ROBERT LAZZARINI

Robert Lazzarini's recent body of work consists of a series of everyday objects subjected to compound distortions. To create his astonishing sculptures, Lazzarini begins by developing a 3-D computer model of an object, then subjects that data to a series of mathematical distortions. Using the computer file as a guideline, Lazzarini fabricates the sculpture from its original materials: a hammer from metal and wood, a shoe from leather and rubber, a human skull from crushed bone. Like computer-generated special effects thrust improbably into the real world, his sculptures seem to hover and stretch in midair, defying our sense of physical possibility and creating a powerful feeling of psychological unease.

Lazzarini's *payphone* resembles the public phones that punctuate the sidewalks of Manhattan. He constructed the sculpture using the same materials that comprise a functioning payphone. All of the elements of an actual payphone are accounted for: handset, push-button dial, coin return, and working advertising lightboxes. Lazzarini gives careful attention to the various surfaces of the object, incorporating different metals, stickers, advertisements, and scratches. As one approaches *payphone*, the static object seems to be moving. It appears to bend at an oblique angle, simultaneously expanding and contracting in space, confounding the viewer's sense of stability. "The forced perspective of the sculpture is at odds with the way perspective occurs naturally," explains Lazzarini. The wholly unnatural visual presence of his work evokes the possibility of an irrational force haunting the objects and materials of everyday life.

Study for *payphone*, 2001. Mixed media, 108 x 84 x 48 in. (274.3 x 213.4 x 121.9 cm). Collection of the artist; courtesy Pierogi, Brooklyn, New York

AZ-ST-5491

Figure 1.1
Aztlán today and tomorrow refuses to be seen but ceases to be imagined.

JOHN LEAÑOS

Installation detail of *Remembering Castration: Bloody Metaphors in Aztlán* at the San Francisco State University Art Gallery, 2000. Photograph in lightbox, dimensions variable. Collection of the artist

For some time there has been a growing loss of faith in the objectivity of history, especially in many academic circles. It has become difficult to believe in the veracity of the historical narratives we inherit, tainted as they are with countless distortions and gaps. Furthermore, "history" is often used propagandistically to justify a particular political or moral position. *Remembering Castration: Bloody Metaphors in Aztlán* is John Leaños's provocative foray into the realm of fictive historical records. Taking the form of a history museum display, *Remembering Castration* uses faux artifacts, documents, photographs, and explanatory texts to present a revisionist history of Aztlán, the area stretching across the United States/Mexico border that has come to be viewed by many contemporary Chicano people as their true ancestral, spiritual, and cultural homeland.

As Leaños explains, "The enigmatic findings presented in this exhibition are the recovered research of Aztec migration by nineteenth-century German archaeologist Helmut Mytusmacher. Lost for over 150 years, this evidence brings forth new insights that link Aztec historical memory to castration of the Aztec warrior. The discovery of Mytusmacher's field data resurfaces an ancient and enigmatic quarrel between Aztec siblings which has forged the cultural memory, forgetting, and mythology of an entire people. In this exhibition, we revisit the passageways of Aztec memory and revise its amnesia by excavating history's complex anomalies and underscoring their significance."

In contrast to the popular myth of Aztlán, Leaños's sardonic version ends not in violent triumph but in the castration of the Aztec warrior-emissaries who have been dispatched by their emperor to find the homeland of the Aztec peoples. Their fate is sealed when they fail to recognize the goddess of the moon, Coyolxuahqui, who proceeds to give them a physical reminder of her power that they will never forget. Thus, Leaños subtly challenges the prevailing reverence for Aztlán, substituting a legend of female empowerment for the usual male-centered myth of conquest and domination.

MARGOT LOVEJOY
WITH HAL EAGAR, JON LEGERE, AND MAREK WALCZAK

The *Turns* website collects and shares personal stories of life turning points. Stories are represented on the site as pebblelike shapes that can be opened, then returned to the narrative pool. Visitors to *Turns* can browse stories according to twelve categories, such as education, relationships, health, trauma, family, or war, or contribute their own narratives. In the "Anthology" section of the website, users can reorganize the stories by filtering them—according to ethnicity or the time at which the turning point was experienced, for example—and access related databases. People may also contribute and draw a "life map," visually representing the course of their lives.

Turns provides connections to lives lived under many circumstances and in a range of time periods. Seen through relational filters, lenses, and links, one's story is understood as part of a social memory. The site is also a reflection on the ways new media are influencing and changing notions of the individual in a social context. With its possibilities for creating networked communities and relational databases of personal experience, the Internet becomes a form of collective, social consciousness.

Screenshot of the "Anthology" interface of *Turns*, with stories filtered according to ethnicity, 2001

www.myturningpoint.com

Friedrichshafen, Harbour, I: August 22–23, 1999, 1999. Unique camera obscura gelatin silver print, 55 x 133 in. (139.7 x 337.8 cm). Collection of the artist; courtesy Fraenkel Gallery, San Francisco

Vera Lutter creates large-scale photographs representing scenes of contemporary architecture, transportation, and industry. The process she uses leads to images that are both immediately recognizable and yet strangely alien. Lutter employs a device known as a camera obscura ("dark room" in Latin), which was used to produce direct images of reality for several centuries before the invention of photography. A camera obscura is made by creating a small opening in an otherwise sealed room or chamber. Light from an external source penetrates the opening, which acts as a lens, and is cast, upside down, on an opposite surface. To make an image, Lutter creates a temporary camera obscura at a site and places a large sheet of photosensitized paper where the projected image falls, exposing it to the light. The exposure may last hours or even days, and Lutter usually remains in the room for the entire period. When the image is developed it is in negative form. *Friedrichshafen, Harbour, I: August 22–23, 1999* is a haunting image of a ship at dock on the shore of Lake Constance. The comings and goings of the passengers and crew are recorded as blurs, while the ship and the static landscape appear fixed in serene eternity.

While Lutter's images are direct, virtually unmediated records of the world as it is, her work should not be mistaken for straightforward objective documentation. As critic and curator Russell Ferguson observes: "Their implacability evokes not the techniques of scientific observation but rather a reverie driven by the equally implacable passing away of time itself. Past and present are brought together in a moment of stillness that is in fact achieved only over an extended period. The long length of the exposure...filters out all the incidental movement and bustle of daily life, leaving only the skeleton of a present that is steadily and irrevocably receding into the past."

CHRISTIAN MARCLAY

Trained as a visual artist, Christian Marclay has been an influential figure in the experimental music scene since the 1970s, when he made pioneering turntable works that paralleled the rise of the hip-hop "scratch" technique. In addition to his great contributions to DJ culture and improvisational music, Marclay has created a large body of related work in video, installation, and sculpture. Much of that work has been concerned with the relationship between imagery and sound.

Marclay's installation *Band* consists of a group of fantastically distorted instruments arranged on a stage under theatrical lights. Sculpturally, these objects at times embody the performative or sonic effect of the instruments they represent, while at other times they wittily deflate the instruments' conventional image. *Drumkit*, for example, is a complete set of drums that has been elongated into a towering monument to the drummer's stereotypically inflated ego. *Virtuoso* is a sinuous, twenty-five-foot-long accordion that visually captures the respiratory nature of the much-maligned instrument. And in *Prosthesis*, Marclay transforms the electric guitar, a symbol of phallic potency, into a piece of flaccid, pink rubber. Although obviously unplayable, these works draw on our memory of music and sound for their impact and meaning.

Vertebrate, 2000. Altered acoustic guitar, 26 1/2 x 15 1/2 x 11 in. (67.3 x 39.4 x 27.9 cm). Collection of the artist; courtesy Paula Cooper Gallery, New York

Virtuoso, 2000. Altered Titano accordion, 300 in. (762 cm) length. Collection of the artist; courtesy Paula Cooper Gallery, New York

Stockholm, 1999. Ink-jet print,
36 x 28 in. (91.4 x 71.1 cm).
Collection of the artist

For the past six years, photographer and filmmaker Ari
Marcopoulos has been documenting an international group
of young snowboarders. Traveling with them around the globe,
from Iran to Switzerland to Japan, he has captured their
activities and daily rituals on film, deftly describing the lives of
these young men who regularly defy not only social conventions
but also physical possibility, and even gravity itself. Marcopoulos
shows both their collective and individual experiences: gathering
at large outdoor and indoor competitions, moving en masse
to techno music, killing time in anonymous hotel rooms, and
plummeting down dangerous peaks. "Snowboarding is a rich
culture because the riders know and feel and assess both extremes—
what it means to be isolated and self-reliant, and what it means
to be in an independent group of people," observes Marcopoulos.

The artist exploits a range of cameras to achieve various ends.
Digital and 35mm cameras, for example, give him the freedom
of movement and spontaneity necessary to capture informal scenes
as well as live-action snowboarding events. With an eight-by-
ten-inch view camera, he is able to capture his subject in minute
detail, from the wisps of snow blowing off a mountain peak
to the patterns of a gigantic artificial slope constructed inside
a sports arena.

Marcopoulos was born in the Netherlands and has always
been fascinated by the characters, composition, and light
of seventeenth-century Dutch paintings. While capturing the
youth, energy, and vitality of a contemporary nomadic tribe,
Marcopoulos's images often also recall the formal sensibility of
the art of this earlier age.

BRUCE McCLURE

Bruce McClure trained as an architect, took up painting, then became interested in the time-based, three-dimensional properties of light and projection. In 1994 he made his first projection work, constructing a projector from black and translucent plastic sheets, colored gels, spray paint, floodlights, and miscellaneous found objects. Later that year, influenced by the rotary disks of Marcel Duchamp, he began to create performances of stroboscopic disks, and also of superimposed projections of hand-processed, colored celluloid surfaces.

McClure's recent work is divided into two groups: "Film Lengths" and "Film Loops." "Film Lengths," he explains, "have an isomorphic relation to discrete intervals of time." That is, film length is converted to time as it passes through the projector at a given rate. McClure shifts this reading of length to something more physical. In *Indeterminate Focus*, he laid out 400 feet of film and sprayed colored dyes and India ink onto its surface. The film is run through a specially altered projector, causing an interference in the passage of light between the projector bulb and the screen. As McClure explains, this interference "liberates light from the tyranny of the rectangle, freeing [the image] to levitate from the screen." Layers of colored light and shadow induce an ambiguous reading of planes in space.

In McClure's "Film Loops," the linear progression of a film is replaced by a fusion of four projections into a simultaneous multiple image, or "quadriplanar space." Short, unsynched loops of hand-sprayed colored film are superimposed onto the others, and overlaid by a rainbow of colored gels on a rotating cardboard disk, which McClure spins in front of the projector. In *XXX, OXX, XOX, XXO (Slapdash Slapstick)*, India ink is splashed onto the film frame, sprocket holes, and sound track, creating a tumbled cacophony of movement and sound as the painted films pass through the projector, colored by rotating colored gels. As McClure observes, his performed film objects present the surface of the film as "a counterpoint of the brain emulsion—as a reagent converting light, color, and motion sequences into intervals of thought, visceral and real."

Stills from *Quarter Draw*, 2001. Four 16mm black-and-white film loops for four projectors, and rotary gels, color, sound; length variable

Inspection, 2000. Compressed charcoal on paper, 20 x 28 in. (50.8 x 71.1 cm). Collection of Alberto Guevara

Drain, 2000. Compressed charcoal on paper, 20 x 28 in. (50.8 x 71.1 cm). Collection of the artist; courtesy NFA Space, Chicago

Conor McGrady's art draws on his personal experiences living in the religiously and politically divided city of Belfast, capturing the profound tension of daily life in Northern Ireland. McGrady finds evidence of violence everywhere, from a seemingly innocuous pair of boots to the architecture of a new housing complex that was designed to facilitate clear lines of fire. Working solely from memory, McGrady strips away excess information, leaving only enigmatic, yet telling details: a cracked floorboard and smashed door, for example, are laconic indications of forced police entries and random home searches. In another work, a mortician's table is reduced to a chilling, bare drain.

McGrady's drawings suggest that in a society under constant scrutiny, even the body becomes a site for penetrating inspection. In one work that ironically recalls the Biblical image of the inspection of Christ's wounds, a cut in a man's torso is probed as if in search for contraband. Not only privacy, but human dignity itself is a casualty of a society torn by conflict. In McGrady's hands even a bucolic landscape is pervaded by an ominous feeling of constant surveillance and incipient attack.

MEREDITH MONK

Meredith Monk creates interdisciplinary performance works that weave together music, movement, visual images, and theater into a single unified form. A composer, singer, filmmaker, director/choreographer, and installation artist, Monk is perhaps best known as the pioneer of "extended vocal technique," a nonverbal method of singing that asks performers to produce a full range of unconventional and idiosyncratic sounds not normally associated with Western vocal traditions. This evocative, abstracted language transforms the human voice into a multifaceted instrument capable of expressing a seemingly limitless range of emotions.

Eclipse Variations is a wordless ensemble vocal piece comprising a series of two-note intervals that are passed from singer to singer, gradually developing into more complex note clusters. As the piece progresses, Monk adds and removes individual vocal parts, creating a series of ethereal layers that overlap and separate into otherworldly sound patterns. "I was interested in the idea of a new sound being revealed when another one disappears," Monk explains. "A sonic equivalent of the light or glow coming from behind the shadow of the moon in an eclipse." Presented as a site-specific installation, *Eclipse Variations* gives the listener the impression of being at the center of a circle of singers. As the celestial sounds of the performers' voices move fluidly back and forth across the space, Monk's work invites us to explore the inseparability of music and movement.

Score of *Eclipse Variations*, 2000.
Colored ink on paper,
7 x 8 1/2 in. (17.8 x 21.6 cm).
Drawn by Allison Sniffin

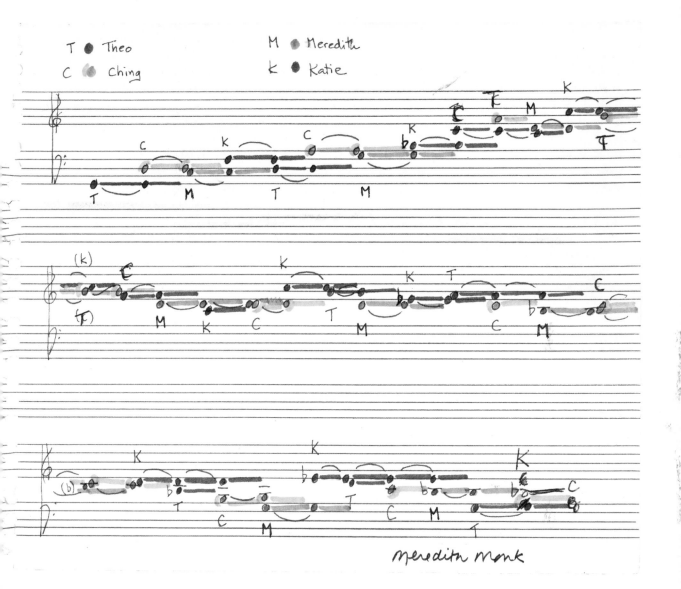

Meredith Monk

Friends and Enemies: Will and Trae, 1999–2000. Chromogenic color print, 48 x 68 in. (121.9 x 172.7 cm). Collection of the artist; courtesy Fredericks Freiser Gallery, New York

Domestic: Betty and Toni, 2001. Chromogenic color print, 40 x 52 in. (101.6 x 132.1 cm). Collection of the artist; courtesy Fredericks Freiser Gallery, New York

Recalling the ethnographic work of the photographer Irving Penn, Julie Moos removes her subjects from their "natural" environment and places them in front of a neutral backdrop. Photographed frontally and almost always in pairs, Moos's sitters are presented directly and objectively. Yet, while they are completely held within the camera's gaze, her subjects are hardly powerless: they look back at the camera and at us with expressions that range from suspicious to serene.

Each of Moos's recent portrait series explores a specific sociocultural milieu. *Friends and Enemies*, for example, was shot entirely at the Altamont School, a private school in Birmingham, Alabama. Inspired by the recent tragic shootings at Columbine High School in Colorado, Moos decided to photograph the students of the class of 2000 in pairs, based on powerful bonds of friendship and enmity that she discovered over the course of several months spent analyzing the school's yearbooks and interviewing guidance counselors, teachers, and the students themselves. The students did not know with whom they would be paired until the moment their portraits were to be taken. Nor are we, the viewers, ever informed whether the couples we see are the best of friends or sworn enemies.

A more recent series, *Domestic*, similarly involves pairs of subjects, in this case wealthy Birmingham residents and their housekeepers. As in *Friends and Enemies*, the subjects of this series are not identified. Perhaps as compelling as the implicit divisions of race and class that these works convey is their powerful evocation of character and personality. For Moos herself, "These photographs are about relationships and about the personal bond between employer and employee."

TRACIE MORRIS

Tracie Morris is a multidisciplinary performance poet who has
been a key figure on the spoken-word scene since the early
1990s. Her distinctive style of poetry blends traditional literary
forms, including haiku, with popular musical genres such as
hip-hop, funk, rock, jazz, and ambient. Using her vocal dexterity
and improvisational skills, Morris, often accompanied by a
small musical ensemble, delivers richly textured narrative
compositions that draw on personal experiences. Believing
that "you can't separate 'who you are' from 'who you are in the
poem,'" her confrontational and affirming lyrics offer reflections
on race, gender, urban culture, and human relationships from
her perspective as a black woman from East New York, one of
Brooklyn's most under-served neighborhoods.

For the 2002 Biennial, Morris has composed a new series
of sound poems, *sound(e)scapes*. While her narrative works break
down conventional syntax to riff off the literal sound and meanings
of words, Morris's sound poems go one step further, tearing apart
the words themselves to get at the heart of spoken language.
An improvisational stream of melodic intonations and rhythmic
inflections taps into the physicality of sound to communicate
ideas that resonate on emotional, visceral, and mental levels.
Although they are ostensibly more abstract than her narrative
works, Morris surprisingly considers the sound poems to be more
"real" in many ways. "Words are abstractions used to describe
things," she observes, "while the physical things they're made of
are more concrete, more of what they actually describe."

Morris creates her sound poems through direct and
spontaneous experimentation with her voice: they come into
being not through a conventional writing process, but through
oration as writing. Rooted in cultural specificity, her work reflects
what Morris regards as the "physics and metaphysics" of African
American poetics. At the same time, her wordless incantations
offer universal expressive possibilities that transcend the
particularity of spoken language.

Tracie Morris performing at The
Kitchen, New York, December 1999

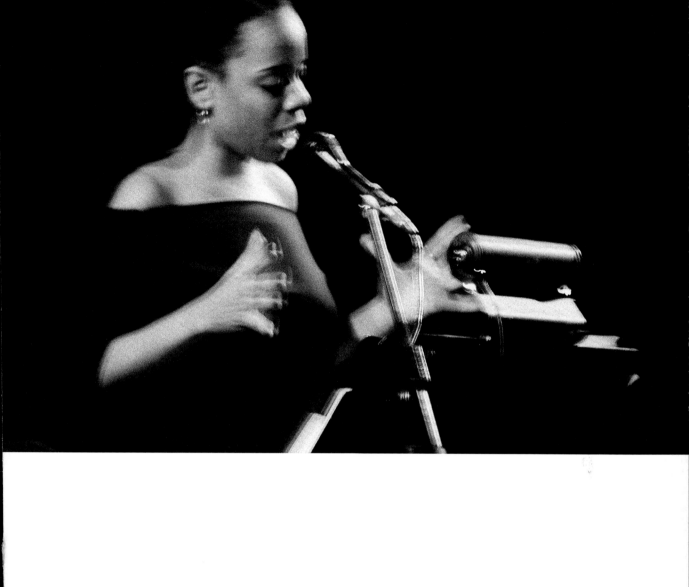

Screenshot from *Riot*, 1999

www.potatoland.org/riot

Mark Napier's *Riot* is an alternative, "cross-content" Web browser. Like its real-world namesake, *Riot* disrupts the accepted rules of property and exposes the fragility of territorial boundaries. Inspired by the clashing classes and ideologies of New York's Lower East Side, Napier created a software "melting pot," a blender that mixes Web pages from separate domains into one browser window. The basic functionality of *Riot* is still rooted in traditional browser conventions: you surf the Web by entering a URL into the location bar or by selecting from bookmarks. Unlike conventional browsers, however, *Riot* builds its pages by combining text, images, and links from the pages any user has recently viewed.

In this way, Napier's project challenges and dissolves traditional ideas of territory, ownership, and authority by squeezing different sites' information, brand names, and corporate logos into one page. The official Vatican site mixes with Hell.com; Microsoft.com bumps up against the hacker quarterly 2600.org. Content and ideologies clash and merge as *Riot* dissolves territorial conventions such as domains, sites, and pages. The result is a beautiful composite based on "controlled randomness" that is produced by both the user's actions and parameters set by the artist.

On the Internet, physical territory and objects are replaced with experiences produced by hardware and software, data and instructions. Information can be recycled and reproduced in seemingly endless ways and distributed in ever-shifting contexts; the alternative space of the Net ultimately resists our traditional, physical model of ownership, copyright, and branding. Although domain names are widely considered "virtual real estate"— a terrain that we buy and own—the nature of the network itself doesn't support this notion. With boisterous visuals, *Riot* questions the assumption that "content is king," dethroning that ruler by undermining control over displaying and separating content, treating it as raw material for aesthetic experiments.

ROBERT NIDEFFER

The term "agent" is used to describe a software program that filters and customizes data, creates user profiles, and tracks user behaviors. Robert Nideffer's *PROXY* is a head-game about agents and agency that revolves around what the artist calls "unorthodox methods of information discovery, file-sharing, data mismanagement, and role-play." Agents come with a wide range of functionality and intelligence, which ultimately defines their beneficial or damaging aspects. The personal agent that lives on your hard drive, manages your files, and reminds you to "empty your trash" may not seem a particularly threatening entity. However, agents that promise to monitor information for us while exchanging that data with other agents have the ability to transform us into digital sitting ducks. By attaching themselves to our data-bodies, they turn us into easy targets for marketers and advertisers.

While most of today's software agents are developed as closed systems for commercial purposes, *PROXY* is an open-ended, multiagent development environment that others may freely extend. Players personalize their agents by rating such things as their ability to "perceive others' emotions," their desire to "be in the limelight," or the stability of their moods and behavior. Once the agent is set up and the system is installed, players can import personal data and begin exploring. *PROXY* uses several interfaces that allude to different gaming experiences, including a text-only interface reminiscent of Multiple User Dungeons (MUDs) and a 3-D, arcade-style game interface. As you move through the environment, you encounter monsters (such as the curator, the professor, or the hacker) in a play on the art world and academia. Players may also choose to sit back and watch what happens as their agents start to work on their behalf.

By facilitating distributed, collective, and slightly out-of-control data processing, *PROXY* is a reminder of what software agents can be: a playful exploration of identity, community, and information exchange, but one that raises rather serious questions about who we are and how we behave in online public space.

Screenshot of the *PROXY* interface, 2001

portal: *proxy.arts.uci.edu/*
agent application: *proxy.arts.uci.edu/agents/*
tutorial: *proxy.arts.uci.edu/tutorial/*

Still from *Time Being*, 2001. Digital video, black-and-white and color, silent and sound; 58 minutes

Andrew Noren is a master of two disciplines. Within the television and film industry, he is regarded as the world authority on archival newsreel collections, and has worked on almost every major documentary produced in the last twenty years. In the world of experimental film, he is regarded as a master of light, and over the past thirty-five years has produced a substantial and highly respected body of films.

In *Time Being*, Noren's first film using digital technology, his mastery of light and shadow is infused with a heightened electronic fluidity. In intimately composed images of his home and garden, shot at different times of day and in different seasons, sunlight pours over each surface like a liquid. Noren dapples the rich light into abstract forms, mixing black and white and color. The polished wood of a table; the serpentine movements of the family cat as it basks in the sunlight on the carpet; the movement of leaves dancing on branches in the garden—Noren's camera captures every detail, responding to the light and shadows contained within each image. The film unfolds into an increasingly abstract symphony of light and shadow, as recognizable images become merged into a powerful rhythmic narrative of black-and-white abstract forms.

Noren's engagement with light began at an early age, during his childhood in Santa Fe. "The light there had a great influence on me, and still does....An early memory of sitting under a cottonwood tree....September afternoon light of great clarity with a wind blowing....I sat there watching in the light and the leaf shadows dancing on the dust, listening to the leaves. It was my first movie...and I was bewitched by it." Noren's work understands cinema as belonging to this natural way of seeing: "Sun's light emanates, projecting image of 'world' through 'eye' and onto camera obscura of brain....Mind imagines...forming a scenario of intent and desire...and projects that light back through 'eye' onto 'world'....This is the great primal cinema of animal consciousness...at which we are all captive spectators, asleep and awake, from first light to final fade."

JOSH ON & FUTUREFARMERS

They Rule is a launchpad for investigating corporate power relationships in the United States. The website allows users to browse through a variety of maps that function as directories to companies such as Pepsi, Coca-Cola, and Microsoft. *They Rule* depicts the connections between companies through diagrams of their power structures, specifically their boards of directors. The minimalist symbolism of these diagrams—CEOs are represented as an iconic male or female holding a briefcase—highlights connections and gives the ruling power elite a kind of uniformity. The directors' weight increases proportionally to the number of boards they sit on. Users can run Web searches on CEOs by clicking on their briefcases and accessing information about them, the donations they have made, or their companies. They can also add to a list of URLs relevant to that company or person or save a map of connections, complete with annotations, for others to view.

Through mergers and takeovers, fewer and fewer companies control more and more of the economy, and these megacorporations exert control in nearly every sector of it. As a many-to-many broadcasting system and vast information resource, the Internet is a perfect medium for making visible the intricate web of relationships between these corporate entities. In its examination of these intertwinings, On's piece evokes C. Wright Mills's book *The Power Elite* (1956), which documented the interconnections among the most powerful people in the United States at that time. *They Rule* employs the features of networked technologies, such as dynamic mapping, hyperlinking, and instant searches, to create its own subnetworks of power systems, and utilizes the Internet's potential for access and data transparency to create a qualitative description of these forces. At a moment when growing e-commerce turns us into transparent customers, *They Rule* subverts the use of the Web as a mere marketing tool and invokes its original promise as a democratizing medium.

Screenshot of a map constructed with *They Rule*, 2001. A view of the interlocking boards of directors of U.S. companies

www.theyrule.net

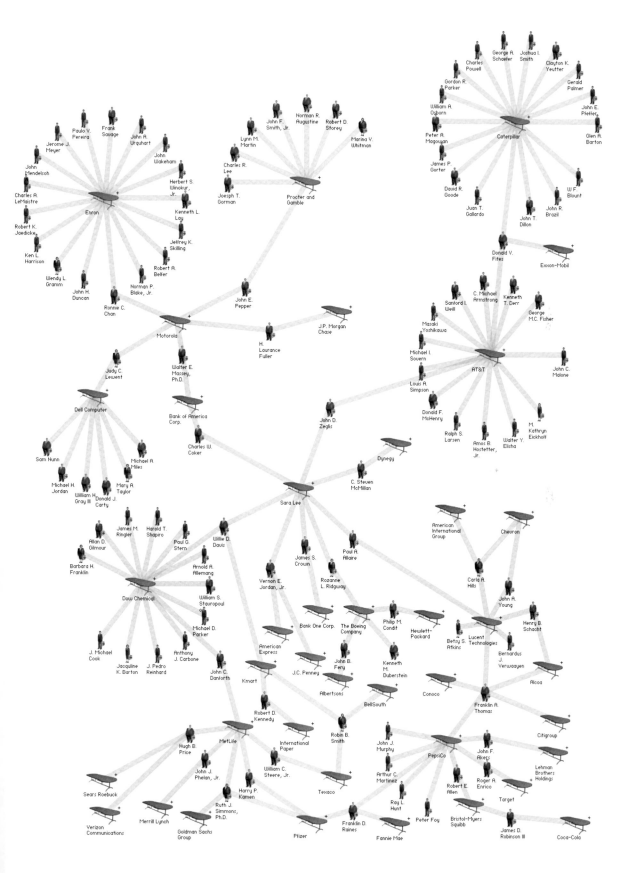

ROXY PAINE

Model for *Bluff*, 2002. Stainless steel,
47 x 43 in. (119.4 x 109.2 cm) overall.
Collection of the artist; commissioned
by the Public Art Fund; special thanks
to James Cohan Gallery, New York.
Whitney Biennial in Central Park,
Organized by the Public Art Fund;
sponsored by Bloomberg

Since the mid-1990s Roxy Paine has created sculptures of various
plant forms whose remarkable realism belies their handcrafted
origins. The plants depicted—including opium poppies, poison ivy,
and hallucinogenic mushrooms—all have potent transformational
effects on human beings. These simulated flora are often exhibited
in clusters of hundreds or even thousands of individual forms.

For the 2002 Biennial, Paine extends his conceptual and formal
parameters with *Bluff*, an approximately fifty-foot-tall metal tree
installed in Central Park. Complete with networks of branches
sprawling in different directions, its design represents an improvised
amalgamation of actual tree species. Unlike Paine's previous
sculptural simulations of natural forms, however, this work does
not have illusionistic pretense, but instead boldly announces its
artificiality. *Bluff* is made from common industrial materials, with a
two-foot-wide trunk of heavy stainless steel plates supporting more
than 5,000 pounds of cantilevered branches welded together from
twenty-four different sizes of steel pipes and rods. Standing among
other trees in Central Park, the sculpture reminds us that the park
itself is an artificial sanctuary, a product not only of natural forces,
but primarily of city planners. Through this juxtaposition, Paine
asks us to reconsider distinctions made between the natural and
the artificial, which are increasingly difficult to discern in a world
filled with genetically engineered substances and products. *Bluff*'s
monumental proportions and glistening surfaces serve as both
a wistful reflection on the tenuous state of the natural world and
a foreboding harbinger of things to come.

HIRSCH PERLMAN

Ever since his recent move from Chicago to Los Angeles, Hirsch Perlman has been using a sequestered room in the Echo Park district to explore a process of seemingly endless creation, transformation, and destruction. In his virtually daily performances over the past four years, Perlman, working only with cardboard left over from the move and copious duct tape, creates figures that occupy the room with him like imaginary companions. Indeed, the photographs that document these performances are shot— with a pinhole camera also made from the packing materials— from the figures' perspective as well as from Perlman's, creating a sensation of fluid subjectivity. The fact that he has brought these figures to life doesn't stop Perlman from tearing them apart again or even subjecting them to primitive forms of torture. In some of the later images in the series, one can see an enormous cardboard head—which has been created from the remains of all the previous figures—being crushed in an improvised vise.

Some of Perlman's images have a humorous, even cartoony appearance. (The tiny red, yellow, and blue pins that attach the works to the wall are, according to the artist, intended to subliminally echo the bright colors of comics.) Nevertheless, the work also has a dark undercurrent. Perlman's ambiguous, often violent relation to his figural subjects recalls his own earlier work concerning methods of interrogation. The hidden nature of his activities and their manipulative, destructive force may call to mind nothing so much as a horrific episode in the recent Bosnian war.

In contrast to Perlman's earlier art, which was characterized by a cool, analytic distance from his subjects, this work is extraordinarily visceral, spontaneous, and direct. The artist is literally *in* the work. "I wanted to change my practice," Perlman says, "to eliminate preconceptions." He embraced a do-it-yourself aesthetic, even making his own pinhole camera to shoot these photographs. Relying on nothing but his own imagination and physical skill, Perlman performs a grotesque apotheosis of the archetypal Romantic artist: tortured, alone, and struggling with the brute materials of his craft.

Day 16.1, 1998–2001. Gelatin silver print, vinyl, tape, paint, and pushpins, 30 x 24 in. (76.2 x 61 cm). Collection of the artist; courtesy Blum & Poe, Santa Monica, California, and Donald Young Gallery, Chicago

Day 101.2, 1998–2001. Gelatin silver print, vinyl, tape, paint, and pushpins, 30 x 24 in. (76.2 x 61 cm). Collection of the artist; courtesy Blum & Poe, Santa Monica, California, and Donald Young Gallery, Chicago

Still from *The Back Steps*, 2001. Digital video, color, sound; 5 1/2 minutes

Leighton Pierce uses the film camera as a gathering device, trawling images from his immediate environment to create short, impressionistic studies of domestic life. *The Back Steps* is constructed from a brief moment at a children's Halloween party held at Pierce's home. Two young girls in colorful dresses run down the wooden steps of the porch in the twilight. Their swift movements become a basic compositional unit that is repeated and abstracted into an intimate tableau. Pierce's painterly images are made using a slow frame rate, which blurs each figure and movement into swathes of colored light. The rustle of the girls' dresses and their childish laughter echoes enigmatically as they run around the corner and down the steps, disappearing into the darkness. The painterliness of the images evokes a dreamlike state, in which the figures appear almost as phantoms melting into the night.

Pierce studied musical composition before moving into film and video, and this early training informs his editing process. In *The Back Steps*, he strips the images of their sound and melds them into a silent narrative, into which sounds are reintroduced in a layering and mixing of different recordings. The images and sounds are looped into a series of overlapping arcs, each a different length, representing a different durational element within the piece as it continually doubles back and advances. Pierce describes his complex temporal composition as resembling "a mechanical clock with many different internal rhythms, all of which move the hands steadily forward."

WILLIAM POPE.L

William Pope.L is a painter, sculptor, wordsmith, and video and performance artist who transforms humble materials and gestures into forcefully irreverent works that question how we define ourselves through often conflicting notions of individual and collective identities. Pope.L is perhaps best known for his physically and psychologically demanding solo performances that expand on the tradition of radical public interventions by art groups such as Fluxus by using extreme acts of endurance and discomfort to, in Pope.L's words, "perform social struggle."

Since 1978, Pope.L has enacted more than forty performances he calls *Crawl* pieces in cities such as Boston, Budapest, and Prague. These unrehearsed, and often unannounced, performances require the artist to dress in a specific costume—such as a business suit or athletic clothing—lower himself to the ground, and inch along public streets until the point of exhaustion. For Pope.L, the *Crawl* performances challenge the idea that living on the street is a passive act of surrender. Rather, he interprets this reality as a courageous enterprise. Embracing the contradictions of fear and freedom associated with inhabiting the streets, Pope.L metaphorically adopts this position by clinging to the sidewalk and crawling.

During the 2002 Biennial, Pope.L embarks on *The Great White Way*, his longest crawl to date. Conducted in segments, it will take him up to five years to complete. Donning a capeless Superman suit and mounting an ergonomic skateboard that allows him to rest on his back while traveling forward, Pope.L will make a twenty-two-mile trek that begins at the Statue of Liberty, traverses the length of Manhattan via one street—Broadway—and then concludes at the far side of the University Heights bridge in the Bronx, where his mother lives.

As he places himself in dangerous and vulnerable positions, Pope.L asks us to witness his physical distress, thereby sparking feelings of unease within ourselves. His act of prostration for an uninformed audience of curious, caring, and callous passersby carries with it the desire for social change, reminding us that abstract compassion for impoverished, homeless, or unemployed individuals is not enough. Only concrete action will suffice.

Training Crawl, Lewiston, ME, Fall 2001, 2001. William Pope.L trains for *The Great White Way*, his marathon, five-year crawl up Broadway in Manhattan

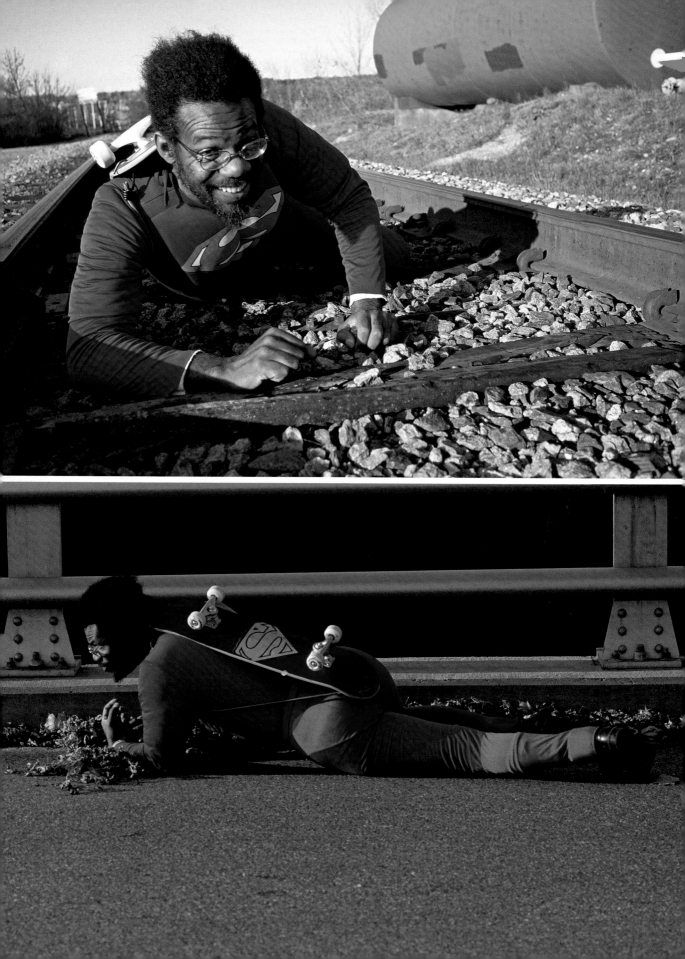

PRAXIS
(DELIA BAJO AND BRAINARD CAREY)

Performance stills from
The New Economy, 1999–2002

For the past two years, Delia Bajo and Brainard Carey, who form the two-person art and performance collaborative Praxis, have used their storefront studio in the East Village of New York City to stage weekly afternoon events. As part of their project *The New Economy*, the husband-and-wife team has offered every Saturday a menu of four free services from which visitors and passersby may choose: foot washes, hugs, Band-Aids to help heal visible or nonvisible wounds, and gifts of dollar bills. Using the rhetoric of systems management, Praxis describes itself as a "software development team" that employs the bodies of Bajo and Carey as hosts with which to test their operating systems. Participants in *The New Economy* "download" the "shareware" created by Bajo and Carey, thereby integrating the altruistic spirit of Praxis into their own "systems."

Though Praxis's language is contemporary, the character of its project draws on strategies from experimental performance art of the 1960s and 1970s. Through direct, yet intimate interactions with the public, for example, *The New Economy* recalls the activities of Fluxus artists, who staged simple events aimed at eradicating boundaries between art and life and effecting positive social change. It also evokes the ideas of the influential artist and teacher Joseph Beuys, whose notion of "social sculpture" substituted the traditional understanding of sculpture, and art more generally, as fixed material objects for a definition of ephemeral actions and processes that could transform everyday lives. In analogous ways, Praxis, through their interactive, nurturing performances, offers alternative modes of economic and social exchange that serve as a comforting antidote to the potentially alienating effects of a world often dominated by technology and consumerism.

SETH PRICE

The work of Seth Price is concerned with the relationship between modernity, popular culture, art history, and technology. *"Painting" Sites* demonstrates Price's interest in the Internet's role as a vast interactive archive that makes accessible otherwise disconnected groups of cultural material, from fine art to popular music. The ease with which material from the past can be recovered and recontextualized at random epitomizes the condition of postmodernity, in which previously fixed cultural canons have become fragmented, fluid, interconnected, and relative.

"Painting" Sites articulates this relativity by creating an ironic, fractured narrative using two classic forms of high culture and popular entertainment: painting and the fairy tale. Reproductions of paintings from various periods in art history, drawn randomly from the Internet, appear one after the other on the screen, as Price narrates a story he wrote in the style of a German Romantic tale. He begins: "In the Wild Woods, west of the Hartz Mountains, lived a man named Ludwig Tieck...." Casting Tieck as the fictional protagonist signals the elliptical structure of the piece: he was one of the canonical Northern European fable writers. As the story unfolds, characters and locations change, and the tale evolves into an elaborate, improbable narrative, a labyrinth in which stories within stories double back on themselves in an endless deferral of resolution. Price manipulates the "ideal" of narrative, with its perpetual promise of something meaningful to come.

Iconic images from the history of art appear, punctuating every phrase—Botticelli's Venus, Leonardo da Vinci's Pietà, a brooding landscape by Jacob Ruysdael. For brief moments, our desire to correlate the images with the story creates an implausible synchronicity, and a pattern seems to emerge. The epiphany is quickly erased as the capricious randomness of the images reasserts itself. The disjunction of logic in *"Painting" Sites* evokes both the creative potential within the inherent randomness of the Internet and the dreamlike boundlessness of fairy tales, in which the normal world is disrupted in order to open up another kind of space, where the unconscious can explore the outer edges of reality.

Still from *"Painting" Sites*, 2001. Video projection, color, sound; 20 minutes

Plate 5

Date:
7/6/88

Distance Between
Horse and Finish Line:
- 28 cm

Race Distance:
1400 m.

Winning Time:
01:49

Average Speed:
45.1 km/hr

Historians' Initials and Bets:
1. KS +101
2. MM +460
3. FF +617
4. PH -010
5. HG -500
6. RO -128
7. AB -238
8. SK -800

Winning Historian and His/Her Winning Time:

AB - 0.0238 sec.

Dr. Fakhouri's Description of the Winning Historian:

He is 71. But for 6 years he was in prison and for 10 years he was under house arrest and in exile, so 16 years should be deducted. Then he is 55.

still from *Missing Lebanese Wars*

WALID RA'AD /
THE ATLAS GROUP

Missing Lebanese Wars, 1999 (detail).
Notebook page, 6 x 9 in. (15.2 x
22.9 cm). Collection of the artist

The Atlas Group is an imaginary nonprofit research foundation, created by Walid Ra'ad in 1976 in Beirut to explore the contemporary history of Lebanon and, in particular, some of the unexamined dimensions of the Lebanese Civil Wars (1975–91). To this end, The Atlas Group has produced various visual and audiovisual documents that, while fictionalized, are often based on real experiences. Through the guise of The Atlas Group Archive, Ra'ad reconsiders the recent internal conflicts in Lebanon not as a concrete set of facts and events, but rather as an abstraction of memories and media made up of diverging individual perspectives.

For the 2002 Biennial, Ra'ad presents several evenings of *The Loudest Muttering Is Over: Documents from The Atlas Group Archive*, his current multimedia lecture presentation of the foundation's archival material. In these presentations Ra'ad uses photographic slides, notebook pages, and videotape excerpts attributed to anonymous sources or invented characters such as Dr. Fadl Fakhouri, a leading historian of Lebanese history, or Souheil Bachar, an ex-hostage. Though concocted, the findings and claims of these figures are inspired by actual circumstances, such as the role of the car bomb in the Lebanese wars, existing captivity narratives, and the Lebanese cultural fascination with horse racing, for example.

Ra'ad's lecture-performances, like his faux documentary films and installations, conjure up an alternate universe that mimics conventional formats of visual and textual representation such as the video documentary or the witness testimonial. Through a strategy of calculated misrepresentations, Ra'ad contests the subjective processes through which multiple versions of actual events are transformed into a single coherent historical account. His archival materials do not document what happened as much as what can be imagined, said, or taken for granted. Using events of the Lebanese Civil Wars as a lens through which to examine the ways we represent, remember, and make sense of war, Ra'ad poses salient questions about the nature of individual and collective memories and their role in the formation of accepted historical narratives.

LUIS RECODER

In Luis Recoder's films and expanded cinema performances, projected light is used to create a perceptual interface between materiality and immateriality. For the past few years, Recoder has used the rectangle of projected light as a primary unit or building block in his work. The narrative space of the film screen is replaced by a painterly surface of subtle hues, engaging the viewer in a perceptual experience of light and rendering West Coast sculptors such as James Turrell and Robert Irwin's sculptural use of light in cinematic form.

In a series of single-screen, cameraless film studies titled *Available Light*, Recoder subjects the celluloid film strip to indirect light exposures, light flares, and fogging. In *Yellow-Red*, for example, a central core of yellow light diffuses gently outwards toward an aurora of red light, shuddering like a blurred candle flame. For *Blue-Violet*, Recoder exposed color negative film directly to light, rendering the film screen a diffused, robin's-egg blue that slowly changes in tone in front of the viewer's eyes.

Recoder is also well known for his live, multiple-screen "expanded cinema" performances, in which he manipulates film projectors in the screening booth. In *Available Light: Shift*, a two-projector work, color negative and positive prints are projected on overlapping screens, dividing a large horizontal rectangle into thirds, alternating between equal parts and one-third/two-thirds ratio of colors.

Recoder's rhythmic sequences of light planes evoke Hans Richter's abstract film compositions of the 1920s, as well as the strident perceptual multiscreen color spaces of Paul Sharits and Tony Conrad's light projections. Recoder's engagement with the visceral purity of projected film light—in deliberate contrast to the pixilated electronic surface of video projection—asserts light as a tangible form of matter.

Film strip from *Available Light: Blue-Violet*, 2000. 16mm film at 18 fps, color, silent; 15 minutes

ERWIN REDL

Installation view of *MATRIX IV, 30/5/01* at Creative Time's "Massless Medium: Explorations in Sensory Immersion," The Brooklyn Bridge Anchorage, Brooklyn, New York. Collection of the artist

MATRIX IV installation is sponsored by a grant from The Greenwall Foundation; in-kind support is provided by Cotco International Ltd. and Marktech Optoelectronics. Additional support is provided by the Austrian Federal Chancellery; the Austrian Cultural Forum, New York; and the Art Council of Lower Austria.

Erwin Redl's art is concerned with the sensuality of structure, or, as he puts it, "how abstraction becomes a physical sensation." The artist has a background in interior design, architecture, and music, and his work builds on basic structural forms such as lines, planes, and grids. For several years, Redl has been exploring LEDs as a sculptural medium. These tiny bright lights are commonly used in digitally programmed arrays to create simple moving texts or pixelated versions of video imagery. Redl liberates the electronic components from their communicative function to create large-scale architectural installations. Stringing together thousands of LEDs, Redl creates what are essentially walls of light, transforming a medium best known as a vehicle for conveying ephemeral, digitized information into building blocks for remarkably powerful structural interventions. Whether slicing a room in half or hovering inches from the floor, Redl's LED arrays are provocative expressions of light as form.

In some cases, Redl programs the LEDs to respond to digital signals, creating moving patterns within the array. His moving-image works are mesmerizingly slow, challenging the conventional perception of computer effects as being synonymous with speed. "I am going to be labeled the prophet of slowness," Redl observes. "On different levels, I am. I'm just focusing on the other side of digital media—very subtle movements and experiences. The computer is very interesting because it is an essential medium; it is just light, there is no object. I am not very interested in object art, like sculpture. I am very interested in light itself."

MARINA ROSENFELD

Marina Rosenfeld is an artist, composer, and musician whose
work combines fixed written composition and improvised
performance. Her works develop from outlined instructions
and loose musical guidelines designed to create new generative
situations, resulting in compositions that are open-ended and
variable. Her unique sonic palette, made up of curious scratches,
melodic fragments, resonant electric hums, and other delicate,
raw noises, is the result of a complex process in which recorded
sounds are transformed through repeated live performances
and re-recordings as well as transfer from medium to medium.

Rosenfeld often begins her process by recording her own live
musical events. Fragments of these original sounds are then
transferred to acetate or vinyl records. These unique records are
"re-performed" on turntables, re-recorded and reprocessed on
a computer, and then performed again. Rosenfeld's new sound
installation for the 2002 Biennial, *Delusional Situation*, is composed
from recorded traces of live performances by her *sheer frost
orchestra*, a loose affiliation of performers who play guitars
with nail polish bottles while kneeling before their floor-bound
instruments. Using scenarios scripted by Rosenfeld and her
invented playing technique, the performers create a work that
is filled with successions of superimposed and intermingling
variations: serene modulations crescendo into cacophonous
wails and then swoop down into gurgles and hums. In *Delusional
Situation*, Rosenfeld circulates samples of the ensemble's
distinctive sounds around the room, transforming the work
into a three-dimensional, hallucinatory sonic vision. Like the
experience of eavesdropping on conversations, sounds—
and traces of sound—appear and disappear, linger and drop off
in unpredictable patterns that tantalize and disorient the listener.
As Rosenfeld places sounds in the room, she alternately makes
her musical phrases seem both very close and far away, creating
the aural illusion of spatial circumstances other than those
immediately perceptible. As sounds swirl into their own
independent microcosm, the piece, as the title suggests, aims to
create a sonic landscape that is the equivalent of a visual mirage.

Marina Rosenfeld performing
in *the sheer frost orchestra* at the
Whitney Museum of American Art
at Philip Morris, New York,
April 26, 2001

THE RURAL STUDIO

Mason's Bend Community Center. *Interior Gathering Space*, 2000. Photograph by Timothy Hursley. Chromogenic color print, 11 x 14 in. (27.9 x 35.6 cm)

Mason's Bend Community Center. *Windshield Wall*, 2000. Photograph by Timothy Hursley. Chromogenic color print, 11 x 14 in. (27.9 x 35.6 cm)

The Rural Studio is an innovative architectural training program founded in 1993 under the direction of Samuel Mockbee as part of the Auburn University School of Architecture. Based in Hale County, Alabama, the Rural Studio consists of small groups of second- and fifth-year architecture students who work with local social service agencies to identify individuals, organizations, and communities in need of new buildings. Under Mockbee's direction, the Rural Studio has developed a distinctive style and powerful working ethos.

Over a dozen Rural Studio structures, both private and public, now exist in Hale County. They are characterized by a Modernist tendency toward clean lines, strong planes, and plentiful light and space. At the same time, the structures borrow from Southern vernacular traditions, often quoting the forms of barns, sheds, and trailers. Most of the materials are salvaged and virtually all of the labor is donated. "The best way to make real architecture is by letting a building evolve out of the culture and place," said Mockbee. "These small projects designed by students at the studio remind us what it means to have an American architecture without pretense. They offer us a glimpse into what is essential to the future of American architecture, its honesty."

In the past few years, the focus of the Rural Studio has shifted away from private residences and toward community-oriented buildings. Among the most successful of these is the Mason's Bend Community Center. Mason's Bend is a community of barely 100 people tucked into a curve in the Black Warrior River. Alerted to the lack of a viable gathering place, students Forrest Fulton, Adam Gerndt, Dale Rush, and Jon Schumann proposed to create a combination community center and chapel. They designed and built a structure made of low-lying rammed-earth walls and stout cypress beams. The transparent roof is made of eighty salvaged Chevrolet Caprice windshields.

SALON DE FLEURUS

Located in a private apartment on New York's Spring Street, the Salon de Fleurus is a re-creation of the legendary Paris salon of Gertrude Stein and Alice B. Toklas. Open to the public during limited hours, and during the Biennial by appointment, the salon is a refuge from the bustling pace of contemporary New York. Entering through a narrow passageway, the visitor is cast back in time: the furniture, the music, the books, the paintings, and even the smell are of a bygone era. Looking around, one sees sepia copies of works from Stein's famed art collection—including many works by Picasso and Matisse—hung throughout the apartment. In one room of the salon are several monochrome paintings reproducing vintage photographs of Stein and her collection.

The Salon de Fleurus is the work of a group of anonymous artists; however, the apartment doorman actively engages visitors in conversation. "A Dutch visitor," he recalls, "called this an ethnographic exhibition of Modern art." This notion of the salon as a kind of museum of Modernism is carried, in the Biennial, into the Whitney itself. Various elements of the Spring Street salon are presented in a display case in the eclectic manner of a sixteenth-century *Wunderkammer*, or cabinet of curiosities. "In the nineteenth century," the doorman observes, "museums created timelines that stretched history, pushing the past back in time and relieving its pressure on the present. Today, however, there is a renewed sense of the past being present, of time occurring horizontally rather than vertically." He gestures around the musty old salon. "This here is the present. What we see outside is the past."

From the Autobiography of Alice B. Toklas, 1992–2001. Acrylic on panel, 24 x 18 in. (61 x 45.7 cm). Collection of Salon de Fleurus

Still from *For the Birds*, 2000.
Digital video, black-and-white,
sound; 8 minutes

Keith Sanborn has worked in film, video, and installation since the early 1980s. He was trained in comparative literature, film, and photography, and his work explores the relationship between narrative and abstraction, using the formal and visceral qualities of both film and digital video. *For the Birds*, part three of a cycle of digital video works titled *Theory of Religion, Theory of Ecstasy*, was inspired by an eleventh-century allegorical Sufi mystical text, *The Conference of the Birds*. As Sanborn explains, the Sufi text explores "transparency and opacity, multiplicity and unity, narrative and insight, the mundane and the ecstatic."

For the Birds translates these literary relationships into a sensory, cinematic form, using sound and light. Over a period of eight minutes, a screen suffused with light undergoes subtle shifts in hue as first one bird, then several, and finally an entire dawn chorus can be heard, chirping a deafening greeting to the day. The simple structure of *For the Birds* articulates each aspect of the Sufi text. The abstract surface of the screen shifts between transparency and opacity, as the light gradually increases and our eyes absorb its subtle shifts. The sounds of individual birds and their collective singing connect the viewer to one of nature's most profound, yet everyday states: dawn. In Sufism, the mystical, most spiritual current of Islam, self-realization can be achieved through a deep meditation on nature. In *For the Birds*, the gradual crescendo of birdsong creates a natural semiotics of sound, in which nature is understood as a text, rendered concrete through layer upon layer of analysis and interpretation. Sanborn, quoting from the Sufi text, observes, "seek the trunk of the tree and do not worry whether the branches do or do not exist."

PETER SARKISIAN

Peter Sarkisian casts projected video images onto unconventional planar surfaces to create primal allegories rich with archetypal imagery. *Hover* consists of a three-foot white cube placed at the center of a darkened room. The cube functions as a three-dimensional screen, with video images projected onto every one of its five visible surfaces. The looped video sequence begins with projections that create the illusion of a transparent cube, within which sits a young woman cradling an infant boy in her lap. Very slowly at first, the two figures explore the spaces and surfaces of their profoundly reduced world. As the pace of their movement quickens, their initial equanimity is transformed into a frenetic rush, while the accompanying audio recording of a gurgling stream increases in volume and intensity, echoing the figures' heightened agitation. When the two protagonists have become nothing more than a blur, they suddenly disappear. Moving from emptiness through being to emptiness again, *Hover* suggests a lifetime condensed into less than ten short minutes.

Still from *Hover*, 1999. Video installation with mixed media, sound, dimensions variable. Collection of the artist; courtesy I-20 Gallery, New York

Bigtop Flophouse Bedspins, 2001.
Stained glass in lightbox, 28 x 38 in.
(71.1 x 96.5 cm). Claire Oliver Fine
Art, New York

Judith Schaechter's artwork is meticulously crafted from pieces of stained glass that are cut, sandblasted, fired, and, finally, soldered together. The result is a kaleidoscopic array of color and shape. "The medium is stunningly beautiful before I even begin working with it," Schaechter observes. Her richly imaginative imagery is reminiscent of Victorian-era fairy painting, which enchanted viewers more than a hundred years ago with fantastical scenes of mischievous elves and winged fairies. Schaechter draws similarly on folklore and mythology, updating the themes with personal overtones of trauma, death, decadence, and debauchery.

In contrast to the traditional method of displaying stained glass in or as windows, Schaechter's pieces are framed in individual lightboxes. Building on the religious and historical connotations of the medium, the artist brings stained glass into the present day. Drawing on wide-ranging influences—from movies, cartoons, and comic books to current rock music—she creates incisive parables of contemporary life.

In *Bigtop Flophouse Bedspins*, a disheveled clown slouches amid a spectacular constellation of eccentric creatures: potbellied bunnies, an anguished cat, a pig, baby chicks, frogs, and even a few sharks swirl around the hapless clown. Cupcakes, bubbles, and a pair of dice add to the manic scene. The clown seems resigned to the chaos circling around him, while the single word "Alas!" hovers tellingly above his head.

COLLIER SCHORR

Stilleben (Shed), 2001. Chromogenic color print, 20 x 24 in. (50.8 x 70 cm). Collection of the artist; courtesy 303 Gallery, New York

Collier Schorr's photography has for many years been engaged with the categories of landscape and portraiture and the ways in which these genres are molded by issues of gender, sexuality, and nationality. She has made extended series describing various subcultures and social groups including high school wrestlers, soldiers, and boxers.

The *Helga/Jens* project combines and extends many of her earlier concerns into a single, complex body of work. The project has been underway for two years and is still in progress. Working with a young German schoolboy named Jens, Schorr has been reconstructing the entirety of Andrew Wyeth's controversial *Helga* series of paintings and drawings. Using Jens as a stand-in for Helga, Schorr has meticulously re-created each of Wyeth's scenes and poses. However, she has intentionally substituted a German landscape for an American one and contemporary clothing and accoutrements for the originals. Jens's new Bundeswehr parka, for example, replaces Helga's own Prussian field coat.

Schorr consciously disturbs our complacent acceptance of the conventions of portraiture and landscape. As she explains, "*Helga/Jens* redefines the female nude as it strives to shift and probe the identity of the male model (while Helga is primarily represented as a nude, Jens always wears pants, suggesting the possibility that he is, in fact, female)." Wyeth's attraction to Helga's Germanic air is raised to an issue of historical specificity when the setting is transferred to an authentically German site and the model replaced by an actual German person. On this shifting ground of being and place, Schorr creates a remarkable study in the dual phenomena of identity and attraction.

The works presented in the Biennial represent an intermediate stage in the project, a series of pages of the Wyeth Helga catalogue onto which Schorr has attached thumbnail prints of her own versions of the same scenes.

[Tapando para ver, 1999-2000]

el periódico,
radicalmente
en los anuncio
mensajes que nos impulsan a consumir
de cierta
forma.
revelar esos
imperativos semi-ocultos,
parecidas a las de una
biblioteca o puesto de revistas.
intervenciones
en
vallas publicitarias

read the newspaper
different
See

billboards
travel,

Tapando para ver (Curator's essay intervened at the Museo de Arte de Puerto Rico), 2000 (detail). Contact paper on wall. Courtesy the artist

Chemi Rosado Seijo's work is based on the idea of *tapando para ver*, or "covering to see." Through selective deletion of imagery and information, Seijo draws subtle messages and meanings to the surface of the raucous, daily barrage of data brought to us by the mass media. The various aspects of his project range from the impromptu transformation of existing commercial street signage, to the remixing and rebroadcast of live radio programs, to the digital scrambling of television signals, to the transformation of daily newspapers into provocative ciphers of meaning.

Seijo's project is cumulative. At each new exhibition site, he brings with him residue from past interventions. The charcoal-covered newspapers, collected from Puerto Rico, Miami, Peru, Paris, Costa Rica, Barcelona, and Madrid, are hung in specially designed folding boxes that stand in a gallery like improvised newsstands. Among his newest endeavors is a site-specific work involving the "covering to see" of an entire *barrio* in Puerto Rico: working with the town's residents, Seijo has painted the houses themselves so that they are camouflaged against the surrounding hillside.

Formally strong, politically incisive, and poetically evocative, Seijo's work is replete with echoes of earlier artistic practices, from the French decollagists of the 1950s and 1960s, who transferred torn street billboards into a gallery context, to the radical restructurings of Gordon Matta-Clark, who once sliced an entire house in half so that it could be seen afresh.

SILT

silt, a San Francisco–based collective set up in 1990 by Jeff Warrin, Keith Evans, and Christian Farrell, creates indoor and outdoor film performances and site-specific installations using projection, mirrors, liquids, lenses, natural materials, and their own bodies. The group operates as a kind of mobile laboratory, conducting perceptual experiments using ideas drawn from science, natural phenomena, and mysticism. They regard their investigation as a paranaturalist enquiry that, they explain, "unlocks the organic dimension of film, blending its technological and mechanical aspects with a palpable sense of its connection to natural processes," which include "the geometry of plant morphology; electromagnetic light anomalies; visual sonic patterns of birdcalls; tectonic plates, [and] pinhole celestiographs."

silt's performances involve multiple film projections, shadow interferences, objects, and sounds. Their films are profoundly material. The prints are rusted, buried in the ground, consumed by mold and bacteria, left to interact with the earth's natural alchemical process like fossilized relics. In performance, the projector beam lights up these organic morphologies, magnetic fields, and bacteria, resampled in the mechanics of editing. silt operates the film projectors like a disc jockey, physically "performing" with the equipment, introducing filters, shadows, organic material, and their own bodies into the projections. Their visual riffs pulsate and metamorphose, creating a perceptual confusion between the film footage and their live interaction. In this merging of projections, objects, shadows, and sounds, the boundaries between the real and the projected, the live and the recorded, become confounded.

Film strips from *All Pieces of a River Shore*, 2002. Biologic material and 16mm film; length variable

LORNA SIMPSON

Still from *Easy to Remember*, 2001.
16mm film transferred to DVD,
sound; 2 1/2 minutes

In this deceptively simple work, *Easy to Remember*, Lorna Simpson presents a grid of fifteen mouths humming in unison the Rogers and Hart song of the same name. Transformed into a great jazz ballad by the legendary saxophonist John Coltrane, the sound of this tune was a familiar memory from Simpson's childhood. To make the work, Simpson hired professional singers to hum the tune while they listened to it on headphones. Their renderings are in sync but slightly varied as they each take the opportunity of the jazz form to interpret the lines personally. The overall effect is of a gentle and reassuring flow of sound.

As in her photographic work of the early 1990s, human presence is indicated through a series of fragments—isolated mouths that stand in for individuals but which also, in their anonymous repetition, suggest a broader social significance. Unmoored from an individual source, the haunting tune wafts through the gallery like a fragment of our collective unconscious. The title of the work and the quiet dignity of the rendition combine to give the piece a distinctly elegiac character.

KIKI SMITH

Public Art Fund

Kiki Smith's recent series of sculptures—sited, during the
Biennial, at the entrance to the Central Park Wildlife Center—
represent Harpies and Sirens, characters from Greek mythology
endowed with the head of a woman and the body of a bird.
The Harpies were known for their destructive capabilities,
spreading filth, stench, and famine; they were famously attacked
by Jason and the Argonauts on his quest for the Golden Fleece.
Smith's Harpies appear relatively mild-mannered, crouching
in wait or standing still with arms raised, as if listening for some
far-off sound. Her Sirens appear even more docile, despite their
reputation as malevolent monsters of the sea. It was the Sirens
who tried to seduce Odysseus with their beautiful songs as
he sailed past their lair. Only by having himself lashed to his
ship's mast and stopping the ears of his crew with wax was the
Greek hero able to resist their fatal attraction. Extracted from
their ancient world and thrust into the present, these beings
carry a subtle message of potent femininity and archetypal power.

"When I first started making figurative work," comments
Smith, "my references came mostly from looking at religious
iconography, not just current religious iconography but mythologies
and cosmology. I was interested in the symbolic morphing of
animals and humans. I found this anthropomorphizing of animals
interesting; the human attributes we give to animals, and
the animal attributes we take on as humans to construct our
identities. I'm trying to think about this relationship between
nature and human nature, their different objectives: what
do animals mean to us in terms of the construction of our own
identity, our well-being, our environment?"

Sirens, 2001. Bronze, dimensions
variable. Collection of the artist;
courtesy PaceWildenstein, New
York. Whitney Biennial in Central
Park, Organized by the Public Art
Fund; sponsored by Bloomberg

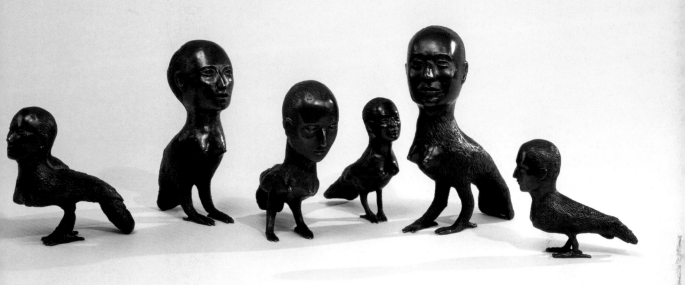

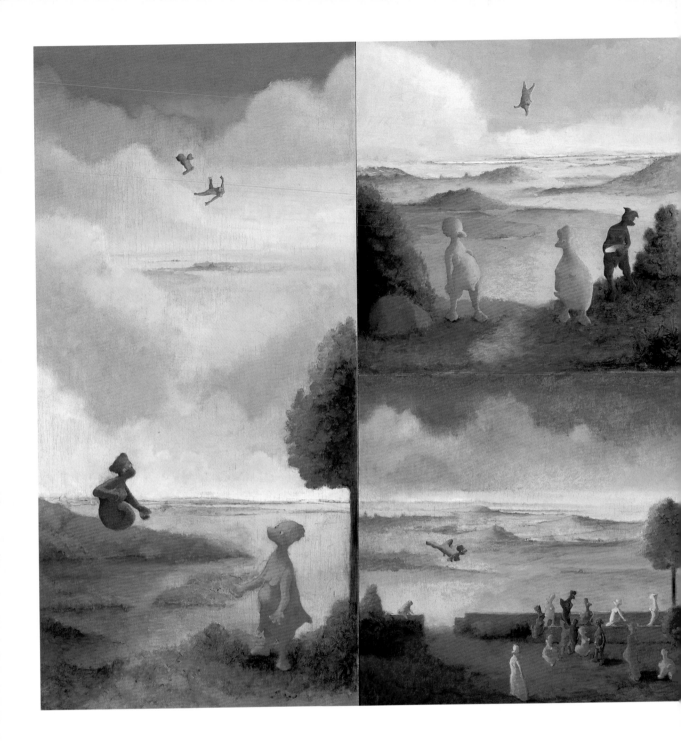

Main Feature, 2001 (first panel). Oil on panel, 32 x 32 in. (81.3 x 81.3 cm). Collection of the artist

The Biblical story of Lot is the subject of Gerry Snyder's multipanel oil paintings *Story Development* and *Main Feature*. As their titles suggest, Snyder has rendered the story in the manner of a Hollywood film, representing each of the key turning points of the tale through evocative storyboardlike vignettes. Lot and the other characters are represented as peculiar interspecies hermaphrodites, and Snyder's pet pug makes several cameo appearances. In contrast to their comiclike format, the scenes are painted in the neoclassical style of such eighteenth-century artists as Watteau and Poussin.

The story of Lot, including the destruction of Sodom and Gomorrah, occurs in Genesis, the first book of the Bible. Although it is one of the best-known Biblical narratives, its particular details, which Snyder has been careful to represent, are not widely remembered. *Main Feature*, for example, includes the scene in which Lot says to the men of Sodom: "I beg you my brothers do not act so wickedly. Behold, I have two daughters who have not known man; let me bring them out to you and do to them as you please, only do nothing to these men, for they have come under the shelter of my roof." In another vignette, Snyder represents the seduction of Lot by his own daughters. "Stories like Lot and his daughters," observes the artist, "show the power of a myth to embody larger social values no matter how unreasonable. The story condones Lot's incestuous relationship while condemning the Sodomites and their culture to complete destruction. The paintings' reference to film is important because of its sophisticated ability to structure even the most disturbing narratives into mundane but consumable events."

STOM SOGO

The films of Stom Sogo are constructed with a fresh, intuitive eye. *Problem's You*, shot just after Sogo dropped out of art school, consists of nine rolls of unedited Super-8 film, capturing streets, interiors, and beaches in and around New York City. Each shot was made in a single take, and the rolls' absence of editing emphasizes the importance Sogo placed on chance and spontaneity, a tendency influenced by Jonas Mekas and John Cage. Details of buildings, trees, and the sea slowly creeping up the sand on the shore are all infused with a sensuality and sensitivity to shifts in light and shadow. Lingering over the surface of a wall, the nodding of tree branches, or the edge of a windowsill, Sogo's eye constructs a deeply personal cinema in which the exploration of a new direction is expressed through a diaristic recording of his immediate environment. The title of the work, *Problem's You*, could indicate a concerned self-questioning and a fear of failure.

In *Guided by Voices*, Sogo constructs a film version of Dennis Cooper's novel *Guide*. The highly abstracted, colored digital video (shot on video and Super-8) evokes a psychedelic experience. As Sogo recalls, "It was 5:45 a.m.; [I was] crashing at a friend's house, deep in Brooklyn, where I was dealing with…a final point in the movie. Then, I crashed with a seizure, all my memories flashed before me, I fell off the stairs and the film finished itself." Once more, Sogo allows chance to direct the structure and meaning of the film in a Cageian belief in the creativity of randomness.

Still from *Problem's You*, 1997–2001. Super-8 film at 18 fps, black-and-white and color, silent; 27 minutes

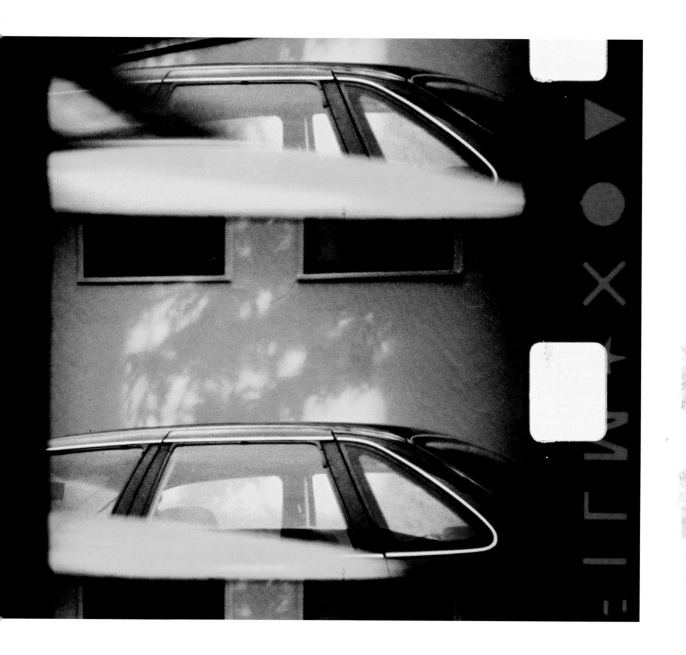

Still from *Twilight Psalm II: "Walking Distance"*, 1999. 16mm film, color, sound; 23 minutes

Phil Solomon's films construct a metaphorical dialogue between the represented image and its altered physical support. Each film unfolds frame by frame in an elliptical sequence, in which one frame dissolves into the next. Solomon is interested in the spatial occurrences of the dissolve and, he says, "how the retina latches onto the frame and follows its transition in space— how shapes change into other." His works, according to fellow experimental filmmaker Stan Brakhage, "disintegrate the entire pictorial 'fabric'...of old movies in various states of emulsion rot. He utilizes the organic mold and dry crack patterns, the natural decay of the footage, until the original subject matter, its anima, crawls with textural 'maggots' of its own chemical decomposition, and dissolves into a beautiful display of multifaceted light."

Solomon's *Twilight Psalm II: "Walking Distance"* almost imperceptibly immerses images of elegiac figures from family home movies, his own films, and found footage in glittering midnight blue and brownish hues. A tightrope walker crosses Niagara Falls, walking through what could be clouds of fire and destruction, or the colors of a hazy film emulsion. This and other barely visible figures are emblems of a certain American history and, perhaps, a mourning for the early days of cinema. Throughout the otherwise abstractly textured film, they appear like ethereal guardian figures, rescuers, or symbols of protection.

Implicit in Solomon's films is a sense of the fragility of history and memory. This is expressed in the film's projection: imagery is revealed as submerged and intertwined; its physical nature is made evident by the subjecting of its surface to extensive photochemical treatment. The image is revealed as a disruption in the skin of the film. Each image denotes a lament for a vanished time, for certain states of mind, for irrecoverable times and places, or the lost days of early childhood. Together, they animate the organs of memory and delve into the dormant layers of the viewer's consciousness.

SCOTT STARK

For twenty years, Scott Stark has used film, digital video, photography, and installation in order to redefine viewers' perception of cinematic space. In *Angel Beach*, anonymous 1970s 3-D photographs of bikini-clad women on Northern California beaches are rendered both three-dimensional and cinematic. Stark reinforces the stereoscopic method by which the photographs were originally created, filming details from the photographs frame by frame, alternating between the left and right stereoscopic image to separate each figure from its background. The strobing suggests the illusion of movement around the figures, which is simultaneously cancelled by their static reality as photographs. Through this paradox, the figures, compressed into the film frame, suggest a hyper-reality of space, within which the exuberant energy of the young women is optically evoked by the images' incessant pulsing. The viewer's attention is drawn, voyeuristically, to individual figures and their bodies, as they sit, sprawl, and play in the sand.

Stark's single-frame separations create movement and spatial relationships between each set of simultaneously recorded images. *Angel Beach* articulates the liminal space between the still and moving image, in which movement is used paradoxically, to underline the concrete nature of photographic stillness within a cinematic space.

Stills from *Angel Beach*, 2001.
16mm film at 18 fps, color, silent;
27 minutes

Still from *Trevor*, 1999. Video, color, sound; 11 minutes. Courtesy Electronic Arts Intermix, New York

Steina is a central figure in the history of video art, creating some of the earliest experimental video works and cofounding the alternative gallery and screening space The Kitchen in New York City. Born in Iceland, Steina studied classical music in Prague before emigrating to the United States in 1965. Her videos use mechanical and digital devices to manipulate and transform images and sound into a narrative of synthesized abstract forms. Her background as a musician has strongly informed many of her videos, in which manipulated digital sound appears to generate, and pull apart, the image.

In *Trevor*, Steina deconstructs footage of a man, Trevor Vishart, singing an experimental vocal composition into a microphone, with his eyes closed. Over a period of eleven minutes, a close-up shot of the singer's head is transformed into an abstracted, almost psychedelic sequence of heavily manipulated images and sounds. Through a rapid slowing of the soundtrack, Trevor's vocals are blurred into an extended drawl, as his head fragments into a staccato sequence of static frames. At one point, Trevor's head becomes a double image that expands backward and forward across the screen in a kind of concertina movement. The soundtrack moves correspondingly in and out of focus, until it is slowed almost to a standstill. Recognizable chords played on an electric organ occasionally surface, only to be plunged once more into a maelstrom of abstract audio that sounds, at certain moments, as though it emanates from under water.

As the sequence proceeds, Trevor becomes distorted into a digitally smeared shape that moves in, out of, and across the screen, resembling the tortured head of a Francis Bacon painting. Steina's technical mastery transforms the recording of Trevor into an interiorized, psychological portrait, in which the formal manipulations of sound and image evoke a roller coaster of intense emotional feeling. His closed eyes, hunched shoulders, shaking head, and primal sounds become, in their distorted form, expressions of an unspoken angst. Through this highly structured sequence, Steina reveals the intrinsic fluidity of the electronic signal, and its ability to manipulate image and sound into a single, synthesized abstract form.

BRIAN TOLLE

Public Art Fund

Brian Tolle's recent public art projects and gallery exhibitions
draw on our collective cultural memory to function as uncanny
eruptions of the past into our present historical moment. These
works combine nostalgia and anxiety as we are confronted with
vague recollections and uncertainties about the veracity of history
as well as the accuracy of our own memories and perceptions.
In some works Tolle addresses major historical events, as in his
Irish Hunger Memorial for Manhattan's Battery Park City (a work
in progress slated to open in summer 2002), while in others the
subject is more private and subtle. *Eureka*, for example, is a full-
size model of the facade of a canal house in Ghent, Belgium.
The reflections of the house in the water—rippling as in a boat's
wake—are permanently frozen in physical form on the sculpture,
which was installed at the canal's edge, at full scale over the
actual building facade.

Waylay brings together the public/historical and the private/
contemplative tendencies in Tolle's work. The artist developed
a similar piece for an exhibition in Arnhem, The Netherlands,
where a series of splashes, some tiny and some rather strong,
occurred in a pond in the middle of Arnhem's city park, Sonsbeek.
The splashes were occasional and unpredictable and, to the
unsuspecting passerby, seemed to be caused by unidentified
objects falling from the sky or bursting from beneath the water's
surface. In Arnhem, the work was both a playful evocation of
the pastime of skipping stones and a distant echo of the terrible
bombing suffered by the town in World War II. Adapted to
New York's Central Park, which served as the model for Arnhem's
Sonsbeek, *Waylay* subtly awakens more recent feelings of anxiety
concerning potential dangers falling from above.

Waylay, 2002 (detail). Mixed media,
dimensions variable. Collection of
the artist; commissioned by the
Public Art Fund. Whitney Biennial
in Central Park, Organized by the
Public Art Fund; sponsored by
Bloomberg

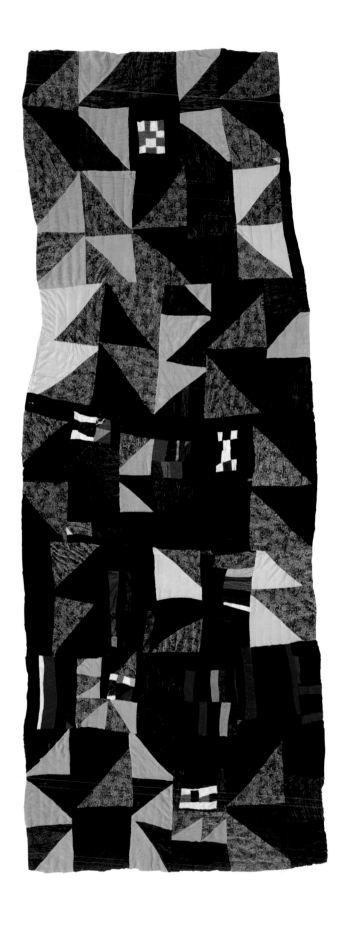

Half-Squares, 2001. Quilted fabric, 107 x 40 in. (271.8 x 101.6 cm). Collection of Eli Leon

Rosie Lee Tompkins's quilts are typically made to be neither functional, as bedcoverings, nor merely decorative objects. Rather, each quilt she makes is inspired by, and is a prayer for, a particular person, often a family member or friend.

Tompkins's works are unusually eccentric in scale, medium, and composition, even within the improvisatory tradition of African American quilting. Her quilts range in size from barely a foot square to over ten feet long, and they are often not perfectly rectilinear but rather possess a distinctively free-form outline. Tompkins herself usually does only the "piecing"—composing the work by cutting out and sewing together the top layer of the quilt—while another person does the "quilting"—sewing pieced sections onto a back covering. In the process, the quilter often has to adjust the form of the work to accommodate geometric irregularities in the pieced section. Such sharing of responsibility for the final outcome is not particularly unusual in a tradition where collaboration is the norm.

Tompkins learned quilting from her mother in rural Arkansas and claims to be inspired only by God. Others have seen traces of different sources in her work. Writers Robert Farris Thompson and Eli Leon, for example, have identified in Tompkins's quilts resonances with the methods and compositions of Central African textile artists, especially the "disintegration/reintegration" style of Mbuti painting and the "improvisational license" of Kuba embroideries and certain Asante kente cloths.

LAURETTA VINCIARELLI

"Light," says Lauretta Vinciarelli, "is the protagonist in my work." Trained as an architect, Vinciarelli has come to imagine and depict spaces whose only occupant is light. In the series of seven ethereal watercolors included in the 2002 Biennial, she creates a syncopated rhythm of geometric forms that loosely define states of inside and outside, above and below, light and shadow. Through a painstaking process of building layer upon layer of complementary orange and blue pigment, she creates works that glow, in the words of architect and critic Diana Agrest, like "annunciations without angels."

Vinciarelli's relationship to matter and material is unusual for an architect; rather than building forms, she speaks of "excavating space." Indeed, there is a sense in her work of almost infinite depth; clearly these are spaces for the mind and spirit rather than for the physical body. As K. Michael Hays, the Whitney's adjunct curator of architecture, observes, unlike "the perspectival-tactile space of architecture and the secure subject position of surveillance it produces, Vinciarelli maintains she is painting a mood, an atmospheric emanation that captures the viewer... in the onrush of light."

It is not surprising that Vinciarelli wonders whether these watercolors can truly be called architecture. Rather, she says, her work aspires to the experience of music. One recent work, for example, titled *Orange Sound* (recalling a Kandinsky painting of a similar name), was based on her recollections of the sonorous tones and counterpoint rhythms of the Baroque organ works her musician father played regularly in the great churches of Rome.

Study for *Luminous Void Volume of Light*, 2001. Watercolor on paper, 30 x 22 in. (76.2 x 55.9 cm). Collection of the artist

Contact microphones affixed to the windows of the 91st floor of the World Trade Center, 1999. Courtesy the artist and The Project, New York and Los Angeles

Stephen Vitiello transforms incidental atmospheric noises into mesmerizing soundscapes that alter our perception of the surrounding environment. While participating in the Lower Manhattan Cultural Council's artist-in-residence program, Vitiello began recording sounds from his studio on the 91st floor of Tower One of the World Trade Center. Vitiello became fascinated with the disparity between the dynamism and vitality of the cityscape below and the unreal silence generated by the building's thick, sealed windows. The challenge, according to Vitiello, was to bring the sound from outside into his studio space. He affixed two contact microphones to the windows in his studio and began adjusting their reception until he could discern sounds from the other side of the glass. The sonic matter gathered by the microphones varied according to the weather conditions and activities on or near the building. Sounds picked up during his six-month residency included chiming church bells and the clamor of people on the streets below, as well as a variety of unidentifiable ambient noises. Vitiello, listening to the live feed through headphones, processed the audio stream only minimally, using a soundboard to accentuate certain frequencies and filter out others.

World Trade Center Recordings: Winds After Hurricane Floyd, a new audio installation created for the 2002 Biennial, charts the unseen activity of air currents churning high above the ground, focusing our attention on the subtle modulations in sound and rhythm that develop as the wind surges and wanes. The work is based on a recording Vitiello made the day after New York was struck by the powerful tropical storm Hurricane Floyd in 1999, and reveals the creaking and cracking noises of the swaying building, causing it to sound more like an old wooden sailing ship than a towering glass and steel structure. Vitiello's sound installation gives the invisible gusty airflow the aural illusion of physical presence, transforming atmospheric sounds into an abstracted sonic portrait of the World Trade Center.

CHRIS WARE

Jimmy Corrigan, the Midwestern antihero of Chris Ware's recent comic series, is a misbegotten young man who, having lived through an emotionally troubled childhood and adolescence, has grown into a nearly mute survivor in a world of oppressive cruelty and ugliness. Serialized since 1993 in Ware's *ACME Novelty Library* series, the complete Jimmy Corrigan story was published in 2000 in the form of a graphic novel, *Jimmy Corrigan, The Smartest Kid on Earth*, which was designed entirely by Ware. Trained as a painter as well as working in sculpture and prints, Ware has mastered the comic form, taking it to new levels of visual complexity and sophistication.

Each page of *Jimmy Corrigan* is broken up into an extraordinary array of narrative compartments, characterized by wildly diverse scale and expressive color. Some pages have no text at all, leading the reader on an elliptical trail through Corrigan's image-memories and distorted everyday perceptions. With compositions that are at times filmic, at times resemble scientific flow-charts, and at times look like abstract painting, Ware combines a variety of visual languages into a single narrative stream. Ware's newest installment of *The ACME Novelty Library* series is a large-format publication with a variety of comics including *Jimmy Corrigan*, *Quimby the Mouse*, *Tales of Tomorrow*, and *Rusty Brown*. On the cover of this booklet Ware declares wryly, "Thus, in embracing all things pubescent, it has been our aim to generate a national art more appropriate to the intellectual lethargy and venal irresponsibility of the American character; inarticulate, bumptious, and slovenly."

Jimmy Corrigan, The Smartest Kid on Earth from *The ACME Novelty Library*, number 15, winter 2001. Brush and ink on board, original printed size, 18 x 22 in. (45.7 x 55.9 cm); original drawing, 24 x 36 in. (61 x 91.4 cm). Courtesy the artist

Creation of the World, 2001.
Mixed media, photographs, wood,
and jumper cable on canvas,
113 x 157 1/2 in. (287 x 400 cm).
Collection of the artist

The paintings of Ouattara Watts express a deeply held belief in the interconnectedness of all things. He was initiated as a youth into the religion of the Senoufo people of the northern Ivory Coast, and his art combines traditional sacred symbols of his ancestors with imagery drawn from Western art history and his own experience living in Europe and America. Watts's religious upbringing was one of syncretic openness, incorporating elements of Christianity, Islam, and Judaism. In Senoufo society, he explains, "you are allowed a vision that is a cosmic rather than a nationalistic or village-oriented one. Therefore, you are the sun, the rain, the Mexican, the American, the Japanese, etc."

Watts's works are amalgams of painted abstract surfaces, found objects, photographs, and painted texts and numbers. Nearly every element has a powerful symbolic function. In *Creation of the World*, for example, two found skateboards were included both because their shape resembles the stone tablets of Moses and because they suggest the "possibility to fly around the world." One of the skateboards is inscribed with a drawing of a planet and the words "circle star." Onto both skateboards Watts has attached jumper cables, as if drawing potent energy from these symbolic forms. Along the top of the painting is a row of photographs, two of which represent a ritual skull made by the artist. The others document the Kapelo festival, an event marking the balance of life and death, which takes place once every fifteen years in Watts's hometown, Korhogo. At the top two corners of the painting, the artist has attached two conical forms. Forms of this kind are common on adobe buildings in the Sahel region of the Ivory Coast; however, for the artist, these peaks embody the mystical power of the pyramid and allude to the Egyptian origins of the Senoufo people.

PETER WILLIAMS

Detroit-based artist Peter Williams layers his paintings with interrelated images that allude to the subtle experience of human identity. Williams endows all of his works with a dreamlike sensation of slippery signification and conflicting symbolism. Images and forms often have multiple references, leaving viewers on their own in the shifting sands of Williams's fertile imagination. "The view through which I see things," says Williams, "is shaped by Black consciousness (decidedly non-Afro-centric), my experience as an amputee, and the postindustrial nature of life in Detroit."

These two paintings share a central, schematic facelike motif, which in the case of *Jasper's Last Breath* is actually cut out of the canvas. The gaping rectilinear holes that define two eyes and a mouth simultaneously recall the caricatured grin of Mickey Mouse (the tips of whose rounded ears poke up in the top corners of both paintings) and a kind of death's head grimace. The painting is certainly apocalyptic in tone: a single, tiny school bus plummets through a gray and desiccated space inhabited only by a number of forlorn yellow ducks, many of which seem strangely compressed into the corner of one of Mickey's eyes.

Esplanier represents an out-of-control plant-form sending its curving tendrils from one end of the picture to the other. Entwined in its branches are an array of images that suggest memories of childhood: a toy-size double-decker bus, a cartoony little house, frogs, insects, and assorted comic-style characters and body parts. Standing beneath this fantastical tree is a figure that looks like a cross between a little boy, a mouse, and a cop. Williams acknowledges that this character is a self-portrait, a symbol of his own ambiguous sense of age and power.

Esplanier, 2001. Oil on canvas, 60 x 72 in. (152.4 x 182.9 cm). Collection of the artist; courtesy Revolution Gallery, Detroit

Jasper's Last Breath, 2001. Oil on canvas, 72 x 96 in. (182.9 x 243.8 cm). Collection of the artist; courtesy Revolution Gallery, Detroit

ANNE WILSON

Details of *Topologies (3-5.02)*, 2002. Lace, thread, cloth, pins, and painted wood support, dimensions variable. Collection of the artist; courtesy Revolution Gallery, Detroit

Anne Wilson's *Topologies (3-5.02)* was created by dissecting bits and pieces of old black lace, then arranging the eccentrically shaped, deconstructed parts across a broad tablelike expanse. Black lace is loaded with a wide assortment of meanings, ranging from sex to death. It is also an archaic material, something associated with eras and generations gone by. Nevertheless, Wilson employs lace as a medium for both the exploration of new technologies and the expression of contemporary social concerns.

"In my new project," writes Wilson, "I am deconstructing the webs and networks of found black lace to create large horizontal topographies, 'physical drawings' that are both complicated and quite delicate. This project is a constantly unfolding process of close observation, dissection, and recreation." In taking the lace apart, the artist developed a keen understanding of its structure. This inspired her to reconstruct the lace in other materials and through other processes, including crochet and netting. She also scanned and processed lace patterns with her computer, which were then printed out on paper. Wilson "rematerialized" these patterns by hand-stitching them on cloth, then placing them in relationship to other examples of genuine and remade lace. "The logic of organization within the topography is based on the concept of like-kinds," the artist explains. "Never exactly repeating, areas of proximity are formed on the basis of the structural and visual characteristics of likeness." Some areas of the piece coalesce into coherent units, while others collide or are separated.

"This project references many things simultaneously," Wilson continues. "Relationships between systems of materiality (textile networks) and systems of immateriality (Internet and the web); microscopic, specimenlike images of biology and the internal body; and macro views of urban sprawl—systems of organization of city structures, interdependent and/or parasitic, processes of expansion. I am not interested in privileging one theme/position over another, rather to work constantly with these multiple references."

LEBBEUS WOODS

The works that architect Lebbeus Woods calls "Terrains" represent artificial landscapes. In contrast to the stable monoliths designed by many architects, Terrains are neither functional buildings nor are they stable in the conventional sense. Rather, Woods embraces the inevitability of change, accident, and even violent interruption, and his work embodies the idea of built space that is in sync with the unending transformations of the human and natural world. "Destruction insists on a new form of stability," Woods writes, "much more dynamic than before, a survival stability, based on the ability to respond quickly and inventively to unpredictable events....In this sense the damaged city can be a model for all cities suffering the unpredictable and sometimes violent changes brought about by continuous technological innovation."

The Terrain works grew directly out of Woods's interest in developing a form of building that would be less prone to catastrophic failure in a strong earthquake. With the insight that an already fractured form would be less likely to pull itself down, Woods evolved a design strategy based on compartments, modules, and facets, with every unit functioning independently, yet in concert with the others. Philosophically, Woods's work reaches deeply into our contemporary condition, providing a sympathetic rendering of constructed space in a world full of unknown dangers.

Woods's exquisite draftsmanship is often directly combined with text and even tables of numbers, all of which he considers to be aspects of the Terrain. Stylistically, the drawings range from repetitive, abstract patterns to a surprisingly realistic rendering of the skyscrapers of Lower Manhattan. In the latter work, made in 1999, Woods presents the radical proposition that parts of the East River and New York Harbor be emptied of water and excavated to create vast granite canyons that would dwarf in scale even the tallest of the city's buildings.

Terrain 6, 1999. Mixed media on board, 19 1/4 x 23 1/4 in. (49 x 59.2 cm). Collection of the artist; courtesy Henry Urbach Architecture, New York

Still from *The Or Cloud*, 2001.
16mm film, black-and-white,
silent; 6 minutes

Since 1976, Fred Worden has made a body of films that articulate
one of the fundamental principles of cinema: the perception
of continuity through intermittent projection. In *The Or Cloud*,
the dynamic force of light is articulated through a sequence of
monochromatic abstract forms that swirl, arc, flicker, and tumble
across the screen in black, white, and gray tones, creating a
vibrating energetic space. Worden creates this space from a single
image of marks made in ink on acetate; he then deconstructs
the image through shifts in registration and different generations
of duplication. The sweeping movements of line and tone evoke
Stan Brakhage's remarks on the film camera's "zooming potential
for exploding space, and its telephonic compression of [space]
to flatten perspective." This subversion of traditional narrative
representation creates what Hans Richter described as an
"imageless cinema." As Worden observes, "One frame...once
energy-infested and in motion...sheds its pictorial guise and
atomizes into a sheer dynamic....A cinema of pure energy...an
endless unfolding."

The unknowable mystery of space is suggested by the title
The Or Cloud, which refers to an astronomical body called the Ort
Cloud, a cluster of orbiting rocks that is slowly descending, like
a dust cloud, through the atmosphere. Worden's rushing stream
of energy evokes this disorienting journey, its ambiguous space
indicated by the word "or." For Worden, "or" signifies the pivot
between two uncertain perceptual states, signified by the shifts
between light and dark, and between each film frame and its
corresponding interval. The interplay between these two states
represents our conscious presence. As the filmmaker observes,
"Light and No-light is almost the same thing as black-and-white,
but is more archaic and fundamental." Worden understands light
as the connecting force between humanity and the universe,
a view that echoes Robert Haller's observation that "light comes
from a realm beyond us; apart from it, we are exiles...cinema is
a path back to that primal spark."

ZHANG HUAN

Zhang Huan draws on personal experience to stage physically arduous, yet poetically expressive performances that use the naked body as a vehicle to comment on acute social realities. While often addressing the repression of artistic freedoms in his native China, Zhang's works transcend their cultural specificity to speak to broader, more universal concerns of humanity. Part of a young group of Chinese artists who responded to the 1989 Tiananmen Square massacre by abandoning traditional art forms in favor of more experimental media, Zhang was a pioneer of Beijing's East Village performance art scene. Beginning in 1993, he presented radical hybrid works that combined Western avant-garde dance, theater, and performance art with elements borrowed from Tibetan, Buddhist, and Muslim rituals as well as movements appropriated from tai chi and yoga.

Although his performances vary considerably in their final form, they almost always require Zhang to submit his naked body to extreme duress. In *12 Square Meters*, for example, Zhang, naked and covered with fish oil and honey, sat still for one hour in the squalor of a fly-infested public toilet. In *Pilgrimage: Wind and Water in New York/New York Fengshui*, a later work, he lay face down on a bed of ice on a traditional Chinese settee surrounded by dogs. The artist explains that it is through such physically and mentally demanding situations that he is able to experience the relationship between body and spirit and to communicate more directly to a viewing public.

Since his expulsion from China in 1998, Zhang has lived in New York and produced unique, site-responsive performance events all over the world. Many of his recent performances have incorporated his impressions of new customs and rituals to which he is exposed when traveling to various countries. Zhang's performance at the Whitney is part of an ongoing series titled *My America* and reflects, in part, his uneasy existence living in a still unfamiliar culture.

Pilgrimage—Santiago, 2001.
Performance at the Plaza de la Quintana, Museo das Perigrinacións, Santiago de Compostela, Spain, May 8, 2001

JOHN ZURIER

Oblaka 31, 2001. Oil on linen, 24 x 36 in. (61 x 91.4 cm). Collection of the artist; courtesy Gallery Paule Anglim, San Francisco

John Zurier's paintings reflect both a deep interest in the process of painting and a sensitivity to the colors, atmospheres, and sensations of daily life. His works are built up layer by layer with various colors of alternately opaque and translucent oil paint. The final appearance of a picture depends on the pigments' unique tones and transparencies; a seemingly light image may overlay and contain resonances of many deeper hues. In addition, Zurier's brush-handling endows each work with a kind of dynamic architecture or directional flow. Rarely purely abstract, however, Zurier's canvases are inspired by conditions of light and color that he encounters during the course of his daily routine. However, as Zurier observes, there is usually a lapse of time between a perception of the world and its appearance in a painting. "It has to do with the way color is out in the world and the way color operates in a painting," he adds. "They're very different things!" These ethereal recollections are balanced by Zurier's interest in the raw physicality of the canvases and their supports. Recently, he has utilized a particular brand of Russian-made canvas, called Oblaka (which means "cloud" in Russian), which is made in a rather crude fashion and functions for the artist as a kind of sculptural, found-object element.

After nearly four years of working almost exclusively on small-scale paintings, Zurier recently returned to large-format canvases. In *MAZ 1* he captures extraordinary nuances of color, light, and space. Like an impenetrable fog bank, the work seems to recede into limitless depth while simultaneously maintaining a melancholy and tantalizing reserve.

ARTISTS' BIOGRAPHIES

All listings and bibliographical
citations are selected.

PEGGY AHWESH

Born in Pittsburgh, 1954
Lives in Brooklyn, New York

SCREENINGS

2001 Cinematexas, Austin, "All the Girls
with Cameras in Their Heads: The
Magnificent Seven"

The Jerusalem Cinematheque, Israel,
"Experimental Video Works by Peggy
Ahwesh"

Joanie 4 Jackie (organizer), "Some Kind
of Loving" (traveled)

Nomads and Residents, New York,
"Laracroft:ism: On Female Heroines"

2000 Exit Art, New York, "Opium Den:
Desires and Disappointments"

The Museum of Modern Art, New York,
"Science Is Fiction: The Films of Jean
Painlevé & Company"

The 46th Robert Flaherty Film
Seminar, Vassar College, Poughkeepsie,
New York

Whitney Museum of American Art,
New York, "The Color of Ritual, the
Color of Thought: Women Avant-Garde
Filmmakers in America 1930–2000"

1999 Solomon R. Guggenheim Museum,
New York

Yerba Buena Center for the Arts,
San Francisco, "Peggy's Playhouse:
A Peggy Ahwesh Retrospective"

BIBLIOGRAPHY

Ahwesh, Peggy. "Lara Croft: Tomb Raider."
Film Comment, 37 (July–August 2001), p. 77.

Gangitano, Lia. "Warhol's Grave." In Steve
Reinke and Tom Taylor, eds. *Lux: A Decade
of Artists' Film and Video*. Toronto: XYZ Books,
2000, pp. 306–11.

Griffin, Tim. "Bury the Lead." *World Art*,
no. 16 (1998), pp. 22–25.

Russell, Catherine. "Culture as Fiction: The
Ethnographic Impulse in the Films of Peggy
Ahwesh, Su Friedrich, and Leslie Thornton."
In Jon Lewis, ed. *The New American Cinema*.
Durham, North Carolina, and London: Duke
University Press, 1998, pp. 353–78.

Taubin, Amy. "Women on Top." *The Village
Voice*, August 5, 1997, p. 74.

BOSMAT ALON

Born in Tel Aviv, 1952
Lives in Jerusalem

ONE-ARTIST EXHIBITIONS
(WITH TIRTZA EVEN)

1999 Ami Steinits Gallery, Tel Aviv

GROUP EXHIBITIONS
(WITH TIRTZA EVEN)

2001 University of Haifa Art Gallery, Israel

2000 Siena Jewish Museum, Italy

SCREENINGS
(WITH TIRTZA EVEN)

2001 École Nationale Supérieure des
Beaux-Arts, Paris, "Travailler à exister"

2000 Chisenhale Gallery, London,
"Exit: International Film and Video"

[d]ivision Festival, Vienna

Palermo International Videoart +
Film + Media Festival, Italy,
"L'Immagine Leggera"

Video of the Millennium, London

VideoArt Festival Locarno, Switzerland

JOSÉ ALVAREZ

Born in New York
Lives in New York and Fort Lauderdale, Florida

GROUP EXHIBITIONS

1999 Quartet Editions, New York, "Inbox"

PERFORMANCES/MEDIA APPEARANCES

2001 Johnson Space Flight Center, Houston,
 July 23

 Parkes Radio Telescope Observatory,
 Parkes, Australia, August 21

2000 Chinese Central Television, Beijing,
 October–November

 Jet Propulsion Lab, Pasadena,
 California, October 5

 "Tell it Like it Is," Chinese Central
 Television, Beijing, October–November

1999 "Primer Impacto," Univision, January

 Teatro Verdi, Padua, Italy, October
 30–31

 Tienanmen Square, Beijing, November

1998 "The Power of Belief," ABC News
 Special, October 6

BIBLIOGRAPHY

Genoni, Tom, Jr. "Exploring Mind, Memory,
and the Psychology of Belief." *The Skeptical
Inquirer*, 19 (March–April 1995), p. 10.

Sagan, Carl. "Carlos." *Parade Magazine*,
December 4, 1994.

MARYANNE AMACHER

Born in Kane, Pennsylvania, 1946
Lives in Kingston, New York

INSTALLATIONS/PERFORMANCES

2001 Avery Center for the Arts, Bard
 College, Annandale-on-Hudson,
 New York

 Mills College, Oakland, California

2000 60dum, Chicago

1998 Dampfzentrale, Bern, Switzerland

 Maastunnel, Rotterdam

GROUP EXHIBITIONS

2000 P.S. 1 Contemporary Art Center/
 Museum of Modern Art, Long
 Island City, New York, "Volume:
 Bed of Sound"

1999 Whitney Museum of American Art,
 New York, Part II, 1950–2000, of
 "The American Century: Art & Culture
 1900–2000"

DISCOGRAPHY

2000 *OHM: The Early Gurus of Electronic Music*
 (compilation). Roslyn, New York:
 Ellipsis Arts

 *Prix Ars Electronica—Cyberarts 2000:
 Digital Musics* (compilation). Linz,
 Austria: ORF/Prix Ars Electronica

1999 *Sound Characters*. New York: Tzadik

BIBLIOGRAPHY

Gann, Kyle. "Maryanne Amacher: Sound
Characters." *The Village Voice*, August 17, 1999,
p. 44.

Hollings, Ken. "Soundcheck: Maryanne
Amacher: Sound Characters (Making The
Third Ear)." *The Wire*, no. 182 (April 1999),
p. 60.

Licht, A. "Expressway to your Skull."
The Wire, no. 181 (March 1999), pp. 42–45.

Richard-San, Mark. "Maryanne Amacher:
Sound Characters." *Pitchfork*, 2001,
www.pitchforkmedia.com/record-reviews/
a/amacher_maryanne/sound-characters.shtml.

Weddle, Eric. "Amacher's long-awaited
recording sounds better when experienced
live." *Indiana Digital Student*, March 31, 1999,
www.idsnews.com/news/033199/arts/
033199live.html.

ARCHIVE
(CHRIS KUBICK AND ANNE WALSH)

Organized in 2000
Based in Los Angeles

Chris Kubick
Born in Detroit, 1970

Anne Walsh
Born in New York, 1962

ONE-ARTIST EXHIBITIONS

2001 Aero and Co., Los Angeles

GROUP EXHIBITIONS

2001 Santa Monica Museum of Art,
 California, "Art in Motion II"

PERFORMANCES

2001 Aero and Co., Los Angeles

DISCOGRAPHY

2001 *Conversations with the Countess of
 Castiglione*. Santa Monica, California:
 ARCHIVE

 Yves Klein Speaks! Santa Monica,
 California: ARCHIVE

BIBLIOGRAPHY

Porter, Gwynneth. "Art After Death." *Log
Illustrated*, no. 14 (Spring 2001), pp. 12–14, 49.

GREGOR ASCH
(DJ OLIVE THE AUDIO JANITOR)

Born in Boston, 1961
Lives in Brooklyn, New York

PERFORMANCES

2001 Holland Festival, Amsterdam

Impakt Festival, Utrecht,
The Netherlands

2000 Centre Georges Pompidou, Paris

Jazz Saalfelden, Austria

Lincoln Center Festival, New York

DISCOGRAPHY

2000 *SYR5* (with Kim Gordon and Ikue
Mori). Hoboken, New Jersey: Sonic
Youth Recordings

WE™, *Decentertainment*. New York:
Home Entertainment

1998 *Composition 11: Audio Roulette for Three
Turntables* (three-LP set). New York:
Home Entertainment

Material with William S. Burroughs,
The Road to the Western Lands (remixed
by the Audio Janitor). New York:
Mercury Records

1995 Liminal, *Nosferatu*. New York: Knitting
Factory Works

BIBLIOGRAPHY

Lolli, Michelle. "Spin Out: DJ Olive." *Urb*,
no. 39 (November 1994), p. 54.

Martin, Jana. "What is Illbient?" *The Village
Voice*, July 23, 1996, pp. 36–41.

Ratliff, Ben. "Combining Jazz and Judaism."
The New York Times, May 1, 1999, p. B16.

Smith, Roberta. "In Tomblike Vaults, the
Future Flickers and Hums." *The New York Times*,
August 9, 1996, p. C25.

Strauss, Neil. "At the Clubs, Murmurs and
Ambient Music." *The New York Times*, March 8,
1996, p. C1.

IRIT BATSRY

Born in Ramat-Gan, Israel, 1957
Lives in New York

ONE-ARTIST EXHIBITIONS

2001 Moagens Harmonia, Porto, Portugal

The Veemvloer, Amsterdam

GROUP EXHIBITIONS

2001 Museo Nacional Centro de Arte Reina
Sofia, Madrid, "Cine et Casí Cine"

SCREENINGS

2001 Cinema de Balie, Amsterdam

Musée d'Art Moderne et
Contemporain, Strasbourg, France

Nelson-Atkins Museum, Kansas City,
Missouri, "Electromediascope"

New York Video Festival, The Film
Society of Lincoln Center

2000 29th International Film Festival
Rotterdam

The 44th Regus London Film Festival

1999 Pacific Film Archive, Berkeley,
California, "Passage to Utopia"

BIBLIOGRAPHY

Chimaera: Irit Batsry. Hérimoncourt, France:
Centre International de Création Vidéo
Montebéliard Belfort, 1994.

Hoptman, Laura. "Two Hands Writing and
Erasing Simultaneously: The Video Work of
Irit Batsry." *Women Artists News*, 13 (Fall 1988),
pp. 11–12, 14.

Landon, Paul. "Irit Batsry." *Parachute*, no. 90
(April–June 1998), pp. 45–46.

Scott, A.O. "In the Flux of Reality
Recomposed." *The New York Times*, July 13,
2001, p. E1.

Taubin, Amy. "Neither There Nor Here."
The Village Voice, July 17, 2001, p. 118.

ROBERT BEAVERS

Born in Brookline, Massachusetts, 1949
Lives in Zumikon, Switzerland

SCREENINGS

2001 The Cleveland Cinematheque

Cornell Cinema, Cornell University,
Ithaca, New York, "An Evening with
Experimental Filmmaker Robert
Beavers"

30th International Film Festival
Rotterdam

New York Film Festival, The Film
Society of Lincoln Center

2000 New York Film Festival, The Film
Society of Lincoln Center

25th Toronto International Film
Festival

1999 28th International Film Festival
Rotterdam

New York Film Festival, The Film
Society of Lincoln Center

Whitney Museum of American Art,
New York, Part II, 1950–2000, of
"The American Century: Art & Culture
1900–2000"

1998 Musée du Louvre, Paris

BIBLIOGRAPHY

Arthur, Paul. "Intimate Strangers."
The Village Voice, May 8, 2001, p. 134.

—. "Between the Place and the Act: *Efpsychi*."
Millennium Film Journal, no. 32–33 (Fall 1998),
pp. 53–59.

Pipolo, Tony. "An Interview with Robert
Beavers." *Millennium Film Journal*, no. 32–33
(Fall 1998), pp. 3–37.

Sitney, P. Adams. "Majestic Images." *Film
Comment*, 37 (March–April 2001), pp. 50–55.

—. "Robert Beavers: Observing and Directing
Wingseed." *Millennium Film Journal*, no. 32–33
(Fall 1998), pp. 45–51.

ZOE BELOFF

Born in Edinburgh, Scotland, 1958
Lives in New York

SCREENINGS

2001 30th International Film Festival
Rotterdam

Lux Centre, London

2000 The 13th Annual Images Festival of
Independent Film and Video, Toronto

Pacific Film Archive, Berkeley,
California, "Light from the Other Side:
Films by Zoe Beloff and Kerry Laitala"

San Francisco Cinematheque

NEW MEDIA PROJECTS

2000 Art Gallery of New South Wales,
Sydney, "World Without End:
Photography and the 20th Century"

Kiasma, Museum of Contemporary Art,
Helsinki, Finland, "Alien Intelligence"

1999 European Media Arts Festival
Osnabrück, Germany

17th World Wide Video Festival,
Amsterdam

1998 Cyber 98, Lisbon, Portugal

BIBLIOGRAPHY

Beausse, Pascal. "Zoe Beloff, Christoph
Draeger: After-Images." *Art Press*, no. 235
(May 1998), pp. 43–47.

Flanagan, Mary. "Navigating the Narrative
in Space: Gender and Spatiality in Virtual
Worlds." *Art Journal*, 59 (Fall 2000), pp. 74–85.

Gehman, Chris. "A Mechanical Medium:
A Conversation with Zoe Beloff and
Ken Montgomery." *Cinémascope*, no. 6
(Winter 2001), pp. 32–35.

Leggett, Michael. "Zoe Beloff." *World Art*,
no. 18 (1998), p. 76.

Shaviro, Steven. "Future Past: Zoe Beloff's
Beyond." *Artbyte*, 1 (August–September 1998),
pp. 17–18.

SANFORD BIGGERS

Born in Los Angeles, 1970
Lives in New York

GROUP EXHIBITIONS
(WITH JENNIFER ZACKIN)

2001 Arizona State University Art Museum,
Tempe, "Not Quite Myself Today:
Video Works by Eight Artists"

The Studio Museum in Harlem,
New York, "Freestyle" (traveled)

2000 Maryland Institute College of Art,
Baltimore, "Culture of Class: Issues
of Class in North American Culture"

BIBLIOGRAPHY

Berwick, Carly. "Power Spins." *Art News*, 99
(November 2000), p. 224.

Cotter, Holland. "A Full Studio Museum Show
Starts with 28 Young Artists and a Shoehorn."
The New York Times, May 11, 2001, p. E36.

Erikson, Erica. "Color Coded." *Artforum*, 39
(May 2001), p. 52.

Griffin, Tim. "Race Matters." *Time Out New
York*, May 24–31, 2001, pp. 55–56.

Stevens, Mark. "In Brief." *New York Magazine*,
34 (May 21, 2001), p. 82.

SUSAN BLACK

Born in Litchfield, Connecticut, 1964
Lives in Brooklyn, New York

GROUP EXHIBITIONS

2001 Bass Museum of Art, Miami,
"Biting Style and Spitting Image"

Bellwether, Brooklyn, New York,
"All American"

2000 VII Bienal de La Habana, Havana, Cuba

P.S. 1 Contemporary Art Center/
The Museum of Modern Art,
Long Island City, New York,
"Special Projects"

18th World Wide Video Festival,
Amsterdam

BIBLIOGRAPHY

Cotter, Holland. "All American." *The New York
Times*, August 3, 2001, p. E32.

Gilman-Sevcik, Frantiska and Tim. "P.S.1
Special Projects." *Flash Art*, 34 (March–April
2001), p. 68.

Zimmer, William. "Light and Heat from
American Indian Women." *The New York Times*
(Westchester County edition), September 24,
1995, p. WC20.

JEREMY BLAKE

Born in Fort Sill, Oklahoma, 1971
Lives in New York

ONE-ARTIST EXHIBITIONS

2001 Feigen Contemporary, New York

2000 The Contemporary Arts Center,
Cincinnati

Feigen Contemporary, New York

Schusev Museum of Architecture,
Moscow

1999 Works on Paper, Inc., Los Angeles

GROUP EXHIBITIONS

2001 San Francisco Museum of Modern Art,
"010101: Art in Technological Times"

Whitney Museum of American Art,
New York, "BitStreams"

2000 CCAC Institute, Oakland, California,
"Scanner"

Centre Georges Pompidou, Paris,
"Elysian Fields"

P.S. 1 Contemporary Art Center/The
Museum of Modern Art, Long Island
City, New York, "Greater New York:
New Art in New York Now"

BIBLIOGRAPHY

Blake, Jeremy, and Theresa Duncan.
"The Red Eye." *Art/Text*, no. 67 (November
1999–January 2000), pp. 52–57.

Griffin, Tim. "Jeremy Blake at Feigen
Contemporary." *Art in America*, 87
(November 1999), p. 144.

Perchuk, Andrew. "Jeremy Blake: Feigen
Contemporary." *Artforum*, 37 (Summer 1999),
pp. 156–57.

Schjeldahl, Peter. "Pragmatic Hedonism."
The New Yorker, April 3, 2000, pp. 94–95.

Simpson, Bennett. "Jeremy Blake in Three
Parts." March 2000, www.PS1.org/cut/java/
essays/blake.html.

AA BRONSON

Born in Vancouver, British Columbia, 1946
Lives in New York and Toronto

ONE-ARTIST EXHIBITIONS

2001 Museum of Contemporary Art, Chicago

2000 The Balcony, Toronto

Plug In, Winnipeg, Ontario

Secession, Vienna

1999 1301PE, Los Angeles

GROUP EXHIBITIONS

2001 Kunsthalle Wien, Vienna,
"Tele(visions)"

Ursula Blickle Foundation, Karlsruhe,
Germany, "Angst"

2000 Centre International d'Art
Contemporain de Montréal,
"La Biennale de Montréal"

The Museum of Modern Art,
New York, "Video Time"

1999 Museum Villa Stuck, Munich,
"Dream City"

BIBLIOGRAPHY

AA Bronson: Negative Thoughts (exhibition
catalogue). Chicago: Museum of Contemporary
Art, 2001.

Obejas, Achy. "Piercing 'Negative Thoughts'
Forces a Rethinking of AIDS Crisis." *Chicago
Tribune*, April 23, 2001, p. 4.

Rosenfeld, Kathryn. "Triple Self-Portrait Minus
Two." *New Art Examiner*, 28 (July/August 2001),
pp. 76–81, 104.

Shewey, Don. "Good Grief." *The Advocate*,
February 13, 2001, p. 55.

Tietjen, Friedrich, ed. *AA Bronson* (exhibition
catalogue). Vienna: Secession, 2000.

JAMES BUCKHOUSE

Born in Logan, Utah, 1972
Lives in San Francisco

ONE-ARTIST EXHIBITIONS

1999 Ebert Gallery, San Francisco

The Mill & Short Gallery, San Francisco

1998 The Mill & Short Gallery, San Francisco

GROUP EXHIBITIONS

2000 Iris and B. Gerald Cantor Center for
Visual Arts, Stanford University,
California, "Refresh: The Art of the
Screen Saver"

VIPER International Festival for Film,
Video and New Media, Basel,
Switzerland

1998 The Mill & Short Gallery, San
Francisco, "Who Murdered Reality?"

BIBLIOGRAPHY

Finley, Chris. "Hotlist." *Artforum*, 39
(May 2001), p. 30.

Fischer, Jack. "Screen-saver Exhibit Creates
Movable Feat." *San Jose Mercury News*,
November 5, 2000, p. 9E.

Lite, Jordan. "When Flying Toasters Were Art."
Wired News, November 4, 2000, www.wired.com/
news/culture/0,1294,39366,00.html.

Mirapaul, Matthew. "Screen Savers as Artists'
Medium." *The New York Times*, November 23,
2000, p. G6.

JAVIER CAMBRE

Born in San Juan, Puerto Rico, 1966
Lives in Queens, New York

GROUP EXHIBITIONS

2001 Cuchifritos Gallery, New York,
"Tomorrow"

Midway Initiative Gallery, Saint Paul,
Minnesota, "Weak Architecture"

2000 FGA Chicago, San Juan, Puerto Rico,
"Sunnyday"

Galería de Arte del Sagrado Corazón,
San Juan, Puerto Rico, "U/topistas"

SculptureCenter, New York,
"Transposed: Analogs of Built Space"

BIBLIOGRAPHY

Hertz, Betty Sue. *Transposed: Analogs of Built
Space* (exhibition catalogue). New York:
SculptureCenter, 2000.

Pasquini, Stefano. "Interview with Javier
Cambre." *New York Arts Magazine*, 5 (May 2000),
p. 41.

U/topistas (exhibition catalogue). San Juan,
Puerto Rico: Michelle Marxuach Galería, 2000.

JIM CAMPBELL

Born in Chicago, 1956
Lives in San Francisco

ONE-ARTIST EXHIBITIONS

2001 Anderson Gallery, Virginia
Commonwealth University, Richmond

2000 Hosfelt Gallery, San Francisco

Yerba Buena Center for the Arts,
San Francisco

1999 Arizona State University Art Museum,
Tempe

1998 San Jose Museum of Art, California

GROUP EXHIBITIONS

2001 Museum of Contemporary Art,
San Diego, "Eureka: New Art from
the Bay Area"

Whitney Museum of American Art,
New York, "BitStreams"

2000 Ars Electronica Center, Linz, Austria,
"Ars Electronica 2000"

CCAC Institute, Oakland, California,
"Scanner"

1998 Wexner Center for the Arts,
Ohio State University, Columbus,
"Body Mécanique: Artistic
Explorations of Digital Realms"

BIBLIOGRAPHY

Baker, Kenneth. "Campbell Lets the Light
In at Hosfelt." *San Francisco Chronicle*, April 29,
2000, p. D1.

Fox, Catherine. "Digital Art Shows Message,
Not Medium, Is Still What Matters." *The
Atlanta Journal-Constitution*, May 6, 2001, p. L3.

Helfand, Glen. "Critic's Choice: Jim Campbell."
San Francisco Bay Guardian, May 10, 2000.

Kurtz, Glenn. "Jim Campbell at Hosfelt
Gallery." *Artweek*, 31 (June 2000), pp. 15–16.

Schumacher, Donna. "Jim Campbell."
Sculpture, 17 (February 1998), pp. 62–63.

KARIN CAMPBELL

Born in San Diego, California, 1962
Lives in Brooklyn, New York

ONE-ARTIST EXHIBITIONS

1998 Courtroom Project Space, Brooklyn,
New York

GROUP EXHIBITIONS

2001 P.S. 1 Contemporary Art Center/The
Museum of Modern Art, Long Island
City, New York, "Special Projects"

SculptureCenter, New York, "Interval"

1999 Exit Art, New York, "Choice 99"

1998 White Columns, New York, "Journey"

PERFORMANCES

2001 Parlour Projects, Brooklyn, New York

P.S. 1 Contemporary Art Center/
The Museum of Modern Art,
Long Island City, New York

2000 Art In General, New York

Bellwether, Brooklyn, New York

Voxpopuli, Philadelphia

BIBLIOGRAPHY

Levin, Caroline. "Karin Campbell."
Special Projects Writers Series, Spring 2001,
www.ps1.org/cut/writers/levine.html.

McKenzie, John. "On Tears: Karin Campbell
and the Genealogy of Crying." *Special Projects
Writers Series*, Spring 2001, www.ps1.org/cut/
writers/mckenzie.html.

PETER CAMPUS

Born in New York, 1937
Lives in East Patchogue, New York

ONE-ARTIST EXHIBITIONS

1998 Paula Cooper Gallery, New York

1997 Rena Bransten, San Francisco

GROUP EXHIBITIONS

2001 Guild Hall, East Hampton, New York, "The Reality Effect: Contemporary American Photography"

San Jose Museum of Art, California, "Blind Vision: Video and The Limits of Perception"

Whitney Museum of American Art, New York, "Into the Light: The Projected Image in American Art 1964–1977"

1999 Neuer Berliner Kunstverein, Berlin, "Rewind to the Future: Technologische Medien zwischen Historie und Zukunft"

Whitney Museum of American Art, New York, Part II, 1950–2000, of "The American Century: Art & Culture 1900–2000"

SCREENINGS

2000 The Museum of Modern Art, New York, "Video Time"

BIBLIOGRAPHY

Decter, Joshua. "New York in Review." *Arts Magazine*, 66 (January 1992), pp. 75–79.

Johnson, Ken. "Art in Review: Peter Campus." *The New York Times*, January 23, 1998, p. E35.

Joselit, David. "The Video Public Sphere." *Art Journal*, 59 (Summer 2000), pp. 46–53.

Pardee, Hearne. "Peter Campus." *Art News*, 97 (May 1998), p. 168.

—. "Durational Perception." *Arts Magazine*, 63 (December 1988), pp. 76–81.

VIJA CELMINS

Born in Riga, Latvia, 1938
Lives in New York

ONE-ARTIST EXHIBITIONS

2001 McKee Gallery, New York

Museum für Gegenwartskunst, Basel, Switzerland

2000 Cirrus Gallery, Los Angeles

1999 Anthony d'Offay Gallery, London

GROUP EXHIBITIONS

2001 Centre Georges Pompidou, Paris, "Les Années Pop"

Tate Liverpool, England, "At Sea"

2000 San Francisco Museum of Modern Art, "Celebrating Modern Art: The Anderson Collection"

1999 Hirshhorn Museum and Sculpture Garden, Smithsonian Institution, Washington, D.C., "Regarding Beauty: A View of the Late Twentieth Century" (traveled)

Whitney Museum of American Art, New York, Part II, 1950–2000, of "The American Century: Art & Culture 1900–2000"

BIBLIOGRAPHY

Hickey, Dave. "Top Ten." *Artforum*, 38 (December 1999), p. 112.

Johnson, Ken. "Vija Celmins." *The New York Times*, June 1, 2001, p. E36.

Princenthal, Nancy. "Vija Celmins at David McKee." *Art in America*, 84 (July 1996), pp. 83–84.

Schjeldahl, Peter. "Dark Star: The Intimate Grandeur of Vija Celmins." *The New Yorker*, June 4, 2001, pp. 85–86.

Smyth, Cherry. "Vija Celmins." *Art Monthly*, no. 229 (September 1999), pp. 40–41.

CHAN CHAO

Born in Kalemyo, Burma, 1966
Lives in Washington, D.C.

ONE-ARTIST EXHIBITIONS

2000 Robert B. Menschel Photography Gallery, Syracuse University, New York (traveled)

Signal 66, Washington, D.C.

GROUP EXHIBITIONS

1999 Corcoran Gallery of Art, Washington, D.C., "Developing Illusions, 1873–1998"

BIBLIOGRAPHY

Burma: Something Went Wrong (exhibition catalogue). Syracuse, New York: Light Work, 2000.

Ciccotti, Susan. "Burma: Something Went Wrong." *The Photo Review*, 24 (Winter–Spring 2001), pp. 25–26, 34.

Grundberg, Andy. "Burma: Something Went Wrong—The Photography of Chan Chao." *Bookforum*, 8 (Spring 2001), p. 48.

O'Sullivan, Michael. "Chao's Burma: It's All in the Hands." *The Washington Post*, February 2, 2001, pp. 61–62.

Wildberger, Sara. "Discovering Self on Burma's Chaotic Borders." *The Washington Post*, February 8, 2001, p. T25.

RICHARD CHARTIER

Born in Alexandria, Virginia, 1971
Lives in Arlington, Virginia

GROUP EXHIBITIONS

2001 Betty Rymer Gallery, The School of the Art Institute of Chicago, "Resynthesis"

1999 Grand Central Art Center, California State University, Fullerton, "Static"

Washington Project for the Arts/ Corcoran Gallery of Art, Washington, D.C., "Fuzzy"

PERFORMANCES

2001 Lovebytes, Sheffield, United Kingdom

Micro Mutek 2, Montreal

Transmissions004, Chicago

DISCOGRAPHY

2002 *of surfaces*. Brooklyn, New York: Line

2001 *decisive forms*. Koblenz, Germany: Trente Oiseaux

2000 *series*. Brooklyn, New York: Line

1999 *a hesitant fold*. Tokyo: Meme

BIBLIOGRAPHY

Fox, David. "Ether Talk." *The Wire*, no. 207 (May 2001), p. 82.

Lewis, Nicole. "Antennae Puts Out Feelers." *The Washington Post*, December 16, 1999, p. C5.

—. "A Site for Sore Ears." *The Washington Post*, November 18, 1999, p. C5.

O'Sullivan, Michael. "'Fuzzy' Wuzzy Bearable." *The Washington Post*, March 26, 1999, pp. 59–60.

Searing, Daniel. "Hears the Grass Grow." *Washington City Paper*, 19 (April 16–22, 1999), p. 54.

TONY COKES

Born in Richmond, Virginia, 1956
Lives in Providence, Rhode Island

SCREENINGS

2001 Impakt Festival, Utrecht, The Netherlands

30th International Film Festival Rotterdam

List Visual Arts Center, Massachusetts Institute of Technology, Cambridge, "Race in Digital Space"

The Ottawa Art Gallery, Ontario, "Take Two"

VideoEx: Video & Experimental Film Festival, Zurich, Switzerland

VideoLisboa, Lisbon, Portugal

19th World Wide Video Festival, Amsterdam

2000 L.A. Freewaves Festival: 7th Celebration of Experimental Media Arts, Los Angeles

The Museum of Modern Art, New York, "Video Time"

18th World Wide Video Festival, Amsterdam

BIBLIOGRAPHY

de Groot, Anita. "Ad Vice." In *18th World Wide Video Festival* (exhibition catalogue). Amsterdam: Stichting World Wide Video Centre, 2000, pp. 146–47.

Fortin, Sylvie. *Take Two: Reprise* (exhibition catalogue). Ottawa, Ontario: The Ottawa Art Gallery, 2001.

Vitiello, Stephen. "Clash or Jam?" In *19th World Wide Video Festival* (exhibition catalogue). Amsterdam: Stichting World Wide Video Centre, 2001.

Willis, Holly. "Signal to Noise: Ad Vice." *L.A. Weekly*, November 3–9, 2000, p. 94.

STEPHEN DEAN

Born in Paris, 1968
Lives in Brooklyn, New York

ONE-ARTIST EXHIBITIONS

2001 Henry Urbach Architecture, New York

Marcel Sitcoske Gallery, San Francisco

2000 Galerie Xippas, Paris

1999 Hales Gallery, London

1998 Galerie Xippas, Paris

GROUP EXHIBITIONS

2001 Weatherspoon Art Gallery, The University of North Carolina, Greensboro, "Finely Drawn: A Recent Gift of Contemporary Drawing"

2000 Domaine de Chamarande, Chamarande, France, "L'Art dans le Vent"

La Galerie du Petit Château, Sceaux, France, "A Ciel Ouvert"

1999 Hales Gallery, London, "Stephen Dean & Anne Deleporte"

1998 Hales Gallery, London, "Group Show"

Marcel Sitcoske Gallery, San Francisco, "Food"

BIBLIOGRAPHY

Amar, Sylvie. "Walk on the Soho Side etc." *Art Press*, no. 215 (July–August 1996), pp. 68–69.

Pratt, Kevin. "Stephen Dean, Pulse." *Time Out New York*, June 28–July 5, 2001, p. 63.

Smith, Roberta. "As Chelsea Expands, a Host of Visions Rush In." *The New York Times*, June 1, 2001, p. E29.

DESTROY ALL MONSTERS COLLECTIVE

Organized circa 1973
Based in Detroit and Los Angeles

MEMBERS

Mike Kelley
Born in Detroit, 1954
Lives in Los Angeles

Cary Loren
Born in Detroit, 1955
Lives in Detroit

Jim Shaw
Born in Midland, Michigan, 1952
Lives in Los Angeles

ONE-ARTIST EXHIBITIONS

2000 Center on Contemporary Art, Seattle

1998 Museum Boijmans Van Beuningen, Rotterdam

GROUP EXHIBITIONS

2001 The Detroit Institute of Arts, "Artists Take on Detroit"

Museum of Contemporary Art, Sydney, Australia, "Art>Music (rock, pop, techno)"

1998 Centrum Beeldende Kunst/Villa Alkmaar, Rotterdam, "Strange Früt: Detroit Culture"

BIBLIOGRAPHY

Carducci, Vincent. "Destroy All Monsters." *New Art Examiner*, 22 (April 1995), p. 49.

Kelley, Mike, et al. *Destroy All Monsters: Geisha This, 1975–1979*. New York: Distributed Art Publishers, 1997.

Loren, Cary. "A Manifesto of Ignorance; Destroy All Monsters." *Furious Green Thoughts*, May 1996, www.furious.com/perfect/dam.html.

KEITH EDMIER

Born in Chicago, 1967
Lives in New York

ONE-ARTIST EXHIBITIONS

2000 Neugerriemschneider, Berlin

1998 The Douglas Hyde Gallery, Trinity College, Dublin

Friedrich Petzel Gallery, New York

Metro Pictures, New York

Sadie Coles HQ, London

GROUP EXHIBITIONS

2001 Barbican Gallery, London, "the americans. new art"

Museum of Contemporary Art, Chicago, "Age of Influence: Reflections in the Mirror of American Culture"

2000 P.S.1 Contemporary Art Center/The Museum of Modern Art, Long Island City, New York, "Greater New York: New Art in New York Now"

San Francisco Museum of Modern Art, "Fact/Fiction: Contemporary Art that Walks the Line"

1999 Tate Gallery, London, "Abracadabra"

BIBLIOGRAPHY

DeBord, Matthew. "The Evil That Men Do." *Frieze*, 33 (March–April 1997), pp. 58–59.

Foss, Paul. "Keith Edmier." *Art/Text*, 63 (November 1998–January 1999), pp. 85–86.

Richard, Frances. "Keith Edmier/Richard Phillips." *Artforum*, 38 (April 2000), p. 143.

Smith, Roberta. "Keith Edmier." *The New York Times*, February 27, 1998, p. E38.

Taplin, Robert, "Keith Edmier at Metro Pictures." *Art in America*, 86 (September 1998), pp. 125–26.

TIRTZA EVEN

Born in Jerusalem, 1963
Lives in New York

ONE-ARTIST EXHIBITIONS

2001 Postmasters Gallery, New York

1999 Ami Steinits Gallery, Tel Aviv (with Bosmat Alon)

GROUP EXHIBITIONS

2000 Israel Museum, Jerusalem, "Wish List: Acquisition Proposals in Israeli Art"

1999 Art Focus 3: International Biennial of Contemporary Art, Jerusalem

Kunst-Werke Berlin, "Warten"

SCREENINGS

2001 The First Digital Flaherty Seminar, Rensselaer Polytechnic Institute, Troy, New York

2000 Palermo International Videoart + Film + Media Festival, Italy, "L'Immagine Leggera" (with Bosmat Alon)

VideoArt Festival Locarno, Switzerland (with Bosmat Alon)

1999 "Transmediale 99," Berlin

1998 27th International Film Festival Rotterdam

BIBLIOGRAPHY

"(Documentary) Gallery One: Tirtza Even." *XCP: Cross-Cultural Poetics*, no. 6 (May 2000), pp. 20–31.

Even, Tirtza. "CityQuilt." In *Proceedings of the Third ACM International Conference on Multimedia*. New York: ACM Press, 1995, pp. 279–80.

OMER FAST

Born in Jerusalem, 1972
Lives in New York

GROUP EXHIBITIONS

2001 Bill Maynes Gallery, New York, "Salad Days"

Fabienne Leclerc, Paris, "Affinités Narratives"

Midway Initiative Gallery, Saint Paul, Minnesota, "Weak Architecture"

2000 Momenta Art, Brooklyn, New York, "Omer Fast and Akiko Ichikawa"

P.S. 1 Contemporary Art Center/The Museum of Modern Art, Long Island City, New York, "Some New Minds"

BIBLIOGRAPHY

Cotter, Holland. "Art in Review: Some New Minds." *The New York Times*, February 23, 2001, p. E37.

Johnson, Ken. "Death Race 2000." *The New York Times*, December 22, 2000, p. E46.

Magsamen, Mary. "White Picket Fences." *WaterfrontWeek*, September 2001, www.h2oweek.com/10-18/film.html.

VINCENT FECTEAU

Born in Islip, New York, 1969
Lives in San Francisco

ONE-ARTIST EXHIBITIONS

2000 greengrassi, London

1999 Marc Foxx, Los Angeles

1998 Feature Inc., New York

GROUP EXHIBITIONS

2001 Gallery Paule Anglim, San Francisco, "Vincent Fecteau and Maureen Gallace"

greengrassi, London, "Smallish"

2000 Nexus Contemporary Art Center, Atlanta, "Here Kitty, Kitty"

1999 ANP, Antwerp, Belgium, "B.m.W. black met white"

1998 South London Gallery, London, "Lovecraft"

BIBLIOGRAPHY

Cotter, Holland. "Vincent Fecteau." *The New York Times*, April 17, 1998, p. E39.

Farquharson, Alex. "Vincent Fecteau." *Frieze*, 56 (January–February 2001), pp. 103–4.

Hainley, Bruce. "Vincent Fecteau Talks about His New Sculptures." *Artforum*, 39 (March 2001), pp. 126–27.

—. "Vincent Fecteau." *Artforum*, 37 (September 1998), p. 154.

Iannaccone, Carmine. "Vincent Fecteau at Marc Foxx." *Art Issues*, no. 69 (September–October 1999), p. 48.

KEN FEINGOLD

Born in Pittsburgh, 1952
Lives in New York

ONE-ARTIST EXHIBITIONS

2001 Postmasters Gallery, New York

1999 Postmasters Gallery, New York

GROUP EXHIBITIONS

2001 J. Paul Getty Museum, Los Angeles, "Devices of Wonder: From the World in a Box to Images on a Screen"

Wilhelm Lehmbruck Museum, Duisburg, Germany, "Under the Skin"

2000 Kiasma, Museum of Contemporary Art, Helsinki, Finland, "Alien Intelligence"

The Museum of Modern Art, New York, "Video Time"

1999 ZKM, Center for Art and Media, Karlsruhe, Germany, "net_condition"

BIBLIOGRAPHY

Huhtamo, Erkki. "Surreal-Time Interaction, or How to Talk to a Dummy in a Magnetic Mirror?" In *ArtIntact 3*. Karlsruhe, Germany: ZKM, Center for Art and Media, 1996, pp. 31–55.

Johnson, Ken. "Ken Feingold." *The New York Times*, February 26, 1999, p. E41.

Kusahara, Machiko. "Presence, Absence, and Knowledge in Telerobotic Art." In Ken Goldberg, ed. *The Robot in the Garden*. Cambridge, Massachusetts: MIT Press, 2000, pp. 207–9.

Lebowitz, Cathy. "David Nyzio and Ken Feingold at Postmasters." *Art in America*, 87 (September 1999), pp. 124–25.

Rush, Michael. *New Media in Late 20th-Century Art*. London: Thames & Hudson, 1999, pp. 201–5.

ROBERT FENZ

Born in Ann Arbor, Michigan, 1969
Lives in Los Angeles

SCREENINGS

2001 New York Film Festival,
The Film Society of Lincoln Center

Viennale: Vienna International
Film Festival

2000 The 13th Annual Images Festival of
Independent Film and Video, Toronto

Viennale: Vienna International
Film Festival

1999 37th Ann Arbor Film Festival,
Michigan (traveled)

Anthology Film Archives, New York,
"Personal Selections from the
Filmmakers' Cooperative"

Whitney Museum of American Art,
New York, Part II, 1950–2000, of
"The American Century: Art & Culture
1900–2000"

1998 Black Maria Film and Video Festival:
Seventeenth Annual, New Jersey City
University (organizer), Jersey City
(traveled)

Pacific Film Archive, Berkeley,
California, "Errantry and Purposeful
Travel"

BIBLIOGRAPHY

Fenz, Robert. "Meditations on Revolution,
Part III: Soledad." In *Viennale: Vienna
International Film Festival* (festival catalogue).
Vienna: Viennale, 2001, p. 133.

Hoolboom, Mike. "Meditations on Revolution,
Part I: Lonely Planet." In *The 13th Annual Images
Festival of Independent Film and Video* (festival
catalogue). Toronto: Images Festival, 2000,
p. 19.

Montalvo, Jeanette, and Charles Myron.
"Meditations on Revolution, Part II:
The Space In Between." In *Viennale: Vienna
International Film Festival* (festival catalogue).
Vienna: Viennale, 2000, p. 139.

MARY FLANAGAN

Born in Milwaukee, 1969
Lives in Eugene, Oregon
www.maryflanagan.com

GROUP EXHIBITIONS

2001 Silicon Gallery/The General Store,
Brooklyn, New York, "Here and Now"

Stuttgart Filmwinter Festival for
Expanded Media, Germany, "Special
3D Exhibition"

2000 Central Fine Arts Gallery, New York,
"DIGITAL 2000" (traveled)

Digital Arts & Culture Conference,
Bergen, Norway, "Career Moves"

SIGGRAPH 2000, New Orleans,
"Art Gallery"

BIBLIOGRAPHY

Adelson, Andrea. "Is Anybody Not Out for
E-Billions? Josie True, for One." *The New York
Times*, March 29, 2000, p. H14.

Lichty, Patrick. "The Cybernetics of
Performance and New Media Art." *Leonardo*,
33 (October–November 2000), pp. 351–54.

Montfort, Nick. "Interactive Art: Digital
Decay." *Technology Review*, 103
(January–February 2000), pp. 92–93.

Swift, Pat. "Program Aims to Give Young
Girls Access to Computers." *The Buffalo News*,
October 2, 1999, p. C7.

Swoger, Kate. "True Role Model in
Cyberspace: University Professor Invents Free
Internet Game to Empower Young Girls."
The Montreal Gazette, November 2, 2000.

GLEN FOGEL

Born in Denver, Colorado, 1977
Lives in Brooklyn, New York

SCREENINGS

2001 Film Direkt, Kino im Kunstmuseum,
Bern, Switzerland, "Suspended
Moments" (traveled)

MMK Museum Moderner Kunst/
Postzollamt, Frankfurt, "Project!"

The Museum of Modern Art, New York,
"Big as Life: An American History of
8mm Films"

Ocularis at Galapagos Art &
Performance Space, Brooklyn,
New York, "Sade Stories"

Robert Beck Memorial Cinema,
New York

2000 Exit Art, New York, "International
Super-8"

The Film Society of Lincoln Center,
New York, "Image Innovators:
New Super 8 New York"

Lux Centre, London, "Obscure Love
and Death"

MassArt Film Society, Boston,
"Compact Film New York"

Short Film and Video Festival, GAle
GAtes et al. and the Fourth Annual
D.U.M.B.O. Art Under the Bridge
Festival, Brooklyn, New York

BIBLIOGRAPHY

Halter, Ed. "Super 8 Supersized and Back on
Track in New York Communities." *Indiewire*,
May 3, 2000, www.indiewire.com/film/
festivals/fes_00Super8_000503_wrap.html.

FORCEFIELD

Organized in 1997
Based in Providence, Rhode Island

CORE MEMBERS

Meerk Puffy

Patootie Lobe

Le Geef

Gorgon Radeo

ONE-ARTIST EXHIBITIONS

2001 Parlour Projects, Brooklyn, New York

Space 1026 Gallery and Studios,
Philadelphia

2000 Welsh-Beck Gallery, Echo Park,
California

1999 Space 1026 Gallery and Studios,
Philadelphia (as Fort Thunder)

PERFORMANCES

2001 AS220, Providence, Rhode Island

The Polish National Home, Brooklyn,
New York

The Rotunda, Philadelphia

DISCOGRAPHY

2001 *Assassins*. Providence, Rhode Island:
self-released

Condominium. Providence, Rhode Island:
self-released

1996 *Lightning Bolt/Forcefield* (split 7"").
Providence, Rhode Island: Load
Records

BIBLIOGRAPHY

Maffeo, Lois. "Fort Thunder." *Nest Magazine*,
(Spring 2001), pp. 134–55.

BENJAMIN FRY

Born in Ann Arbor, Michigan, 1975
Lives in Boston
acg.meda.mit.edu/people/fry

GROUP EXHIBITIONS

2001 Ars Electronica Center, Linz, Austria,
"Ars Electronica 2001"

The Museum of Modern Art, New York,
"Workspheres"

2000 Herb Lubalin Study Center of Design
and Typography, The Cooper Union,
New York, "Graduate Student Projects
from the MIT Media Lab Aesthetics +
Computation Group"

SIGGRAPH 2000, New Orleans,
"Art Gallery"

1999 Art Directors Club, New York,
"Organic Information"

BIBLIOGRAPHY

Cannon, Steve. "I.D. Magazine's Forty Under
Thirty: Ben Fry." *I.D. Magazine*, 47
(January–February 2000), pp. 94–95.

Dodge, Martin, and Rob Kitchin. "Mapping
the Web." In *Atlas of Cyberspace*. Harlow, Great
Britain: Pearson Education, 2001, pp. 106–9.

Kahn, Paul, and Krzysztof Lenk. "Conclusions:
Mapping Practice and Experience." In *Mapping
Websites: Digital Media Design*. Crans-Près-
Céligny, Switzerland: RotoVision, 2001, pp.
120–37.

Mau, Bruce. *Life Style*. Edited by Kyo Maclear
with Bart Testa. London: Phaidon Press, 2000,
p. 56.

Sume, David, Loring Leifer, and Richard Saul
Wurman. "Finding Things." In *Information
Anxiety 2*. Indianapolis: Que, 2000, pp. 161–65.

BRIAN FRYE

Born in San Francisco, 1974
Lives in New York

SCREENINGS

2001 Robert Beck Memorial Cinema,
New York, "The Seeds of Cinema"

2000 Sixth Annual International Festival
of Experimental Film and Video Art,
Windsor, Ontario

Pacific Film Archive, Berkeley,
California, "New Century/New
Cinema"

The 46th Robert Flaherty Film
Seminar, Vassar College, Poughkeepsie,
New York

San Francisco Art Institute
8 Millimeter Film Festival

Wisconsin Union Film, Madison,
"Starlight Cinema"

1999 CCAC Institute and San Francisco
Cinematheque, "Consciousness
Cinema: An Art of Its Time"

Eiga Arts, Saga City, Japan,
"L'Etoile au Front"

1998 Chicago Filmmakers, "Pictures of an
Exhibition(ist): Films by Brian Frye"

BIBLIOGRAPHY

Camper, Fred. "Reality in Reverse." *Chicago
Reader*, September 11, 1998, pp. 44–45.

Halter, Ed. "Memorial Cinema." *New York Press*,
December 23–29, 1998, p. 8.

Hoberman, J. "Attack of the Mutants."
The Village Voice, March 14, 2000, pp. 115–20.

Jones, Kirstin. "Closing the American Century:
The Avant-Garde in '99." *Film Comment*, 36
(January–February 2000), pp. 28–29.

Privett, Ray, and James Kreul. "A Cinema of
Possibilities: Brian Frye Interview." *Millennium
Film Journal*, no. 37 (Fall 2001), pp. 27–49.

DAVID GATTEN

Born in Ann Arbor, Michigan, 1971
Lives in Ithaca, New York

SCREENINGS

2001 Images Festival of Independent Film and Video, Toronto

30th International Film Festival Rotterdam

New York Film Festival, The Film Society of Lincoln Center

2000 38th Ann Arbor Film Festival, Michigan (traveled)

New York Film Festival, The Film Society of Lincoln Center

Pacific Film Archive, Berkeley, California, "Correspondences: David Gatten and Luis A. Recoder"

Telluride International Experimental Cinema Exposition, Colorado

1999 Art Gallery of Ontario and Cinematheque Ontario, Toronto, "The Independents"

Impakt Festival, Utrecht, The Netherlands

Whitney Museum of American Art, New York, Part II, 1950–2000, of "The American Century: Art & Culture 1900–2000"

BIBLIOGRAPHY

Gehman, Chris. "Experimental Film in the Nineties: A Survey." *Cinémascope*, no. 2 (Winter 2000), pp. 104–6.

Holden, Stephen. "Marching in the Vanguard." *The New York Times*, October 9, 1999, p. B19

MacDonald, Scott. "L'Envoi." In *The Garden in the Machine: A Field Guide to Independent Films about Place.* Berkeley: University of California Press, 2001, pp. 372–76.

Mijlin, Erika. "Flood Survivors." *F Newsmagazine* (April 1997), p. 13.

Stephens, Maura. "New Professor Goes Fishing...with Film." *Ithaca College Quarterly*, no. 1 (January 2000), pp. 10–11.

JOE GIBBONS

Born in Providence, Rhode Island, 1953
Lives in New York

SCREENINGS

2001 European Media Arts Festival, Osnabrück, Germany

30th International Film Festival Rotterdam

The Museum of Modern Art, New York, "Big as Life: An American History of 8mm Films"

2000 29th International Film Festival Rotterdam

Whitney Museum of American Art, New York, "2000 Biennial Exhibition"

1999 European Media Arts Festival, Osnabrück, Germany

San Francisco Cinematheque

Whitney Museum of American Art, New York, Part II, 1950–2000, of "The American Century: Art & Culture 1900–2000"

1998 Impakt Festival, Utrecht, The Netherlands

New York Video Festival, The Film Society of Lincoln Center

BIBLIOGRAPHY

Gibbons, Joe, Richard Pontius, and Holladay Weiss. "'and THEN what happened???': An Interview with Joe Gibbons." *Motion Picture*, 4 (Summer 1991), pp. 31–35.

Hoberman, J. "Acting Out." *The Village Voice*, October 16, 1984, p. 55.

Holden, Stephen. "Galleries and Greed in an Art-World Satire." *The New York Times*, April 2, 1993, p. C34.

Pruitt, John. "Joe Gibbons' Living in the World." *Motion Picture*, no. 1 (Spring–Summer 1986), pp. 14–15.

Taubin, Amy. "Neither There Nor Here." *The Village Voice*, July 17, 2001, p. 118.

LUIS GISPERT

Born in Jersey City, New Jersey, 1972
Lives in Brooklyn, New York

GROUP EXHIBITIONS

2001 The Bronx Museum of the Arts, New York, "One Planet under a Groove: Hip Hop and Contemporary Art"

NFA Space, Chicago, "It Doesn't Matter if It's True as Long as They Believe It"

2000 Museum of Art, Fort Lauderdale, Florida, "Publikulture: A Social Experiment by Eight Miami Artists"

Museum of Contemporary Art, North Miami, Florida, "Making Art in Miami: Travels in Hyperreality"

Wooster Projects, New York, "Young Miami"

BIBLIOGRAPHY

Cassola, Jose. "Filmmaker's Coming Attractions Are the Whole Show." *The Herald* (Miami), May 9, 1999, p. 18.

Moreno, Gean. "The Present Absent: Eight Artists from Miami." *Art Papers*, 24 (May–June 2000), pp. 39–40.

—. "Miami." *Art Papers*, 23 (November–December 1999), pp. 42–43.

Schlegell, Mark von. "Luis Gispert, Jonathan Horowitz, John Williams." *Art/Text*, no. 73 (May–July 2001), pp. 76–77.

Turner, Gary. "Young Miami." *New York Arts Magazine*, 5 (July–August 2000), p. 15.

GOGOL BORDELLO

Organized in 1999
Based in New York

CORE MEMBERS

Rachel Comey

Eliot Ferguson

Eugene Hütz

Oren Kaplan

Ori Kaplan

Sasha Kazatchkoff

Yuri Lemeshev

Piroshka Racz

Sergei Ryabtsev

PERFORMANCES

2001 Central Park SummerStage, New York

2000 Bowery Ballroom, New York

Fez, New York

Joe's Pub, New York

La MaMa Theatre, New York

Westbeth Theatre Center, New York

1998 Art Space, New York

DISCOGRAPHY

2002 *When the trickster goes a-poking.*
New York: Rubrick Records

1999 *Voi-La Intruder.* New York: Sunken
Bell/Naked Spur Productions

BIBLIOGRAPHY

Buoniconti, Dana. "Bloc Rock." *CMJ
New Music*, no. 88 (December 2000), p. 20.

Kazakina, Katya. "Eastern Bloc Party."
The New York Times, June 25, 2000, p. 9:3.

Shelton, Maeve. "Chernobyl's Loss:
Gogol Bordello." *Privy Magazine*, May 2001,
www.privymagazine.com/gogol_bordello_
interview.html.

—. "Gogol Bordello: Voi-la Intruder." *Privy
Magazine*, May 2001, www.privymagazine.com/
gogol_bordello_review.html.

Wolff, Zoe. "Gogol Bordello." *Time Out
New York*, May 11–18, 2000, p. 129.

JANINE GORDON

Born in Queens, New York, 1966
Lives in Brooklyn, New York

ONE-ARTIST EXHIBITIONS

2001 Refusalon, San Francisco

2000 Xavier LaBoulbenne, New York

1999 ANP, Antwerp, Belgium

1998 ANP, Antwerp, Belgium

GROUP EXHIBITIONS

2001 Gallerym, New York, "Urban Odyssey
2001: Reflections on Urban Culture"

Nikolaj Copenhagen Contemporary
Art Center, Denmark, "Masculinities:
Representations of Men in
Contemporary Art"

Smack Mellon Studios, Brooklyn,
New York, "Peppermint"

Swiss Institute, New York, "Directory"

Whitney Museum of American Art,
New York, "Pollock to Today:
Highlights from the Permanent
Collection"

BIBLIOGRAPHY

Arning, Bill. "Latin Class." *The Village Voice*,
March 5, 1996, pp. 63–64.

Baker, Kenneth. "Janine Gordon at Refusalon."
San Francisco Chronicle, August 18, 2001, p. B4.

Lifson, Ben. "Janine Gordon." *Artforum*, 34
(Summer 1996), p. 111.

Northcross, Wayne. "A Hothouse Mirror of
Masculine Desire." *Lesbian and Gay New York*,
June 29, 2000, p. 30.

Turner, Grady T. "Aperto New York: Ringing
Cash Registers at the Idea Depot." *Flash Art*, 33
(Summer 2000), pp. 57–60.

ALFRED GUZZETTI

Born in Philadelphia, 1942
Lives in Brookline, Massachusetts

SCREENINGS

2001 Harvard Film Archive, "An Evening
with Alfred Guzzetti"

Palermo International Videoart + Film
+ Media Festival, Italy, "L'Immagine
Leggera"

Pandaemonium: Biennial of Moving
Images, London

The Photography Center, Copenhagen,
"Digital Room"

2000 The 13th Annual Dallas Video Festival

Göttingen International Ethnographic
Film Festival, Germany

Margaret Mead Film and Video
Festival, American Museum of Natural
History, New York

New York Video Festival, The Film
Society of Lincoln Center

1999 4ième Manifestation de Vidéo et Art
Electronique, Montreal

1998 European Media Arts Festival,
Osnabrück, Germany

BIBLIOGRAPHY

Askew, Kelly. "Khalfan and Zanzibar."
American Anthropologist, 103 (March 2001),
pp. 189–90.

Canby, Vincent. "Nicaraguans Seen Then
and Now." *The New York Times*, November 5,
1991, p. A11.

Charlip, Julie A., and Charly Bloomquist.
"Pictures from a Revolution." *The American
Historical Review*, 97 (October 1992), p. 1166–68.

Rothman, William. "Alfred Guzzetti's 'Family
Portrait Sittings.'" *Quarterly Review of Film
Studies*, 2 (February 1977), pp. 96–113.

Sutherland, Allan T. "Family Portrait." *Sight
and Sound*, 48 (Winter 1978–79), pp. 29–30.

TRENTON DOYLE HANCOCK

Born in Oklahoma City, 1974
Lives in Houston

ONE-ARTIST EXHIBITIONS

2001 Contemporary Arts Museum, Houston (traveled)

James Cohan Gallery, New York

2000 Dunn and Brown Contemporary, Dallas

1998 Gerald Peters Gallery, Dallas

GROUP EXHIBITIONS

2001 James Cohan Gallery, New York, "The Big Id"

The Studio Museum in Harlem, New York, "Freestyle" (traveled)

2000 Contemporary Arts Museum, Houston, "Out of the Ordinary: New Art from Texas"

Whitney Museum of American Art, New York, "2000 Biennial Exhibition"

1998 Blue Star Art Space, San Antonio, Texas, "Texas Dialogues: Parallels"

BIBLIOGRAPHY

Cotter, Holland. "A Full Studio Museum Show Starts with 28 Young Artists and a Shoehorn." *The New York Times*, May 11, 2001, p. E36.

Johnson, Patricia C. "Boyhood Musings Lend Artist's Works a Sense of Fantasy." *The Houston Chronicle*, September 15, 2001, p. 9.

Mitchell, Charles Dee. "Trenton Doyle Hancock at Gerald Peters." *Art in America*, 86 (November 1998), p. 138.

Newhall, Edith. "This Hamburger's Got Legs." *Art News*, 99 (April 2000), p. 140.

Smith, Roberta. "Trenton Doyle Hancock— 'The Legend is in Trouble.'" *The New York Times*, July 13, 2001, p. E31.

RACHEL HARRISON

Born in New York, 1966
Lives in Brooklyn, New York

ONE-ARTIST EXHIBITIONS

2001 Arndt & Partner, Berlin

Greene Naftali Gallery, New York

1999 Greene Naftali Gallery, New York

GROUP EXHIBITIONS

2001 Audiello Fine Art Inc., New York, "Spiritual America"

2000 Delfina Project Space, London, "New York Projects"

The Museum of Modern Art, New York, "Walker Evans & Company"

P.S. 1 Contemporary Art Center/The Museum of Modern Art, Long Island City, New York, "Greater New York: New Art in New York Now"

1998 The Museum of Modern Art, New York, "New Photography 14"

BIBLIOGRAPHY

Arning, Bill. "The Harrison Effect." *Trans>*, no. 7 (2000), pp. 169–73.

Hunt, David. "Rachel Harrison." *Art/Text*, no. 74 (August–October 2001), pp. 79–80.

Schmerler, Sarah. "Garbage Fan." *Art News*, 98 (September 1999), p. 86.

Schwabsky, Barry. "Rachel Harrison." *Artforum*, 39 (Summer 2001), p. 184.

Smith, Roberta. "Rachel Harrison." *The New York Times*, April 13, 2001, p. E33.

TIM HAWKINSON

Born in San Francisco, 1960
Lives in Los Angeles

ONE-ARTIST EXHIBITIONS

2001 Hirshhorn Museum and Sculpture Garden, Smithsonian Institution, Washington, D.C.

2000 MASS MoCA, North Adams, Massachusetts

The Power Plant, Toronto

1999 Ace Gallery, New York

Akira Ikeda Gallery, Nagoya, Japan

GROUP EXHIBITIONS

2001 Barbican Gallery, London, "the americans. new art"

2000 Serpentine Gallery, London, "The Greenhouse Effect"

1999 48th Venice Biennale

Whitney Museum of American Art at Champion, Stamford, Connecticut, "Zero G: When Gravity Becomes Form"

1998 Carousel, Paris, "Persona"

BIBLIOGRAPHY

Duncan, Michael. "Recycling the Self." *Art in America*, 85 (May 1997), pp. 112–15.

Krauss, Nicole. "Tim Hawkinson at Ace." *Art in America*, 87 (October 1999), pp. 159–60.

Miles, Christopher. "A Thousand Words: Tim Hawkinson Talks About Überorgan." *Artforum*, 39 (September 2000), pp. 152–53.

Miller, Keith. "North Adams, Massachusetts." *Art Papers*, 25 (March–April 2001), p. 45.

Newhouse, Kristina. "Tim Hawkinson: Mechanical Follies." *Sculpture*, 19 (December 2000), pp. 10–11.

ARTURO HERRERA

Born in Caracas, Venezuela, 1959
Lives in New York

ONE-ARTIST EXHIBITIONS

2001 UCLA Hammer Museum, Los Angeles

Whitney Museum of American Art,
New York

2000 ArtPace, A Foundation for
Contemporary Art, San Antonio, Texas

P.S. 1 Contemporary Art Center/
The Museum of Modern Art,
Long Island City, New York

1998 The Art Institute of Chicago

GROUP EXHIBITIONS

2001 Walker Art Center, Minneapolis,
"Painting at the Edge of the World"

2000 The Institute of Contemporary Art,
Boston, "From a Distance: Landscape
in Contemporary Art"

P.S.1 Contemporary Art Center/The
Museum of Modern Art, Long Island
City, New York, "Greater New York:
New Art in New York Now"

1999 Württembergischer Kunstverein
Stuttgart, "Colour Me Blind! Malerei in
Zeiten von Computergame und Comic"
(traveled)

1998 Stephen Friedman Gallery, London,
"Arturo Herrera and Kara Walker"

BIBLIOGRAPHY

Caniglia, Julie. "Arturo Herrera."
Artforum, 39 (January 2001), p. 139.

Dunn, Melissa. "Redrawing the Line."
Flash Art, 33 (October 2000), p. 60.

Helguera, Pablo. "The Edges of the Invisible."
Art Nexus, no. 33 (August–October 1999),
pp. 48–52.

Hixson, Kathryn. "Arturo Herrera."
Flash Art, no. 184 (October 1995), pp. 111–12.

Kamps, Toby. "Arturo Herrera." *New Art
Examiner*, 23 (January 1996), pp. 47–48.

EVAN HOLLOWAY

Born in La Mirada, California, 1967
Lives in Los Angeles

ONE-ARTIST EXHIBITIONS

2001 The Approach, London

Marc Foxx, Los Angeles

1999 Marc Foxx, Los Angeles

GROUP EXHIBITIONS

2001 Barbican Gallery, London,
"the americans. new art"

2000 Kapinos Gallery, Berlin,
"Extraextralarge"

Santa Monica Museum of Art,
California, "Mise-en-Scène:
New LA Sculpture" (traveled)

1999 Gagosian Gallery, Los Angeles,
"Standing Still & Walking in
Los Angeles"

University Art Gallery, University
of California, Irvine, "Play Mode"
(traveled)

BIBLIOGRAPHY

Cooper, Jacqueline. "Evan Holloway." *New Art
Examiner*, 25 (February 1998), pp. 53–54.

Hainley, Bruce. "Towards a Funner Laocoön."
Artforum, 38 (Summer 2000), pp. 166–73.

—. "Evan Holloway." *Artforum*, 36 (January
1998), pp. 106–7.

Intra, Giovanni. "Evan Holloway: When
Bad Attitude Becomes Form." *Art/Text*, 72
(February–April 2001), pp. 52–55.

Pagel, David. "A Few Tests to See How Much
Input the Brain Can Handle." *Los Angeles Times*,
June 8, 2001, p. F22.

DENNIS HOPPER

Born in Dodge City, Kansas, 1936
Lives in Los Angeles

ONE-ARTIST EXHIBITIONS

2001 Stedelijk Museum, Amsterdam

2000 Galerie Thaddeus Ropac, Salzburg,
Austria

MAK Center, Los Angeles

1998 Ansel Adams Center, San Francisco

GROUP EXHIBITIONS

2000 Austin Museum of Art, Texas,
"The New Frontier: Art and Television,
1960–1965"

Harriet and Charles Luckman Fine Arts
Gallery, Los Angeles, "Urban Hymns"

1999 Norton Simon Museum of Art,
Pasadena, California, "Radical Past:
Contemporary Art and Music in
Pasadena, 1960–1974"

1998 The Power Plant, Toronto, "American
Playhouse: The Theatre of Self-
Presentation"

SCREENINGS

1999 Whitney Museum of American Art,
New York, Part II, 1950–2000, of
"The American Century: Art & Culture
1900–2000"

1998 Sundance Film Festival, Park City, Utah

BIBLIOGRAPHY

Bunbury, Stephanie. "No Easy Ride." *Holland
Herald*, 36 (March 2001), pp. 12–14.

Clothier, Peter. "Hip Hopper." *Art News*, 96
(September 1997), pp. 124–27.

Esman, Abigail R. "Dennis Hopper Stars in
Leading Role at the Stedelijk." *Art & Auction*,
23 (February 2001), p. 129.

Hainley, Bruce. "Dennis Hopper." *Artforum*, 36
(October 1997), pp. 105–6.

Hayward, Brooke. "Once Upon a Time in L.A."
Vanity Fair, 493 (September 2001), pp. 384–97.

PETER HUTTON

Born in Detroit, 1944
Lives in Annandale-on-Hudson, New York

ONE-ARTIST EXHIBITIONS

2000 Shoshana Wayne Gallery, Santa
 Monica, California

SCREENINGS

2001 American Museum of the Moving
 Image, Astoria, New York

 George Eastman House, Rochester,
 New York

 30th International Film Festival
 Rotterdam

 New York Film Festival, The Film
 Society of Lincoln Center

 Pacific Film Archive, Berkeley,
 California

 Viennale: Vienna International Film
 Festival

2000 Anthology Film Archives, New York

 New York Film Festival, The Film
 Society of Lincoln Center

1999 Whitney Museum of American Art,
 New York, Part II, 1950–2000, of
 "The American Century: Art & Culture
 1900–2000"

BIBLIOGRAPHY

Gunning, Tom. "The Image and Its Eclipse:
The Films of Peter Hutton." *Spiral*, no. 4
(July 1985), pp. 7–10.

Hoberman, J. "Peter Hutton: A Tale of Two
Cities." *Artforum*, 25 (October 1986), pp. 93–97.

MacDonald, Scott. "Peter Hutton as Luminist."
In *The Garden in the Machine: A Field Guide to
Independent Films about Place*. Berkeley:
University of California Press, 2001,
pp. 273–88.

—. "Peter Hutton." In *A Critical Cinema 3*.
Berkeley: University of California Press, 1998,
pp. 241–52.

Scalapino, Leslie. "Silence and Sound/Text."
In *The Public World/Syntactically Impermanence*.
Middletown, Connecticut, and Hanover,
New Hampshire: Wesleyan University Press
and University Press of New England, 1999,
pp. 29–33.

KEN JACOBS

Born in New York, 1933
Lives in New York

SCREENINGS

2001 American Museum of the Moving
 Image, Astoria, New York

 30th International Film Festival
 Rotterdam

 Lux Centre, London, "Visionaries
 of the Screen"

 Solomon R. Guggenheim Museum,
 New York, "Preserving the Immaterial,
 Conference on Variable Media"

2000 The 44th Regus London Film Festival

 Sundance Channel, "Not Every Picture
 Tells a Story: Classic and
 Contemporary Work from the
 American Underground"

1999 Whitney Museum of American Art,
 New York, Part II, 1950–2000, of
 "The American Century: Art & Culture
 1900–2000"

1998 The Museum of Modern Art, New York,
 "Big as Life: An American History of
 8mm Films"

 New York Film Festival, The Film
 Society of Lincoln Center

 Virginia Film Festival, University of
 Virginia, Charlottesville

BIBLIOGRAPHY

Arthur, Paul. "Creating Spectacle from Dross:
The Chimeric Cinema of Ken Jacobs." *Film
Comment*, 33 (March–April 1997), pp. 58–63.

Brakhage, Stan. "Ken Jacobs." In *Film at Wit's
End: Eight Avant-Garde Filmmakers*. Kingston,
New York: Documentext, 1989, pp. 149–69.

Hampton, Julie. "An Interview with Ken
Jacobs." *Millennium Film Journal*, no. 32–33
(Fall 1998), pp. 131–40.

Jones, Kristin M. "Ken Jacobs." *Artforum*, 35
(February 1997), pp. 90–91.

Sterritt, David. "Who's Running that
Projector?" *Christian Science Monitor*,
November 4, 1993, p. 13.

CHRISTIAN JANKOWSKI

Born in Göttingen, Germany, 1968
Lives in Berlin

ONE-ARTIST EXHIBITIONS

2001 Swiss Institute, New York

2000 De Appel, Amsterdam

 Wadsworth Atheneum, Hartford,
 Connecticut

1999 Kölnischer Kunstverein, Cologne,
 Germany

1998 Portikus, Frankfurt

GROUP EXHIBITIONS

2001 ArtPace, A Foundation for
 Contemporary Art, San Antonio,
 Texas, "[New Works: 01.2]"

 2nd Berlin Biennale

2000 Neuer Aachener Kunstverein, Aachen,
 Germany, "Modell, Modell…"

1999 The Institute of Contemporary Art,
 London, "Crash"

 48th Venice Biennale

BIBLIOGRAPHY

Lapp, Alex. "The Turner Preis?" *Art Monthly*,
no. 242 (December 2000–January 2001),
pp. 12–15.

Smolik, Noemi. "Christian Jankowski."
Artforum, 38 (February 2000), p. 127.

LISA JEVBRATT

Born in Vaxholm, Sweden, 1967
Lives in San Jose, California

GROUP EXHIBITIONS

2000 Iris and B. Gerald Cantor Center for Visual Arts, Stanford University, California, "Refresh: The Art of the Screen Saver"

New Museum of Contemporary Art, New York, "Fresh: The Altoids Curiously Strong Collection 1998–2000"

"Transmediale 2000," Berlin

Walker Art Center, Minneapolis, "Art Entertainment Network"

1999 Ars Electronica Center, Linz, Austria, "Open X"

BIBLIOGRAPHY

Baumgärtel, Tilman. "Webscape." *Flash Art*, 33 (January–February 2000), p. 58.

Dietz, Steve. "Hotlist." *Artforum*, 39 (October 2000), p. 41.

—. "Public and Private in an Age of Dataveillance." *Camerawork: A Journal of Photographic Art*, 26 (Spring–Summer 1999), pp. 14–17.

Goldberg, David. "Mapping the Terrain of Cybersurveillance." *Artweek*, 31 (September 2000), pp. 18–19.

Mirapaul, Matthew. "On This Network, Nothing but Internet Art." *New York Times on the Web*, February 10, 2000, www.nytimes.com/2000/02/10/technology/10artsatlarge.html.

YUN-FEI JI

Born in Beijing, 1963
Lives in Brooklyn, New York

ONE-ARTIST EXHIBITIONS

2001 Pierogi, Brooklyn, New York

GROUP EXHIBITIONS

2001 The Aldrich Museum of Contemporary Art, Ridgefield, Connecticut, "Best of the Season"

The Drawing Center, New York, "Selections"

Palm Beach Institute of Contemporary Art, Florida, "Brooklyn!"

2000 Yerba Buena Center for the Arts, San Francisco, "Multiple Sensations: Series, Collections, Obsessions"

1998 Jack Tilton Gallery, New York, "Yun-Fei Ji, Andrea Dezso, Randy Wray"

BIBLIOGRAPHY

Cotter, Holland. "A Flock of Fledglings, Testing Their Wings." *The New York Times*, August 1, 1997, p. C26.

Shaw, Lytle. "Yun-Fei Ji." *Time Out New York*, June 21–28, 2001, p. 56.

Smith, Roberta. "Yun-Fei Ji." *The New York Times*, June 29, 2001, p. E31.

CHRIS JOHANSON

Born in San Jose, California, 1968
Lives in San Francisco

ONE-ARTIST EXHIBITIONS

2001 Jack Hanley Gallery, San Francisco

UCLA Hammer Museum, Los Angeles

Vedanta Gallery, Chicago

2000 Alleged Galleries, New York

1999 Purple Institute, Paris

GROUP EXHIBITIONS

2001 Deitch Projects, New York, "Widely Unknown"

Institute of Contemporary Art, University of Pennsylvania, Philadelphia, "East Meets West: 'Folk' and Fantasy from the Coasts"

Wendy Cooper Gallery, Madison, Wisconsin, "Chris Johanson and Laura Heyman"

2000 Yerba Buena Center for the Arts, San Francisco, "Extra(Super)Meta"

1998 The Drawing Center, New York, "Selections Summer '98"

BIBLIOGRAPHY

Golonu, Berin. "'Scopic: Magnify the Times' at the San Jose Institute of Contemporary Art." *Artweek*, 31 (February 2000), p. 17.

Knight, Christopher. "Life in the Big City." *Los Angeles Times*, June 15, 2001, p. F26.

Loehr, Cindy. "Chris Johanson." *New Art Examiner*, 28 (May–June 2001), p. 90.

Smith, Roberta. "Chris Johanson." *The New York Times*, April 7, 2000, p. B38.

Yood, James. "Chris Johanson." *Tema Celeste*, no. 84 (March–April 2001), p. 100.

MIRANDA JULY

Born in Barre, Vermont, 1974
Lives in Portland, Oregon

PERFORMANCES

2001 The Institute of Contemporary Art, London

30th International Film Festival Rotterdam

Portland Institute for Contemporary Art, Oregon

2000 The Kitchen, New York

Walker Art Center, Minneapolis

1999 New York Video Festival, The Film Society of Lincoln Center

DISCOGRAPHY

1999 *Girls on Dates* (with IQU) (EP and CD). Olympia, Washington: K Records

1998 *The Binet-Simon Test* (LP and CD). Olympia, Washington: Kill Rock Stars

1997 *Ten Million Hours a Mile* (LP and CD). Olympia, Washington: Kill Rock Stars

1996 *Margie Ruskie Stops Time* (with The Need) (7"). Olympia, Washington: Kill Rock Stars

BIBLIOGRAPHY

Calhoun, Ada. "Performance Artist Miranda July and Her Do-It-Yourself Girl Revolution." *The Austin Chronicle*, September 17, 1999, p. 68.

Chang, Chris. "Renaissance Riot Grrrl Rising." *Film Comment*, 36 (July/August 2000), pp. 16–17.

Gragg, Randy. "Notes From the 'Underground.'" *The Oregonian*, March 23, 2001, p. 57.

Holden, Stephen. "A Thematic Feast of Avant-Garde Videos." *The New York Times*, July 16, 1999, p. E1.

Taubin, Amy. "The 24-Hour Woman." *The Village Voice*, July 6, 1999, p. 70.

YAEL KANAREK

Born in New York, 1967
Lives in New York
www.worldofawe.net

ONE-ARTIST EXHIBITIONS

2001 Moving Image Gallery, New York

GROUP EXHIBITIONS

2001 AIR Gallery, New York, "Technically Engaged"

Kleine Humboldt Galerie, Humboldt Universität, Berlin, "Auf der Suche nach der verloren Kunst"

Moving Image Gallery, New York, "net.ephemera"

VIPER International Festival for Film, Video and New Media, Basel, Switzerland

2000 FILE: Electronic Language International Festival, São Paulo

BIBLIOGRAPHY

Anderson, Lessley. "Selling Out for Art." *The Industry Standard*, August 7, 2000, pp. 108–9.

Jana, Reena. "Net Art With a Groove." *Wired News*, September 27, 2000, www.wired.com/news/culture/0,1284,39063,00.html.

"New Coder of the Week: July 4.2000." *Newcoder.com*, July 4, 2000, www.newcoder.com/coder/coder_070400.shtml.

Perra, Daniele. "Focus On: www.worldofawe.com." *Tema Celeste*, 86 (May–June 2001), p. 28.

Whid, T. "Screen~: It Hurts My Eyes." *Sandbox Magazine*, no. 9 (Summer 2001), pp. 44–45.

MARGARET KILGALLEN

Born in Washington, D.C., 1967
Died 2001

ONE-ARTIST EXHIBITIONS

2000 UCLA Hammer Museum, Los Angeles

1999 Deitch Projects, New York

1998 John Berggruen Gallery, San Francisco

GROUP EXHIBITIONS

2001 Deitch Projects, New York, "Widely Unknown"

Institute of Contemporary Art, University of Pennsylvania, Philadelphia, "East Meets West: 'Folk' and Fantasy from the Coasts"

Los Angeles County Museum of Art, "Made in California: Art, Image, and Identity, 1900–2000"

1999 The Institute of Contemporary Art, Boston, "Frieze"

1998 Forum for Contemporary Art, Saint Louis, Missouri, "On the Wall: Selections from the Drawing Center"

BIBLIOGRAPHY

Cotter, Holland. "Margaret Kilgallen— 'To Friend and Foe.'" *The New York Times*, October 1, 1999, p. E36.

Pepin, Elizabeth. "Freehand: The Art of Margaret Kilgallen." *Juxtapoz*, no. 20 (May–June 1999), pp. 44–48.

Porges, Maria. "Margaret Kilgallen." *Artforum*, 35 (May 1997), pp. 113–14.

Turner, Grady T. "Son of a Guston." *Flash Art*, 32 (January–February 1999), p. 58.

Venus, Rosa. "The Artists in Their Studios: Barry McGee and Margaret Kilgallen." *Flaunt*, March 2000, pp. 132–35.

KIM SOOJA

Born in Taegu, Korea, 1957
Lives in New York

ONE-ARTIST EXHIBITIONS

2001 Kunsthalle Bern, Switzerland

P.S. 1 Contemporary Art Center/
The Museum of Modern Art,
Long Island City, New York

2000 NTT InterCommunication Center,
Tokyo

Rodin Gallery, Seoul

1999 Center for Contemporary Art,
Kitakyushu, Japan

GROUP EXHIBITIONS

2000 Kunsthaus Zürich, Switzerland,
"Hypermental. Rampant Reality
1950–2000: From Salvador Dalí to
Jeff Koons"

1999 Museum Ludwig, Cologne, Germany,
"Art Worlds in Dialogue: Global Art
Rheinland"

48th Venice Biennale

1998 24th São Paulo Biennale

1997 CAPC Musée d'Art Contemporain de
Bordeaux, France, "Cities on the Move"
(traveled)

BIBLIOGRAPHY

Dailey, Meghan. "A Stitch in Time." *Frieze*
(international edition), no. 61 (September
2001), pp. 86–87.

Kim, Airyung. "Soo-Ja Kim: A Solitary
Performance with Old Fabric." In *Echolot*
(exhibition catalogue). Kassel, Germany:
Museum Fridericianum, 1998.

Kim Sooja: A Needle Woman (exhibition
catalogue). Bern, Switzerland: Kunsthalle
Bern, 2001.

Obrist, Hans-Ulrich. "Soo-Ja Kim: Wrapping
Bodies and Souls." *Flash Art*, 30
(January–February 1997), pp. 70–73.

Schwabsky, Barry. "Folds and Loose Threads:
Kim Soo-ja." *Art/Text*, 65 (May–July 1999),
pp. 36–39.

DIANE KITCHEN

Born in Akron, Ohio, 1949
Lives in Brown Deer, Wisconsin

SCREENINGS

2001 23rd Annual Big Muddy Film Festival,
Carbondale, Illinois

11th First Peoples' Festival, Montreal

The 13th Onion City Film and Video
Festival, Chicago

Toronto International Film Festival

2000 38th Ann Arbor Film Festival,
Michigan (traveled)

11th Native American Film & Video
Festival, National Museum of the
American Indian, New York

San Francisco Cinematheque

1999 15th Annual Film Arts Festival of
Independent Cinema, San Francisco

Pacific Film Archive, Berkeley,
California, "Made in the Midwest"

Walker Art Center, Minneapolis, "The
1999 Midwest Film/Video Showcase"

BIBLIOGRAPHY

Hanson, Christian, Catherine Needham,
and Bill Nichols. "Pornography, Ethnography,
and the Discourses of Power." In Bill Nichols,
*Representing Reality: Issues and Concepts in
Documentary*. Bloomington: Indiana University
Press, 1991, pp. 201–28.

McKee, James. "The Endangered Music
Project: Cooperation Brings 'Culturally
Threatened' Music to a Wider Audience."
Library of Congress Information Bulletin, May 31,
1993, pp. 217–22.

JOHN KLIMA

Born in Redondo Beach, California, 1965
Lives in Brooklyn, New York
www.cityarts.com

ONE-ARTIST EXHIBITIONS

2001 Postmasters Gallery, New York

2000 Media Z Lounge, New Museum of
Contemporary Art, New York

1999 Postmasters Gallery, New York

GROUP EXHIBITIONS

2001 P.S. 1 Contemporary Art Center/
The Museum of Modern Art, Long
Island City, New York, "Animations"

VIPER International Festival for Film,
Video and New Media, Basel,
Switzerland

Whitney Museum of American Art,
New York, "BitStreams"

2000 NTT InterCommunication Center,
Tokyo, "New Media, New Faces—
New York"

SIGGRAPH 2000, New Orleans,
"VRML-ART," "Art Gallery," and
"Web3d Roundup"

BIBLIOGRAPHY

Ante, Spencer. "A Digital Artist's Portrait of
Economic Darwinism." *Business Week online*,
June 6, 2001, www.businessweek.com/
technology/content/jun2001/tc2001066_366.htm.

Berwick, Carly. "Predator and Prey: Tech
Artist Puts Viewers in Ultimate Game."
The Village Voice, March 20, 2001, p. 30.

Bodow, Steve. "The Whitney's Digital
Sampler." *New York Magazine*, March 26,
2001, pp. 72–77.

Dixon, Pam. "Breakthrough Artist Hitches
His Rising Star to 3-D Web Art." *San Diego
Union Tribune*, September 10, 2000, p. F4.

Mirapaul, Matthew. "Three-Dimensional
is the New Frontier for the Internet."
The New York Times, October 5, 2000, p. G7.

MARK LAPORE

Born in Tacoma, Washington, 1952
Lives in Chestnut Hill, Massachusetts

SCREENINGS

2001 George Eastman House, Rochester, New York

30th International Film Festival Rotterdam

Pacific Film Archive, Berkeley, California, "Light Spill"

2000 The Museum of Modern Art, New York, "Big as Life: An American History of 8mm Films"

New York Film Festival, The Film Society of Lincoln Center

San Francisco Cinematheque

1999 28th International Film Festival Rotterdam

Whitney Museum of American Art, New York, Part II, 1950–2000, of "The American Century: Art & Culture 1900–2000"

1998 27th International Film Festival Rotterdam

Pandaemonium: The London Festival of Moving Images

BIBLIOGRAPHY

Anker, Steve. "Big as Life." In *Big as Life: An American History of 8mm Films* (exhibition catalogue). San Francisco: Cinematograph, 1998, pp. 4–15.

Armstrong, Alice. "Questions Concerning Documentary Film in Light of Mark LaPore's 'Medina.'" *Cinematograph*, 1 (1985), pp. 92–95.

Arthur, Paul. "The Avant-Garde in '97." *Film Comment*, 34 (January–February 1998), pp. 8–11.

Frye, Brian. "En Garde: 'Views from the Avant-Garde' at the New York Film Festival." *The Independent Film & Video Monthly*, 24 (January–February 2001), pp. 18–19.

Gunning, Tom. "Towards a Minor Cinema." *Motion Picture*, 3 (Winter 1989–90), pp. 2–5.

ROBERT LAZZARINI

Born in Parsippany, New Jersey, 1965
Lives in New York

ONE-ARTIST EXHIBITIONS

2000 Pierogi, Brooklyn, New York

1998 Pierogi 2000, Brooklyn, New York

GROUP EXHIBITIONS

2001 Brent Sikkema Gallery, New York, "Summer 2001"

Whitney Museum of American Art, New York, "BitStreams"

2000 Southeastern Center for Contemporary Art, Winston-Salem, North Carolina, "minutiae"

Yerba Buena Center for the Arts, San Francisco, "Multiple Sensations: Series, Collections, Obsessions"

1998 Stefan Stux Gallery, New York, "Invitational 98"

BIBLIOGRAPHY

Clifford, Katie. "BitStreams." *Art News*, 100 (June 2001), p. 127.

Henry, Max. "Robert Lazzarini." *Tema Celeste*, no. 83 (January–February 2001), pp. 64–65.

Kimmelman, Michael. "Creativity, Digitally Remastered." *The New York Times*, March 23, 2001, pp. E31, E36.

Krauss, Nicole. "Still Life with Phone and Gun." *Art News*, 100 (June 2001), p. 84.

Rosenbaum, Lee. "Tech Art: Boom or Bust?" *The Wall Street Journal*, April 6, 2001, p. W14.

JOHN LEAÑOS

Born in Pomona, California, 1969
Lives in San Francisco

GROUP EXHIBITIONS

2001 Galería de la Raza, San Francisco, "Tecno-Promesas: Putografia Virtual" (with Los Cybrids)

2000 Arte Américas, Fresno, California, "Hecho en Califas: The Last Decade"

Mexican Museum, San Francisco, "Chicanos en Mictlán: Día de los Muertos in California"

Southern Exposure, San Francisco, "Mission Voices 2000"

1999 Oakland Museum of California, Oakland, "El Color de la Muerte: Altars and Offerings for Days of the Dead" (with [Re]Generation)

PERFORMANCES

2001 The LAB, San Francisco, "The Global WarMaquina: The Internet and Its Discontents" (with Los Cybrids)

Lilli Ann mural, San Francisco, "High Sweat Tech Shop" (with Los Cybrids)

San Francisco Museum of Modern Art, "Ultrabaroque: Aspects of Post-Latin American Art" (with Los Cybrids)

2000 Art Strikes Back!, San Francisco, "Ese, the Last Mexican in the Mission District"

City Hall, San Francisco, "Chuy y Luy: Dos Chicanos Yuppies"

BIBLIOGRAPHY

Fricke, Erika. "Writing on the Wall." *San Francisco Bay Guardian*, December 22, 1999, p. 13.

Hamlin, Jesse. "Lively Dead: Oakland Museum Showing Colorful Day of the Dead Folk Art, Traditional and Brand-new." *San Francisco Chronicle*, October 20, 1999, p. D1.

Mieszkowski, Katharine. "Blow Up the Internet!" *Salon.com*, July 24, 2000, www.salon.com/tech/log/2000/07/24/los_cybrids/index.html.

Nowinski, Amanda. "Culture Crash." *San Francisco Bay Guardian*, July 12–18, 2000, cover.

MARGOT LOVEJOY

Born in Campbellton, New Brunswick, 1930
Lives in Queens, New York

ONE-ARTIST EXHIBITIONS

2001 The Phillips Museum of Art, Franklin
and Marshall College, Lancaster,
Pennsylvania

2000 Stephen Gang Gallery, New York
(with Miles Dudgeon)

1998 Arizona State University Art Museum,
Tempe (with Miles Dudgeon)

1997 Neuberger Museum of Art, Purchase
College, SUNY, New York

GROUP EXHIBITIONS

2001 Institute of Contemporary Arts,
Taipei, Taiwan, "The Gravity of the
Immaterial"

Masters of Graphic Arts Biennial,
Győr, Hungary

1999 Islip Art Museum, East Islip, New York,
"Site Specifics"

The San Francisco Center for the Book,
"Back East: Artists' Books from the
Northeastern States"

1998 The American Federation of Arts,
New York (organizer), "Artist/Author:
Contemporary Artists' Books"

Islip Art Museum, East Islip, New York,
"Site Specifics"

BIBLIOGRAPHY

Braff, Phyllis. "Social Issues Fused with
Technology." *The New York Times* (Long Island
edition), March 23, 1997, p. 13:14.

Drucker, Johanna. "The Book as Sequence:
Narrative and Non-Narrative." In *The Century of
Artists' Books*. New York: Granary Books, 1995,
p. 258.

Harrison, Helen A. "Back to the Future, as
Seen by a 'Black Box.'" *The New York Times*
(Long Island edition), April 12, 1992, p. 12:15.

Hubert, Judd D., and Renée Riese Hubert.
"The Book, the Museum, and Public Art."
In *The Cutting Edge of Reading: Artists' Books*.
New York: Granary Books, 1999, pp. 140–45.

Russo, Catherine J. "Received and Noted:
Paradoxic Mutations." *Afterimage*, 22 (October
1994), p. 11.

VERA LUTTER

Born in Kaiserslautern, Germany, 1960
Lives in New York

ONE-ARTIST EXHIBITIONS

2001 Kunsthalle Basel, Switzerland

2000 Fraenkel Gallery, San Francisco

1998 Wooster Gardens, New York

GROUP EXHIBITIONS

2001 Whitney Museum of American Art,
New York, "What's New: Recent
Acquisitions in Photography"

2000 Andrew Kreps Gallery, New York,
"Photography About Photography"

The Museum of the City of New York,
"New York Now"

1999 Dia Center for the Arts, New York,
"Time Traced: Rodney Graham and
Vera Lutter"

Middlebury College Museum of Art,
Vermont, "The Big Picture: Large
Format Photography"

BIBLIOGRAPHY

Baker, Kenneth. "Lutter Illuminates Bleak
Landscapes/Camera Obscura Photographs."
San Francisco Chronicle, April 8, 2000, p. B1.

Fergussen, Russell. *Vera Lutter* (exhibition
catalogue). Basel, Switzerland: Kunsthalle
Basel, 2001.

Hammond, Anna. "Vera Lutter at Dia Center
for the Arts." *Art in America*, 88 (September
2000), pp. 144–45.

Ho, Cathy Lang. "Picture Window."
Architecture, 89 (March 2000), pp. 80–81.

Holliday, Taylor. "Vera Lutter." *Art News*, 98
(January 1999), p. 127.

CHRISTIAN MARCLAY

Born in San Rafael, California, 1955
Lives in New York

ONE-ARTIST EXHIBITIONS

2001 Museum of Contemporary Art, Chicago

Paula Cooper Gallery, New York

Saint Louis Art Museum, Missouri

2000 New Museum of Contemporary Art,
New York

1999 ArtPace, A Foundation for
Contemporary Art, San Antonio, Texas

GROUP EXHIBITIONS

2001 The Aldrich Museum of Contemporary
Art, Ridgefield, Connecticut, "Best of
the Season"

Whitney Museum of American Art,
New York, "In Sync: Cinema and Sound
in the Work of Julie Becker and
Christian Marclay"

2000 Centre Georges Pompidou, Paris,
"Le temps, vite!"

Centre International d'Art
Contemporain de Montréal,
"La Biennale de Montréal"

1999 Museum of Modern Art, Oxford,
England, "Notorious: Alfred Hitchcock
and Contemporary Art"

BIBLIOGRAPHY

Aukeman, Anastasia. "Christian Marclay at
Paula Cooper." *Art in America*, 89 (September
2001), p. 147.

Diehl, Carol. "Christian Marclay at Paula
Cooper." *Art in America*, 88 (June 2000), p. 128.

Goldberg, RoseLee. "Christian Marclay."
Artforum, 39 (April 2001), p. 138.

Levin, Thomas Y. "Indexicality Concrète:
The Aesthetic Politics of Christian Marclay's
Gramophonia." *Parkett*, no. 56 (1999),
pp. 162–69.

Tallman, Susan. "Always This Tüdelditüt:
Christian Marclay's 'Graffiti Composition.'"
Art on Paper, 5 (July–August 2000), pp. 28–33.

ARI MARCOPOULOS

Born in Amsterdam, 1957
Lives in Sonoma, California

ONE-ARTIST EXHIBITIONS

2001 Alleged Galleries, New York

 The Deep Gallery, Tokyo

 Partobject Gallery, Carrboro,
 North Carolina

GROUP EXHIBITIONS

2001 303 Gallery, New York, "Overnight
 to Many Cities"

2000 Gavin Brown's Enterprise Corp.,
 New York, "A Beastie Boys Exhibition"

1999 Alleged Galleries, New York,
 "Coup d'État"

SCREENINGS

2000 Museum of Fine Arts, Houston

 The Museum of Modern Art, New York,
 "New Documentaries"

1999 911 Media Arts Center, Seattle,
 "Captain Powder: Exploring the
 Snow Sport Genre"

 San Francisco Film Society,
 42nd San Francisco International
 Film Festival

BIBLIOGRAPHY

Cortez, Diego, ed. *Transitions and Exits.*
New York: powerHouse Books, 2000.

Marcopoulos, Ari. *Pass the Mic: Beastie Boys
1991–1996.* New York: powerHouse Books,
2001.

—. *Portraits from the Studio and the Street.*
Amsterdam: Bert Bakker, 1998.

BRUCE MCCLURE

Born in Washington, D.C., 1959
Lives in Brooklyn, New York

SCREENINGS

2000 CEC International Partners and
 Anthology Film Archives, New York,
 "Avant-Garde Alternatives: The
 Evolution of American Experimental
 Film" (traveled)

 Chicago Filmmakers, Columbia
 College, Chicago, "Beyond the Circle
 of Confusion"

 DEAF_00, Dutch Electronic Art
 Festival, Rotterdam

 Exit Art, New York, "Conspiracies"

 The Film Society of Lincoln Center,
 New York, "Image Innovators:
 New Super 8 New York"

 Lugaritz Kultur Etexa, Danostia and
 La Enana Marron, Madrid, Spain,
 "Zine Animau"

 Robert Beck Memorial Cinema,
 New York, "Bruce McClure: Three
 Frame Manifesto"

 San Francisco Cinematheque,
 "From Cine-povera to Cine-spolverare:
 Sound Film Propositions"

1999 Non Sequitur Festival, Composers'
 Collaborative and Here, New York,
 "Where Wavelengths Meet"

 SUNY Binghamton, New York,
 "Abstracted Material: Along a Line
 or In a Circle"

BIBLIOGRAPHY

Halter, Ed. "Super 8 Supersized and Back on
Track in New York Communities." *Indiewire*,
May 3, 2000, www.indiewire.com/film/
festivals/fes_00Super8_000503_wrap.html.

CONOR MCGRADY

Born in Downpatrick, Northern Ireland, 1970
Lives in Chicago

ONE-ARTIST EXHIBITIONS

2000 Contemporary Art Workshop, Chicago

 Féile an Phobail, Belfast, Northern
 Ireland

 NFA Space, Chicago

GROUP EXHIBITIONS

2001 Beacon Street Gallery, Chicago,
 "There Goes my Hero"

2000 CEPA Gallery, Buffalo, New York,
 "Unlimited Partnerships Part II:
 Culture & Conflict"

1999 Glass Curtain Gallery, Chicago,
 "Agitator"

1998 Angel Orensanz Foundation for the
 Arts, New York, "Binlids: Culture &
 Conflict"

 Gallery 2, Chicago, "G2 Group Show"

BIBLIOGRAPHY

Mutscheller, Charles. "Conflicted Views,
Part 2: NFA Space." *New Art Examiner*, 28
(November 2000), p. 52.

Trubow, Alan. "Agitator Exhibit at Glass
Curtain Gallery." *Columbia Chronicle Online*,
33, March 13, 2000, www.ccchronicle.com/
back/00mar13/ae4.html.

MEREDITH MONK

Born in New York, 1942
Lives in New York

ONE-ARTIST EXHIBITIONS

1999 Frederieke Taylor TZ'Art, New York

PERFORMANCES

2001 Archa Theatre, Prague

Hermitage Theater, St. Petersburg

Wexner Center for the Arts, Columbus, Ohio

2000 Davies Symphony Hall, San Francisco

Lincoln Center Festival, New York

Novel Hall, Taipei, Taiwan

DISCOGRAPHY

1997 *Volcano Songs.* New York: ECM

1996 *Monk and the Abbess: The Music of Meredith Monk and Hildegard von Bingen.* New York: BMG/Catalyst

1993 *Atlas: an opera in three parts.* Munich: ECM

BIBLIOGRAPHY

Anderson, Jack. "Mysteries of Life, In Images and Music." *The New York Times*, July 23, 2001, p. E5.

Goldberg, RoseLee. "Meredith Monk: Joyce Theater." *Artforum*, 38 (April 2000), p. 144.

Kosman, Joshua. "Mavericks of All Stripes." *San Francisco Chronicle*, June 12, 2000, p. D1.

Moody, Rick. "Heroes: Meredith Monk." *Men's Journal*, 10 (May 2001), p. 107.

Scherr, Apollinaire. "Keeping Two Talents in Balance." *The New York Times*, July 15, 2001, p. 2:4.

Swed, Mark. "The Wonder of 'Magic Frequencies.'" *Los Angeles Times*, February 29, 2000, p. F1.

JULIE MOOS

Born in Ottawa, Ontario, 1965
Lives in Birmingham, Alabama

ONE-ARTIST EXHIBITIONS

2001 Fredericks Freiser Gallery, New York

2000 Cabaniss Fine Arts Center, The Altamont School, Birmingham, Alabama

Fredericks Freiser Gallery, New York

1999 Marcia Wood Gallery, Atlanta

1998 Clayton Staples Gallery, Wichita State University, Kansas

GROUP EXHIBITIONS

2001 Contemporary Arts Center, New Orleans, "Chelsea Rising"

Jan Weiner Gallery, Kansas City, Missouri, "Full Frontal"

2000 Exit Art, New York, "Collector's Choice"

1999 Sable-Castelli Gallery, Toronto, "Marianna Gartner, Maja Kulenovic, Julie Moos"

1998 Twenty First Street Studios, Birmingham, Alabama, "Void"

BIBLIOGRAPHY

Coman, Victoria L. "Facing the Future." *The Birmingham News*, January 12, 2000, p. 1S.

Johnson, Ken. "Julie Moos." *The New York Times*, October 6, 2000, p. E40.

Norman, Bud. "From Behind the Photographer's Eye." *The Wichita Eagle*, March 15, 1998, pp. 1D, 6D.

Thorson, Alice. "Challenging Beauty." *The Kansas City Star*, April 13, 2001, pp. 28–29.

Wiegand, Susan. "Photography and the Human." *Review*, April 2001, p. 40.

TRACIE MORRIS

Born in Brooklyn, New York
Lives in Brooklyn, New York

PERFORMANCES

2001 Centre for Creative Arts, University of Natal, Durban, South Africa

Kelly Writers House, University of Pennsylvania, Philadelphia

Lincoln Center Out of Doors, New York

MASS MoCA, North Adams, Massachusetts

Steppenwolf Theater, Chicago

2000 BAM Café, Brooklyn Academy of Music, New York

Celebrate Brooklyn!, Prospect Park

1999 The Kitchen, New York

DISCOGRAPHY

2000 Uri Caine Ensemble, *The Goldberg Variations.* Munich: Winter & Winter

Our Souls Have Grown Deep Like the Rivers: Black Poets Read Their Work (compilation). Los Angeles: Rhino Records

BIBLIOGRAPHY

Goodman, Peter. "Poetry in Motion: Manhattan is a Poetry Corner for all Bards This Weekend." *Newsday*, March 30, 2001, p. B13.

Johnson, Martin. "NYC Nights/Well-Versed in the Art of Making Poetic Music." *Newsday*, August 12, 1999, p. 5.

Pareles, John. "A Steamy Mix of Poetry, Afrocentric Themes and Love." *The New York Times*, December 18, 1999, p. B20.

Sachs, Lloyd. "'LA/CHI/NY' at Steppenwolf Theater." *Chicago Sun-Times*, February 28, 2001, p. 48.

Sengupta, Somini. "A Hip-Hop Poet Looks Beyond Her Roots." *The New York Times*, February 1, 1998, p. 2:46.

MARK NAPIER

Born in Springfield, New Jersey, 1961
Lives in New York
www.potatoland.org

GROUP EXHIBITIONS

2001 San Francisco Museum of Modern Art,
 "010101: Art in Technological Times"
 (online)

 Whitney Museum of American Art,
 New York, "Data Dynamics"

2000 Walker Art Center, Minneapolis,
 "Art Entertainment Network"

 ZKM, Center for Art and Media,
 Karlsruhe, Germany, "Der
 anagrammatische Körper"

1999 ZKM, Center for Art and Media,
 Karlsruhe, Germany, "net_condition"

BIBLIOGRAPHY

Atkins, Robert. "Surface Pleasures." *Artbyte*,
4 (June 2001), pp. 66–68.

Greene, Rachel. "Web Work: A History
of Internet Art." *Artforum*, 38 (May 2000),
pp. 162–67, 190.

Helfand, Glen. "Words and Pictures:
Potatoland and Turnstile II Turn Them Inside
Out." *SF Gate*, July 22, 1999, www.sfgate.com/
cgi-bin/article.cgi?file=/technology/archive/
1999/07/22/transgressive.dtl.

Ippolito, John. "Should Some Code Be
Censored?" *Artbyte*, 2 (January–February 2000),
pp. 28–29.

Spingarn-Koff, Jason. "A Full-Scale Fete for Net
Art." *Wired News*, July 29, 2000, www.wired.com/
news/culture/0,1284,3761,00.html.

ROBERT NIDEFFER

Born in Ventura, California, 1964
Lives in Los Angeles
proxy.arts.uci.edu/~nideffer

GROUP EXHIBITIONS

2000 Arizona State University Art Museum,
 Tempe, "Digital Secrets: New
 Collaborations in Visual Art and
 Technology"

 Axis Foundation for Art and Gender,
 Amsterdam, "Gameshow"

 Kiasma, Museum of Contemporary Art,
 Helsinki, Finland, "Alien Intelligence"
 (online)

1999 "Cracking the Maze: Game Plug-ins
 and Patches as Hacker Art,"
 switch.sjsu.edu/CrackingtheMaze/

 MECAD, Media Centre of Art & Design,
 Sabadell-Barcelona, Spain, "Second
 International CD-ROM Art Show"

BIBLIOGRAPHY

Chang, Richard. "From the Arcade to the Art
Gallery: Playing with an Art Form." *The Orange
County Register*, October 17, 2000, p. 4.

Johansson, Catrine. "Exploring UCI's Outer
Limits." *Irvine Spectrum News*, October 23, 2000.

Letran, Vivian. "Getting Digitized for Their
Arts' Sake." *Los Angeles Times* (Orange County
edition), October 17, 2000, pp. B1, B4.

—. "UCI's New Digital Show Puts You in
'Shift-CTRL.'" *Los Angeles Times* (Orange County
edition), October 17, 2000, p. B8.

Muchnic, Suzanne. "Art & Architecture:
The Festival That Defies Description."
Los Angeles Times, Sunday Calendar, November
5, 2000, pp. 56–57.

ANDREW NOREN

Born in Santa Fe, New Mexico, 1943
Lives in Holmdel, New Jersey

SCREENINGS

2001 Centre Georges Pompidou, Paris

 Cinematheque Ontario, Toronto

 George Eastman House, Rochester,
 New York

 New York Film Festival, The Film
 Society of Lincoln Center

 The University of Wisconsin,
 Milwaukee

1999 Whitney Museum of American Art,
 New York, Part II, 1950–2000, of
 "The American Century: Art & Culture
 1900–2000"

BIBLIOGRAPHY

Camhi, Gail. "The Films of Andrew Noren."
Film Culture, no. 70–71 (1983), pp. 100–112.

Elder, R. Bruce. "The Pneumatic Body:
The Films of Andrew Noren." In *Body of Vision:
Representations of the Body in Recent Film and
Poetry*. Waterloo, Ontario: Wilfrid Laurier
University Press, 1997, pp. 316–50.

MacDonald, Scott. "Andrew Noren."
In *A Critical Cinema 2*. Berkeley: University
of California Press, 1992, pp. 175–205.

—. "Illuminations: An Interview with
Andrew Noren." *Film Quarterly*, 44 (Spring
1991), pp. 30–43.

Pruitt, John. "Metamorphosis: Andrew
Noren's *The Lighted Field*." *Cinematrix*, 1
(Winter 1999), pp. 5–8.

JOSH ON

Born in Christchurch, New Zealand, 1972
Lives in San Francisco

GROUP EXHIBITIONS

2001 Deitch Projects, New York,
 "Tirana Biennale"

 IdN Fresh Conference, Sydney,
 Australia

 The Office Gallery, San Francisco,
 "La Perruque (The Wig)"

 Spiral Gallery, Los Angeles,
 "The T-Shirt Show"

2000 Royal College of Art, London,
 "The Show 2000"

BIBLIOGRAPHY

Coupland, Ken. "Screen Space." *Metropolis*, 21
(November 2001), p. 126.

ROXY PAINE

Born in New York, 1966
Lives in New York

ONE-ARTIST EXHIBITIONS

2001 Galerie Thomas Schulte, Berlin

 Grand Arts, Kansas City, Missouri

 James Cohan Gallery, New York

1999 Ronald Feldman Fine Arts, New York

1998 Musée d'Art Américain, Giverny,
 France (traveled)

GROUP EXHIBITIONS

2001 Palm Beach Institute of Contemporary
 Art, Florida, "Brooklyn!"

 San Francisco Museum of Modern Art,
 "010101: Art in Technological Times"

2000 The Institute of Contemporary Art,
 Boston, "From a Distance: Landscape
 in Contemporary Art"

 P.S. 1 Contemporary Art Center/The
 Museum of Modern Art, Long Island
 City, New York, "Greater New York:
 New Art in New York Now"

1999 Brooklyn Museum of Art, New York,
 "Working in Brooklyn: Beyond
 Technology"

BIBLIOGRAPHY

Iannaccone, Carmine. "Roxy Paine." *Frieze*,
61 (September 2001), pp. 93–94.

Johnson, Ken. "Roxy Paine." *The New York
Times*, January 15, 1999, p. E42.

Klein, Mason. "Roxy Paine." *Artforum*, 37
(April 1999), p. 123.

Landi, Ann. "The Big Dipper." *Art News*, 100
(January 2001), pp. 136–39.

Nahas, Dominique. "Roxy Paine." *Flash Art*,
32 (May–June 1999), pp. 114–15.

HIRSCH PERLMAN

Born in Chicago, 1960
Lives in Los Angeles

ONE-ARTIST EXHIBITIONS

2001 Blum & Poe, Santa Monica, California

1997 Friedrich Petzel Gallery, New York

GROUP EXHIBITIONS

2001 Museum of Contemporary Art,
 Chicago, "No Harm in Looking"

2000 Stadtforum, Munich, "Sprache—
 Identität—Europa"

1999 Gallery 400, University of Illinois,
 Chicago, "Hello Mr. Soul"

 Von der Heydt-Museum, Wuppertal,
 Germany, "Talk Show" (traveled)

BIBLIOGRAPHY

Frank, Peter. "Martin Kersels, Hirsch
Perlman." *L.A. Weekly*, April 13–19, 2001,
p. 179.

Hapgood, Susan. "Hirsch Perlman at the
Museum of Modern Art." *Art in America*, 85
(January 1997), p. 99.

Iannaccone, Carmine. "Hirsch Perlman." *Art
Issues*, no. 69 (September–October 2001), p. 52.

Kravagna, Christian. "Hirsch Perlman."
Artforum, 34 (May 1996), pp. 111–12.

Pagel, David. "A Tragicomic Yet Hilarious
Drama With Hirsch Perlman's Compelling
Characters." *Los Angeles Times*, April 13, 2001,
p. F28.

LEIGHTON PIERCE

Born in Rochester, New York, 1954
Lives in Iowa City, Iowa

SCREENINGS

2001 European Media Arts Festival,
Osnabrück, Germany

30th International Film Festival
Rotterdam

San Francisco Film Society, 44th
San Francisco International Film Festival

Toronto International Film Festival

2000 Black Maria Film and Video Festival:
Nineteenth Annual, New Jersey City
University (organizer), Jersey City
(traveled)

The 13th Annual Images Festival of
Independent Film and Video, Toronto

Impakt Festival, Utrecht,
The Netherlands

1999 Walker Art Center, Minneapolis,
"1999 Midwest Film/Video Showcase"

Whitney Museum of American Art,
New York, Part II, 1950–2000, of
"The American Century: Art & Culture
1900–2000"

1998 36th Ann Arbor Film Festival,
Michigan (traveled)

BIBLIOGRAPHY

Anker, Steve, Irina Leimbacher, and David
Sherman. *Consciousness Cinema: An Art of Its
Time* (exhibition catalogue). San Francisco:
CCAC Institute and San Francisco
Cinematheque, 1999.

MacDonald, Scott. "Transcendental
Domesticity: Leighton Pierce." *Independent
Film and Videomakers Monthly*, 22 (July 1999),
pp. 32–35.

Smith, Gavin. "Best of '98: Moments Out
of Time." *Film Comment*, 35 (January–February
1999), pp. 32–38.

Williams, Cam. "Being and Nothingness."
Afterimage, 25 (November–December 1997),
p. 15.

WILLIAM POPE.L

Born in Newark, New Jersey, 1955
Lives in Lewiston, Maine

ONE-ARTIST EXHIBITIONS

2001 The Project, New York

2000 VAV Gallery, Concordia University,
Montreal

1998 The Project, New York

GROUP EXHIBITIONS

2001 Palm Beach Institute of Contemporary
Art, Florida, "Video Jam"

1998 Museum of Contemporary Art,
Los Angeles, "Out of Actions:
Between Performance and the Object
1949–1979"

PERFORMANCES

2001 Yoyogi Park, Shibuya, Tokyo

2000 School of the Museum of Fine Arts,
Boston

SculptureCenter, New York

Thread Waxing Space, New York

1999 Postmasters Gallery, New York

BIBLIOGRAPHY

Carr, C. "The Generation Gap." *The Village
Voice*, July 18, 2000, p. 55.

—. "Some Kind of Protest." *The Village Voice*,
March 4, 1997, p. 52.

Cotter, Holland. "William Pope.L."
The New York Times, June 8, 2001, p. E31.

Lieberman, Claire. "That Food Thing You Do."
Sculpture, 19 (December 2000), pp. 46–53.

Pope.L, William. "Notes on Crawling Piece."
Art Journal, 56 (Winter 1997), pp. 65–66.

PRAXIS
(DELIA BAJO AND BRAINARD CAREY)

Organized in 1999
Based in New York

Delia Bajo
Born in Madrid, 1972

Brainard Carey
Born in New York, 1963

PERFORMANCES

2001 P.S. 1 Contemporary Art Center/
The Museum of Modern Art,
Long Island City, New York

1999 Rotunda Gallery, Brooklyn, New York

BIBLIOGRAPHY

"Playing in the Neighborhood." *The New York
Times*, October 17, 1999, p. 14:15.

Miller, Sara B. "Feet Get Washed; Hugs
Are Given: Is This Art?" *Brooklyn Daily Eagle*,
September 22, 1999, p. 13.

SETH PRICE

Born in East Jerusalem, 1973
Lives in Long Island City, New York

GROUP EXHIBITIONS

2001 Stefan Stux Gallery, New York

SCREENINGS

2001 9ᵉ Biennale de l'image en mouvement, Centre pour l'image contemporaine, Geneva, Switzerland

"Boxhead Ensemble: Stories, Maps and Notes from the Half Light" (traveled)

30th International Film Festival Rotterdam

The Museum of Modern Art, New York, "Video Viewpoints"

Palm Beach Institute of Contemporary Art, Florida, "Video Jam"

2000 Impakt Festival, Utrecht, The Netherlands

29th International Film Festival Rotterdam

"Transmediale 2000," Berlin

1998 New York Video Festival, The Film Society of Lincoln Center

BIBLIOGRAPHY

Plante, Mike. "American Graffity." *Cinemad*, no. 5 (2001), p. 51.

Smith, Gavin. "Best of '98." *Film Comment*, 35 (January–February 1999), p. 31.

WALID RA'AD / THE ATLAS GROUP

Born in Chbanieh, Lebanon, 1967
Lives in Brooklyn, New York

GROUP EXHIBITIONS

2001 b-space.be, Kunsten Festival des Arts, Brussels

CEPA Gallery, Buffalo, New York, "Paradise in Search of a Future"

Wiener Festwochen, Vienna, "Du Bist Die Welt"

ZKM, Center for Art and Media, Karlsruhe, Germany, "Rhetorics of Surveillance from Bentham to Big Brother"

2000 Kunst-Werke Berlin, "The State of Things"

PERFORMANCES

2001 9ᵉ Biennale de l'image en mouvement, Centre pour l'image contemporaine, Geneva, Switzerland

Kunsten Festival des Arts, Brussels

Leipzig University, Germany

Palais des Beaux-Arts, Brussels

Wiener Festwochen, Vienna

BIBLIOGRAPHY

Marks, Laura U. *The Skin of the Film*. Durham, North Carolina: Duke University Press, 1999.

Naficy, Hamid. *An Accented Cinema: Exilic and Diasporic Filmmaking*. Princeton, New Jersey: Princeton University Press, 2001, p. 104.

Quilty, Jim. "Hysterically Authentic: Lebanese-American Research Group Takes Different Approach to History of Civil War." *The Daily Star* (Beirut), December 15, 2000, n.p.

LUIS RECODER

Born in San Francisco, 1971
Lives in New York

SCREENINGS

2001 Anthology Film Archives, New York

Cornell Cinema, Cornell University, Ithaca, New York, "Liminal Lumen"

Pacific Film Archive, Berkeley, California, "Correspondences: David Gatten and Luis A. Recoder"

2000 29th International Film Festival Rotterdam

International Film Series, University of Colorado, Boulder, "First Person Cinema"

Viennale: Vienna International Film Festival

1999 The Film Society of Lincoln Center, New York, "Image Innovators: The Poetics of Interference"

Robert Beck Memorial Cinema, New York, "Opticka Res Extensa"

San Francisco Cinematheque

Whitney Museum of American Art, New York, Part II, 1950–2000, of "The American Century: Art & Culture 1900–2000"

BIBLIOGRAPHY

Anker, Steve, Irina Leimbacher, and David Sherman. *Consciousness Cinema: An Art of Its Time* (exhibition catalogue). San Francisco: CCAC Institute and San Francisco Cinematheque, 1999, p. 17.

Camper, Fred. "Onion City Film Festival." *Chicago Reader*, September 14, 2001, p. 16.

Jones, Kirstin. "Closing the American Century: The Avant-Garde in '99." *Film Comment*, 36 (January–February 2000), pp. 28–29.

ERWIN REDL

Born in Gföhl, Austria, 1963
Lives in New York

ONE-ARTIST EXHIBITIONS

2001 Florence Lynch Gallery, New York

2000 Galerie Stadtpark, Krems, Austria

1999 Apex Art, New York

Courtney Gallery, New Jersey City University, Jersey City

1998 Austrian Cultural Institute, New York

GROUP EXHIBITIONS

2001 Creative Time, Brooklyn Bridge Anchorage, New York, "Massless Medium: Explorations in Sensory Immersion"

Cummings Art Galleries, Connecticut College, New London, "Lights, Camera, Action"

2000 Klosterneuburg, Austria, "Essl Collection—Contemporary Art"

1999 Art & Idea, Mexico City, "Punto Ciego"

1998 P.S. 1 Contemporary Art Center, Long Island City, New York, "Wish You Luck"

BIBLIOGRAPHY

Jusidman, Yishai. "Espectro de Luz." *Poliester*, 8 (Fall 1999), p. 53.

Smith, Roberta. "Massless Medium: Explorations in Sensory Immersion." *The New York Times*, July 20, 2001, p. 34.

MARINA ROSENFELD

Born in New York, 1968
Lives in Brooklyn, New York

PERFORMANCES

2001 Tonic, New York

Whitney Museum of American Art at Philip Morris, New York

2000 Ars Electronica Center, Linz, Austria, "Ars Electronica 2000"

Pro Musica Nova, Bremen, Germany

1999 Musikprotokoll im Steirischen Herbst, Graz, Austria

DISCOGRAPHY

2001 *BitStreams* (compilation). New York and Amsterdam: Whitney Museum of American Art and JDK Productions

City at the Edge of the 21st Century: A 2001 Collection (compilation). New York: Harvestworks

the sheer frost orchestra—Drop, Hop, Drone, Scratch, Slide & A for Anything. Vienna: Charhizma

1999 *theforestthegardenthesea: music from fragment opera.* Vienna: Charhizma

theheavens(fragment)1999 (7"). San Francisco: Yerba Buena Center for the Arts

BIBLIOGRAPHY

Cox, Christoph. "Marina Rosenfeld: Gender War at 33 and a Third." *The Wire*, no. 213 (November 2001), p. 10.

Gershman, Gil. "Marina Rosenfeld: One Good Turn Deserves Another." *Signal to Noise*, no. 21 (Spring 2001), p. 13.

Klopotek, Felix. "Marina Rosenfeld." *Spex*, no. 227 (October 1999), p. 8.

Powers, Ann. "Marina Rosenfeld: Note by Note, A Manicure." *The New York Times*, April 28, 2001, p. B15.

Scheib, Christian. "Disconcertingly Beautiful: Marina Rosenfeld." *SKUG: Journal für Musik und Positionnen*, no. 42 (June 2000), pp. 38–39.

THE RURAL STUDIO

Founded in 1993 under the direction of Samuel Mockbee, FAIA, at Auburn University
Based in Hale County, Alabama

EXHIBITIONS

2001 Contemporary Arts Center, Cincinnati

2000 Max Protetch Gallery, New York

BIBLIOGRAPHY

Cawthon, Raad. "Samuel Mockbee's Vision in an Invisible World." *The Oxford American*, 41 (Fall 2001), pp. 56–61.

Jodidio, Philip. *Contemporary American Architects, volume IV.* Cologne: Taschen, 1998, pp. 124–25.

Mays, Vernon. "The Super Shed: Not Your Typical Dorm." *Architecture*, 89 (May 2000), pp. 192–99.

Pera, Brian. "At Home with the Harrises." *Nest Magazine*, Spring 2001, pp. 56–69.

Stewart, Doug. "Class Act." *Smithsonian*, 32 (October 2001), pp. 106–13.

SALON DE FLEURUS

Organized in 1992
Based in New York

EXHIBITIONS

2001 Gallery of Contemporary Art, Celje,
Slovenia, "Fiction Reconstructed"

Mücsarnok/Kunsthalle Budapest,
Hungary, "Fiction Reconstructed"

2000 Skuc Gallery, Ljubljana, Slovenia,
"Fiction Reconstructed"

1999 Karl Ernst Osthaus Museum, Hagen,
Germany, "Museum der Museen"

1992– Salon de Fleurus, New York
present

BIBLIOGRAPHY

Attila, Nemes, Júlia Fabényi, and Zsolt
Petrányi, eds. *Mücsarnok* (exhibition catalogue).
Budapest: Kunsthalle Budapest, 2001.

Cottingham, Laura. "New York Moves in
with Gertrude Stein." *The European*, November
1993.

Gržinić, Marina. "Salon de Fleurus in a
New York's Soho Apartment: From Fiction
to Virtuality." In *The Last Futurist Show: Salon de
Fleurus, K. Malevich, Armory Show, Globalization,
Politics, New Media Technology*. Ljubljana: Maska,
2001, pp. 10–19.

Levin, Kim. "Heal Thyself: Salon de Fleurus."
The Village Voice, January 19, 1993, p. 81.

KEITH SANBORN

Born in Wichita, Kansas, 1952
Lives in Brooklyn, New York

GROUP EXHIBITIONS

2001 Exit Art, New York, "Danger"

SCREENINGS

2001 47th International Short Film Festival,
Oberhausen, Germany

Pacific Film Archive, Berkeley,
California

2000 Centre Georges Pompidou and Scratch
Projection, Paris, "Monter/Sampler,
l'enchantillage généralisée"

European Media Arts Festival,
Osnabrück, Germany

Gallery 101, Ottawa, Ontario,
"Corps Parlants/Speaking Bodies"

Impakt Festival, Utrecht,
The Netherlands

29th International Film Festival
Rotterdam

6a Mostra de Video Independent &
Fenòmens Interactius, Centre de
Cultura Contemporànea de Barcelona,
Spain

1999 Whitney Museum of American Art,
New York, Part II, 1950–2000, of
"The American Century: Art & Culture
1900–2000"

BIBLIOGRAPHY

Beauvais, Yann, and Jean-Michel Bouhours.
"La Propriété, c'est le vol." In *Monter/Sampler,
l'enchantillage généralisée* (exhibition catalogue).
Paris: Centre Georges Pompidou and Scratch
Projection, 2000, pp. 18–34.

Camper, Fred. "The Memory of History:
Films by Wüst, Thompson, and Sanborn."
Chicago Reader, April 6, 2001, p. 18.

Dargis, Manohla. "The Deadman." *Artforum*,
28 (May 1990), pp. 29–30.

Gingras, Nicole. *Corps Parlant/Speaking Bodies*
(exhibition catalogue). Ottawa, Ontario:
Gallery 101, 2000.

Walworth, Dean. *Document & Dream*
(exhibition catalogue). New York: Artists
Sp 989.

PETER SARKISIAN

Born in Glendale, California, 1965
Lives in Santa Fe, New Mexico

ONE-ARTIST EXHIBITIONS

2001 I-20 Gallery, New York

2000 Picasso Museum, Antibes, France

1999 The Woodstreet Galleries at the
Pittsburgh Cultural Trust, Pennsylvania

1998 SITE Santa Fe

University Art Gallery, University
of California, San Diego

GROUP EXHIBITIONS

2001 Phoenix Art Museum, Arizona,
"Triennial Exhibition"

2000 Ackland Art Museum, University
of North Carolina at Chapel Hill,
"Illuminations: Contemporary Film
and Video Art"

Palm Beach Institute of Contemporary
Art, Florida, "Making Time: Considering
Time as a Material in Contemporary
Video and Film" (traveled)

Real Art Ways, Hartford, Connecticut,
"Moving Pictures"

La Rotonda della Besana, Milan,
"Rooms and Secrets"

BIBLIOGRAPHY

Amy, Michaël. "Peter Sarkisian at I-20."
Art in America, 86 (September 1998), p. 123.

Bonetti, David. "Sarkisian at Haines."
San Francisco Chronicle, August 11, 2001, p. D1.

Dikeou, Devon. "A Conversation with Peter
Sarkisian." *Zing Magazine*, 2 (Winter 1999),
p. 199.

Jarrett, Dennis. "Sarkisian, Sarkisian:
Eccentricity Runs in the Family. An Interview
with Paul and Peter Sarkisian." *Arté
Contemporary*, no. 1 (Fall 1999), pp. 41–48.

Kendricks, Neil. "Videodrome: Tony Oursler,
Peter Sarkisian and Bill Viola Expand the
Dynamics of Video Art." *Ray Gun*, no. 72
(October 1999), pp. 81–83.

JUDITH SCHAECHTER

Born in Gainesville, Florida, 1961
Lives in Philadelphia

ONE-ARTIST EXHIBITIONS

2000 Smålands Museum, Växjö, Sweden

Snyderman Gallery, Philadelphia

1999 Agni Fine Art, The Hague,
The Netherlands

1998 Pennsylvania Academy of the
Fine Arts, Philadelphia

GROUP EXHIBITIONS

2001 Heller Gallery, New York,
"The Glass Canvas"

1999 Tampa Museum of Art, Florida,
"Clearly Inspired: Contemporary
Glass and Its Origins"

1998 Philadelphia Museum of Art, "Twenty
Philadelphia Artists: Celebrating
Fleisher Challenge at Twenty"

Smithsonian Institution Traveling
Exhibition Service (SITES) (organizer),
"American Glass: Masters of the Art"
(traveled)

BIBLIOGRAPHY

Brown, Gerard. "Looking Through a Heart
of Glass." *Juxtapoz*, 7 (March–April 2000),
pp. 46–51.

Fitzpatrick, Laurie. "Judith Schaechter."
New Art Examiner, 22 (April 1995), p. 43.

Mills, Michael. "Breakthrough Glass."
New Times (Broward and Palm Beach),
December 23–29, 1999, p. 41.

Paine, Janice T. "Clearly Inspired:
Contemporary Glass and Its Origins." *American
Craft*, 59 (October–November 1999), pp. 106–7.

Scott, Bill. "Judith Schaechter at the ICA."
Art in America, 83 (November 1995), p. 120.

COLLIER SCHORR

Born in New York, 1963
Lives in Brooklyn, New York

ONE-ARTIST EXHIBITIONS

2001 303 Gallery, New York

2000 Emily Tsingou Gallery, London

1999 Georg Kargl, Vienna

Partobject Gallery, Carrboro,
North Carolina

303 Gallery, New York

GROUP EXHIBITIONS

2001 P.S. 1 Contemporary Art Center/
The Museum of Modern Art,
Long Island City, New York,
"Uniform: Order and Disorder"

White Cube, London, "Settings
and Players: Theatrical Ambiguity
in American Photography"

2000 CAPC Musée d'Art Contemporain
de Bordeaux, France, "Presumed
Innocent"

Contemporary Arts Center,
New Orleans, "Photography Now:
An International Survey of
Contemporary Photography"

Dee/Glasoe, New York, "Innuendo"

BIBLIOGRAPHY

Cotter, Holland. "Collier Schorr."
The New York Times, October 15, 1999, p. E37.

Hainley, Bruce. "Like a Man." *Artforum*, 37
(November 1998), pp. 96–99.

Saltz, Jerry. "Collier Schorr, 'The Sound of
One Hand.'" *Time Out New York*, April 9–16,
1998, p. 51.

Siegel, Katy. "Collier Schorr." *Artforum*, 38
(November 1999), pp. 141–42.

Valdez, Sarah. "Collier Schorr at 303 Gallery."
Art in America, 88 (February 2000), p. 127.

CHEMI ROSADO SEIJO

Born in Vega Alta, Puerto Rico, 1974
Lives in San Juan, Puerto Rico

ONE-ARTIST EXHIBITIONS

2001 Viota Galería de Arte, San Juan,
Puerto Rico

2000 Fundació Joan Miró, Barcelona

1998 Michelle Marxuach Galería,
San Juan, Puerto Rico

GROUP EXHIBITIONS

2001 M&M Proyecto, Madrid, "ARCO 2001"

Temporary Services, Chicago,
"Public Inventions & Interventions"

2000 Galería de Arte del Sagrado Corazón,
San Juan, Puerto Rico, "U/topistas"

Museo de Arte de Puerto Rico,
San Juan, "Un Oasis en el Desierto Azul"

1999 Museo de Arte Contemporáneo,
San Juan, Puerto Rico, "Juego/Tensión"

BIBLIOGRAPHY

U/topistas (exhibition catalogue). San Juan,
Puerto Rico: Michelle Marxuach Galería, 2000.

SILT

Organized in 1990
Based in San Francisco

CORE MEMBERS

Keith Evans
Born in Columbus, Ohio, 1965

Christian Farrell
Born in San Leandro, California, 1967

Jeff Warrin
Born in Plainfield, New Jersey, 1965

SCREENINGS

2001 Hunters Point Naval Shipyard,
San Francisco Cinematheque,
"Sink or Swim"

Pacific Film Archive, Berkeley,
California, "Touch Tones: Sound/Image
Works & Performance"

San Francisco Film Society, 44th
San Francisco International Film Festival

2000 Anthology Film Archives, New York,
"A Place Not Like Home"

CCAC Institute, Oakland, California,
"Black Box"

Headlands Center for the Arts, Marin
Headlands, California, "Heremusic"

1999 Exploratorium, San Francisco, "LBRTR:
Interference and Periodic Objects"

1998 Headlands Center for the Arts, Marin
Headlands, California, "Field Studies #2"

The Museum of Modern Art,
New York, "Big as Life: An American
History of 8mm Films"

BIBLIOGRAPHY

Camper, Fred. "Kuch Nai." *Chicago Reader*,
May 28, 1993, p. 4.

Gerhard, Susan. "Silt Filmmakers: Super-8
Spirituality." *San Francisco Bay Guardian*,
September 13–19, 1995, p. 43.

Johnston, Mark, and Leslie Holzman. "silt."
In *Contemporary Art in Northern California*,
San Francisco: Chronicle Books, 2002.

Ortiz, Selena. "Silt Speaks." *Headlands Center
for the Arts Calendar*, Summer 1998, n.p.

silt. "Silt...On Seven Giant Sea Turtles."
Cantrills Filmnotes, nos. 79–80 (November 1995),
pp. 67–70.

LORNA SIMPSON

Born in Brooklyn, New York, 1960
Lives in Brooklyn, New York

ONE-ARTIST EXHIBITIONS

2001 Sean Kelly Gallery, New York

University of Michigan Museum of Art,
Ann Arbor

2000 Addison Gallery of American Art,
Phillips Academy, Andover,
Massachusetts

1999 Walker Art Center, Minneapolis

1998 Galería Javier López, Madrid

GROUP EXHIBITIONS

2001 The Studio Museum in Harlem,
New York, "Red, Black and Green"

UCLA Hammer Museum, Los Angeles,
"I'm Thinking of a Place"

Whitney Museum of American Art at
Philip Morris, New York, "A Way with
Words: Selections from the Whitney
Museum of American Art"

2000 Contemporary Arts Center, New
Orleans, Louisiana, "Photography Now:
An International Survey of
Contemporary Photography"

The Museum of Modern Art, New York,
"Open Ends: Actual Size"

BIBLIOGRAPHY

Enwezor, Okwui. "Social Grace: The Work of
Lorna Simpson." *Third Text*, no. 35 (Summer
1996), pp. 43–58.

Feaster, Felicia. "Lorna Simpson." *New Art
Examiner*, 25 (December 1997–January 1998),
p. 53.

Hegarty, Laurence. "Gillian Wearing; Lorna
Simpson; Rosemarie Trockel." *Art Papers*, 22
(January–February 1998), p. 56.

Schwartz, Alexandra. "Lorna Simpson:
University of Michigan Museum of Art."
New Art Examiner, 28 (May–June 2001), p. 87.

Smith, Cherise. "Fragmented Documents:
Works by Lorna Simpson, Carrie Mae Weems,
and Willie Robert Middlebrook at the Art
Institute of Chicago." *Museum Studies*, 24
(1999), pp. 244–59, 271–72.

KIKI SMITH

Born in Nuremberg, Germany, 1954
Lives in New York

ONE-ARTIST EXHIBITIONS

2001 International Center of Photography,
New York

2000 John Berggruen Gallery, San Francisco

1999 Indianapolis Museum of Art

1998 Hirshhorn Museum and Sculpture
Garden, Smithsonian Institution,
Washington, D.C.

Mattress Factory, Pittsburgh

GROUP EXHIBITIONS

2000 MASS MoCA, North Adams,
Massachusetts, "Unnatural Science"

1999 Hirshhorn Museum and Sculpture
Garden, Smithsonian Institution,
Washington, D.C., "Regarding Beauty:
A View of the Late Twentieth Century"
(traveled)

Whitney Museum of American Art,
New York, Part II, 1950–2000, of
"The American Century: Art & Culture
1900–2000"

1998 List Visual Arts Center, Massachusetts
Institute of Technology, Cambridge,
"Mirror Images: Women, Surrealism,
and Self-Presentation" (traveled)

The Museum of Modern Art,
New York, "Giacometti to Judd:
Prints by Sculptors"

BIBLIOGRAPHY

Boxer, Sarah. "Fairy Tales in a Forest
of Women and Fruit." *The New York Times*,
April 27, 2001, pp. E30–31.

Kimmelman, Michael. "Making Metaphors
of Art and Bodies." *The New York Times*,
November 15, 1996, pp. C1, C22.

Landi, Ann. "Kiki Smith." *Art News*, 100
(June 2001), p. 128.

McQuaid, Cate. "Kiki Smith Beholds the
Animal Powers." *The Boston Globe*, February 11,
1999, p. E3.

Reilly, Maura. "Notes On Kiki Smith's
Fall/Winter." *Art Journal*, 58 (Winter 1999),
pp. 6–7.

GERRY SNYDER

Born in Nampa, Idaho, 1953
Lives in Santa Fe, New Mexico

GROUP EXHIBITIONS

2001 Bill Maynes Gallery, New York, "Salad Days"

1995 Apex Art, New York, "Diverse Group, One Direction"

1994 450 Broadway Gallery, New York, "Page 5"

STOM SOGO

Born in Osaka, Japan, 1975
Lives in San Francisco

SCREENINGS

2001 Lux Centre, London

8th New York Underground Film Festival

La Panadería, Mexico City, "Wish You Were Here: Mexican Films by Gringos"

2000 CEC International Partners and Anthology Film Archives, New York, "Avant-Garde Alternatives: The Evolution of American Experimental Film" (traveled)

The Film Society of Lincoln Center, New York, "Image Innovators: New Super 8 New York"

New York Film Festival, The Film Society of Lincoln Center

Ocularis at Galapagos Art & Performance Space, Brooklyn, "Flicks & Kicks"

Underground Film Festival, Vevey, Switzerland (traveled)

1999 Baktun, New York, "Casio '99"

1998 The Museum of Modern Art, New York, "Big as Life: An American History of 8mm Films"

BIBLIOGRAPHY

Frye, Brian. "En Garde: 'Views from the Avant-Garde' at the New York Film Festival." *The Independent Film & Video Monthly*, 24 (January–February 2001), pp. 18–19.

Halter, Ed. "Views from the Avant-Garde." *New York Press*, October 4–10, 2000, pp. 44, 46.

—. "Super 8 Supersized and Back on Track in New York Communities." *Indiewire*, May 3, 2000, www.indiewire.com/ film/festivals/fes_00Super8_000503_wrap.html.

Schwendener, Martha. "Tampering with the Reel." *Time Out New York*, July 17–24, 1997, p. 37.

Taubin, Amy. "Original Sins and Future Shock." *The Village Voice*, October 3, 2000, p. 232.

PHIL SOLOMON

Born in New York, 1954
Lives in Broomfield, Colorado

SCREENINGS

2001 European Media Arts Festival, Osnabrück, Germany

2000 38th Ann Arbor Film Festival, Michigan (traveled)

Black Maria Film and Video Festival: Nineteenth Annual, New Jersey City University (organizer), Jersey City (traveled)

Impakt Festival, Utrecht, The Netherlands

San Francisco Film Society, 43rd San Francisco International Film Festival

Viennale: Vienna International Film Festival

1999 The Museum of Modern Art, New York, "Cineprobe"

New York Film Festival, The Film Society of Lincoln Center

Whitney Museum of American Art, New York, Part II, 1950–2000, of "The American Century: Art & Culture 1900–2000"

1998 The Museum of Modern Art, New York, "Big as Life: An American History of 8mm Films"

BIBLIOGRAPHY

Brakhage, Stan. "Time...on Dit." *Musicworks*, no. 62 (Summer 1995), pp. 36–40.

Camper, Fred. "The Limits of Imagery." *Chicago Reader*, September 11, 1992, pp. 14, 25.

Holden, Stephen. "Marching in the Vanguard." *The New York Times*, October 9, 1999, p. B19.

Marks, Laura. "Loving a Disappearing Image." In *Touch: Sensuous Theory and Multisensory Media*. Minneapolis: University of Minnesota Press, 2002, pp. 132–55.

Solomon, Phil. "The Frame." *Millennium Film Journal*, no. 35–36 (Fall 2000), pp. 121–35.

SCOTT STARK

Born in Milwaukee, 1953
Lives in San Francisco

SCREENINGS

2001　New York Film Festival, The Film Society of Lincoln Center

San Francisco Cinematheque, "Don't Even Think: A Scott Stark Retrospective"

2000　Pacific Film Archive, Berkeley, California, "Awakening from the 20th Century...in San Francisco"

San Francisco Art Institute 8mm Film Festival

1999　The Museum of Modern Art, New York, "Big as Life: An American History of 8mm Films"

The Museum of Modern Art, New York, "Cineprobe"

Pacific Film Archive, Berkeley, California

San Francisco Museum of Modern Art, "Shake the Nation: San Francisco Experimental Film"

Whitney Museum of American Art, New York, Part II, 1950–2000, of "The American Century: Art & Culture 1900–2000"

1998　Chicago Filmmakers, Chicago Cultural Center, "Cultural Foreplay and Urban Sabotage"

BIBLIOGRAPHY

Camper, Fred. "Onion City Film Festival." *Chicago Reader*, September 14, 2001, p. 16.

Crouse, Edward E. "Goldies '98: Scott Stark." *San Francisco Bay Guardian*, September 23, 1998, p. 49.

Dixon, Wheeler Winston. *The Exploding Eye: A Re-visionary History of 1960s American Experimental Cinema.* Albany: State University of New York Press, 1997, pp. 204–5.

Holden, Stephen. "The Avant-Garde Lens, Heavenly and Harrowing." *The New York Times*, October 10, 1998, p. B18.

Marks, Laura U. "Outtakes at the Flaherty." *Afterimage*, 27 (September–October 1999), p. 5.

STEINA

Born in Reykjavík, Iceland, 1940
Lives in Santa Fe, New Mexico

ONE-ARTIST EXHIBITIONS

1999　The National Gallery of Iceland, Reykjavík

Philadelphia Museum of Art

1998　NTT InterCommunication Center, Tokyo (with Woody Vasulka)

GROUP EXHIBITIONS

2001　The Museum of Contemporary Photography, Chicago, "Audible Imagery"

2000　MASS MoCA, North Adams, Massachusetts, "Unnatural Science"

The Museum of Modern Art, New York, "Video Time"

The National Gallery of Iceland, Reykjavík, "New Worlds: Digital Visions"

1998　Harvestworks, New York, "Downtown Arts Festival"

SCREENINGS

2001　Moscow International Film Festival, "Media Forum"

2000　"Transmediale 2000," Berlin

BIBLIOGRAPHY

Baker, Kenneth. "Camera Turns on Itself." *San Francisco Chronicle*, February 20, 1996, p. D1.

Barden, Lane. "Image Medusas." *Artweek*, 25 (September 1994), pp. 19–20.

Kenton, Mary Jean. "Steina and Woody Vasulka." *Sculpture*, 16 (December 1997), p. 74.

Muchnic, Suzanne. "A Visit with the First Couple of Video Art." *Los Angeles Times*, July 30, 1994, p. F1.

Pagel, David. "Vasulka's Installations a One-two Punch." *Los Angeles Times*, September 1, 1994, p. F8.

Vasulka, Steina. "My Love Affair with Art: Video and Installation Work." *Leonardo*, 28 (1995), pp. 15–18.

BRIAN TOLLE

Born in Queens, New York, 1964
Lives in New York

ONE-ARTIST EXHIBITIONS

2000　Shoshana Wayne Gallery, Santa Monica, California

1999　Parsons School of Design, New York

1998　Basilico Fine Arts, New York

Schmidt Contemporary Art, Saint Louis, Missouri

GROUP EXHIBITIONS

2001　Queens Museum of Art, New York, "Crossing the Line"

Sonsbeek 9, Arnhem, The Netherlands, "LocusFocus" (public project)

2000　Stedelijk Museum voor Actuele Kunst, Ghent, Belgium, "Over the Edges: The Corners of Ghent"

1998　Kunsthalle Bern, Switzerland, "Genius Loci"

The Saatchi Collection, London, "Young Americans 2: New American Art at The Saatchi Gallery"

BIBLIOGRAPHY

Avgikos, Jan. "Brian Tolle." *Artforum*, 90 (October 1998), pp. 123–24.

Blackwell, Josh. "Brian Tolle at Shoshana Wayne." *Art Issues*, no. 63 (Summer 2000), p. 49.

Dunlap, David W. "Memorial to Hunger, Complete with Old Sod." *The New York Times*, March 15, 2001, pp. E1, E8.

Kaizen, William R. "Brian Tolle." *Bomb*, no. 76 (Summer 2001), pp. 56–63.

Scanlan, Joe. "Brian Tolle." *Frieze*, 33 (March–April 1997), pp. 85–86.

ROSIE LEE TOMPKINS

Born in Arkansas, 1936
Lives in Richmond, California

ONE-ARTIST EXHIBITIONS

1997 Berkeley Art Museum, Berkeley,
California

GROUP EXHIBITIONS

1999 CCAC Institute, San Francisco,
"Searchlight: Consciousness at the
Millennium"

1998 Kent State University School of Art
Gallery, Kent, Ohio, "Connecting
Threads: African Textiles and the
African American Quilt"

BIBLIOGRAPHY

Baker, Kenneth. "Group Show Aims a
'Searchlight' at Consciousness." *San Francisco
Chronicle*, September 25, 1999, p. E1.

Leonard, Pamela Blume. "Breaking the
Pattern: African-Americans Stretch Boundaries
of Quiltmaking." *The Atlanta Constitution*,
October 11, 1996, p. 10.

Lyles, C.Y. "Redesigning Cultural Roots:
Diversity in African-American Quilts." *Surface
Design Journal*, 20 (Spring 1996), pp. 13–14.

Smith, Richard. "Rosie Lee Tompkins
at the Berkeley Art Museum." *Artweek*, 28
(September 1997), p. 20.

Smith, Roberta. "Memo to Art Museums:
Don't Give up on Art." *The New York Times*,
December 3, 2000, pp. 2:1, 35.

LAURETTA VINCIARELLI

Born in Italy, 1943
Lives in New York

ONE-ARTIST EXHIBITIONS

1998 San Francisco Museum of Modern Art

BIBLIOGRAPHY

Hays, K. Michael. "Not Architecture But
Evidence that it Exists: A Note on Lauretta
Vinciarelli's Watercolors." *Assemblage*, no. 38
(April 1999), pp. 48–57.

Hodge, Brooke, et al. *Not Architecture But
Evidence that it Exists*. New York: Princeton
Architectural Press, 1998.

Stein, Karen D. "Imagined Spaces."
Architectural Record, 181 (September 1993),
pp. 106–9.

Woods, Lebbeus. "Lauretta Vinciarelli:
The Architecture of Light." *A+U: Architecture
and Urbanism*, 261 (June 1992), pp. 5–11.

STEPHEN VITIELLO

Born in New York, 1964
Lives in New York

ONE-ARTIST EXHIBITIONS

2001 Diapason, New York

2000 Dia Center for the Arts, New York
(Internet project)

Texas Gallery, Houston

GROUP EXHIBITIONS

2001 San Francisco Museum of Modern Art
(in collaboration with Goethe-Institut;
ZKM, Center for Art and Media,
Karlsruhe, Germany; and Walker Art
Center, Minneapolis) (Internet sound
project)

2000 The Project, New York, "Camille
Norment, Nadine Robinson,
Stephen Vitiello"

DISCOGRAPHY

2001 *Bright and Dusty Things*. San Francisco:
New Albion Records

17:48 at Texas Gallery. Houston:
Texas Gallery

2000 *Scratchy Marimba*. New York and
London: Sulfur U.S. and Sulfur U.K.

1999 *Uitti/Vitiello* (collaboration with
Frances-Marie Uitti). Amsterdam:
JDK Productions

BIBLIOGRAPHY

Cooke, Lynne. "Interview with Tony Oursler,
Stephen Vitiello, and Constance De Jong."
In Tony Oursler and Eckhard Schneider,
Tony Oursler (exhibition catalogue). Hannover,
Germany: Kunstverein, 1999, pp. 88–94.

Gann, Kyle. "It's Sound, It's Art and Some
Call It Music." *The New York Times*, January 9,
2000, p. 2:41.

Khazam, Rahma. "Stephen Vitiello's Art of
Noises Are a Moveable Feast." *The Wire*, no.
185 (July 1999), p. 76.

Vitiello, Stephen. "The View from Downtown:
Music from the 91st Floor." *The Wire*, no. 213
(November 2001), pp. 31–32.

CHRIS WARE

Born in Omaha, Nebraska, 1967
Lives in Chicago

ONE-ARTIST EXHIBITIONS

2000 Presspop Gallery, Kyoto

1999 Fumetto Luzerner Comix Festival,
Lucerne, Switzerland

1998 Galerie Année, Haarlem,
The Netherlands

GROUP EXHIBITIONS

2001 The Frances Lehman Loeb Art
Center, Vassar College, Poughkeepsie,
New York, "Summer Reading"

Roq La Rue, Seattle, "Dan Clowes &
Chris Ware"

1999 Cultureel Centrum Romaanse Poort,
Leuven, Belgium, "Daniel Clowes/
Chris Ware"

PUBLICATIONS

The ACME Novelty Library, Nos. 1–15. Seattle:
Fantagraphics Books, 1993–2001.

"Apartment Building." Monthly comic strip
for Hangar 21 (Switzerland), 2000–01.

Jimmy Corrigan, The Smartest Kid on Earth,
New York: Pantheon Books, 2000.

Quimby: A One-Mouse Theater of the Absurd.
Seattle: Fantagraphics Books, 2001.

BIBLIOGRAPHY

Branigan, Tanya. "Cartoon Strip Seeks to
be the First of the First Books." The Guardian,
August 24, 2001, p. 7.

Bulka, Michael. "Chicago's Last Five Minutes
of Art History: There's Something Funny
Going On." New Art Examiner, 26 (October
1998), pp. 16–19.

Edwards, Gavin. "Cool Book: Chris Ware."
Rolling Stone, 866 (April 12, 2001), p. 108.

Nadel, Daniel. "Jimmy Corrigan, The Smartest
Kid on Earth." Graphis, 57 (May–June 2001),
p. 13.

Strauss, Neil. "Creating Literature, One Comic
Book at a Time: Chris Ware's Graphic Tales
Mine His Own Life and Heart." The New York
Times, April 4, 2001, p. E1.

OUATTARA WATTS

Born in Abidjan, Ivory Coast, 1957
Lives in New York

ONE-ARTIST EXHIBITIONS

2001 Magazzino d'Arte Moderna, Rome

1999 Magazzino d'Arte Moderna, Rome

1998 Baldwin Gallery, Aspen, Colorado

GROUP EXHIBITIONS

2001 Gorney Bravin & Lee, New York

Katonah Museum of Art, New York,
"Constellations: Jazz and Visual
Improvisations"

Museum Villa Stuck, Munich,
"The Short Century: Independence
and Liberation Movements in Africa"

1999 Ackland Art Museum, University
of North Carolina at Chapel Hill,
"Transatlantic Dialogue: Contemporary
Art In and Out of Africa" (traveled)

1998 Art for the World (organizer),
P.S. 1 Contemporary Art Center, Long
Island City, and the United Nations,
New York, "The Edge of Awareness"

BIBLIOGRAPHY

Cotter, Holland. "Claudia and Julia Mueller,
Olu Oguibe, Senam Okudzeto, Ouattara
Watts." The New York Times, July 27, 2001, p. E29.

—. "Mix of Cultures, Politics and Bravado."
The New York Times, May 19, 1995, p. C30.

Heartney, Eleanor. "Ouattara at 65
Thompson." Art in America, 84 (January 1996),
p. 98.

Kalman, Vanessa Rae. "See the Music."
Smock, 1 (Summer 2000), pp. 92–97.

PETER WILLIAMS

Born in Nyack, New York, 1952
Lives in Detroit

ONE-ARTIST EXHIBITIONS

2001 Revolution Gallery, Detroit

2000 Meadow Brook Art Gallery, Oakland
University, Rochester, Michigan

1999 A.R.C. Gallery, Chicago

GROUP EXHIBITIONS

2001 Detroit Contemporary, "Sex"

The Detroit Institute of Arts,
"A Celebration of Black Cultures"

2000 Paint Creek Center for the Arts,
Rochester, Michigan, "German
Art/Michigan Art"

1999 Center Galleries, Center for Creative
Studies, Detroit, "On the Verge of
Abstraction"

Houghton House Galleries, Hobart
and William Smith Colleges, Geneva,
New York, "Looking Forward, Looking
Black" (traveled)

BIBLIOGRAPHY

Carducci, Vincent. "Peter Williams's Black
Humor." New Art Examiner, 29 (November–
December 2001), pp. 66–73.

Colby, Joy Hakanson. "Peter Williams Paints
with Passion About His Experiences as a Black
Man." Detroit News, February 23, 2001, p. E11.

Crawford, Lynn. "Peter Williams at
Revolution." Art in America, 89 (September
2001), p. 159.

Isaak, Jo Anna, ed. Looking Forward,
Looking Black (exhibition catalogue). Geneva,
New York: Hobart and William Smith
Colleges Press, 1999.

Rizk, Mysoon. "Peter Williams: Meadow
Brook Art Gallery." New Art Examiner, 28
(February 2001), p. 56.

ANNE WILSON

Born in Detroit, 1949
Lives in Evanston, Illinois

ONE-ARTIST EXHIBITIONS

2001 Aurobora Press, San Francisco
Revolution Gallery, Detroit

2000 Museum of Contemporary Art, Chicago

1999 The Museum for Textiles
Contemporary Gallery, Toronto
(collaboration with A.B. Forster)

1998 Revolution Gallery, Detroit (traveled)

GROUP EXHIBITIONS

2001 University Art Gallery, University of
California, San Diego, "Obsessions"

2000 Boulder Museum of Contemporary Art,
Colorado, "Colorado 2000"

1999 Angel Row Gallery, Nottingham,
England, "Textures of Memory:
The Poetics of Cloth" (traveled)

1998 Bowdoin College Museum of Art,
Brunswick, Maine, "Memorable
Histories and Historic Memories"

1997 Arizona State University Art Museum,
Tempe, "Art on the Edge of Fashion"
(traveled)

BIBLIOGRAPHY

Heartney, Eleanor. "Anne Wilson at
Revolution." Art in America, 87 (March 1999),
pp. 114–15.

Hixson, Kathryn. Anne Wilson: Body into Culture
(exhibition catalogue). Madison, Wisconsin:
Madison Art Center, 1993.

Nawrocki, Dennis Alan. "Anne Wilson."
New Art Examiner, 26 (December 1998–January
1999), p. 63.

Sorkin, Jenni. "Anne Wilson." Make (London),
no. 89 (September–November 2000), pp. 34–35.

Ullrich, Polly. "Anne Wilson." Sculpture, 20
(March 2001), pp. 63–64.

LEBBEUS WOODS

Born in Lansing, Michigan, 1940
Lives in Brooklyn, New York

ONE-ARTIST EXHIBITIONS

2000 Henry Urbach Architecture, New York
Intersection for the Arts, San Francisco
Rosenwald-Wolf Gallery, The University
of the Arts, Philadelphia

1998 MU Art Foundation, Eindhoven,
The Netherlands

GROUP EXHIBITIONS

2000 Cooper-Hewitt, National Design
Museum, Smithsonian Institution,
New York, "Design Culture Now:
National Design Triennial"

Martin-Gropius-Bau, Berlin,
"Seven Hills: Images and Signs of
the 21st Century"

The Museum of Contemporary Art,
Los Angeles, "At the End of the
Century: One Hundred Years of
Architecture" (traveled)

1999 Kunsthalle Düsseldorf, Germany,
"Metaforms: Deconstructivist Positions
in Architecture and Art"

BIBLIOGRAPHY

Hartley, Christine Schwartz. "Henry Urbach:
Building a Market for Architecture."
Art & Auction, 21 (April 15, 1999), p. 26.

Muschamp, Herbert. "Ideazapoppin': Images
Fly at Cooper-Hewitt." The New York Times,
March 10, 2000, p. E35.

Porcu, Michèle. "Lebbeus Woods: Architecture
is War, War is Architecture." Abitare, no. 362
(May 1997), pp. 115–17.

Schumacher, Donna. "San Francisco."
Art Papers, 24 (July–August 2000), p. 46.

Woods, Lebbeus. "Wild City." Architectural
Design, 69 (July–August 1999), pp. 70–73.

FRED WORDEN

Born in New York, 1946
Lives in Silver Spring, Maryland

SCREENINGS

2001 30th International Film Festival
Rotterdam

New York Film Festival, The Film
Society of Lincoln Center

Pacific Film Archive, Berkeley,
California, "New/Re/View 3"

Toronto International Film Festival

2000 Centre Georges Pompidou, Paris,
"A la Rencontre avec Fred Worden"

European Media Arts Festival,
Osnabrück, Germany

29th International Film Festival
Rotterdam

The Museum of Modern Art, New York,
"Cineprobe"

Pacific Film Archive, Berkeley,
California, "Strangely Moving:
Experimental Animation"

1999 Whitney Museum of American Art,
New York, Part II, 1950–2000, of
"The American Century: Art & Culture
1900–2000"

BIBLIOGRAPHY

Dargis, Manohla. "Counter Currents."
The Village Voice, January 31, 1989, p. 68.

Jacobs, Ken. "Film in the Nineties." Film
Comment, 30 (January–February 2000), p. 56.

Taubin, Amy. "Fred Worden: A Program of
Film and Video." The Village Voice, March 16,
1999, p. 88.

JENNIFER ZACKIN

Born in Waterbury, Connecticut, 1970
Lives in Brooklyn, New York

GROUP EXHIBITIONS
(WITH SANFORD BIGGERS)

2001 Arizona State University Art Museum,
Tempe, "Not Quite Myself Today:
Video Works by Eight Artists"

The Studio Museum in Harlem,
New York, "Freestyle" (traveled)

2000 Maryland Institute College of Art,
Baltimore, "Culture of Class: Issues
of Class in North American Culture"

BIBLIOGRAPHY

Cotter, Holland. "A Full Studio Museum Show
Starts with 28 Young Artists and a Shoehorn."
The New York Times, May 11, 2001, p. E36.

Griffin, Tim. "Race Matters." *Time Out New
York*, May 24–31, 2001, pp. 55–56.

Stevens, Mark. "In Brief." *New York Magazine*,
34 (May 21, 2001), p. 82.

Viveros-Faune, Christian. "Freestyle." *New York
Press*, May 30–June 5, 2001, pp. 32–33.

ZHANG HUAN

Born in An Yang City, He Nan Province,
China, 1965
Lives in Queens, New York

ONE-ARTIST EXHIBITIONS

2001 Luhring Augustine, New York
The Power Plant, Toronto

1999 Artspace, Sydney, Australia
Max Protetch Gallery, New York

GROUP EXHIBITIONS

2001 Pacifico Yokohama, Japan,
"Yokohama 2001: International
Triennale of Contemporary Art"

1999 48th Venice Biennale

1998 San Francisco Museum of Modern
Art and the Asia Society, New York,
"Inside Out: New Chinese Art" (traveled)

PERFORMANCES

2001 Museo das Peregrinacións,
Santiago de Compostela, Spain

2000 National Gallery of Australia, Canberra

1998 P.S. 1 Contemporary Art Center,
Long Island City, New York

BIBLIOGRAPHY

Anton, Saul. "Zhang Huan: Maoist Mask
of an Anonymous Everyman." *Flash Art*,
32 (Summer 1999), p. 96.

Hung, Wu. "Speaking the Unspeakable."
In *Transience: Chinese Experimental Art at the
End of the Twentieth Century*. Chicago:
The David and Alfred Smart Museum of Art,
1999, pp. 102–7.

Olesen, Alexa. "Making Art of Masochism
and Tests of Endurance." *The New York Times*,
November 11, 2001, p. AR3.

Smith, Roberta. "Zhang Huan."
The New York Times, February 12, 1999, p. E2.

Zhijian, Qian. "Performing Bodies: Zhang
Huan, Ma Liuming, and Performance Art
in China." *Art Journal*, 71 (Summer 1999),
pp. 60–71.

JOHN ZURIER

Born in Santa Monica, California, 1956
Lives in Berkeley, California

ONE-ARTIST EXHIBITIONS

2001 Larry Becker Contemporary Art,
Philadelphia

2000 Gallery Paule Anglim, San Francisco

1999 Aurobora Press, San Francisco

GROUP EXHIBITIONS

2001 Berkeley Art Museum, Berkeley,
California, "Minimalism: Then
and Now"

Gallery Paule Anglim, San Francisco,
"Louise Fishman/John Zurier," 2001

1999 Barbara Davis Gallery, Houston,
"Paintings"

1998 Armory Center for the Arts, Pasadena,
California, "Practice and Process:
New Painterly Abstraction in California"

CCAC Institute, Oakland, California,
"Undercurrents and Overtones"

BIBLIOGRAPHY

Baker, Kenneth. "Paintings Move Toward
the Vanishing Point." *San Francisco Chronicle*,
January 8, 2000, pp. B1, B6.

—. "Deborah Butterfield, John Zurier."
Art News, 93 (October 1994), p. 194.

Bonnetti, David. "Return of the Abstract
at Mills College." *San Francisco Examiner*,
December 6, 1996, p. C3.

Martin, Victoria. "'Practice and Process: New
Painterly Abstraction' at the Armory Center
for the Arts." *Artweek*, 29 (April 1998), p. 24.

Webster, Mary Hull. "Anne Appleby, Gregg
Renfrow and John Zurier at Arts Benecia
Center Gallery." *Artweek*, 27 (April 1996),
pp. 19–20.

WORKS IN THE EXHIBITION*

*as of December 21, 2001

Dimensions are in inches followed
by centimeters; height precedes width
precedes depth.

PEGGY AHWESH
She Puppet, 2001
Video, color, sound; 15 minutes

BOSMAT ALON AND TIRTZA EVEN
Kayam Al Hurbano (Existing on Its Ruins), 1999
Digital video, color, sound; 35 minutes
Sound design by Brian Karl

JOSÉ ALVAREZ
In perpetuity throughout the Universe, 2001
Multimedia installation, dimensions variable
Collection of the artist

MARYANNE AMACHER
Excerpts: Neurophonic Exercises, 2002
DVD surround sound mix; approximately
12 minutes
Previously unreleased

ARCHIVE (CHRIS KUBICK AND ANNE WALSH)
A Visit with Joseph Cornell, 2002
Digital audio, approximately 10 minutes
Previously unreleased

GREGOR ASCH (DJ OLIVE THE AUDIO JANITOR)
Roof Music: Sunrise on a Rooftop in Brooklyn, 2001
DVD surround sound mix; 11:11 minutes
Previously unreleased
Produced by Gregor Asch at Skin Tone
Riddles, Brooklyn, New York, © G. Asch 2001

IRIT BATSRY
*These Are Not My Images
(Neither There Nor Here)*, 2000
Video, color, sound; 80 minutes
Soundtrack by Stuart Jones

ROBERT BEAVERS
The Painting, 1972–99
35mm film, color, sound; 12 minutes

Work Done, 1972–99
35mm film, color, sound; 22 minutes

The Ground, 2001
35mm film, color, sound; 20 minutes

ZOE BELOFF
A Mechanical Medium, 2000
Stereoscopic séance with live sound by Gen
Ken Montgomery. Performance for Model B

Kodascope 16mm film projector, stereoscopic
slide projector, 3-D slides, 78 rpm hand-
cranked phonograph, Tri-Signal Telegraph
Unit Toy, pocket Theramin, and sine-wave
generator

Shadow Land or Light from the Other Side, 2000
16mm stereoscopic film, black-and-white,
sound; 32 minutes

SANFORD BIGGERS AND JENNIFER ZACKIN
a small world…, 1999
Video installation, dimensions variable;
6 1/2 minutes
Collection of the artists

SUSAN BLACK
Heaven on Earth, 2001
Video, color, sound; 3 minutes

JEREMY BLAKE
Winchester, 2001–02
16mm film, drawings, and digital artwork
transferred to DVD, sound, dimensions
variable
Collection of the artist; courtesy Feigen
Contemporary, New York

AA BRONSON
Felix Partz, June 5, 1994, 1994 and 1999
Lacquer on vinyl, 84 x 168 (213.4 x 426.7)
Collection of the artist

JAMES BUCKHOUSE
in collaboration with Holly Brubach
Tap, 2002
Website with downloadable components
for screen saver and PDAs (personal digital
assistants)
Beaming station
Commissioned by Dia Center for the Arts,
New York
Presented in cooperation with Creative Time,
with support from Palm, Inc. and hi beam

JAVIER CAMBRE
Habitat en Tránsito: Piñones (Displaced), 2002
Wood, paint, graphite wall drawings,
hammock, and wood shack, dimensions
variable
Collection of the artist; with support from
Milly and Chilo Andreu, John T. Belk III and
Margarita Serapión, Diana and Moisés

Berezdivin, Compañiá de Turismo de Puerto Rico, Alfredo Cubiñá, Mari and Alberto De la Cruz, Luis Gutiérrez and Carmen Bermúdez, Chetin and Pedro Muñoz Marín, Instituto de Cultura Puertorriqueña

JIM CAMPBELL

5th Avenue cutaway #1, 2001
LEDs, custom electronics, and treated Plexiglas, 22 x 30 x 12 (55.9 x 76.2 x 30.5)
Collection of the artist; courtesy Hosfelt Gallery, San Francisco
Made with the financial assistance of the Daniel Langlois Foundation for Art, Science, and Technology

5th Avenue cutaway #2, 2001
LEDs, custom electronics, and treated Plexiglas, 22 x 30 x 12 (55.9 x 76.2 x 30.5)
Collection of the artist; courtesy Hosfelt Gallery, San Francisco
Made with the financial assistance of the Daniel Langlois Foundation for Art, Science, and Technology

5th Avenue cutaway #3, 2001
LEDs, custom electronics, and treated Plexiglas, 22 x 30 x 4 (55.9 x 76.2 x 10.2)
Collection of the artist; courtesy Hosfelt Gallery, San Francisco
Made with the financial assistance of the Daniel Langlois Foundation for Art, Science, and Technology

KARIN CAMPBELL

When I Close My Eyes, 2001–02
Performance

PETER CAMPUS

Death Threat: Receiving Radiation, Disappearance, Death Threat, 2000
Video, color, sound; 11 minutes
Courtesy Electronic Arts Intermix, New York

VIJA CELMINS

Untitled (Web), 2000
Oil on canvas, 15 1/4 x 18 (38.7 x 45.7)
Collection of Lyn and Gerald Grinstein

Web #2, 2000–01
Oil on linen, 15 x 18 (38.1 x 45.7)
Private collection, New York

CHAN CHAO

Htun Htun Naing and Maung Nyo, May 1997, 2001
Chromogenic color print, 36 x 26 (91.4 x 66)
Collection of the artist; courtesy Numark Gallery, Washington, D.C.

Kyaw Htoo and Robey, June 1997, 2001
Chromogenic color print, 36 x 26 (91.4 x 66)
Collection of the artist; courtesy Numark Gallery, Washington, D.C.

Member of KNLA, August 1996, 2001
Chromogenic color print, 36 x 26 (91.4 x 66)
Collection of the artist; courtesy Numark Gallery, Washington, D.C.

Sein Win Tin and Nay Htoo, June 1997, 2001
Chromogenic color print, 36 x 26 (91.4 x 66)
Collection of the artist; courtesy Numark Gallery, Washington, D.C.

Solomon, January 1998, 2001
Chromogenic color print, 36 x 26 (91.4 x 66)
Collection of the artist; courtesy Numark Gallery, Washington, D.C.

Thaung Han and Myat Soe, May 1997, 2001
Chromogenic color print, 36 x 26 (91.4 x 66)
Collection of the artist; courtesy Numark Gallery, Washington, D.C.

Thaung Tin and Friend, May 1997, 2001
Chromogenic color print, 36 x 26 (91.4 x 66)
Collection of the artist; courtesy Numark Gallery, Washington, D.C.

Trin Taw Liang, January 1998, 2001
Chromogenic color print, 36 x 26 (91.4 x 66)
Collection of the artist; courtesy Numark Gallery, Washington, D.C.

Win Soe, May 1997, 2001
Chromogenic color print, 36 x 26 (91.4 x 66)
Collection of the artist; courtesy Numark Gallery, Washington, D.C.

Young Buddhist Monk, June 1997, 2001
Chromogenic color print, 36 x 26 (91.4 x 66)
Collection of the artist; courtesy Numark Gallery, Washington, D.C.

Young Recruit for CNF, January 1998, 2001
Chromogenic color print, 36 x 26 (91.4 x 66)
Collection of the artist; courtesy Numark Gallery, Washington, D.C.

RICHARD CHARTIER

series, 2000
Digital audio; 12:21 minutes
Three excerpts from the CD *series*.
Brooklyn, New York: Line, 2000

TONY COKES

2@, 2000
Video, color, sound; 6 1/2 minutes
Courtesy Electronic Arts Intermix, New York

STEPHEN DEAN

Pulse, 2001
DVD projection, sound, dimensions variable; 7 1/2 minutes
Collection of the artist; courtesy Henry Urbach Architecture, New York

DESTROY ALL MONSTERS COLLECTIVE

Strange Früt: Rock Apocrypha, 2000–01
Installation including:

Amazing Freaks of the Motor City, 2000
Acrylic on canvas, 96 x 138 (243.8 x 350.5)
Collection of the artists; courtesy Patrick Painter Inc., Santa Monica, California

Greetings from Detroit, 2000
Acrylic on canvas, 120 x 228 (304.8 x 579.1)
Collection of the artists; courtesy Patrick Painter Inc., Santa Monica, California

The Heart of Detroit by Moonlight, 2000
Acrylic on canvas, 120 x 204 (304.8 x 518.2)
Collection of the artists; courtesy Patrick Painter Inc., Santa Monica, California

Mall Culture, 2000
Acrylic on canvas, 96 x 138 (243.8 x 350.5)
Collection of the artists; courtesy Patrick Painter Inc., Santa Monica, California

Strange Früt: Rock Apocrypha, 2000
Single-channel video on DVD, sound; 60 minutes
Collection of the artists; courtesy Patrick Painter Inc., Santa Monica, California

KEITH EDMIER

Emil Dobbelstein and Henry Drope, 1944, 2002
Bronze and granite, 96 1/2 x 34 x 34 (245.1 x 86.4 x 86.4)
Collection of the artist; a project of the Public Art Fund program *In the Public Realm*, which is

supported by the National Endowment for
the Arts, The New York State Council on the
Arts, a State Agency, the New York City
Department of Cultural Affairs, the Office
of the Brooklyn Borough President, The
Greenwall Foundation, The Silverweed
Foundation, The JPMorgan Chase Foundation,
and friends of the Public Art Fund
Special thanks to Friedrich Petzel Gallery
Whitney Biennial in Central Park, Organized
by the Public Art Fund; sponsored by
Bloomberg

OMER FAST
Glendive Foley, 2000
Two-channel video installation, surround
sound, dimensions variable
Collection of the artist

VINCENT FECTEAU
Untitled, 1999
Foamcore, collage, and plastic,
4 x 17 x 15 (10.2 x 43.2 x 38.1)
Collection of Marc Foxx

Untitled, 1999
Foamcore, collage, paper, and metal,
6 3/8 x 12 5/8 x 6 3/8 (16.2 x 32.1 x 16.2)
Collection of the artist; courtesy Feature Inc.,
New York

Untitled, 1999
Foamcore, collage, and mixed media,
6 1/2 x 12 3/4 x 10 1/2 (16.5 x 32.4 x 26.8)
Collection of Kenneth L. Freed

Untitled, 2000
Foamcore, papier-mâché, acrylic, and enamel,
16 x 14 1/4 x 14 (40.6 x 36.2 x 35.6)
Collection of Kenneth L. Freed

Untitled, 2001
Foamcore, papier-mâché, acrylic, balsa wood,
wood, and rope, 14 x 15 3/8 x 5 (35.6 x 39.1 x
12.7)
Collection of Rena Conti and Dr. Ivan
Moskowitz

KEN FEINGOLD
If/Then, 2001
Silicone, pigment, fiberglass, steel, and
electronics, 24 x 28 x 24 (61 x 71.1 x 61)
Collection of the artist; courtesy Postmasters
Gallery, New York

ROBERT FENZ
Soledad: Meditations on Revolution III, 2001
16mm film, black-and-white, silent;
15 minutes

MARY FLANAGAN
[collection], 2001
Networked software, computer, projector,
projection surface
Production engineer: Christopher Egert

GLEN FOGEL
Reflex, 1999
Hand-processed Super-8 film, color, sound;
3 1/2 minutes

Endless Obsession, 2000
Video transferred to Super-8 film, color,
sound; 5 minutes

Ascension, 2001
Video transferred to 16mm film,
superimposed film and gelled light
projection, color, sound; 6 minutes

Control Sequences, 2001
Video and Super-8 film, superimposed film
and video projection, black-and-white and
colored gels, sound; 6 minutes

FORCEFIELD
Third Annual Roggabogga, 2002
Mixed-media installation, dimensions variable
Collection of the artists

BENJAMIN FRY
Valence, 1999
Networked software, computer, screen

BRIAN FRYE
Oona's Veil, 2000
16mm film, black-and-white, sound;
8 minutes

Wormwood's Dog and Monkey Show, 2001
16mm film, black-and-white, sound;
11 minutes

DAVID GATTEN
*Moxon's Mechanick Exercises, or, The Doctrine of
Handy-Works Applied to the Art of Printing*, 1999
16mm film at 18 fps, black-and-white, silent;
26 minutes

JOE GIBBONS
Confessions of a Sociopath, 2001
Video and Super-8 film transferred to video,
color and black-and-white, sound; 60 minutes

LUIS GISPERT
Remix (Extended Beats), 2001
Walnut, mahogany, cherry, redwood, maple,
leather, fur, speakers, chrome rims, and
rhinestones, dimensions variable. Collection
of the artist; courtesy Massimo Audiello,
New York

Untitled (Single Floating Cheerleader), 2001
Fujiflex print mounted on aluminum,
72 x 40 (182.9 x 101.6)
Collection of the artist; courtesy Massimo
Audiello, New York

Untitled (Three Asian Cheerleaders), 2001
Fujiflex print mounted on aluminum,
40 x 72 (101.6 x 182.9)
Collection of the artist; courtesy Massimo
Audiello, New York

GOGOL BORDELLO
*Transylvanian Rural Avant-Hard
(Occurrence on the Border)*, 2002
Performance

JANINE GORDON
I'm a human bomb, 2001
Nine gelatin silver prints, 72 x 108
(182.9 x 274.3) overall
Collection of the artist; courtesy Refusalon,
San Francisco

Left, Right, Hook, 2001
Three gelatin silver prints, 60 x 24
(152.4 x 60.9) overall
Collection of the artist; courtesy XL Xavier
LaBoulbenne, Berlin

Plant your feet on the ground and propel, 2001
Gelatin silver print, 30 x 40 (76.2 x 101.6)
Collection of the artist; courtesy Refusalon,
San Francisco

Tesaõ, 2001
Two gelatin silver prints, 20 x 48
(50.8 x 121.9) overall
Collection of the artist; courtesy XL Xavier
LaBoulbenne, Berlin

ALFRED GUZZETTI
The Tower of Industrial Life, 2000
Digital video, color, sound; 15 minutes

TRENTON DOYLE HANCOCK
The Life and Death of #1, 2001
Mixed media on canvas, 80 x 108
(203.2 x 274.3)
Neuberger Berman Collection; courtesy James
Cohan Gallery, New York, and Dunn and
Brown Contemporary, Dallas

Rememor with Membry, 2001
Collage, pieced acrylic on canvas, 60 1/8 x 72 1/2
(152.7 x 184.2)
Whitney Museum of American Art, New York;
purchase, with funds from the Contemporary
Committee 2001.229

RACHEL HARRISON
Bustle in Your Hedgerow, 1999
Wood, polystyrene, cement, Parex, and
chromogenic color print from digital file of
Elizabeth Taylor from *The National Enquirer*,
64 1/2 x 97 x 27 (163.8 x 246.4 x 68.6)
Collection of Laura Steinberg and Bernardo
Nadal Ginard

The Fourth Shade, 2000
Wood, cardboard, plaster, lamp, and
chromogenic color print, 85 x 32 x 24 3/4
(215.9 x 81.3 x 62.8)
Collection of Laura Steinberg and Bernardo
Nadal Ginard

Unplugged, 2000
Wood, electrical outlet, and chromogenic
color print of Michael Jackson touching a
rabbi's head, 68 x 40 x 24 (172.7 x 101.6 x 61)
Collection of Diane and David Waldman

TIM HAWKINSON
Mirror, 1999
Polyurethane on canvas,
76 x 16 1/2 x 2 (193 x 41.9 x 5.1)
Collection of Akira Ikeda

Emoter, 2002
Photo collage, monitor, and various
mechanical components, two parts: 36 x 48
(91.4 x 122); 68 x 17 x 30 (172.7 x 43.2 x 76.2)
Collection of the artist; courtesy Ace Gallery,
Los Angeles

Taper, 2002
Photo collage, 36 x 72 (91.4 x 182.9)
Collection of the artist; courtesy Ace Gallery,
Los Angeles

ARTURO HERRERA
At Your Side, 2000
Wool felt, 65 x 240 (165.1 x 609.6)
Marieluise Hessel Collection on permanent
loan to the Center for Curatorial Studies, Bard
College, Annandale-on-Hudson, New York

EVAN HOLLOWAY
Gray Scale, 2000
Tree branches, paint, and metal,
78 x 30 x 100 (198.1 x 76.2 x 254)
Collection of Kenneth L. Freed

Wildly Painted Warped Lumber #2, 2000
Wood, painted steel, and celvinyl,
63 x 11 x 96 (160 x 27.9 x 243.8)
Collection of the artist; courtesy Marc Foxx,
Los Angeles

Symmetry Demonstration, 2001
Metal, paper, paint, and graphite,
34 x 40 x 47 (86.4 x 101.6 x 119.4)
Collection of the artist; courtesy Marc Foxx,
Los Angeles

DENNIS HOPPER
Homeless, 2000
Digital video, color, sound; 9 minutes

PETER HUTTON
Time and Tide, 2001
16mm film, color and black-and-white, silent;
35 minutes

KEN JACOBS
Flo Rounds a Corner, 1999
Digital video, color, silent; 6 minutes

Crystal Palace (Chandeliers For The People),
A Nervous Magic Lantern Performance, 2000
Animated magic lantern, color, sound;
approximately 40 minutes

CHRISTIAN JANKOWSKI
The Holy Artwork, 2001
Featuring Pastor Peter Spencer, Harvest
Fellowship Church, San Antonio, Texas
DVD projection, sound, dimensions variable;
16 1/2 minutes

Collection of the artist; courtesy Maccarone
Inc., New York, and Klosterfelde, Berlin;
originally commissioned by ArtPace,
A Foundation for Contemporary Art,
San Antonio, Texas

LISA JEVBRATT/C5
1:1, 1999
Website, computer, screen
New Museum of Contemporary Art, New York

YUN-FEI JI
Dinner at the Forbidden City, 2001
Mineral pigment on rice paper, 54 x 67
(137.2 x 170.2)
Collection of the artist; courtesy Pierogi,
Brooklyn, New York

The Garden of Double Happiness, 2001
Mineral pigment on rice paper, two parts,
27 1/4 x 111 1/2 (69.2 x 283.2) each
Collection of the artist; courtesy Pierogi,
Brooklyn, New York

*A Monk's Meditation on a Woman's Vagina Being
Interrupted*, 2001
Mineral pigment on rice paper, 19 x 108
(48.3 x 274.3)
Collection of the artist; courtesy Pierogi,
Brooklyn, New York

CHRIS JOHANSON
*This is a picture about the place we live in called
Earth that is inside of this place we call space*, 2002
Wood, acrylic paint, latex paint, and wire,
dimensions variable
Collection of the artist; courtesy Jack Hanley
Gallery, San Francisco

MIRANDA JULY
Nest of Tens, 2000
Video, color, sound; 27 minutes

The Drifters, 2002
Digital audio; approximately 20 minutes
Music by Zac Love
Recorded by Tim Renner
Previously unreleased

YAEL KANAREK
World of Awe, 2000
Website, computer, screen

MARGARET KILGALLEN
Main Drag, 2001
Mixed-media installation, dimensions variable
(adapted for the Whitney Museum)
Courtesy the artist's estate and Deitch
Projects, New York

KIM SOOJA
Deductive Object, 2002
Korean bedcovers, dimensions variable
Collection of the artist, commissioned by
the Public Art Fund
Whitney Biennial in Central Park, Organized
by the Public Art Fund; sponsored by Bloomberg

DIANE KITCHEN
Wot the Ancient Sod, 2001
16mm film, color, silent; 17 minutes

JOHN KLIMA
EARTH, 2001
Networked software, two user stations,
projection surface, projector
Courtesy Postmasters Gallery, New York

MARK LAPORE
The Glass System, 2000
16mm film, color, sound; 20 minutes

ROBERT LAZZARINI
payphone, 2002
Mixed media, 108 x 84 x 48 (274.3 x 213.4 x
121.9)
Collection of the artist; courtesy Pierogi,
Brooklyn, New York

JOHN LEAÑOS
*Remembering Castration: Bloody Metaphors
in Aztlán*, 2000
Multimedia installation, dimensions variable
Collection of the artist

MARGOT LOVEJOY
with Hal Eagar, Jon Legere, and Marek Walczak
Turns, 2001
Website, computer, screen

VERA LUTTER
Friedrichshafen, Harbour, I: August 22–23, 1999,
1999
Unique camera obscura gelatin silver print,

55 x 133 (139.7 x 337.8)
Collection of the artist; courtesy Fraenkel
Gallery, San Francisco

Frankfurt Airport, XIII: May 2, 2001, 2001
Unique camera obscura gelatin silver print,
86 x 168 (218.4 x 426.7)
Collection of the artist; courtesy Fraenkel
Gallery, San Francisco

CHRISTIAN MARCLAY
Drumkit, 1999
Altered drum kit, 163 x 60 x 72 (414 x 152.4 x
182.9)
Collection of the artist; courtesy Paula Cooper
Gallery, New York

Lip Lock, 2000
Altered tuba and pocket trumpet, 34 1/2 x 20 x
18 (87.6 x 50.8 x 45.7)
Collection of the artist; courtesy Paula Cooper
Gallery, New York

Prosthesis, 2000
Silicone rubber and metal guitar stand,
44 x 13 x 2 1/2 (111.8 x 33 x 6.4)
Collection of the artist; courtesy Paula Cooper
Gallery, New York

Vertebrate, 2000
Altered acoustic guitar, 26 1/2 x 15 1/2 x 11
(67.3 x 39.4 x 27.9)
Collection of the artist; courtesy Paula Cooper
Gallery, New York

Virtuoso, 2000
Altered Titano accordion, 300 (762) length
Collection of the artist; courtesy Paula Cooper
Gallery, New York

ARI MARCOPOULOS
Globe 1, 1999
Ink-jet print, 36 x 48 (91.4 x 121.9)
Collection of the artist

Hole in the Wall (detail), 1999
Ink-jet print, 49 x 33 (124.5 x 83.8)
Collection of the artist

It was a good day, 1999
Ink-jet print, 36 x 28 (91.4 x 71.1)
Collection of the artist

Juneau, AK, 1999
Ink-jet print, 33 x 49 (83.8 x 124.5)
Collection of the artist

Michi, 1999
Ink-jet print, 36 x 28 (91.4 x 71.1)
Collection of the artist

Mushroom Hike, 1999
Ink-jet print, 33 x 49 (83.8 x 124.5)
Collection of the artist

Stockholm, 1999
Ink-jet print, 36 x 28 (91.4 x 71.1)
Collection of the artist

Untitled (Phone and Tickets), 1999
Ink-jet print, 36 x 28 (91.4 x 71.1)
Collection of the artist

Checking the Line, 2000
Ink-jet print, 33 x 49 (83.8 x 124.5)
Collection of the artist

Eero, 2000
Ink-jet print, 33 x 49 (83.8 x 124.5)
Collection of the artist

Johan, 2000
Ink-jet print, 36 x 28 (91.4 x 71.1)
Collection of the artist

Mosquito, 2000
Ink-jet print, 36 x 25 (91.4 x 63.5)
Collection of the artist

Cordova Peak, 2001
DVD, sound; 3 minutes
Collection of the artist

Tokyo Dome, 2001
Lambda print, 30 x 45 (76.2 x 114.3)
Collection of the artist

BRUCE MCCLURE
Indeterminate Focus, 1999
16mm film for prepared projector, color,
sound; 12 minutes

Quarter Draw, 2001
Four 16mm black-and-white film loops for
four projectors, and rotary gels, color, sound;
length variable

*Section Through a Cone Taken Down with No
Regard for Frames Then Projected at 24 Frames Per
Second*, 2001
16mm film, color, silent; 12 minutes

XXX, OXX, XOX, XXO (Slapdash Slapstick), 2001
Three 16mm black-and-white film loops for
four projectors, and rotary gels, color, sound;
length variable

CONOR McGRADY

Boots, 2000
Compressed charcoal on paper, 20 x 28 (50.8 x 71.1)
Collection of the artist; courtesy NFA Space, Chicago

Door, 2000
Ink on paper, 9 x 12 (22.9 x 30.5)
Collection of the artist; courtesy NFA Space, Chicago

Drain, 2000
Compressed charcoal on paper, 20 x 28 (50.8 x 71.1)
Collection of the artist; courtesy NFA Space, Chicago

Entertainment, 2000
Compressed charcoal on paper, 20 x 28 (50.8 x 71.1)
Collection of the artist; courtesy NFA Space, Chicago

Flags, 2000
Gouache on paper, 14 x 17 (35.6 x 43.2)
Collection of the artist; courtesy NFA Space, Chicago

Floor, 2000
Ink on paper, 9 x 12 (22.9 x 30.5)
Collection of the artist; courtesy NFA Space, Chicago

Inspection, 2000
Compressed charcoal on paper, 20 x 28 (50.8 x 71.1)
Collection of Alberto Guevara

Oath, 2000
Compressed charcoal on paper, 20 x 28 (50.8 x 71.1)
Collection of the artist; courtesy NFA Space, Chicago

Penetrate, 2000
Compressed charcoal on paper, 20 x 28 (50.8 x 71.1)
Collection of the artist; courtesy NFA Space, Chicago

Tribunal, 2000
Compressed charcoal on paper, 20 x 28 (50.8 x 71.1)
Collection of the artist; courtesy NFA Space, Chicago

Unconquered, 2000
Compressed charcoal on paper, 20 x 28 (50.8 x 71.1)
Collection of the artist; courtesy NFA Space, Chicago

MEREDITH MONK

Eclipse Variations, 2000
DVD surround sound mix; 6:11 minutes
Performed by Theo Bleckmann, Katie Geissinger, Meredith Monk, Ennis Smith (voices); Allison Sniffin (esraj); John Hollenbeck (drum pad)
Commissioned by Starkland for its 2000 surround sound *Immersion* DVD-Audio recording

JULIE MOOS

Friends and Enemies: Drew and Monica, 1999–2000
Chromogenic color print, 48 x 68 (121.9 x 172.7)
Collection of the artist; courtesy Fredericks Freiser Gallery, New York

Friends and Enemies: Kristin and Abby, 1999–2000
Chromogenic color print, 48 x 68 (121.9 x 172.7)
Collection of the artist; courtesy Fredericks Freiser Gallery, New York

Friends and Enemies: Will and Trae, 1999–2000
Chromogenic color print, 48 x 68 (121.9 x 172.7)
Collection of the artist; courtesy Fredericks Freiser Gallery, New York

Domestic: Betty and Toni, 2001
Chromogenic color print, 40 x 52 (101.6 x 132.1)
Collection of the artist; courtesy Fredericks Freiser Gallery, New York

Domestic: Mae and Margaret, 2001
Chromogenic color print, 40 x 52 (101.6 x 132.1)
Collection of the artist; courtesy Fredericks Freiser Gallery, New York

Domestic: Martin and Raymond, 2001
Chromogenic color print, 40 x 52 (101.6 x 132.1)
Collection of the artist; courtesy Fredericks Freiser Gallery, New York

TRACIE MORRIS

sound(e)scapes, 2002
Digital audio; approximately 10 minutes
Previously unreleased

MARK NAPIER

Riot, 1999
Web browser, computer, screen

ROBERT NIDEFFER

PROXY, 2001
Networked software, website

ANDREW NOREN

Time Being, 2001
Digital video, black-and-white and color, silent and sound; 58 minutes

JOSH ON & FUTUREFARMERS

They Rule, 2001
Website, computer, screen

ROXY PAINE

Bluff, 2002
Stainless steel, 50 ft. (15.2 m) height
Collection of the artist, commissioned by the Public Art Fund; special thanks to James Cohan Gallery, New York
Whitney Biennial in Central Park, Organized by the Public Art Fund; sponsored by Bloomberg

HIRSCH PERLMAN

Day 1.1, Day 1.2, Day 2.1, Day 4.2, Day 6.4, Day 6.6, Day 13.1, Day 16.1, Day 21.3, Day 23.2, Day 23.4, Day 23.5, Day 28.3, Day 30.4, Day 31.5, Day 33.1, Day 33.2, Day 33.4, Day 35.1, Day 44.1, Day 44.5, Day 48.3, Day 49.1, Day 52.1, Day 53.1, Day 53.2, Day 57.2, Day 71.3, Day 71.4, Day 71.6, Day 79.4, Day 79.6, Day 83.3, Day 93.1, Day 93.4, Day 100.1, Day 101.2, Day 120.1, Day 145.1, Day 147.1, Day 147.4, Day 147.6, Day 148.4, Day 150.1, Day 148.1, Day 146.1, Day 86.6, Day 148.2, 1998–2001
Forty-eight gelatin silver prints, vinyl, tape, paint, and pushpins, 24 x 30 (61 x 76.2) or 30 x 24 (76.2 x 61) each
Collection of the artist; courtesy Blum & Poe, Santa Monica, California, and Donald Young Gallery, Chicago

LEIGHTON PIERCE

The Back Steps, 2001
Digital video, color, sound; 5 1/2 minutes

WILLIAM POPE.L
The Great White Way: 22 miles, 5 years,
1 street, 2002
Performance
Courtesy The Project, New York and
Los Angeles

PRAXIS (DELIA BAJO AND
BRAINARD CAREY)
The New Economy, 1999–2002
Performance

SETH PRICE
"Painting" Sites, 2001
Video projection, color, sound; 20 minutes

WALID RA'AD/THE ATLAS GROUP
The Loudest Muttering Is Over: Documents from
The Atlas Group Archive, 2001–02
Performance

LUIS RECODER
Available Light: Yellow-Red, 1999
16mm film at 18 fps, color, silent; 15 minutes

Available Light: Blue-Violet, 2000
16mm film at 18 fps, color, silent; 15 minutes

Available Light: Shift, 2001
16mm double-projection film, color, silent;
12 minutes

Glass: Liquid Light, 2001
16 mm filmless film, white light, sound; 15
minutes

Space, 2001
16mm cinemascope film, color, sound;
14 minutes

ERWIN REDL
MATRIX VI, 2002
LED installation, dimensions variable
Collection of the artist
Installation is sponsored by a grant from
The Greenwall Foundation; in-kind support
is provided by Cotco International Ltd. and
Marktech Optoelectronics. Additional support
is provided by the Austrian Federal Chancellery;
the Austrian Cultural Forum, New York; and
the Art Council of Lower Austria.

MARINA ROSENFELD
Delusional Situation, 2002
DVD surround sound mix; approximately
9 minutes
Previously unreleased

THE RURAL STUDIO
Mason's Bend Community Center, Hale County,
Alabama, completed August 2000
Bass wood
Model, 12 x 24 x 36 (30.5 x 61 x 91.4)
Base, 50 x 33 x 47 (127 x 83.8 x 119.4)
Collection of The Rural Studio; courtesy
Max Protetch Gallery, New York

East Entrance to the Community Center, 2000
Photograph by Timothy Hursley
Chromogenic color print, 11 x 14 (27.9 x 35.6)
Courtesy Timothy Hursley

Interior Gathering Space, 2000
Photograph by Timothy Hursley
Chromogenic color print, 11 x 14 (27.9 x 35.6)
Courtesy Timothy Hursley

West Entrance to the Community Center, 2000
Photograph by Timothy Hursley
Chromogenic color print, 11 x 14 (27.9 x 35.6)
Courtesy Timothy Hursley

Windshield Wall, 2000
Photograph by Timothy Hursley
Chromogenic color print, 11 x 14 (27.9 x 35.6)
Courtesy Timothy Hursley

Newbern Baseball Club, Hale County, Alabama,
completed May 2001
Bass wood
Model, 10 x 36 x 60 (25.4 x 91.4 x 152.4)
Base, 36 x 36 x 60 (91.4 x 91.4 x 152.4)
Collection of The Rural Studio; courtesy
Max Protetch Gallery, New York

Newbern Tigers Dugout, 2001
Photograph by Timothy Hursley
Chromogenic color print, 11 x 14 (27.9 x 35.6)
Courtesy Timothy Hursley

Refrigerator Box Seating and Newbern Tigers
Dugout, 2001
Photograph by Timothy Hursley
Chromogenic color print, 11 x 14 (27.9 x 35.6)
Courtesy Timothy Hursley

Visiting Team Bench and Bleachers, 2001
Photograph by Timothy Hursley
Chromogenic color print, 11 x 14 (27.9 x 35.6)
Courtesy Timothy Hursley

Visitors Dugout from Bleachers, 2001
Photograph by Timothy Hursley
Chromogenic color print, 11 x 14 (27.9 x 35.6)
Courtesy Timothy Hursley

Lucy's House, Hale County, Alabama, to be
completed May 2002
Bass wood
Model, 12 x 24 x 33 (30.5 x 61 x 83.8)
Base, 50 x 28 x 37 (127 x 71.1 x 94)
Collection of The Rural Studio; courtesy
Max Protetch Gallery, New York

Drawings by Samuel Mockbee:
Obliquity of the Ecliptic, 2001
Mixed media on paper, 18 x 24 (45.7 x 61)
Courtesy the artist's estate and
Max Protetch Gallery, New York

Tupac, One Love, 2001
Mixed media on paper, 18 x 24 (45.7 x 61)
University of Alabama, College of Arts and
Sciences

SALON DE FLEURUS
Salon de Fleurus, 41 Spring Street #1AR,
New York City, 1992–present
Mixed-media installation, dimensions variable
Biennial hours: open by appointment only,
Wednesday–Saturday, 8–10 pm
For appointments, please call (212) 334-4952,
11 am–1 pm.

Vitrine, 2002
Mixed-media installation, dimensions variable
Collection of Salon de Fleurus, New York

KEITH SANBORN
For the Birds, 2000
Digital video, black-and-white, sound;
8 minutes

PETER SARKISIAN
Hover, 1999
Video installation with mixed media, sound,
dimensions variable
Collection of the artist; courtesy I-20 Gallery,
New York

JUDITH SCHAECHTER
PaleOval, 1999
Stained glass in lightbox, 29 x 25 (73.7 x 63.5)
Collection of Morgan Lawrence

Speech Balloon, 1999
Stained glass in lightbox, 28 x 24 (71.1 x 61)
Collection of the artist; courtesy Snyderman
Gallery, Philadelphia

Rejects, 2000
Stained glass in lightbox, 26 x 33 (66 x 83.8)
Collection of Richard Vague

Bigtop Flophouse Bedspins, 2001
Stained glass in lightbox, 28 x 38 (71.1 x 96.5)
Claire Oliver Fine Art, New York

COLLIER SCHORR
*An Accounting of Jens F. (Notes from the Helga/
Jens Project)*, 1999–2002
Chromogenic color prints, gelatin silver
prints, and graphite and ink on paper,
twenty-eight parts, 12 x 21 (30.5 x 53.3) each
Collection of the artist; courtesy 303 Gallery,
New York

CHEMI ROSADO SEIJO
Tapando para ver, 1999–2002
Charcoal on paper on newspaper, wood,
and wire, dimensions variable
Collection of the artist, Marta Gutiérrez, Fam.
Andreu Pietri, Teruca Rullán, John T. Belk III
and Margarita Serapión, and Armando Viota

Para TV, 2000/2002
Single-channel video
Collection of the artist; courtesy M & M
Proyectos, San Juan, Puerto Rico

SILT
All Pieces of a River Shore, 2002
Film installation and performance with
Super-8, 16mm, and 35mm film, color and
black-and-white, live sound, multiple Super-8
and 16mm projectors, hand-cranked 35mm
projector, and multiple sculptural screens;
approximately 30 minutes

LORNA SIMPSON
Easy to Remember, 2001
16mm film transferred to DVD, sound;
2 1/2 minutes
Commissioned by the Whitney Museum of
American Art, New York, and Cartier Inc.
Presented to Philip H. Geier, Jr., Chairman
Emeritus, The Interpublic Group of
Companies, Inc.

Untitled (Music Box), 2001
Mechanical music box, CD, CD player, and
amplifier, 13 x 11 (33 x 27.9) overall
Commissioned by the Whitney Museum of
American Art, New York, and Cartier Inc.
Presented to Philip H. Geier, Jr., Chairman
Emeritus, The Interpublic Group of
Companies, Inc.

KIKI SMITH
Kneeling Harpy, 2001
Bronze, 31 x 10 x 17 (78.7 x 25.4 x 43.2)
Collection of the artist; courtesy
PaceWildenstein, New York
Whitney Biennial in Central Park,
Organized by the Public Art Fund;
sponsored by Bloomberg

Sirens, 2001
Bronze, dimensions variable
Collection of the artist; courtesy
PaceWildenstein, New York
Whitney Biennial in Central Park,
Organized by the Public Art Fund;
sponsored by Bloomberg

Squatting Harpy, 2001
Bronze, 32 x 17 x 16 (81.3 x 43.2 x 40.6)
Collection of the artist; courtesy
PaceWildenstein, New York
Whitney Biennial in Central Park,
Organized by the Public Art Fund;
sponsored by Bloomberg

Standing Harpy, 2001
Bronze, 49 x 17 x 15 (124.5 x 43.2 x 38.1)
Collection of the artist; courtesy
PaceWildenstein, New York
Whitney Biennial in Central Park,
Organized by the Public Art Fund;
sponsored by Bloomberg

GERRY SNYDER
Main Feature, 2001
Oil on panel, triptych, 32 x 32 (81.3 x 81.3)
each panel
Collection of the artist

Story Development, 2001
Water-based oil on watercolor paper, triptych,
38 x 28 (96.5 x 71.1) each
Collection of the artist

STOM SOGO
Problem's You, 1997–2001
Super-8 film at 18 fps, black-and-white and
color, silent; 27 minutes

Guided by Voices, 1999–2000
Video and Super-8 film transferred to digital
video, color, sound; 12 minutes

PHIL SOLOMON
Twilight Psalm II: "Walking Distance", 1999
16mm film, color, sound; 23 minutes

SCOTT STARK
Angel Beach, 2001
16mm film at 18 fps, color, silent; 27 minutes

STEINA
Trevor, 1999
Video, color, sound; 11 minutes
Courtesy Electronic Arts Intermix, New York

BRIAN TOLLE
Waylay, 2002
Mixed media, dimensions variable
Collection of the artist; commissioned by
the Public Art Fund
Whitney Biennial in Central Park,
Organized by the Public Art Fund;
sponsored by Bloomberg

ROSIE LEE TOMPKINS
Half-Squares, 2000
Quilted fabric, 46 x 26 (116.8 x 66)
Collection of Eli Leon

Half-Squares, 2001
Quilted fabric, 100 x 70 (254 x 177.8)
Collection of Eli Leon

Half-Squares, 2001
Quilted fabric, 107 x 40 (271.8 x 101.6)
Collection of Eli Leon

LAURETTA VINCIARELLI
Luminous Void Volume of Light #1, 2001
Watercolor on paper, 30 x 22 (76.2 x 55.9)
Collection of the artist

Luminous Void Volume of Light #2, 2001
Watercolor on paper, 30 x 22 (76.2 x 55.9)
Collection of the artist

Luminous Void Volume of Light #3, 2001
Watercolor on paper, 30 x 22 (76.2 x 55.9)
Collection of the artist

Luminous Void Volume of Light #4, 2001
Watercolor on paper, 30 x 22 (76.2 x 55.9)
Collection of the artist

Luminous Void Volume of Light #5, 2001
Watercolor on paper, 30 x 22 (76.2 x 55.9)
Collection of the artist

Luminous Void Volume of Light #6, 2001
Watercolor on paper, 30 x 22 (76.2 x 55.9)
Collection of the artist

Luminous Void Volume of Light #7, 2001
Watercolor on paper, 30 x 22 (76.2 x 55.9)
Collection of the artist

STEPHEN VITIELLO
World Trade Center Recordings: Winds After Hurricane Floyd, 1999/2002
DVD surround sound mix; 8:20 minutes
Previously unreleased
Collection of the artist; courtesy The Project,
New York and Los Angeles

CHRIS WARE
Untitled (original drawings for *The ACME Novelty Library*), 1999–2000
India ink and white gouache on
Bristol board, dimensions variable
Collection of the artist

Untitled (original drawings for *Jimmy Corrigan, The Smartest Kid on Earth*), 1999–2000
India ink and white gouache on board,
15 x 23 3/4 (38.1 x 60.3) each
Collection of the artist

Assembled cut-out paper objects from
The ACME Novelty Library, 1999–2001
Ink and glue on paper, dimensions variable
Collection of the artist

Untitled sketchbook pages, 1999–2002
Ink, watercolor, and correction fluid on paper,
9 x 11 (22.9 x 27.9)
Collection of the artist

Jimmy Corrigan, The Smartest Kid on Earth,
New York: Pantheon Books, 2000
Hardcover book
Collection of the artist

The ACME Novelty Library, Seattle:
Fantagraphics Books, 2001
Softcover book
Collection of the artist

OUATTARA WATTS
Face of God, 2000
Mixed media, silkscreen, and fabric on
canvas, 118 x 157 1/2 (299.7 x 400)
Collection of the artist; courtesy Gagosian
Gallery, New York

Untitled, 2000–01
Mixed media and photographs on canvas,
98 x 92 1/2 (248.9 x 234.9)
Collection of the artist

Creation of the World, 2001
Mixed media, photographs, wood, and jumper
cable on canvas, 113 x 157 1/2 (287 x 400)
Collection of the artist

PETER WILLIAMS
Esplanier, 2001
Oil on canvas, 60 x 72 (152.4 x 182.9)
Collection of the artist; courtesy Revolution
Gallery, Detroit

Jasper's Last Breath, 2001
Oil on canvas, 72 x 96 (182.9 x 243.8)
Collection of the artist; courtesy Revolution
Gallery, Detroit

ANNE WILSON
Topologies (3-5.02), 2002
Lace, thread, cloth, pins, and painted wood
support, dimensions variable
Collection of the artist; courtesy Revolution
Gallery, Detroit

LEBBEUS WOODS
Terrain 1–10, 1999
Sanded paper collages with electrostatic print,
ink, graphite, pastel, and colored pencil,
ten parts, 19 1/4 x 23 1/4 (49 x 59.2) each
Collection of the artist; courtesy Henry
Urbach Architecture, New York

Excavation, 2002
Illuminated wood and Plexiglas with
three polystyrene models, 72 x 18 x 36
(182.9 x 45.7 x 91.4) overall
Collection of the artist; courtesy Henry
Urbach Architecture, New York

FRED WORDEN
The Or Cloud, 2001
16mm film, black-and-white, silent; 6 minutes

ZHANG HUAN
My New York, 2002
Performance

JOHN ZURIER
Hematite #4, 1998–2000
Oil on linen, 26 x 18 (66 x 45.7)
Collection of the artist; courtesy Gallery Paule
Anglim, San Francisco

MAZ 1, 2000
Oil on canvas, 93 x 126 (236.2 x 320)
Collection of the artist; courtesy Gallery Paule
Anglim, San Francisco

Oblaka 31, 2001
Oil on linen, 24 x 36 (61 x 91.4)
Collection of the artist; courtesy Gallery Paule
Anglim, San Francisco

Oblaka 44, 2001
Oil on linen, 20 x 16 (50.8 x 40.6)
Collection of the artist; courtesy Gallery Paule
Anglim, San Francisco

PHOTOGRAPH AND REPRODUCTION CREDITS

© Ace Gallery: 102; The Atlas Group: 178; Patterson Beckwith: 73; Geoffrey Clements: 25; Paula Court: 185; Dennis Cowley: 166; Kathy Cullen: 49; © Luc Demers 2001: 173; Aaron Diskin: 217; Charles Eshelman © 2001: 26; Harrell Fletcher: 122; Courtesy Greene Naftali Inc., New York: 101; Donald Greenhaus: 220; Robert Lee Hughie: 157; © Timothy Hursley: 186; Courtesy Sean Kelly Gallery, New York: 202; Lamay Photo, courtesy Friedrich Petzel Gallery: 66; Herbert Lotz: 206; Courtesy the artist and Luhring Augustine, New York: 237; Johnna MacArthur: 222; © Gerard Malanga: 26; Original photo by Eric Mattson: 57; Laura McPhee: 134; Courtesy MIT Media Laboratory, Aesthetics + Computation Group © 1999–2002: 82; Courtesy the artist: 153; Courtesy the artist and NFA Space, Chicago: 150; Fredrik Nilsen: 62; Tom Powel: 145; Praxis: 174; Lidith Ramos: 198; Courtesy the artist: 182; Sharon Risedorph Photography: 218; Joseph Santarromana: 25; Daniel Sheriff: 93; Lee Jong Soo: 129; John Bigelow Taylor, NYC, courtesy McKee Gallery, New York: 53; Tim Thayer: 229; Joshua White: 169; Ellen Page Wilson: 205

ACKNOWLEDGMENTS

The curators wish to thank the following individuals: Dominic Angerame, Canyon Cinema; Matthew Arnett, Tinwood Books; Paul Arnett, Tinwood Books; William Arnett, Tinwood Books; Bill Arning, MIT List Visual Arts Center; Anne Arrasmith, Space One Eleven; Michael Auping, Modern Art Museum of Fort Worth; Alex Baker, Pennsylvania Academy of the Fine Arts; John Ballinger, Midway Initiative Gallery; Sharon Bates, Albany International Airport Gallery; Robert Beck, Electronic Arts Intermix; Ian Berry, The Tang Teaching Museum and Art Gallery; Teresa Bramlette; Kathy Brew, Lower Manhattan Cultural Council; Susan Cahan; Amy Cappelazzo; Julie Ann Cavnor, Maryland Art Place; Susan R. Channing, Spaces; Hilary Chartrand, California College of Arts and Crafts; Rebecca Cleman, Electronic Arts Intermix; Dennis Cooper; Amada Cruz, Center for Curatorial Studies and Art in Contemporary Culture, Bard College; Sarah Cunningham, Albany Center Galleries; Dean Daderko, Parlour Projects; Rosa de la Cruz; Peter Dubeau, School 33 Art Center; Jody Elff; Will Eggleston of Genelec Inc.; Bradley Eros; Courtney Fink, California College of Arts and Crafts; Jane Fonda; Ira Friedman of JBA; Patrick Friel, Chicago Filmmakers; Dana Friis-Hansen, Austin Museum of Art; Boo Froebel; Louis Grachos, SITE Santa Fe; Suzy Greenberg, Soo Visual Arts Center; Dara Greenwald, Video Data Bank, School of The Art Institute of Chicago; Jeffrey D. Grove, The Cleveland Museum of Art; Marina Gržinić; Ed Halter, New York Underground Film Festival; J. Heickes, The Waiting Room; Joseph Holtzman, *Nest Magazine*; Stuart Horodner, Portland Institute for Contemporary Art; Kate Horsfield, Video Data Bank, School of The Art Institute of Chicago; Billy Howard, Howard House; Michael Hoyt, Intermedia Arts; Randolph Hudson of Broadness; Scott Hull at Classic Sound; Galen Joseph-Hunter, Electronic Arts Intermix; Kathryn Kanjo, ArtPace; Sean Kelley, Grand Arts; Marilu Knode, Institute of Visual Arts, University of Wisconsin, Milwaukee; Paul Kotula, Revolution; Mauricio Laffitte-Soler; Jane Livingston; Abina Manning, Video Data Bank, School of The Art Institute of Chicago; Anthony Marcellini, It Can Change; Michelle Marxuach; John Massier, Hallwalls Contemporary Arts Center; Vincent Mazeau of Big Room; Elizabeth McDade, Rochester Contemporary; Kate Midgett, The Project Room, Philadelphia; Laurence Miller; Margaret A. Miller, University of South Florida Contemporary Art Museum; Helen Molesworth,

The Baltimore Museum of Art; Paola Morsiani, Contemporary
Arts Museum, Houston; Dave Muller; Michael Oatman; Dónal Ó
Céilleachair, Ocularis; Linda Pace, ArtPace; Tim Peterson, Franklin
Art Works; Carolina Ponce de León, Galería de la Raza; Peter Prinz,
Space One Eleven; Jack Rasmussen, Maryland Art Place; John
Rasmussen, Midway Initiative Gallery; Karyn Riegel, Ocularis;
David S. Rubin, Contemporary Arts Center New Orleans; Mark
Russell, P.S. 122; M.M. Serra, New York Film Makers' Cooperative;
Francesco X. Siqueiros; Terri Smith, Cheekwood Botanical Garden
and Museum of Art; Arthur Solway, James Cohan Gallery; John D.
Spiak, Arizona State University Art Museum; Matthew Stadler;
John Thomson, Electronic Arts Intermix; Aaron Timlin, Detroit
Contemporary; Sara Tucker, Dia Center for the Arts; Pedro Velez;
Haydee Venegas; Philippe Vergne, Walker Art Center; Robin
and Carolyn Wade; Alvia J. Wardlaw, The Museum of Fine Arts,
Houston; Martha Wilson, Franklin Furnace Archive Inc.; Matt
Wobensmith; Christina Yang, The Kitchen Center for Video,
Music, Dance, Performance, Film and Literature; and Lori Zippay,
Electronic Arts Intermix.

WHITNEY MUSEUM OF AMERICAN ART
OFFICERS AND TRUSTEES*

Leonard A. Lauder, *Chairman*

Joel S. Ehrenkranz, *President*

Robert J. Hurst, *Vice Chairman*

Emily Fisher Landau, *Vice Chairman*

Thomas H. Lee, *Vice Chairman*

Robert W. Wilson, *Vice Chairman*

Samuel J. Heyman, *Vice President*

Adriana Mnuchin, *Vice President*

Joanne Leonhardt Cassullo, *Secretary*

Raymond J. McGuire, *Treasurer*

Maxwell L. Anderson, *Director*

Steven Ames

Daniel C. Benton

Melva Bucksbaum

Joan Hardy Clark

Chuck Close

Beth Rudin DeWoody

Fiona Donovan

Arthur Fleischer, Jr.

Aaron I. Fleischman

Henry Louis Gates, Jr.

Philip H. Geier, Jr.

Sondra Gilman Gonzalez-Falla

James A. Gordon

Ulrich Hartmann

J. Tomilson Hill

George S. Kaufman

Henry Kaufman

Michael L. Klein

L. Dennis Kozlowski

Raymond J. Learsy

John A. Levin

Faith G. Linden

Gilbert C. Maurer

Brooke Garber Neidich

Veronique Pittman

Steven Roth

Henry R. Silverman

Laurie Tisch Sussman

Thomas E. Tuft

Flora Miller Biddle, *Honorary Trustee*

B.H. Friedman, *Honorary Trustee*

Susan Morse Hilles, *Honorary Trustee*

Michael H. Irving, *Honorary Trustee*

Roy R. Neuberger, *Honorary Trustee*

Marvin G. Suchoff, *Assistant Treasurer*

Marilou Aquino, *Assistant Secretary*

*as of October 3, 2001

This exhibition and publication were organized by Lawrence R. Rinder, Anne and Joel Ehrenkranz Curator of Contemporary Art; Chrissie Iles, curator of film and video; Christiane Paul, adjunct curator of new media arts; Debra Singer, associate curator of contemporary art; Kirstin Bach, Biennial coordinator; Glenn Phillips, former Biennial coordinator; Elizabeth Fleming, Biennial assistant; Evelyn Hankins, curatorial assistant; Henriette Huldisch, curatorial coordinator, film and video; Tanya Leighton, curatorial assistant; Chris Perez, curatorial assistant; and Alexander Villari, grantswriter.

This publication was produced by the Publications and New Media Department at the Whitney Museum: Garrett White, director of Publications and New Media; *Editorial*: Susan Richmond, managing editor; Thea Hetzner, assistant editor; Libby Hruska, assistant editor; *Design*: Makiko Ushiba, senior graphic designer; Christine Knorr, graphic designer; *Production*: Vickie Leung, production manager; *Rights and Reproductions*: Anita Duquette, manager, rights and reproductions; Jennifer Belt, photographs and permissions coordinator; Carolyn Ramo, Publications and New Media assistant.

Catalogue Design: J. Abbott Miller and Roy Brooks, Pentagram
Project Manager: Kate Norment
Editor: David E. Brown
Printing: Gardner Lithograph, Buena Park, California
Binding: Roswell Bookbinding, Phoenix, Arizona
Printed and bound in the United States